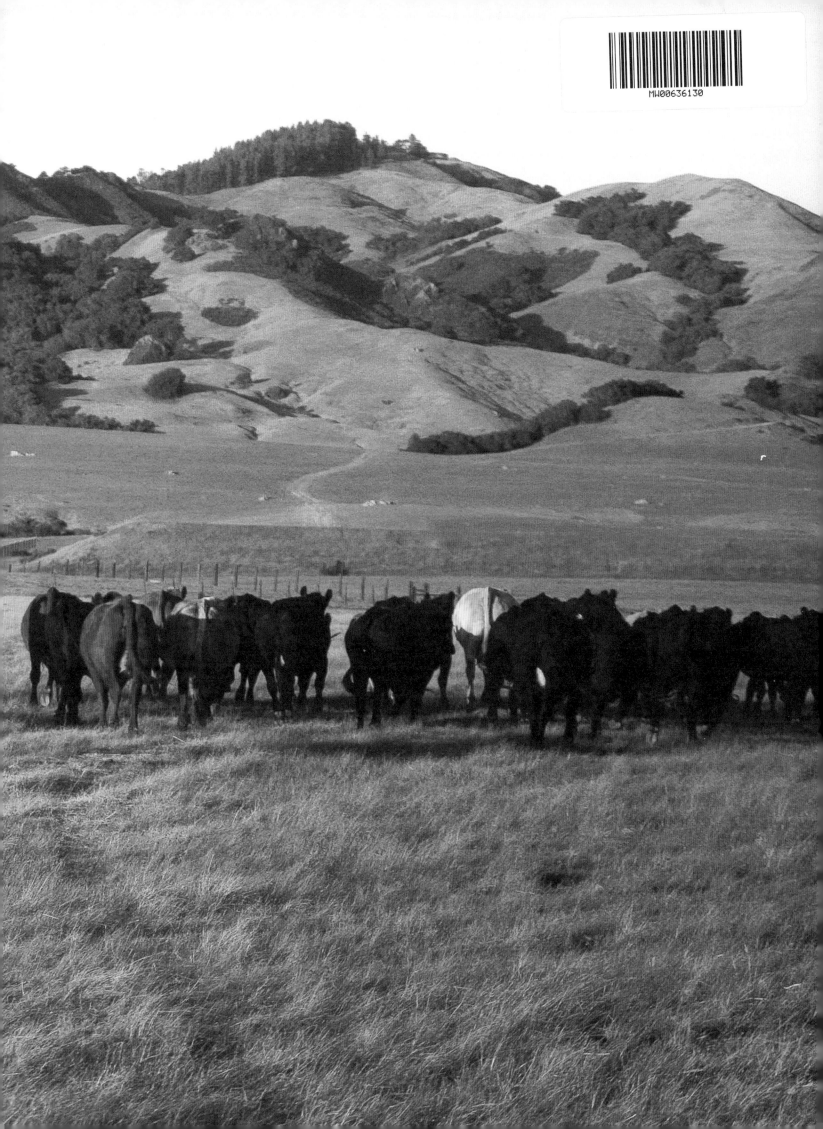

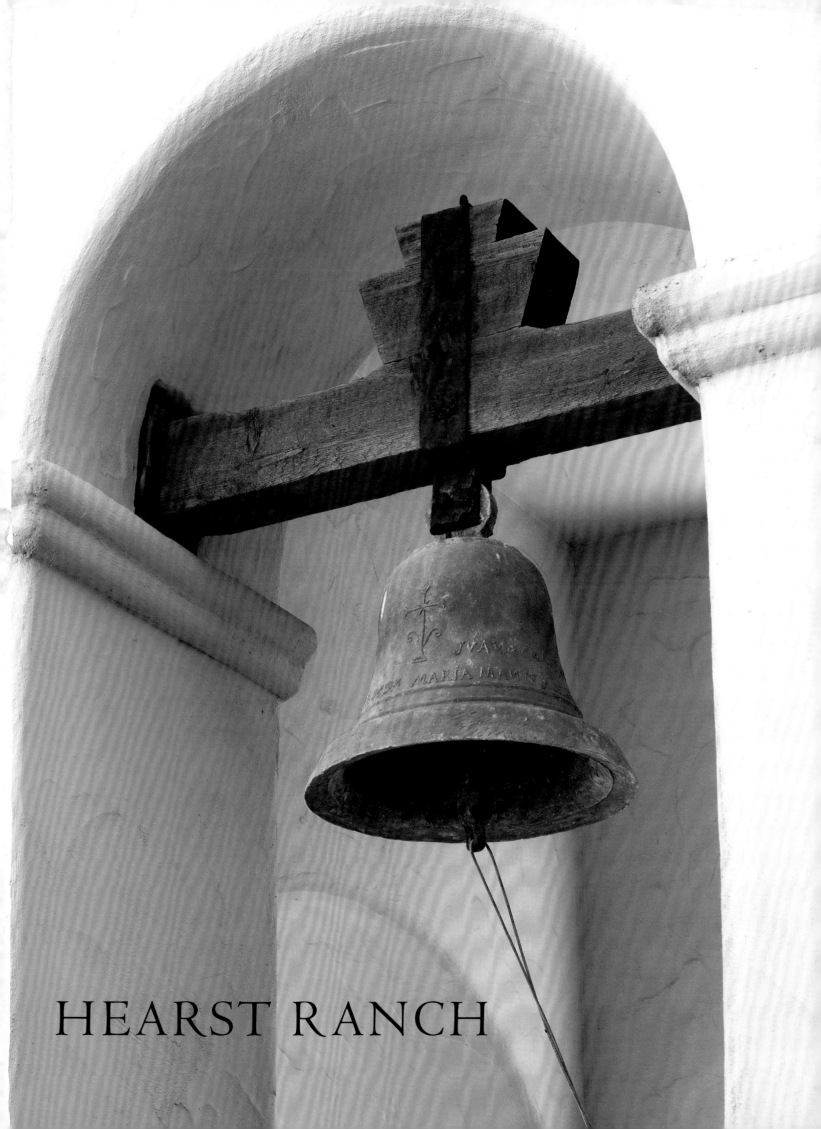

HEARST RANCH

PAGE 1: A bronze bell ornaments Julia Morgan's Mission Revival–style warehouse in San Simeon.

PAGE 2: Cattle brands are like coats of arms. These heraldic symbols tell the stories of the historic ranches of the West. Top row: Three brands from George R. Hearst Jr.'s Estrella Ranch in Paso Robles. From left: the backward GH with a bar, the bar lazy V, and the backward EC. Bottom row: Three brands from the Hearst Ranches. From left: The H slash, the circle C from the Jack Ranch, and the G with a hanging H.

PAGE 3: George R. Hearst Jr., 1927–2012

PAGES 4–5: The poultry ranch manager's house, designed by Julia Morgan in 1928, with Hearst Castle in the distance.

PAGE 6: The Hearst Ranch was originally named the Piedra Blanca Rancho, after the large white rocks standing beside its shoreline. Spanish explorers christened them the *piedras blancas*.

PAGE 8 TOP: The Hearst Ranch herds are primarily Black Angus, Red Angus, and Hereford. All are free-range cattle, grass-fed and grass-finished, raised as they have been for centuries.

CENTER: What is known today as Hearst Castle was formally named La Cuesta Encantada (The Enchanted Hill) by William Randolph Hearst. He generally referred to his entire estate as "the ranch at San Simeon."

BOTTOM: The Hearst Ranch contains 130 square miles of land surrounding Hearst Castle. Many of its cowboys and other employees still live on the property.

PAGE 9: The Hearst Ranch has been a working cattle ranch for the Hearst family since 1865. Today it raises approximately three thousand cattle per year.

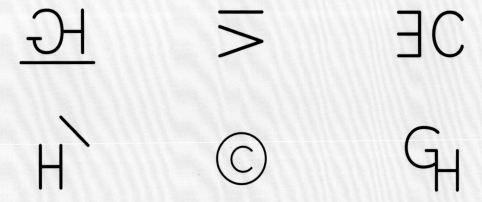

George R. Hearst Jr.

1927 – 2012

HEARST RANCH

Family, Land, and Legacy

FOREWORD BY Stephen T. Hearst TEXT BY Victoria Kastner

Abrams, New York

CONTENTS

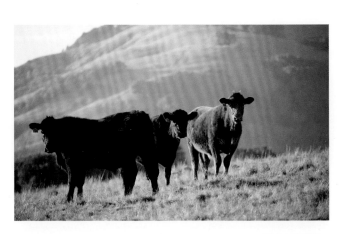

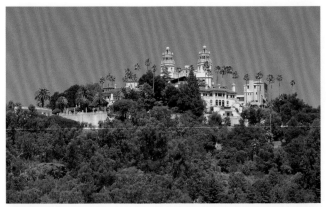

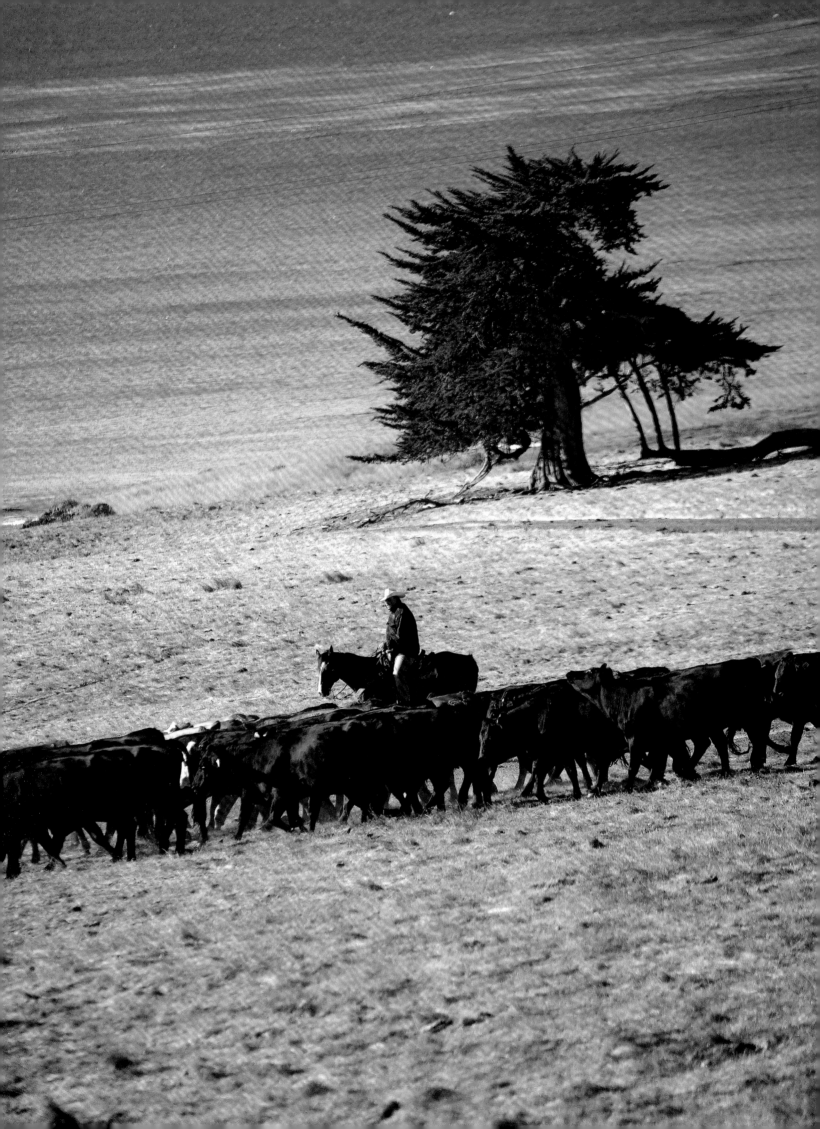

FOREWORD

Seven generations of the Hearst family have been privileged to be part of the Piedra Blanca Rancho, the original name of the Hearst Ranch at San Simeon, California. I believe this very special place is home to every member of our family, no matter where they get their mail.

My great-grandfather, William Randolph Hearst, was a larger-than-life American. W. R., as he is known within the family, transformed the communications industry when he built an empire of twenty-eight newspapers, fourteen magazines, eight radio stations, a newswire service, and two film companies. His other pursuits were equally legendary: collecting art and antiques, building elaborate estates, making movies, and of course enjoying this ranch, his favorite place on earth.

W. R.'s father, George Hearst, had begun purchasing land along the Central Coast in 1865, when his son was just two years old. George was a self-made and very successful miner who bought the property for his love of the landscape and its coastal views, for its potential as a horse and cattle ranch, and, of course, for the business opportunities it offered. George controlled a great deal of local commerce in the San Simeon Bay area. He built its first deepwater commercial pier, which extended one thousand feet into the bay, where large ships could dock and load and unload their commodities. He also built a warehouse on the shore where he stored the goods. These structures later received and stored the countless materials his son, W. R., would need to build, furnish, and decorate his house on La Cuesta Encantada (the Enchanted Hill).

The Hearst Ranch eventually grew to approximately 250,000 acres. Following the deaths of his father and his mother, Phoebe Apperson Hearst, W. R. told his architect, Julia Morgan, that he wanted to build "a little something"

on the hilltop overlooking San Simeon Bay. Apparently he was tired of sleeping in tents when his family camped at the ranch. Hearst Castle, as it is referred to today, encompasses 127 acres and 165 rooms, including the main house (Casa Grande) and three guesthouses. These hilltop buildings were donated to California by the Hearst family and the Hearst Corporation in 1957. That millions of visitors have viewed them since is one reason the Hearst Ranch property is so well known, but it is not the focus of this story. The Ranch has its own rich history, beginning long before the Castle was built, and it is told here for the first time by Victoria Kastner.

The Hearst Ranch still raises some of the finest cattle and horses known today. Its employees and managers rank among the best in the world. I have heard two phrases many times: "If you get work at the Hearst Ranch, hang on to it," and "There is a line of good, qualified cowboys waiting to get on the payroll." I know this to be true because I have the résumés. It is nice to know that people want to work for the Hearst Ranch. It is also nice to know that many of our employees have worked there for years, and most of them live on the property. In this beautiful book, readers will finally see the ranch buildings and scenic backcountry the Hearst family and ranch employees know so well.

The Hearst Ranch now comprises more than 82,000 acres, making it the largest cattle ranch on the California coast. Many former ranches in the state have been turned into cities or resorts, and that fate almost befell the Hearst Ranch as well. But after twenty-five years of working with the Hearst Corporation's newspaper division, in 1998 I was offered the opportunity to manage this property. I was then able to be part of dramatic changes in direction and philosophy when we moved away from a development plan

William Randolph Hearst (1863–1951) is best known as a media mogul and art collector. He was also a lifelong rancher who was involved in every aspect of running the Piedra Blanca Rancho.

and instead adopted a conservation solution for the Hearst Ranch. This process required an incredible team of professionals, the full support of the Hearst Corporation's board of directors, the Hearst family, and millions of dollars in resources to complete the task. In 2005, we concluded a deal that preserves and shares the coastline with the public and also maintains the Hearst Ranch in perpetuity. Without these people and their support, this conservation project would never have been accomplished.

Seven generations of the Hearst family have known and loved this Ranch. With the publication of *Hearst Ranch: Family, Land, and Legacy*, readers will be able to explore its beauty and learn its fascinating history for the first time.

Stephen T. Hearst
April 2013

INTRODUCTION

I love this ranch. It is wonderful. I love the sea and I love the mountains and the hollows in the hills and the shady places in the creeks and the fine old oaks and even the hot brushy hillsides—full of quail—and the canyons—full of deer. It is a wonderful place. I would rather spend a month at the ranch than any-place in the world.[1]

William Randolph Hearst wrote these words to his mother, Phoebe Apperson Hearst, in 1917, while camping with his wife, Millicent, and their five sons on a sunny hilltop overlooking the Pacific. Today Hearst Castle occupies this site. Hearst and his talented architect, Julia Morgan, began building this vast twin-towered mansion in 1919 and con-tinued its construction for twenty-eight years. At the time of this letter, however, the hill was bare except for a small cabin and a few tent platforms. William Randolph Hearst formed a deep attachment to this land, which he had known since childhood. His letter still provides an accu-rate description of his beloved ranch at San Simeon.

In his devotion to the site, William Randolph Hearst followed a family tradition. His father, George Hearst, was a wealthy miner who bought property near San Simeon Bay in 1865, when William was only two. George built a long wharf and a large warehouse on the bay, and raised thor-oughbred horses nearby. As he gradually acquired more ranchland, he discouraged local commerce rather than increasing it. His land agent griped that George wasn't aggressive enough, preferring instead to leave San Simeon unaltered "for the boy." Phoebe Apperson Hearst sur-vived her husband, who died in 1891, and she too acquired property at San Simeon until her death in 1919. William Randolph Hearst made the largest acquisition of all, buying

ABOVE: William Randolph Hearst poses in costume for one of the silent home movies filmed at the ranch. He was generally the author, director, and star of these elaborate productions. He wrote amusing titles, including "The hero has the fattest part / And gets the greatest glory / But that's because he runs the ranch / And also writes the story."

OPPOSITE: At its height in the 1920s, the Hearst Ranch encompassed approximately 250,000 acres. Today it is a substantial 82,000 acres, a rare survivor among the numerous nineteenth-century cattle ranches that once lined California's coast.

The family tradition of camping high above San Simeon Bay began in the 1870s, when William Randolph Hearst was a boy. He later joked that the horseback ride to these hilltop tents was so steeply sloped that he managed it by hanging on to the tail of his pony. This view of their camp was taken circa 1917.

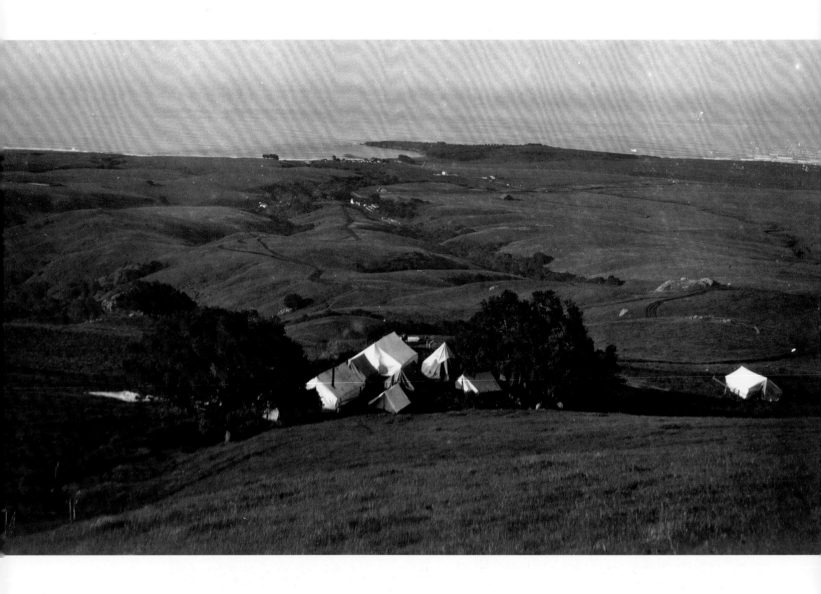

TOP: William Randolph Hearst's wife Millicent costarred in the photoplays, as these silent films were called. Here, bandits have captured her and tied her to a tree, where she awaits rescue by the hero, played by Hearst.

BOTTOM: Three of Hearst and Millicent's five sons play cowboys with their companion Charlie Mayer, circa 1912. Mayer is on the far left. The Hearst boys are identified on the back of this photograph (from left) as Jolly John, Gusty George, and Bunco Bill.

153,000 acres of adjoining ranchland to the northeast. In 1925, when the ranch was at its height, it encompassed approximately 250,000 acres.

In expanding and improving the ranch, Hearst pursued the interests of both of his parents. His hilltop Castle honored his mother's love of art and architecture. He kept his father's ranching traditions alive as well. Though George Hearst spent far more time apart from his son than with him—pursuing mining investments throughout the West—he and young Willie (as W. R. was known in early years) often camped together at San Simeon.

William Randolph Hearst was the first member of his family who chose to be a rancher. His parents were both raised on Missouri farms. When they came west to California in 1862, they were hoping to leave their agrarian past behind. As the sole heir to their vast mining fortune, Hearst could have lived in the city and devoted himself solely to commerce. Instead, he became a powerful newspaperman who owned twenty-eight dailies, more than a dozen magazines, and numerous radio and film companies. Through it all, he remained active in every aspect of ranching at San Simeon, as thousands of letters he exchanged with Julia Morgan and with his ranch employees attest. Morgan's many original ranch buildings not only survive, but remain in daily use today.

The Hearst family's early stewardship of this site continues, though the ranch was nearly developed after William Randolph Hearst's death in 1951. The Hearst Corporation received approval in 1964 to build eight concrete-and-glass cities for 65,000 residents—with amenities including a large university, a commercial airport, and a yacht harbor in San Simeon Bay. When this ambitious scheme was dropped, the corporation pursued various development proposals over the next forty years, including plans for a 650-room luxury hotel, a twenty-seven-hole golf course, and a desalination plant. In 2005, under the direction of Hearst's great-grandson Stephen Hearst these efforts were finally averted. The corporation created a conservation

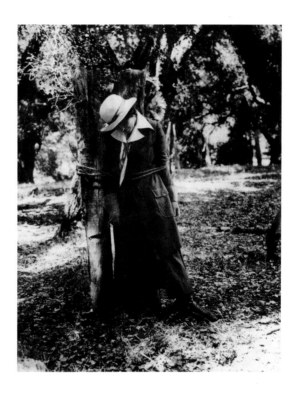

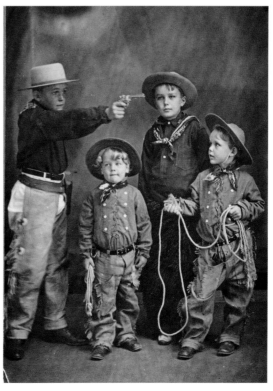

BELOW: The pastures of the Hearst Ranch are a mosaic of largely native grasses, the perfect setting for raising cattle. Spanish missions grazed their longhorn cattle on this site as far back as the late eighteenth century.

OPPOSITE: Hearst Ranch cowboys still tend their cattle the old-fashioned way, on horseback, with cow dogs.

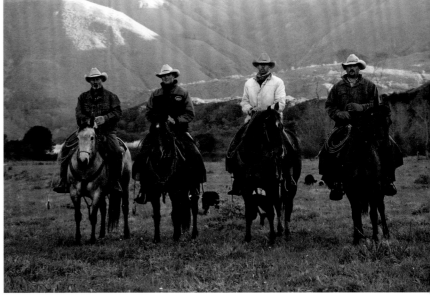

easement, ensuring that San Simeon's 82,000 acres will remain a family cattle ranch in perpetuity. They also donated thirteen miles of pristine coastline to the people of California, protecting this vast stretch of beautiful and accessible shoreline from commercial development, in what has been described as the largest and most complex conservation deal in the United States.

George, Phoebe, and William Randolph Hearst would surely approve. In 1922, W. R. (as he was known in adulthood) told an investigative reporter: "I am a rancher enjoying life on the high hills overlooking the broad Pacific. If you want to talk about Herefords I will talk with you, but not about politics."[2] One hundred fifty years after the Hearst Ranch began, Hereford and Angus cattle still graze these pastures, and its high hills still overlook the broad, unspoiled Pacific. Here is the story of a nineteenth-century family ranch that still survives, nearly unaltered, in the twenty-first century—and the remarkable family who created it.

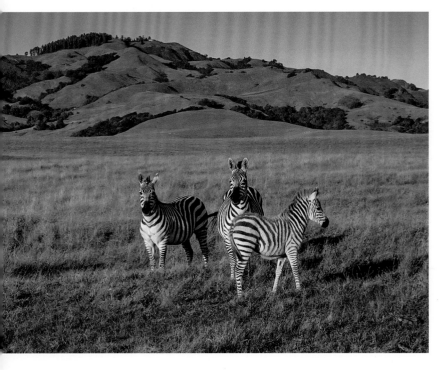

OPPOSITE: In the 1920s, Hearst established an extensive private zoo on his San Simeon ranch. Most of the animals were donated to public zoos by the late 1930s, but a few exotic species remain. The descendants of Hearst's zebra herd still roam these pastures.

BELOW: In 2005, a landmark conservation agreement was signed, ensuring the Hearst Ranch would not be developed into a large resort. It will instead remain a working cattle ranch in perpetuity, operated by the Hearst Corporation and overseen by the California Rangeland Trust.

CALIFORNIA.

Its Past History

ITS PRESENT POSITION

ITS FUTURE PROSPECTS.

SCENE ON A BRANCH OF THE SACRAMENTO.

London.

Printed for the Booksellers.

1850.

I
GEORGE HEARST GOES WEST

veryone has heard of William Randolph Hearst, the press lord who built a castle at San Simeon and filled it with European art objects and Hollywood film stars. George Hearst's name is far less familiar, but without him there would be no Hearst Castle and no Hearst Ranch. George Hearst was William Randolph Hearst's father, a plainspoken miner who left Missouri in 1850, among the countless throngs of fortune seekers lured west by the Gold Rush. Once he reached California, George began enterprises in journalism and land investment that still constitute major assets of the Hearst Corporation today. George's greatest contribution, however, came in 1865, fifteen years after his arrival in California. He took the profits from his first lucky silver strike and purchased a huge ranch located on the gentle hillsides skirting San Simeon Bay. Here, George began the Piedra Blanca Rancho (or as it came to be known, the Hearst Ranch at San Simeon), and sparked his family's passion for this special landscape—a devotion that continues to this day.

George was born in Franklin County, Missouri, in either September 1820 or 1821—he was never sure which year. His parents, William and Elizabeth Hearst, were prosperous ranchers whose Scottish-Presbyterian ancestors sailed to America in the seventeenth century. The family name was spelled "Hyrst" at that time—a Saxon word meaning a thicket, or clump of trees. These forebears fled to America because of religious persecution. They settled in South Carolina and owned plantations, slaves, and businesses.

When George's father, William G. Hearst, married Elizabeth Collins in 1817, both their families were already living in Franklin County, a fertile valley in central

The California Gold Rush began in 1848, bringing an estimated 300,000 fortune seekers to the region. George Hearst left Missouri for California in 1850, by which time many of the so-called forty-niners who had come west in search of gold were already returning home, tapped out and empty-handed.

Missouri near the Meramec River. Late in life, George penned a brief memoir that described his father: "[He] died when I was quite young, and therefore I knew him but slightly. I do know, however, that he was a very muscular man, not very large, but strong. . . . He was a farmer, and I don't think there was his equal in the country for lifting weights and such like." William could defend himself when necessary, George recalled: "I can recollect that if anyone did anything outrageous towards him, he would try to clean him out; those were rough days, remember. . . . He was very kind to his neighbors, giving away a great deal. I remember that he was not very strict in the family; in fact, I never got a licking from my mother or father at any time. I think it was his idea merely to set a good example. . . . He was a man of some considerable influence, and had the best farm, and indeed the best of everything in his neighborhood."

George inherited his father's energy and industry, and like him, was largely self-taught. He attended grammar school for less than two years—for three months at age eight, and for fifteen months beginning at age fifteen. "I liked the school first rate, and was very ambitious to learn everything, and it would worry me terribly if I could not succeed."[1] William died in 1846, when George was sixteen. As the eldest child, and the hardiest—his sister was three years younger, and his younger brother, Phillip, was crippled—George supported the family. His father had made a number of poor investments in his final years, leaving them ten thousand dollars in debt. George managed the family's three mortgaged farms, sold cattle and horses, and studied at the Franklin County School of Mining while he struggled to resolve their debts.

He was already fascinated with mining, having worked the mines in the region from boyhood. "My ideas seemed naturally to lead to mining. I can think of the places I saw when I was fifteen years old, and can see them just as vividly today in my mind as then." George had carefully observed the French lead miners who lived nearby: "[They] would let us little fellows pick away into the big banks of dirt

and we would often thus make from four to six bits a day. We would dig down and get little bits of lead." His skill in finding precious metals was said to have earned him a nickname, bestowed by the Indians of the region: Boy-That-Earth-Talks-To.[2] George continued: "There was a big lead mine discovered near us. I got a little bit familiar with mining then, and when I was twenty-two years old I went to mining and made a little money out of it, and finally got interested in copper and iron, and made some money out of them, too."

George was in his late twenties by the time gold was discovered in California in 1848. Like most young men of the era, he was eager to join the Gold Rush—but his family responsibilities took precedence. "I recollect talking over California with my mother. She did not like it at all, but then I told her they were making forty and fifty dollars a day there and that it seemed to me it was by far the best thing to do, as it was pretty hard pulling here." George discussed his plans with the father of a girl he was "sweet on": "I told him I had an intention of going to California, but he said, 'No, don't go. There is nothing new there. This gold was discovered some seventy-five years ago, by the Jesuits.' He went and pulled down some books and read it out to me. It was of course the Coast Range, as I now know, but I thought that he might be right about it, and that this would blow out, too. Next year, however, I made up my mind sure to go. I had already made a pretty fair success in life."[3]

From this time forward, George relied more on his own instincts than on the advice of others. He said of his early years: "I never thought that I was a man until I was over 30 years old, and until that age never could make up my mind that I knew as much as anyone else." In fact, he had run multiple farms, saved his family from bankruptcy, and worked as a miner for nearly fifteen years by the time he left for California. He sold the family's copper mine to earn $1,900 to finance the trip, turning the farm's management over to William Patton, a family friend. George joined his cousin and fifteen others, departing for Califor-

nia in mid-May of 1850. For the first few days, his mother and his sister Patsy rode alongside the group, and George confessed many years later that bidding them good-bye was difficult: "If it had not been for pride when my mother and sister left me, I would not have thought of going, in fact nothing would have induced me to leave them the way I did, if it had not been for pride."[4]

George's reluctance was understandable. Many years later, his son, William Randolph Hearst, wrote: "Many were the difficulties and dangers, but at length the Argonauts reached California in safety, except for those who died of cholera or were drowned by the floods or were killed by the Indians—except for those who tarried by the wayside under crude crosses and little hasty heaps of stone."[5]

George himself almost "tarried by the wayside." He nearly died of cholera near Fort Kearney, Nebraska. His only medicine was some pills he bought from another miner and a gallon of brandy he had purchased in St. Louis for sixteen dollars. "I recollect that the grass was about six feet high and I thought that if they would let me lie there I would give anything." After a day and a half, he recovered enough to catch up with his party. Many miners died on the journey. Estimates of death on the trails ran as high as six percent.[6] George recalled: "I don't suppose we saw more than half the graves, and yet we approached graves every mile." After six months, they arrived in Hangtown, a mining town in the Sierra Nevada foothills known today as Placerville: "I had just a five-franc piece left. The last money of any account that I had, I paid for a sack of flour, $100 for a hundred pounds."[7]

George worked mostly at quartz mining, which by 1850 had largely replaced the earlier practice of panning for gold in rivers and streams. His early training helped him evaluate surface rocks to determine if precious mineral deposits were hidden deep inside. He quickly made a lucky strike, on a quartz mine near an abandoned sawmill. While gold primarily occurs within quartz deposits, this particular strike contained very little gold, so George

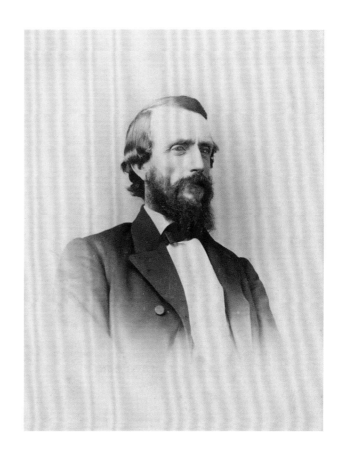

continued searching. He invested in several other businesses as well, including a store in Sacramento and a theater and lecture hall in Nevada City. Many years later, Mark Twain wrote an article about himself in the third person, describing his time in the gold fields and his long friendship with George Hearst: "the veteran prospector who was Mark Twain's partner in the days of long ago. [When he came into town for supplies] it was George's habit to take up a brief residence . . . start a dignified drunk, pack Johnny [George's mule] with bacon, flour, and baking powder, and depart at the end of one week to the exact hour, returning to the tunnel he is running to display the glories of his vein to some 'Eastern gent' with thousands."[8]

Twain's lighthearted account glosses over the solitary and arduous hardships of a miner's life. George's efforts were unsuccessful for nine long years. He missed his family, most especially his mother. George's 1858 letter to his stepfather, Joseph Funk, reveals his bluff honesty and his unwavering determination: "You say you would like for me to come home; now, I would like to see you and mother and some of the people, and particularly that little old dried up Uncle Austin and Aunt Anne, much better than you suppose, but to come home without money is out of the question. . . . You say I must not get out of heart; that is the greatest trouble in this country, but I have got nerve and can stand anything until death calls for me, and then I must weaken, and not until then. The only thing that gives me much trouble is my old mother. I would like to see her have all that life could desire, and be with me a part of the time, but if God has fixed and ordained otherwise, so it must be."[9] George's financial difficulties were worse than ever at this time, because his family's ranch in Missouri had been sold after a rumor circulated that he had died in the gold fields in 1853.

In 1859 George's luck finally changed. The Washoe Excitement was a strike that brought scores of miners—including George—rushing to a distant part of the eastern Sierra where gold had been found. George made the trip by

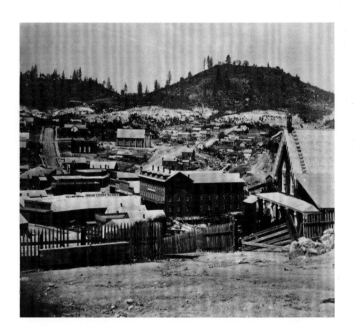

horseback—but just barely. He bought a horse and a saddle, and was on his way out of town when he was detained by a constable. He owed forty dollars to the local store. He hadn't the money to pay it, but his companions took up a collection.[10] Along with his two friends Melvin Atwood and A. E. Head, George also managed to raise $450 and bought a half interest in the LeCompton mine. Its blackish ore—which nearby miners were discarding—turned out to be silver. With the money from this strike, George bought a one-sixth interest in the Ophir mine for $3,500, and thus in March 1860 was among the first to discover the fabled Comstock Lode—still the richest vein of silver ever found in America. George recalled: "We worked away till we got out about 45 tons. Some people said it was no good, and nobody believed that it was silver. . . . It looked so much like lead."[11] They shipped the ore from Virginia City to San Francisco for the enormous sum of $140 a ton, then paid an additional $412 a ton for it to be refined. Nevertheless, they saw a profit of $90,000—a 400 percent return on George's investment. The ensuing silver rush was equivalent to the

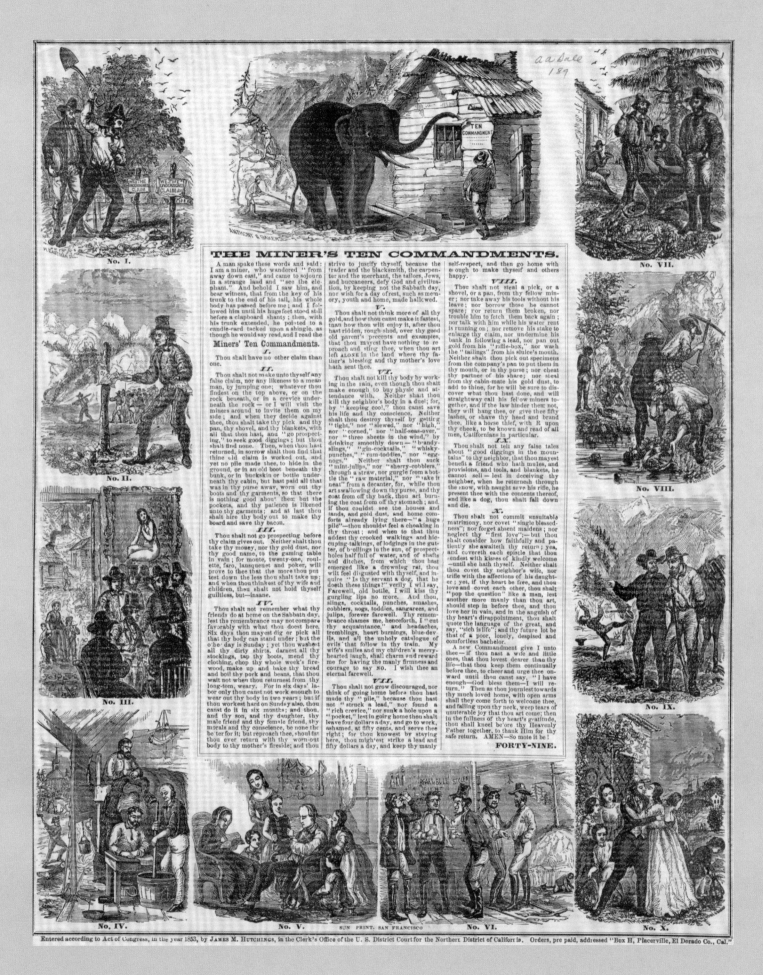

THE MINER'S TEN COMMANDMENTS.

A man spake these words and said: I am a miner, who wandered "from away down east," and came to sojourn in a strange land and "see the elephant." And behold I saw him, and bear witness, that from the key of his trunk to the end of his tail, his whole body has passed before me; and I followed him until his huge feet stood still before a clapboard shanty; then, with his trunk extended, he pointed to a candle-card tacked upon a shingle, as though he would say read, and I read the

Miners' Ten Commandments.

I.

Thou shalt have no other claim than one.

II.

Thou shalt not make unto thyself any false claim, nor any likeness to a mean man, by jumping one; whatever thou findest on the top above, or on the rock beneath, or in a crevice underneath the rock — or I will visit the miners around to invite them on my side; and when they decide against thee, thou shalt take thy pick and thy pan, thy shovel, and thy blankets, with all that thou hast, and "go prospecting," to seek good diggings; but thou shalt find none. Then, when thou hast returned, in sorrow shalt thou find that thine old claim is worked out, and yet no pile made thee, to hide in the ground, or in an old boot beneath thy bunk, or in buckskin or bottle underneath thy cabin, but hast paid all that was in thy purse away, worn out thy boots and thy garments, so that there is nothing good about them; but the pockets, and thy patience is likened unto thy garments; and at last thou shalt hire thy body out to make thy board and save thy bacon.

III.

Thou shalt not go prospecting before thy claim gives out. Neither shalt thou take thy money, nor thy gold dust, nor thy good name, to the gaming table in vain; for monte, twenty-one, roulette, faro, lansquenet and poker, will prove to thee that the more thou put test down the less thou shalt take up; and when thou thinkest of thy wife and children, thou shalt not hold thyself guiltless, but—insane.

IV.

Thou shalt not remember what thy friends do at home on the Sabbath day, lest the remembrance may not compare favorably with what thou doest here. Six days thou mayest dig or pick all that thy body can stand under; but the o'ber day is Sunday; yet thou washest all thy dirty shirts, darnest all thy stockings, tap thy boots, mend thy clothing, chop thy whole week's firewood, make up and bake thy bread and boil thy pork and beans, that thou wait not when thou returnest from thy long-tom, weary. For in six days' labor only thou canst not work enough to wear out thy body in two years; but if thou workest hard on Sunday also, thou canst do it in six months; and then, and thy son, and thy daughter, thy male friend and thy female friend, thy morals and thy conscience, be none the be'ter for it; but reproach thee, shouldst thou ever return with thy worn-out body to thy mother's fireside; and thou strive to justify thyself, because the trader and the blacksmith, the carpenter and the merchant, the tailors, Jews, and buccaneers, defy God and civilization, by keeping not the Sabbath day, nor wish for a day of rest, such as memory, youth and home, made hallowed.

V.

Thou shalt not think more of all thy gold, and how thou canst make it fastest, than how thou wilt enjoy it, after thou hast ridden, rough-shod, over thy good old parent's precepts and examples, that thou mayest have nothing to reproach and sting thee, when thou art left ALONE in the land where thy father's blessing and thy mother's love hath sent thee.

VI.

Thou shalt not kill thy body by working in the rain, even though thou shalt make enough to buy physic and attendance with. Neither shalt thou kill thy neighbor's body in a duel; for, by "keeping cool," thou canst save his life and thy conscience. Neither shalt thou destroy thyself by getting "tight," nor "slewed," nor "high," nor "corned," nor "half-seas-over," nor "three sheets in the wind," by drinking smoothly down— "brandy-slings," "gin-cocktails," "whisky-punches," "rum-toddies," nor "egg-nogs." Neither shalt thou suck "mint-julep," nor "sherry-cobblers," through a straw, nor gurgle from a bottle the "raw material," nor "take it neat" from a decanter, for, while thou art swallowing down thy purse, and thy coat from off thy back, thou art burning the coat from off thy stomach; and, if thou couldst see the houses and lands, and gold dust, and home comforts already lying there—"a huge pile"—thou shouldst feel a choaking in thy throat; and when to that thou addest thy crooked walkings and hic-cuping-talkings, of lodgings in the gutter, of b-oilings in the sun, of prospect-holes half full of water, and of shafts and ditches, from which thou hast emerged like a drowning rat, thou wilt feel disgusted with thyself, and inquire "Is thy servant a dog, that he doeth these things?" verily I will say, Farewell, old bottle, I will kiss thy gargling lips no more. And thou, slings, cocktails, punches, smashes, cobblers, nogs, toddies, sangarees, and julips, forever farewell. Thy remembrance shames me, henceforth, I "cut thy acquaintance," and headaches, tremblings, heart burnings, blue-devils, and all the unholy catalogue of evils that follow in thy train. My wife's smiles and my children's merry-hearted laugh, shall charm and reward me for having the manly firmness and courage to say NO. I wish thee an eternal farewell.

VII.

Thou shalt not grow discouraged, nor think of going home before thou hast made thy "pile," because thou hast not "struck a lead," nor found a "rich crevice," nor sunk a hole upon a "pocket," lest in going home thou shalt leave four dollars a day, and go to work, ashamed, at fifty cents, and serve thee right; for thou knowest by staying here, thou migh'est strike a lead and fifty dollars a day, and keep thy manly self-respect, and then go home with e ough to make thyself and others happy.

VIII.

Thou shalt not steal a pick, or a shovel, or a pan, from thy fellow miner; nor take away his tools without his leave; nor borrow those he cannot spare; nor return them broken, nor trouble him to fetch them back again; nor talk with him while his water rent is running on; nor remove his stake to enlarge thy claim, nor undermine his bank in following a lead, nor pan out gold from his "riffle-box," nor wash the "tailings" from his sluice's mouth. Neither shalt thou pick out specimens from the company's pan to put them in thy mouth, or in thy purse; nor cheat thy partner of his share; nor steal from thy cabin-mate his gold dust, to add to thine, for he will be sure to discover what thou hast done, and will straightway call his fellow miners together, and if the law hinder them not, they will hang thee, or give thee fifty lashes, or shave thy head and brand thee, like a horse thief, with R upon thy cheek, to be known and read of all men, Californians in particular.

IX.

Thou shalt not tell any false tales about "good diggings in the mountains" to thy neighbor, that thou mayest benefit a friend who hath mules, and provisions, and tools, and blankets, he cannot sell—lest in deceiving thy neighbor, when he returneth through the snow, with naught save his rifle, he present thee with the contents thereof, and like a dog, thou shalt fall down and die.

X.

Thou shalt not commit unsuitable matrimony, nor covet "single blessedness"; nor forget absent maidens; nor neglect thy "first love";—but thou shalt consider how faithfully and patiently she awaiteth thy return; yea, and coverteth each epistle that thou sendest with kisses of kindly welcome —until she hath thyself. Neither shalt thou covet thy neighbor's wife, nor trifle with the affections of his daughter; yet, if thy heart be free, and thou love and covet each other, thou shalt "pop the question" like a man, lest another more manly than thou art, should step in before thee, and thou love her in vain, and in the anguish of thy heart's disappointment, thou shalt quote the language of the great, and say, "sich is life"; and thy future lot be that of a poor, lonely, despised and comfortless bachelor.

A few Commandment give I unto thee—if thou hast a wife and little ones, that thou lovest dearer than thy life—that thou keep them continually before thee, to cheer and urge thee onward until thou canst say, "I have enough—God bless them—I will return." Then as thou journiest towards thy much loved home, with open arms shall they come forth to welcome thee, and falling upon thy neck, weep tears of unutterable joy that thou art come; then in the fullness of thy heart's gratitude, thou shalt kneel be'ore thy Heavenly Father together, to thank Him for thy safe return. AMEN—So mote it be!

FORTY-NINE.

No. I. No. II. No. III. No. IV. No. V. SUN PRINT, SAN FRANCISCO No. VI. No. VII. No. VIII. No. IX. No. X.

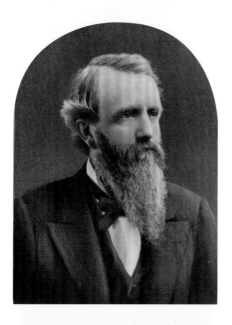

gold rush a decade earlier. George and his two partners, Atwood and Head, helped ignite the firestorm of investment. They established the Ophir Silver Mining Company in April 1860 and formed the Gould and Curry Mining Company two months later. Its shares sold for five hundred dollars each, part of the stock rush, buoyed by eager investors.[12]

Just two months later, George sold his interest in the Ophir mine and left the gold country, heading east to Missouri. He had received news that his mother was gravely ill. Flush with wealth for the first time, he made the trip home in one month, by the fastest method possible at the time—sailing from San Francisco to Panama, boarding a steamer there for New York, riding a train to St. Louis, and finally boarding a train for St. Clair, two miles outside his family's homestead. He arrived in time to see Elizabeth just before she died. Though he had intended to leave after a few months, George ended up staying in Franklin County for a year and a half, struggling to resolve the lawsuits that had resulted from William Patton's mismanagement of the family's many properties.

During this time he began courting a quiet young woman from a neighboring farm. Though Phoebe Apperson had been a child of eight when George first departed Missouri, she was now nineteen—and George was forty-one. The Apperson and Hearst families had long known one another, and in fact, Phoebe's middle name, Elizabeth, was in homage to George's mother: "My wife was named after my mother, but I had no idea how she looked like, I just knew there was such a person."[13] Phoebe's parents, Randolph Walker Apperson and Drucilla Whitmire Apperson, ran Drucilla's grandparents' farm and were not as wealthy as George's parents. Active members of the Cumberland Presbyterian Church, they taught their daughter to love education.

Phoebe studied French and was soft-spoken, small, and graceful. As a girl, she longed to visit St. Louis—which was twenty-five miles away—a goal her schoolmates found

ridiculously grand and unattainable. She decided to become a teacher, attending the St. James Academy in Steelville and serving for a time as a private tutor. George must have been impressed by Phoebe's education, since his own formal schooling had been brief. He signed a portion of his mining stock over to her before their marriage—perhaps in tacit acknowledgment of his greater age and his perilous profession.[14] They married on June 15, 1862, in the neighboring town of Steelville and sailed to San Francisco via the Isthmus of Panama. A young and eager bride who had never left Franklin County, Phoebe doubtless felt that the marvelous sights she glimpsed on their journey exceeded even the wonders of distant St. Louis.

Phoebe struggled in the early years of their marriage, partly due to George's long absences in the mine fields and also because of concerns over their fluctuating finances. The contrast between their natures was profound: George was large, disheveled, and rough-hewn; Phoebe diminutive, graceful, and cultivated. At first she had hopes for a closer connection. They exchanged loving letters throughout their marriage, but it was clear within the first few years that they were going to spend much more time apart than together. When Phoebe branched out into San Francisco society, or into sightseeing, George did not follow. In time she grew to accept, and finally enjoy, her independence. Occasionally she made a wry comment on George's long absences, for instance when she wrote a friend about her visit to Yosemite: "We had some hard traveling and rough fare, but so much fun. I should just like to tell you the half of it. Mr. Hearst could not go. Then you know it is very difficult to persuade him to go anywhere for pleasure. If there is any prospect of finding a mine, he is ready."[15]

Instead Phoebe focused her considerable energies on another companion: their only child, William Randolph Hearst, who was born on April 29, 1863, in San Francisco. George had moved his young bride into the Lick House, a respectable family hotel where William was born. George was prospecting in Virginia City at the time. Soon after, the family moved into a fashionable home on Rincon Hill, and in the spring of 1864, into a truly elegant Chestnut Street house on Russian Hill, the most prestigious neighborhood in San Francisco. Though she traveled to Virginia City in 1864 and visited George several times in various mining camps, their marriage pattern was set from its earliest days: Phoebe and Willie pursued education and culture together while George lived the solitary life of a miner in the backcountry.

To keep her company, Phoebe's parents and her brother Elbert moved west. George and Phoebe bought them a small farm south of San Francisco, near the town of Alviso. George planned to raise horses and build a racetrack on the site.[16] Instead, in 1864 he opened the Bayview Racetrack, the largest public racetrack in San Francisco.

Phoebe often chided George about his rough manners and slipshod dress. He was plainspoken and utterly without pretension—a lover of good stories and good whiskey. He was described by a contemporary: "When I first saw George Hearst he looked the ideal of a young Western backwoodsman. Over six feet in height, straight as an arrow, long, swinging arms, big feet and hands, a somewhat awkward gait, a pleasant, ever-smiling face, a drawling but musical voice, and the pronounced accent of a Southerner. In dress he is slouchy, and all the tailors on earth could not fix him up to make him look otherwise."[17] Phoebe frequently pleaded with him: "I do hope you will have respect enough for yourself & me, to keep yourself well dressed & clean. Nothing can make me feel worse than to think you are going about shabby or dirty. I suppose you are at the Hotel, you did not say. Please write to me if you have any new clothes & if you have your washing done & be sure not to forget to pay for it. I know how careless & forgetful you are, though you don't intend to be so."[18]

George could indeed present a rather comical appearance. On one occasion, he returned to San Francisco during one of Phoebe's tea parties. He passed through her soiree "in his stocking feet, carrying his boots in his right

hand while the left supported the regulation crooked cane. He looked neither to the right nor to the left, but glided through the apartment like a ghost, to the intense amusement of the guests."[19]

In 1865, George ran as a Democrat and was elected to the state assembly. He served only one term, living for a time in Sacramento, where Phoebe and Willie frequently sailed by steamer to visit him. Early that year, he also began buying land. After the first flush of profits waned in the gold fields, land was looked upon as the surest path to riches. George bought several lots in San Francisco and in addition, he purchased approximately 50,000 acres of ranchland two hundred miles to the south, alongside quiet San Simeon Bay.

This land was home to native peoples for more than nine thousand years—largely the Salinan and the Chumash, who fished its bay in well-built canoes sealed with tar. When the Spanish explorer Juan Rodriguez Cabrillo entered its harbor in 1542, he noted the large *piedras blancas* (guano-covered white rocks) beside the shoreline. In 1769, a Spanish expedition led by Captain Gaspar de Portóla traveled overland establishing missions in the region, including San Miguel Arcángel to the north and San António de Padua to the northeast. Both claimed portions of San Simeon as grazing lands. The name San Simeon was likely conferred by the mission padres to honor San Simeon Stylites, a fifth-century Roman Catholic saint.

Spain relinquished its ownership of California to Mexico in the 1830s, at which time the land was apportioned into three large ranchos. In 1840 José de Jesus Pico received the maximum acreage for a land grant—48,805 acres, or 76 square miles, including 14 miles of coastline. It was known as Rancho de la Piedra Blanca. Pico agreed to build a residence and stock the land with cattle, but he never resided on the rancho. The southern part of what ultimately became the Hearst Ranch was the 13,184 acres awarded to Juliano Estrada in 1841, known as the Santa Rosa Rancho. In payment for a loan, Estrada turned much

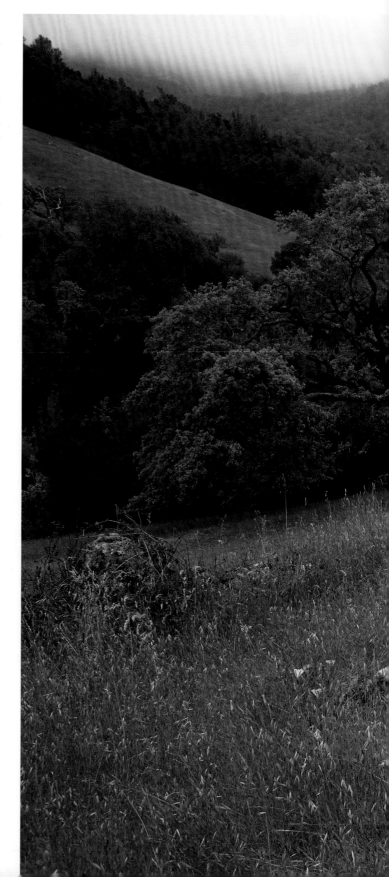

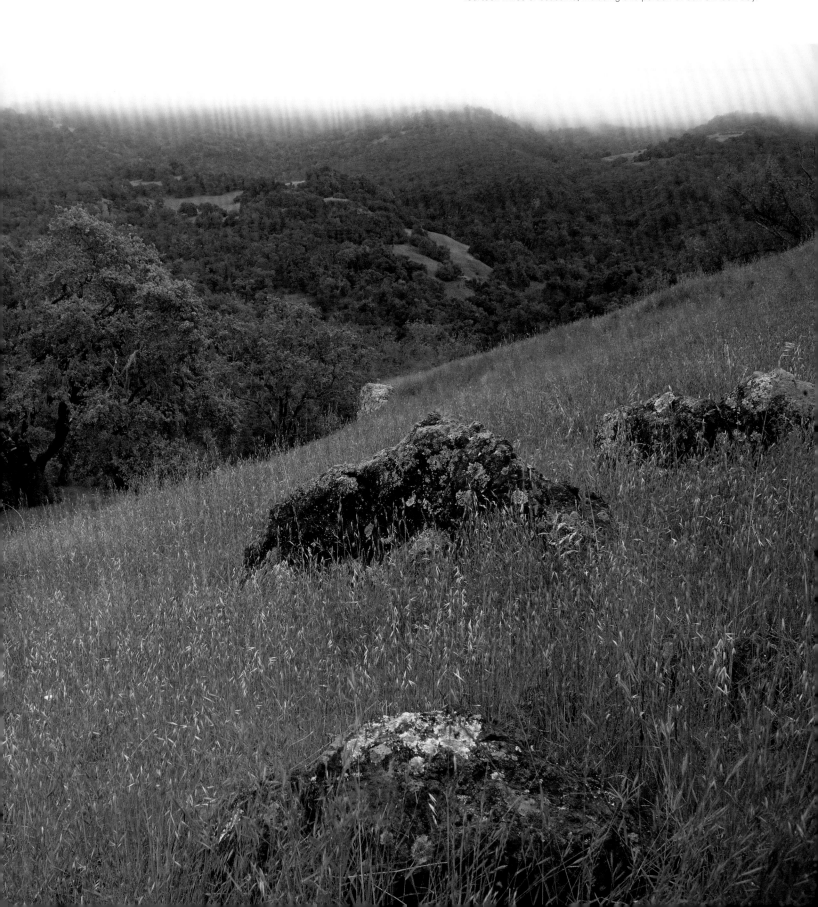

BELOW: For more than nine thousand years, this land was home to native peoples of the Salinan and Chumash tribes, the latter famed for their well-crafted canoes. After 1769, two California missions—San António de Padua and San Miguel Arcángel—claimed it for grazing. This Mission era was disastrous for the indigenous peoples, whose population was decimated by hardship and disease. A small number of their descendants still reside in the region.

OVERLEAF: After Spain relinquished its ownership of California to Mexico in the 1830s, the San Simeon area was apportioned into three land grants. Rancho de la Piedra Blanca was the largest one, presented to José de Jesus Pico in 1840. It contained nearly fifty thousand acres of land and fourteen miles of coastline, including this portion of San Simeon Bay.

The Mexican government granted 4,500 acres south of San Simeon Bay (known as Rancho San Simeon) to José Ramon Estrada in the 1840s. Still further south was the 13,184-acre Rancho Santa Rosa, initially granted to other members of the Estrada family. Land in the entire region featured many water sources. Here is the mouth of San Carpoforo Creek, north of San Simeon.

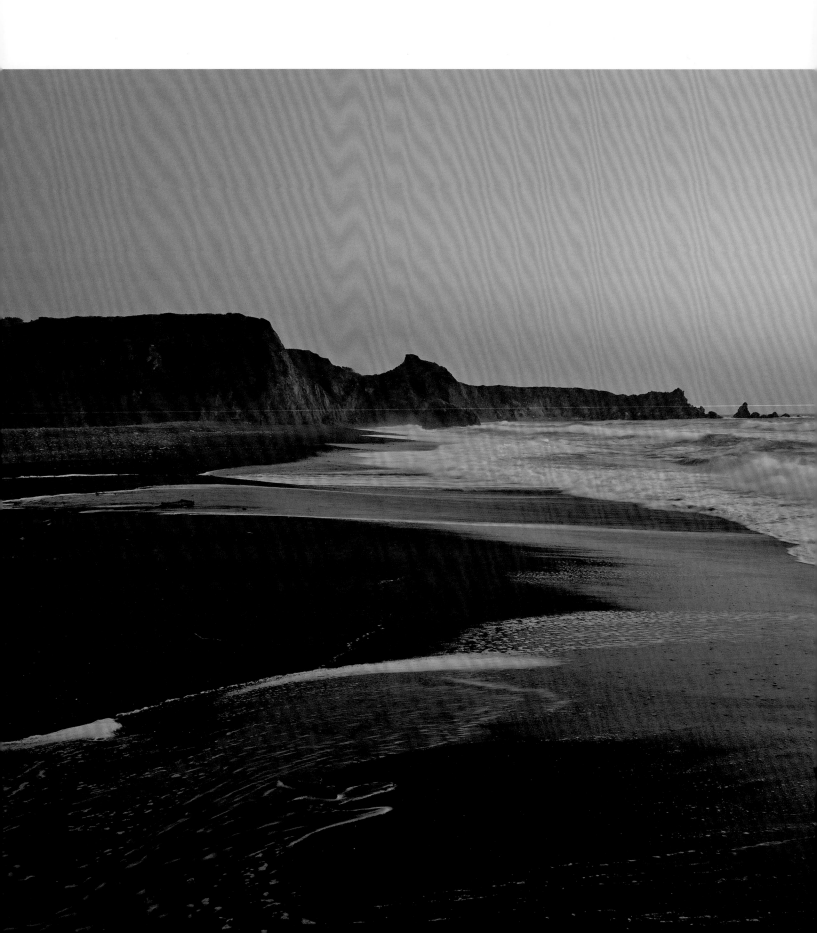

of the land over to Domingo Pujol, a local lawyer who within eight years ended up owning all but 1,500 acres, on which Juliano Estrada built an adobe. Juliano's son, Don Francisco "Pancho" Estrada, was born there in 1854, and later became one of the Hearst family's most trusted employees and devoted friends.[20] The third land grant ultimately making up the ranch was awarded to Juliano's brother, José Ramon Estrada. Known as Rancho San Simeon, its 4,500 acres were bordered by Rancho de la Piedra Blanca to the north and San Simeon Creek to the south. Estrada broke up the rancho and sold it in 1845. In 1848, gold was discovered in California, a bonanza that quickly brought the Mexican era to a close. California joined the United States in 1850.

Fifteen years later, acreage in the San Simeon region was available for purchase because of a series of disasters, both natural and man-made. California experienced tremendously volatile weather during the first half of the 1860s, beginning with winter flooding in 1861–62, which destroyed crops and killed cattle. This deluge was replaced by an even more crippling drought in 1862–64—the worst drought of the entire nineteenth century. These forces were devastating on their own, but they were accompanied by another disaster. Inexact title boundaries dating to the creation of the Mexican land grants provoked extended litigation in the early 1860s. The Mexican and American families who owned large swathes of ranchland from the 1830s onward were financially ruined by tax increases and legal bills. Cattle prices also fluctuated widely at this time, in part because the *Californio* rancheros were often forced to sell their herds below cost in order to pay their debts.[21]

The region was—and is—superbly suited to cattle. Its ranchlands are surmounted by the Santa Lucias, a coastal mountain range running parallel with the Pacific, with elevations that occasionally exceed 3,000 feet. Creeks and rivers flow year-round from these peaks to the ocean, providing a natural water source. The range's undulating slopes are covered with grasslands, chaparral, and native

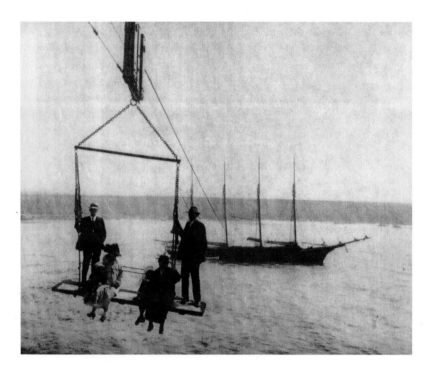

oaks, while the lower foothills are mostly coastal prairie extending to the bluffs above the Pacific. Along the coast, fogs hug the shoreline during warm-weather months, and the median rainfall is generally eighteen to twenty inches. As elevations climb, however, the temperature rises and annual rainfall reaches around forty inches. On the eastern side of the Santa Lucias, the temperatures are higher and the annual precipitation is seventeen to twenty-three inches. Along the shore, San Simeon's landscape could become quite mysterious in the coastal fogs, as one traveler in the 1860s described: "The fog from the Pacific drifted in great waves, and obscured hill and ravine. For a week, indeed, this fog hung over the Coast Range, and as settlers afterwards told me, old ranchers were lost within a mile of their own homes, and wandered about for hours, until the sight of some familiar landmark enabled them to discover their location."[22]

George wrote very little about San Simeon, other than one rather lackluster description in his own memoir: "I may say that besides mining, I have been somewhat interested in stock raising and have a large ranch near Monterey, some forty-five thousand acres, where I raise cattle and hogs. The land is not very valuable, because it is too boggy; however, it makes a very good dairy ranch, and that is what I use it for."[23] It is clear, however, both from George's own actions and the correspondence of his land agents, that the Piedra Blanca Rancho was of tremendous importance to him. The Hearst family tradition of camping on the ranch began when Willie was very young. Father and son often stayed at the mouth of Pico Creek, a year-round tributary south of San Simeon, where they had easy access to the shoreline. Sometimes they camped on a high hill above the fog and admired the incomparable ocean view. Fifty years later, William Randolph Hearst built his lavish home on this site and named it La Cuesta Encantada, the Enchanted Hill.

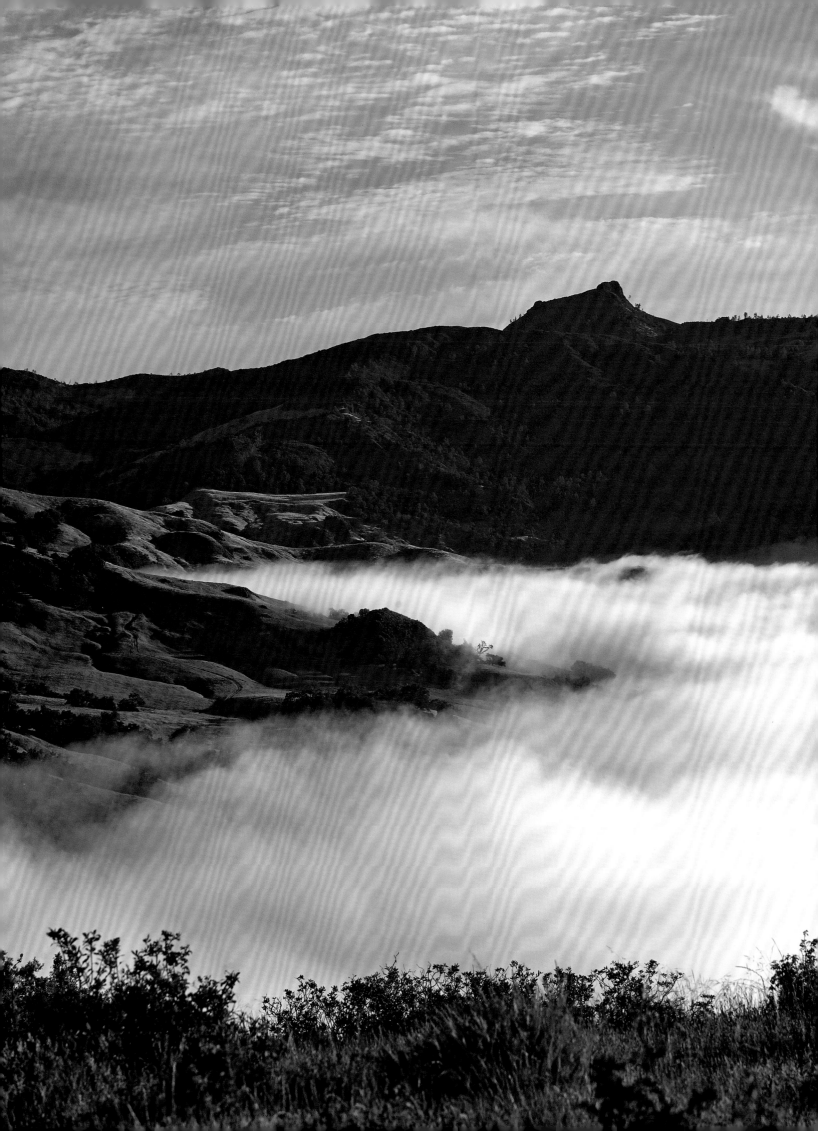

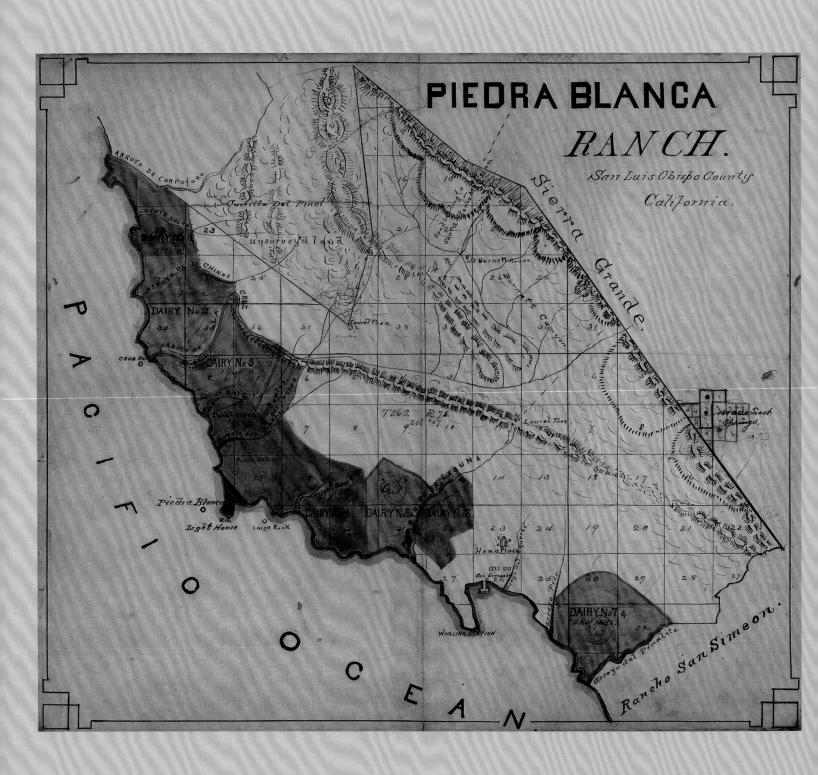

PIEDRA BLANCA
RANCH.
San Luis Obispo County

California.

2

EARLY YEARS AT THE RANCH

George Hearst hired the prominent attorney James Van Ness as his land agent, requesting him to quietly acquire additional property on his behalf. Van Ness frequently fumed at George's slowness to buy more real estate. George was in fact experiencing a money shortage in the late 1860s, and often couldn't afford the purchases. Much of the land George did buy was leased to dairy farmers, as shown in this map of the region circa 1880.

The land around San Simeon was recognized as a sound investment long before George's first purchase in 1865. It was praised in the press for its natural south-facing harbor and its shipping potential by land and sea: "San Simeon Bay, situated on the coast about thirty miles northwest of San Luis Obispo, is attracting considerable attention at the present time. Should [a proposed road] succeed, you may expect to hear, at no very distant day, of San Simeon ranking among the big cities of the state."[1]

This glowing prediction was refuted in the same newspaper just two months later, however, when another correspondent visited the region and labeled these claims "absurdly false. The weather is foggy; the chief vegetation is fern and tar weed; the earth is covered with grasshoppers; the soil is barren; the trade of the place amounts to about $15 a week; 100 sacks of smutty wheat were raised within twenty miles of it last season; and the wealthiest people in that vicinity grind their wheat in hand mills."[2]

These defamatory charges prompted a spirited rebuttal, one that provides a detailed portrait of San Simeon at the time:

Vessels can approach within 100 yards of the shore, and rest in perfect security, except from southeast gales. I have seen Chinese fishing junks moored in the harbor for weeks at a time, and the sailing craft in the coast trade always run in and discharge without difficulty. . . . The country is strikingly beautiful and picturesque. Pine forests, in many places, reach within a few hundred yards of the shore. The coast mountains in the rear, covered with forests of pine and oak, with the broad ocean in front, make a

magnificent and lovely prospect. . . . Whenever the lands in the vicinity shall be sold out into small farms, and changed from grazing land to agricultural uses, it will be found one of the most desirable places on the coast.[3]

George must have concurred with this favorable description, since he purchased approximately 50,000 acres of the Piedra Blanca Rancho from José de Jesus Pico in 1865. George paid close to a dollar per acre for the land—a large sum at the time—doubtless because of its abundant natural springs and proximity to San Simeon Bay.

George immediately began to explore other resources in the region. He opened a copper mine, although the copper industry was flagging in San Luis Obispo County at the time. The press described George's Phoenix mine: "He is a man of means and energy and having invested of late in real estate here, and the copper prospects having been brought to his notice, he determined to try his hand. . . . He has six or eight men employed, driving a tunnel, which is being worked night and day."[4] George soon called off this effort, and did not mine in the region, even though a quicksilver boom swept through the area in the 1870s.

Instead he focused his efforts on buying land, keeping his identity secret when possible (a practice he also employed when he purchased mining claims). George hired James Van Ness as his land agent, instructing him to acquire sufficient property to ensure control of the port. Van Ness was often frustrated by George's delays and lack of communication, writing him:

My advice to you is—close this matter at once, if you have any faith whatever in the future of San Simeon. With this interest secured you have three-fourths of the whole port—enough to enable you to arrange things pretty much as you like. I hope you will not fail to let me hear from you by return mail about this matter. . . . I do not know how you are to work it to get

hold of more land in any reasonable time along the Coast. Everyday makes this land more valuable, and more tedious in securing, in view of the increase in population, and the success in finding mines. There is scarcely anywhere in California such land, and so admirably located, with so good a climate, as that laying along the whole Coast from here to San Simeon.[5]

There was a reason for George's silence. By 1866, he was deeply in debt. The Ophir mine was played out and his other mining investments were failing. A financial panic crippled the country, and George owed his creditors $400,000. He explained years later: "I quit the Comstock in 1867 and went into other things, went into real estate . . . for instance, where I lost all the loose money I had."[6] But in spite of these financial problems, George purchased approximately 1,500 acres of the Santa Rosa Rancho from Juliano Estrada in 1868. It would later transpire that Estrada did not actually own the property, having lost title to the rapacious land attorney Domingo Pujol, who foreclosed when Estrada failed to meet his annual interest payments of 27 percent. George pursued many years of ultimately fruitless litigation against Pujol. Phoebe had approved of George's purchase at the time, writing him: "I hope you will not sell your Southern lands—we may want to go there to live. They will no doubt be very valuable in two or three years."[7]

George kept ownership of his San Simeon ranch properties, but did not capitalize on their commercial potential. Van Ness complained to an associate: "If he has no intention of subdividing the land at San Simeon, and selling it, or of selling it in bulk, he will, I suppose, lease it—and I am told it is his intention to keep it . . . 'for his boy.'"[8] George clandestinely purchased additional ranchland later that year, on Van Ness's recommendation: "Go on quietly and make this survey and you can buy the land before any one will get wind of what has been done. Harris tells me that the body of fine timber on the Eastern slope of

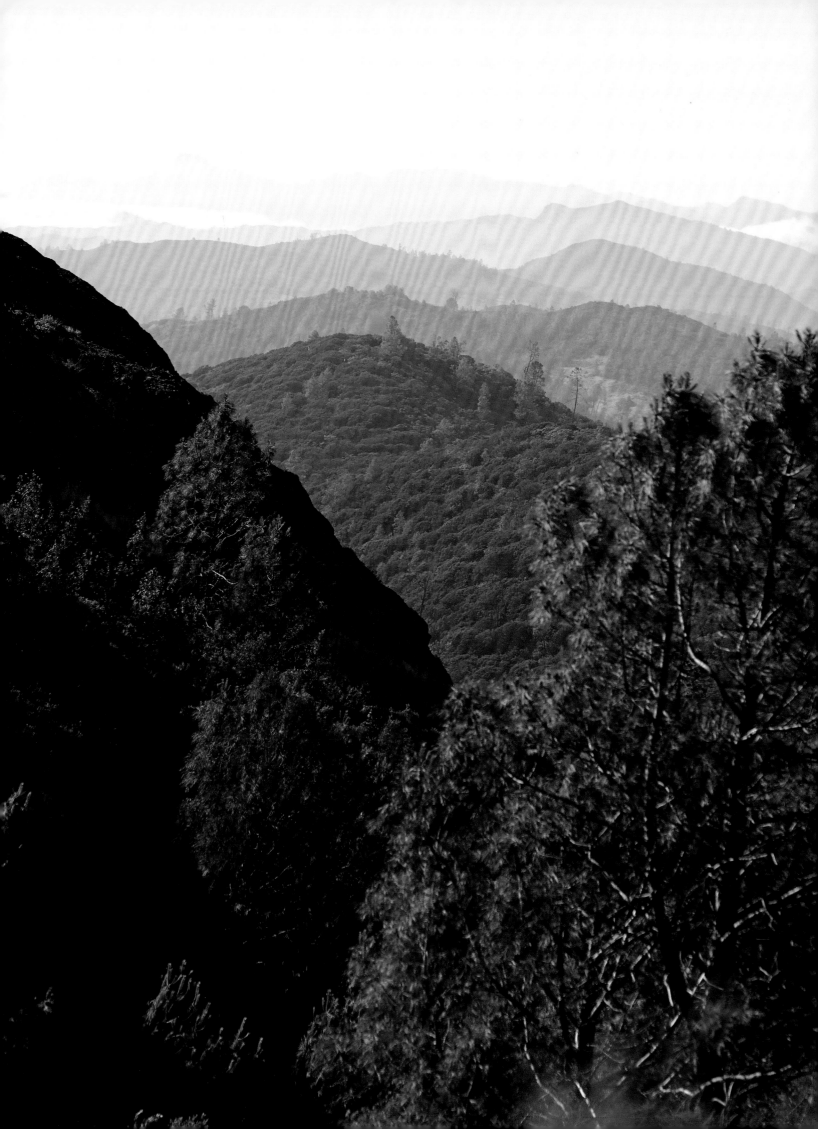

that Peak is immense and magnificent—the trees running up perfectly straight—without a limb 80 and 100 feet—and that the Pine forest on the Pico Ranch or the Santa Rosa bears no comparison to it—and that a body of available lumber on the border of your Rancho—will make the whole property—that is—what you own now—with the Pico portion included—and this addition—a most valuable estate."[9]

Both George and Van Ness expected the Southern Pacific Railroad would soon be built along San Simeon's coast (though it ultimately bypassed the area, favoring an inland route in 1894). They also expected a road to be constructed to link San Simeon with California's central valley two hundred miles east, eliminating the need for coastal steamer transport. George wrote to another investment partner: "Did you get the Norcross Sheep from Jack in San Luis Obispo? Have you seen Short since he returned from surveying the railroad? You seem to be afraid of that road but I tell you, within five years after completion it will pay 25% of its cost of construction." He also directed: "I wish you would send to the Padre Blanco [sic] ranch 200 or 300 small trees, mostly Yellow Pine and Monte Rey [sic] cypress to set out on the ridge above the landing for the purpose of stopping the sand blow and breaking the wind." Both George and Phoebe regarded their ranch at San Simeon as "a nest egg, in case of misfortune."[10]

Therefore they made their economies elsewhere. Phoebe rented out the Chestnut Street house, sold their carriage and horses, and moved herself and Willie onto her parents' Santa Clara ranch. She wrote to young Willie's nursemaid, Eliza Pike: "Mr. Hearst is going down to San Luis Obispo to look after the ranch [for] a few weeks. He has sent some of his Missouri relations down on a small part of it & gives them a start. Mr. H. has not suffered by the panic, excepting that he made arrangements to sell a mine to a N.Y. Co. and they could not take it so he feels that it is difficult to carry so much that does not pay, for one must spend money on a mine to get more out of it. Money is close, but times not bad."[11]

OPPOSITE: In spite of money shortages, Phoebe and young Willie toured Europe for the first time in 1873. She was twenty-nine and Willie was ten. Phoebe often worried about finances, but nevertheless, they stayed eighteen months. They discovered a new world of art and culture, and it changed them both forever.

OVERLEAF: George could buy land at San Simeon because the drought of 1862–64 had ruined the Mexican landholders, forcing them to sell off their property in the region. They also had to pay high legal bills in efforts to establish their titles after California became a state in 1850. After 1865, Italian-Swiss farmers moved in, replacing the wiry Spanish cattle with dairy breeds.

During this retrenchment, Phoebe took ten-year-old Willie to Europe for eighteen months. She wrote George frequently about their finances during the trip. She clearly felt guilty about her lavish spending, but was having a wonderful time and did not wish to return home too soon. She explained to Eliza: "I had hoped Mr. Hearst would come abroad, but business has been in such an unsettled state this year, he finds it impossible to leave. He has been away from S. F. nearly all the time since we left. When he is there, he seems much more lonely than when he is in the mines. Although I miss home & feel it is not right to be so long away, yet it is about as well. Mr. Hearst is away from us if we are there. We may as well have the advantage of improving our minds & have pleasure instead of running my feet off for visitors, which I shall make a desperate effort not to do when we return."[12]

This first European journey changed them both forever. Phoebe was eager to learn about art and culture, and educated herself while educating her son. Willie at ten was rambunctious and fond of practical jokes. Late in life, he described some of his European escapades: he caught goldfish in a fountain, using bent pins; he shot his toy gun into a hotel ceiling, which came down in a shower of plaster; he lit a small fire in a pan of alcohol, set it on the floor with a red light behind it, locked his bedroom door, merrily yelled "Fire!" and "awaited events."[13] Hearst often told jokes on himself, so some poetic license should be presumed. However, there is no doubt that Billy Buster, as he was sometimes called by his parents, was quite spoiled and frequently got into trouble. He was also a very sensitive child. Willie's passion for art collecting began on this trip and never abated. He also witnessed cruelty to animals for the first time. Phoebe wrote how shocked and saddened he was at the sight of the broken-down and beaten horses in Ireland.[14]

While Phoebe and Willie were abroad, George solved his money troubles permanently by partnering with two investors: James Ben Ali Haggin and Haggin's brother-in-law, Lloyd Tevis. Haggin was born in 1822 in his father's native Kentucky, but his mother had been raised in Turkey. He practiced law in Mississippi before heading to California with Tevis in 1850. The new partners invested in the Ontario Mine, strictly on George's evaluation of its silver potential. It ultimately yielded $14 million, ensuring George a vast fortune safe from minor fluctuations. They also invested in the spectacularly successful Homestake gold mine in South Dakota, followed by the Anaconda copper mine in Montana. George wrote much later about his legendary status and the inevitable overrepresentations of his wealth: "They tell such a variety of lies about me that I don't bother contradicting them any more. They tell about my appalling ignorance, about my ambition and about my wealth. I am commonly quoted as worth $20,000,000. This ain't so, nor anything near it. If anybody wants to buy me out, bag and baggage, for $5,000,000, just say I'll trade."[15]

Still, it is no exaggeration to state that George built one of the country's most colossal fortunes. This capital allowed him to expand his San Simeon investments in the late 1870s, acquiring additional land and enlarging its shipping trade. Italian-Swiss dairy farmers had moved in along the coast throughout the decade, replacing the wiry Spanish beef cattle with more profitable American breeds. Shipping also increased after the Piedras Blancas Light Station was completed in 1875. Eight miles north of San Simeon Bay, it warned sailors about the perilous white rocks along the coast. San Simeon also profited from shore whaling at the time. George did not participate in this business, but he capitalized on the results.

California gray whales were unfortunately in high demand in the mid-nineteenth century. Their oil was used for fuel (prior to the widespread adoption of petroleum) and their baleen was sought after for its flexibility in buggy whips and corsets. Captain Joseph Clark (born José Machado in the Azores) began his San Simeon whaling operation in 1864. Portuguese sailors had long been recruited from the Azores to join whaling ships. They were renowned for their seamanship, work ethic, and

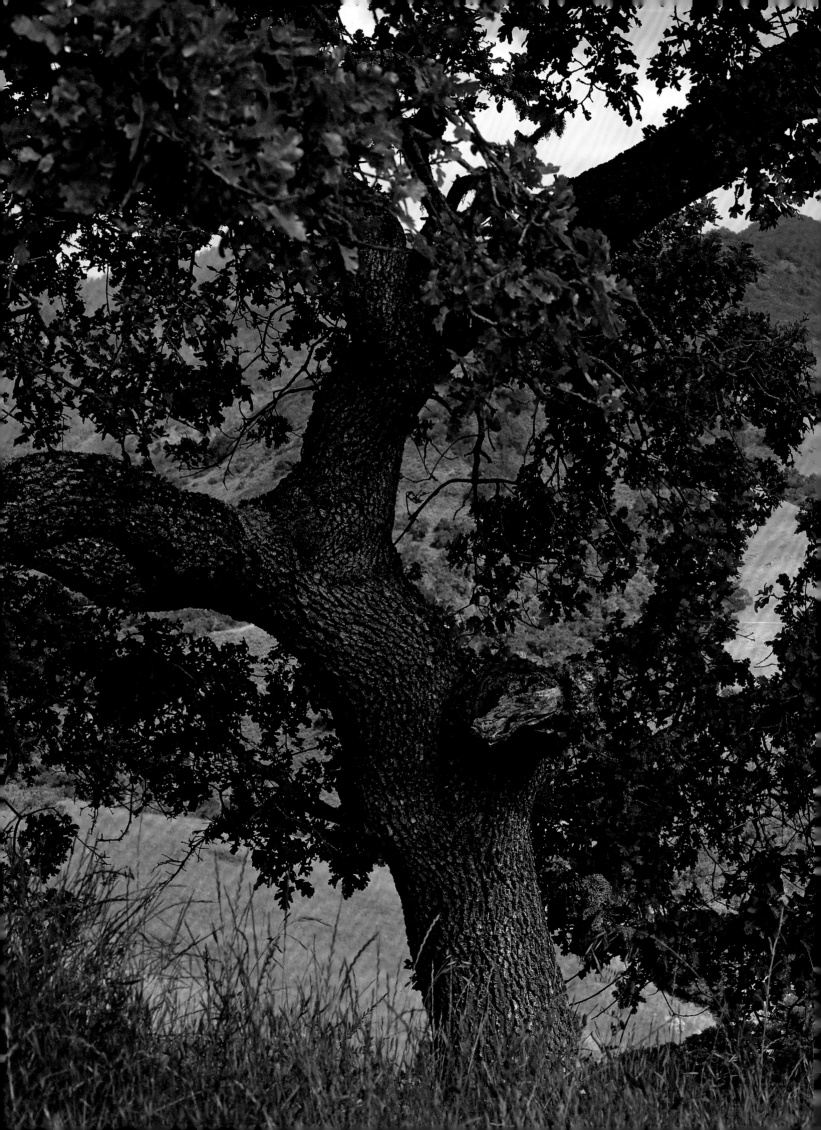

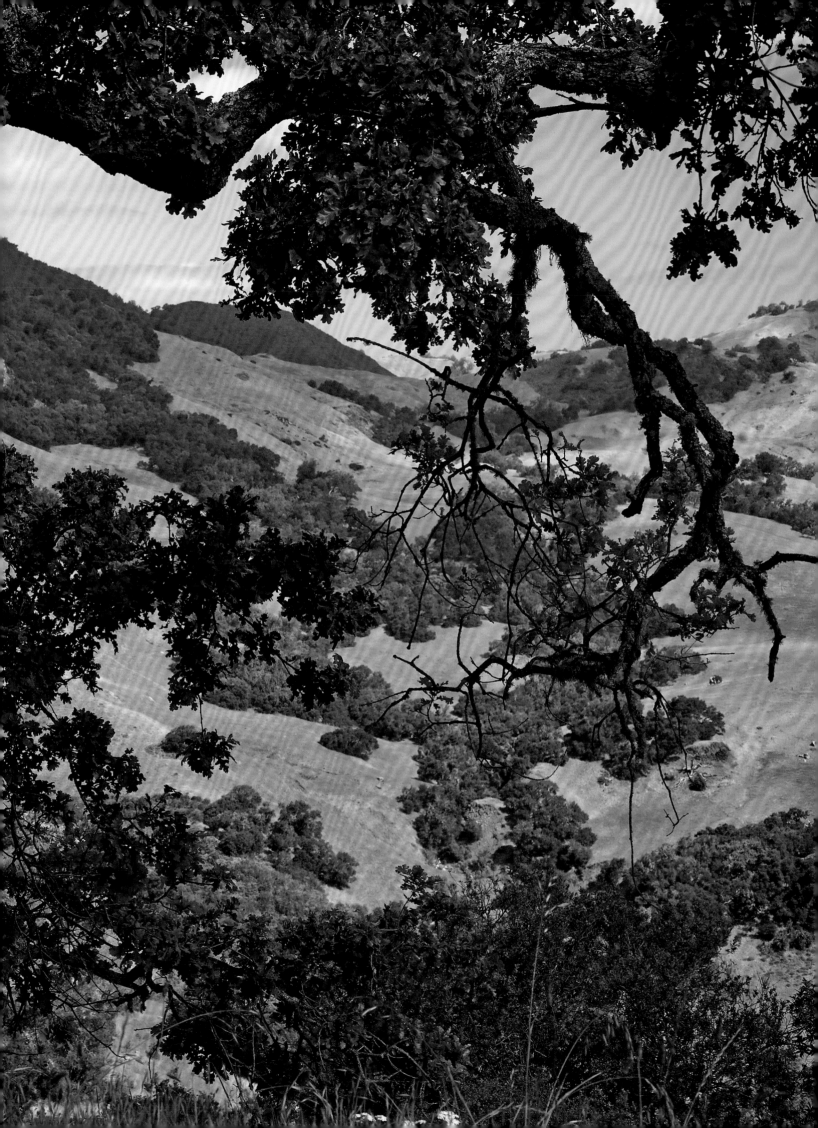

particular ability to spot whales from shore.[16] Clark led a group of squatters who settled on San Simeon Point. It was not an ideal location for a residence, since it lacked both fresh water and beachfront. The local newspaper wrote: "The hills adjoining the bay are bleak and bare and present anything but an inviting appearance."[17]

Whales migrated just off the coast from December to February, then headed to milder waters off Mexico for calving. In April, they went north again, but this time the males stayed near the coastline, while the females remained further out to sea with their calves. At its height, Clark employed as many as twenty men and maintained a fleet of five whaling boats. He built a small wharf, just high enough to clear the tides. A wooden ramp extended from the wharf to the edge of San Simeon Point, where whale blubber was melted down into oil. Near the Point were quarters for the men, a boathouse, and a building known today as Sebastian's store, then owned by L. V. Thorndyke and used as a commissary. An additional whaling outpost was located on Piedras Blancas Point to the north. It served as the primary lookout to alert San Simeon crews when a whale was coming down the coast. In its first decade (1864–74), an average of twenty-two whales was taken each year. As their population declined, these numbers decreased.[18]

George partnered with Joseph Clark to construct a wharf inside San Simeon Bay in 1869. It quickly proved insufficient—too short and often affected by tidal swells. In 1878, when he was awarded the franchise to improve it, George built his own twenty-foot-wide wharf, extending nearly one thousand feet into the bay. It was fitted with rails for easy hauling and augmented by a large warehouse along the shore (which he built for $20,000, and which remains in use today). George was authorized to charge one dollar for nearly all wharfage fees (though rates for food were one-sixth that amount).

San Simeon shipped hides, whale oil, abalone, grain, foodstuffs, and one less familiar product: enormous quantities of seaweed. Chinese farmers lived along the coast and harvested *ulva*, or sea lettuce, a type of bright green algae found on tidal rocks. They scrubbed and prepared the rocks to encourage its growth, carefully picked it, and dried it in the sun. It was packed into enormous bales and shipped to China by coastal steamer.

Chinese immigrants came to California in vast numbers from 1848 to 1882, when Congress passed the Chinese Exclusion Act banning their entry. Frequently persecuted, they worked on California's most difficult jobs, including building the Southern Pacific Railroad. Employee records indicate that there were nearly always Chinese cooks employed at the Hearst Ranch from the 1870s on. George wrote of the Chinese: "They can do more work than our own people, and live on less. . . . It is nonsense to say that the Chinaman is of no account, or that he is dirty; what I am afraid of is, that he is a better man than I am, and I want him out of the country because I believe we cannot compete with him."[19]

In the early years, George and Willie visited the ranch without Phoebe. When weather permitted, the Pacific Steamship Company's coastal schooners docked in the bay and a bosun's chair (resembling a mechanical trapeze) lifted them over the water to a small tug that ferried them ashore. If it was stormy, they sailed to Avila Beach, a harbor south of San Luis Obispo, then traveled by coach and driver over fifty miles of rutted roads. Once they arrived, they often camped in the hills—a journey altogether too arduous for Phoebe's taste. In 1878, while building his wharf and warehouse, George constructed a handsome Victorian ranch house one-half mile inland, on a rise alongside Arroyo del Puerto Creek. Its eighteen rooms included quarters for the ranch manager as well as comfortable accommodations for the Hearst family. Built of redwood in an Italianate style, it featured a front porch that faced west. In the years before the ranch house gardens' coastal redwoods, eucalyptus, and magnolia trees matured, it provided a view of San Simeon Bay at sunset.

By the time the ranch house was completed, young

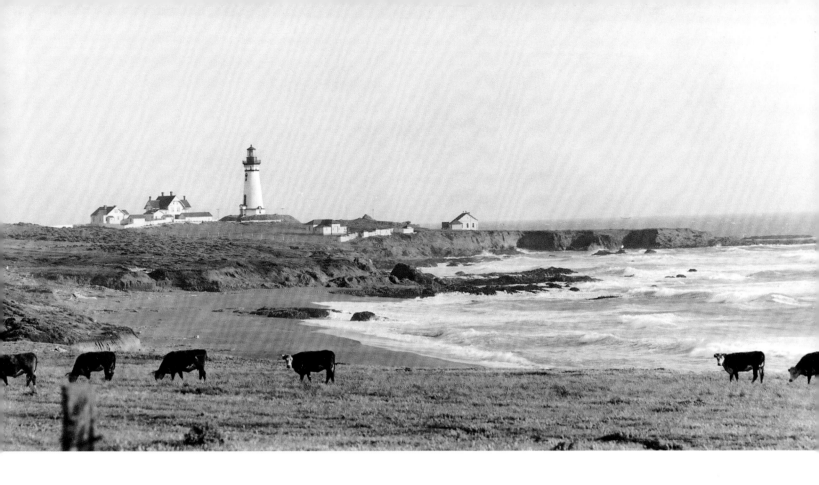

Willie was in New England. Like most sons in wealthy American families, he was educated in the East. He wrote to Phoebe from St. Paul's School for Boys in New Hampshire: "I have settled into a state of perpetual homesickness, which although not quite so bad as when I first came, is pretty bad and I think it will continue until I see you again. I never knew how much time there was in two months before, and how long it could be strung out." He hated the cold winters and the hot summers equally: "It is SO hot. The thermometer is 95° in the shade and shows a tendency to bust the tube and spout off into space. And the mosquitos and the gnats and the June bugs buzz around your ears and entangle themselves in your hair and finally burn themselves up in the gas light, and make night hideous. Oh, for the balmy breezes of the Pacific!"[20]

Will (who had outgrown his childhood name of Willie by this time) received a respite from St. Paul's when Phoebe took him to Europe again when he was sixteen. Their financial situation had stabilized, but Phoebe had another concern: George was in the Dakotas and she worried about attacks by the Indians. She wrote to him: "I hope you will avoid 'Black Hills' and all Indian countries where there may be danger. We don't want anything to happen [to] you. The money would be of little value if you could not enjoy it with us. I fear there has not been much rain in Cal. Am anxious to know how things are going on at the ranch.

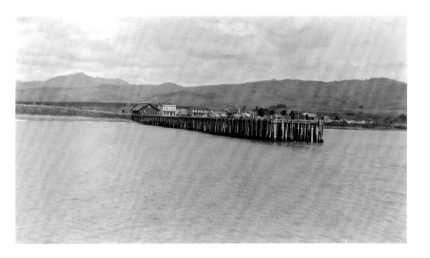

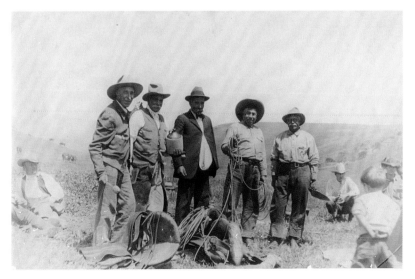

Did you go into the fish project? I am afraid there would be no profit in it, but if it gave you pleasure there would be something in that. Have you really bought Castro's ranch?"[21] Phoebe was referring to the Santa Rosa Rancho, directly south of San Simeon. Neither she nor George missed an opportunity to increase their acreage. Will's letters to George were more independent and outdoorsy: "I wish I could spend a few days in the Black Hills. I would like to have a shot at some of those deer, elk and maybe grizzly bears I heard you talk about."[22]

When Will moved from St. Paul's to Harvard, his misery with the climate and his homesickness for California did not abate. He wrote to Phoebe: "It has been awful weather. . . . Oh! So dreary and desolate and gloomy and depressing. Everybody is miserable: Everybody wants to go home and I most of all. Every living being has the blues, and every inanimate object seems to be afflicted with the dark greys."[23]

Will found Harvard insular and stultifying, and he longed to return to California, far from the "dreary bean eaters" of Boston: "I long to get out into the woods and breathe the fresh mountain air and listen to the moaning of the pines. It makes me almost crazy with homesickness when I think of it, and I hate this weak pretty New England scenery—with its gently rolling hillsides, its pea green foliage, its vistas—tame enough to begin with, but totally disfigured by houses and barns which could not be told apart save for the respective inhabitants. I hate it as I do

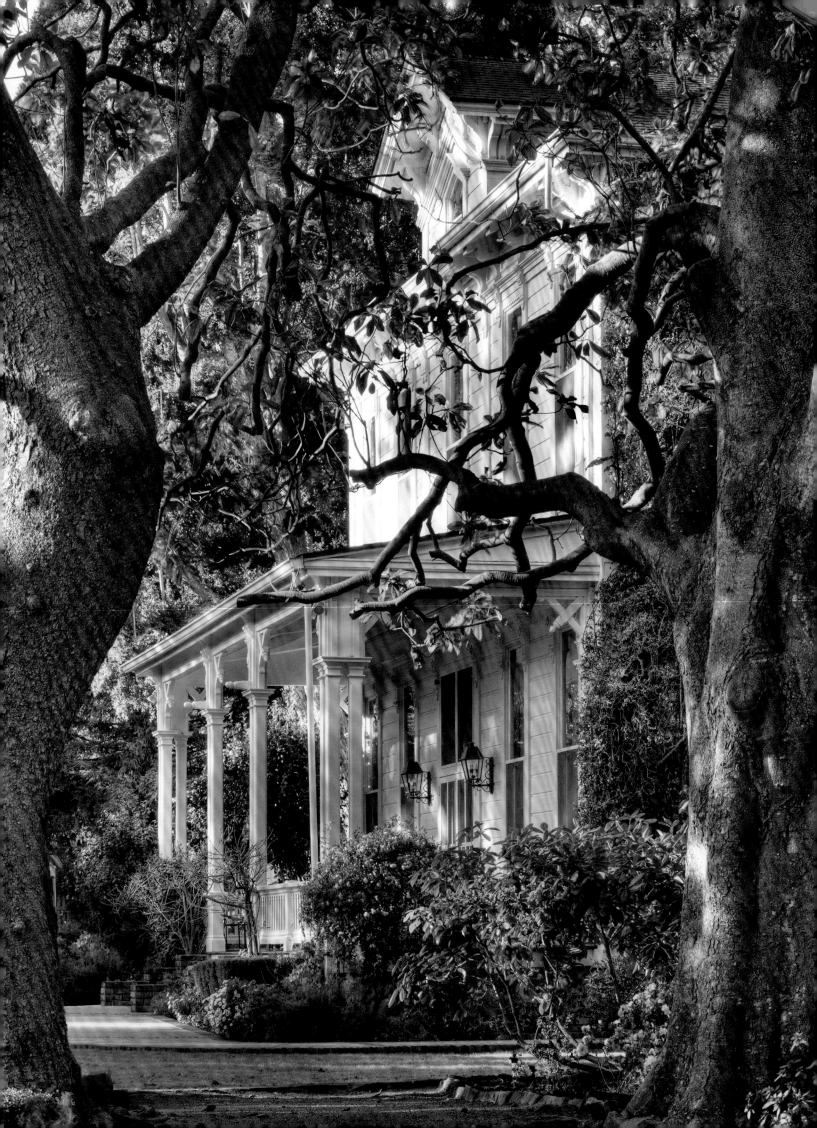

OPPOSITE: In 1878, George built a Victorian ranch house in the Italianate style. It contained eighteen rooms and overlooked San Simeon from a low rise along Arroyo del Puerto Creek. When it was completed, Phoebe Hearst began to visit the area, arriving by steamer or coach. There was no train service in the county until 1894.

BELOW: The ranch house was both comfortable and elegant, in contrast with San Simeon's two commercial hotels. It accommodated the Hearst family as well as a succession of ranch managers, many of whom were Hearst relations.

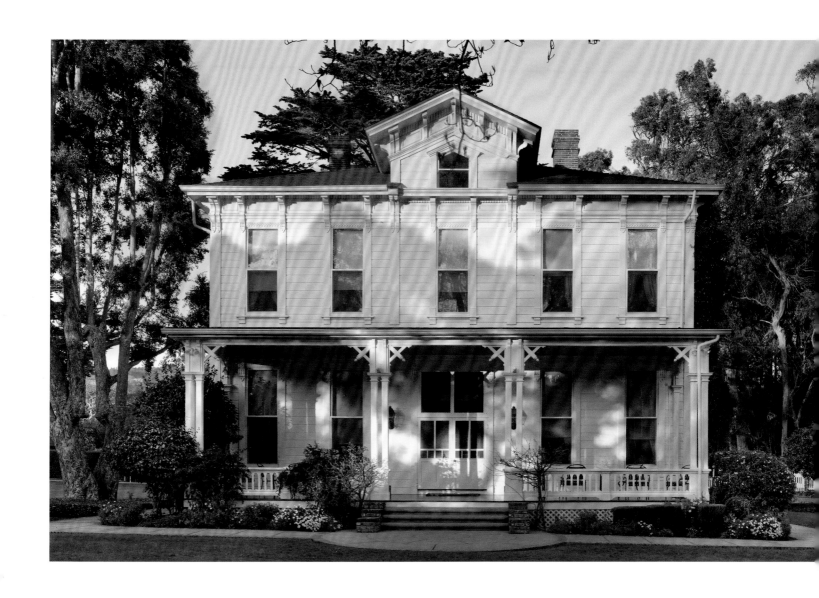

The ranch house included this spacious dining room. After it was completed, the Hearsts began bringing guests to San Simeon.

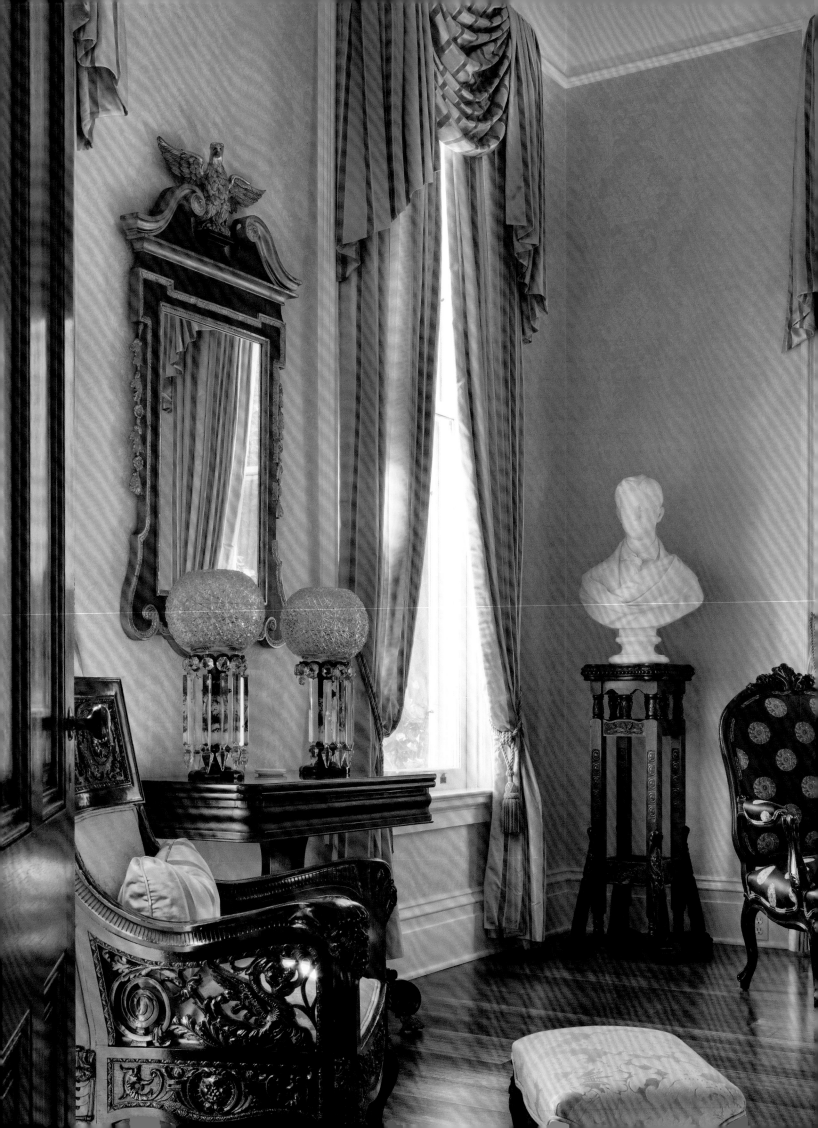

a weak pretty face without force or character. I long to see our own woods, the jagged rocks and towering mountains, the majestic pines—the grand impressive scenery of the far West. I shall never live anywhere but in California. I like to be away for a while only to appreciate [it] the more when I return."[24]

Will sometimes brought his college friends to the ranch on summer breaks—most likely Eugene Lent and Jack Follansbee, fellow Californians and Will's closest friends at Harvard. At least once, they rode south from Monterey to San Simeon, traversing 120 miles along sheer cliffs that dropped five hundred feet to the ocean below. (Highway 1, the winding road that connected Monterey to San Simeon, was not completed until 1937, fifty years later.) They rode into an old gold miner's camp and asked him if he had any butter. "Butter!" he replied. "What in hell is that? I haven't seen any in twenty years."[25]

During the school term, Will wrote Phoebe jaunty letters about how hard he was studying at Harvard, but his grades certainly did not reflect this. George recalled, "He was four years in Harvard. I do not think, however, that he worked very hard there, because he was too fond of fun."[26] Will was delighted when Phoebe and George sold their San Francisco home on Van Ness Avenue: "And since the house is sold, Vive le ranch!—Now we must get Mr. Briggs's brother who is a young architect of considerable reputation, to plan us a $25,000 house to be erected on our estate in the country, don't ye know." Will was twenty at the time, and already full of advice on what they should build at San Simeon, recommending that they pick a site atop the mountain, not below: "The object of this document is to exhort beseech implore you not to build any house on the ranch until you have investigated these eastern houses thoroughly. I have seen houses that cost twenty or twenty five thousand dollars that were so artistic and so unique and so conveniently and cosily arranged that you would rather live in them than in our big house that sold for two hundred thousand. And on the ranch in such a house nestled between two hills, protected from the wind, commanding

a view of the sea &c., why existence would be perfect. And the garden of Eden couldn't hold a candle to it. We could then have those friends that we wanted (wanted in italics please) and could entertain them with fishing and hunting and buttermilk. . . . Then we could spend part of the winters East and part of the other time in San Francisco and finally when we became wealthy enough to have a city house we couldn't be persuaded to live in town."[27] When William Randolph Hearst finally did build his mountaintop home overlooking San Simeon Bay in 1919, he had been planning it for at least thirty-five years.

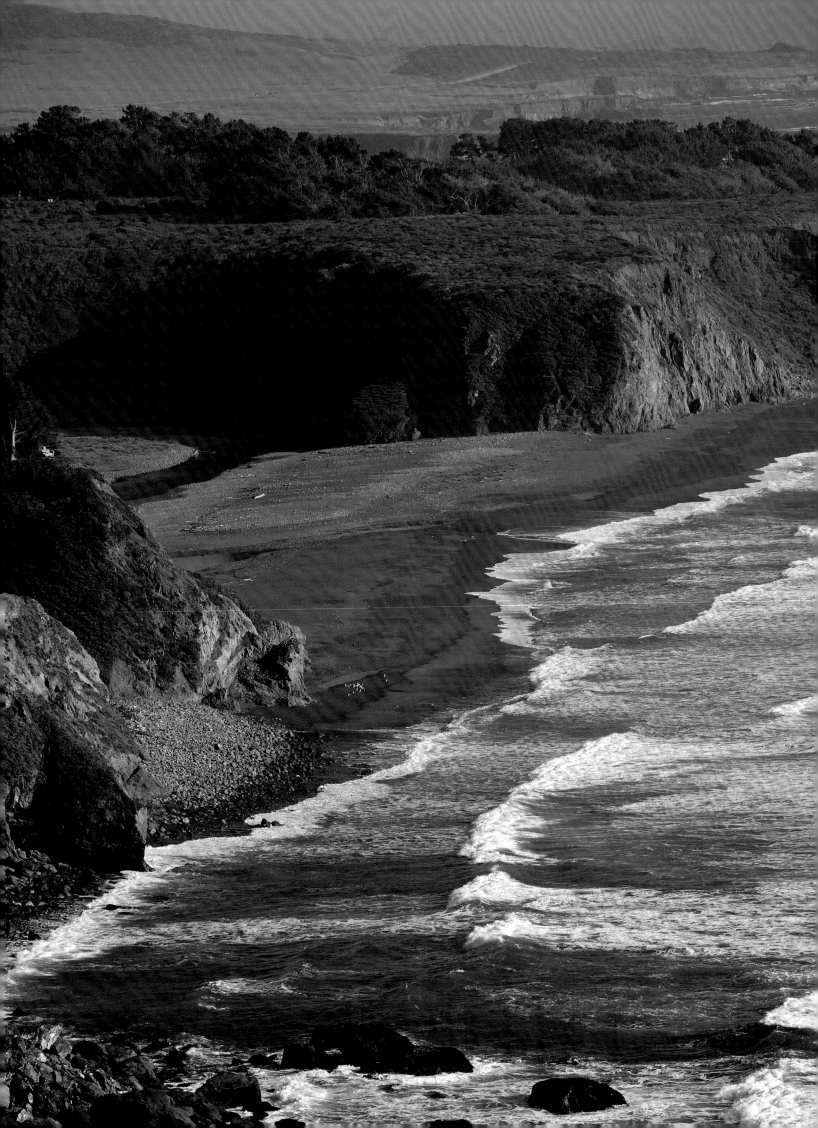

3

THE HEARST FAMILY AT SAN SIMEON

ill's Harvard education was life-changing in one sense. He became the business editor of the college satire newspaper, the *Harvard Lampoon*. This job was perfect for the richest student on campus, because the *Lampoon* was a notorious money-loser. Under Will's enthusiastic management, however, it prospered. He sold ads, built circulation, and commenced his lifelong fascination with newspapers. Will's letters to his father increasingly focused on his suggestions for running the *San Francisco Examiner*, the small newspaper George acquired in 1880 (in return for an unpaid debt, according to family legend) to advance his bid for a Democratic seat in the United States Senate. George wrote to Phoebe in 1882: "I hope the boy will be able . . . to take charge of the paper soon after he leaves college, as it will give him more power than anything else."[1] George clearly was enthusiastic about Will running the paper after he left Harvard. Scholars have sometimes stated that Will had to convince his father to give him the newspaper. In fact, Will's struggles usually involved George's lack of response to his missives, not criticism of his efforts.

Will also pleaded with George and Phoebe to find a position for Jack Follansbee, who was forced to leave Harvard due to financial difficulties. "He has been the best friend I have had in college so far. . . . But he must go, he says, and make some money, and this is where I want you to help him." He wrote to Phoebe: "I had a letter from Jack the other day and I hope papa is doing something for him as he seems to be trying very hard to learn all about the business and is eagerly looking forward to the time when he and I will have a ranch together."[2]

Will's plans to own a ranch with Follansbee and his preoccupation with the *Examiner* caused his grades to fall

even further. Phoebe headed east when she learned he was in danger of being ejected. She wrote George from New York: "Our boy seemed glad to have his mother here. I sent you a telegram that night as I thought you would like to hear from us before going to the ranch." She then sketched out her plan. She had hired a tutor and was going to stay and supervise his studies, since Will "*says* he wants to get his degree, especially as he thinks the Dean don't want him to get it."[3] This contrarian reasoning provides a fair portrait of Will's attitude about Harvard.

Phoebe's pleas to the university's chancellor and George's large gift of rare minerals to the mining department failed to secure Will a place in the senior class. The administration was particularly displeased by a boisterous fireworks display he launched in the commons to celebrate Grover Cleveland's presidential victory. Will was rusticated soon after, meaning he left Harvard to pursue his studies elsewhere and could petition to be readmitted. That certainly did not happen. Will was unrepentant and far too preoccupied with heading west to worry about a diploma. He wrote to George:

> Please get us that ranch you promised. The first thing you know all the good land will be gone and the fact that you have your eye on a ranch won't prevent somebody else from stepping in and buying it. I've seen men who had their eye on the whole Pacific slope and never realized a cent off of it. It really seems to me that everybody I know is going out West to buy land and I am afraid that by the time I graduate there won't be a decent ranch to be had. You will probably admit that all this is very true and yet never think of it again. . . . If I thought that you were waiting for me to leave college I would leave tomorrow and be home in a week, for I really feel that opportunities are now offered which will never occur again.

George appears to have been unresponsive, since Will wrote him soon afterward: "Will you kindly take some slight notice of your only son. Will you be so good as to answer his letters and let him know that you at least appreciate his kindness in allowing you to draw upon his large experience and giant intellect."[4]

Will's other preoccupation upset Phoebe even more: his romance with her former protégée Eleanor Calhoun, a talented actress. Will proposed to Eleanor at the Del Monte Hotel in Monterey, writing Phoebe about their upcoming visit to San Simeon: "The Wednesday steamer to the ranche [sic] is a miserable one. Saturday's is of course a miserable one, too, but it is preferable to the other. Let us therefore remain until Saturday next before starting for the ranche and let us——us being you, Mrs. Calhoun, Miss Calhoun, Virgie, and myself—let us spend the intervening time in this most delightful of summer resorts, Monterey. . . . You see it is only for a few days and as the life here is a contrast to that of the ranche it would serve as an agreeable prelude and the ranche life would be all the more enjoyable after a few days spent here. There is tennis, bowling, and the baths; there is a little whirl of gayety [sic] in the evening, a very small eddy indeed."[5]

Phoebe was appalled at the prospect of an actress for a daughter-in-law, and she soon engineered their breakup. Miss Calhoun traveled to Europe to study acting in the fall of 1886, while Will withdrew from Harvard and boarded a train for northern Mexico with Jack Follansbee. Phoebe was determined to put an unbridgeable distance between her son and Eleanor. She and George also wanted Will to visit Babicora, the vast Mexican cattle ranch George had acquired in 1884. Located in the state of Chihuahua along the ridges of the Sierra Madre mountains, Babicora was an arid, high-desert landscape, with elevations exceeding five thousand feet. George initially purchased an astonishingly large 670,000 acres. He continued to quietly acquire land (paying the low price of twenty to forty cents an acre) until he owned nearly a million acres, an acquisition made possible by George's close friendship with Mexican governor Porfirio Diaz. Will returned to Babicora many times over

OVERLEAF: While at Harvard, Will returned to San Simeon whenever possible. He often brought his college friends to hunt, ride, and explore the ranch. Will also helped during the roundups. Grazing cattle still forge the trails visible on San Simeon's hillsides.

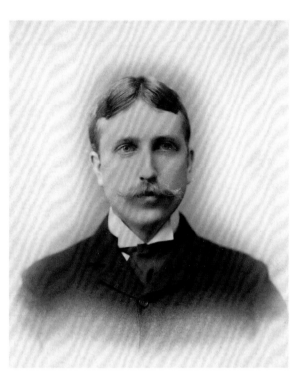

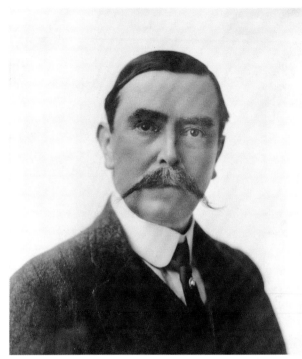

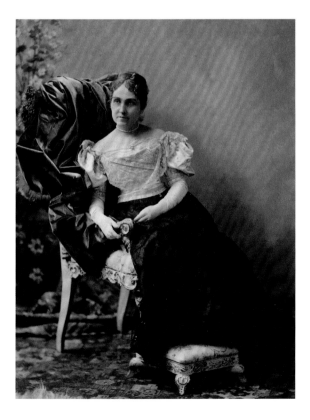

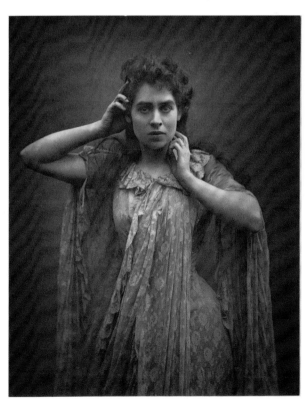

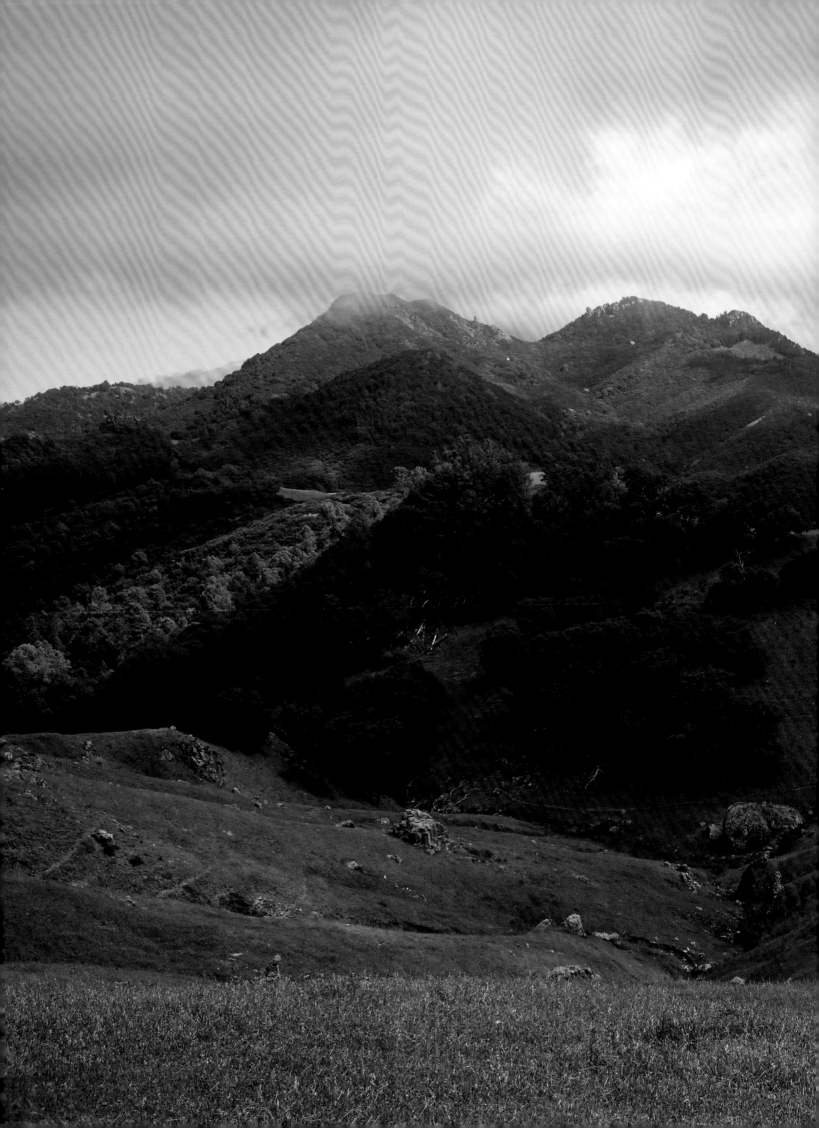

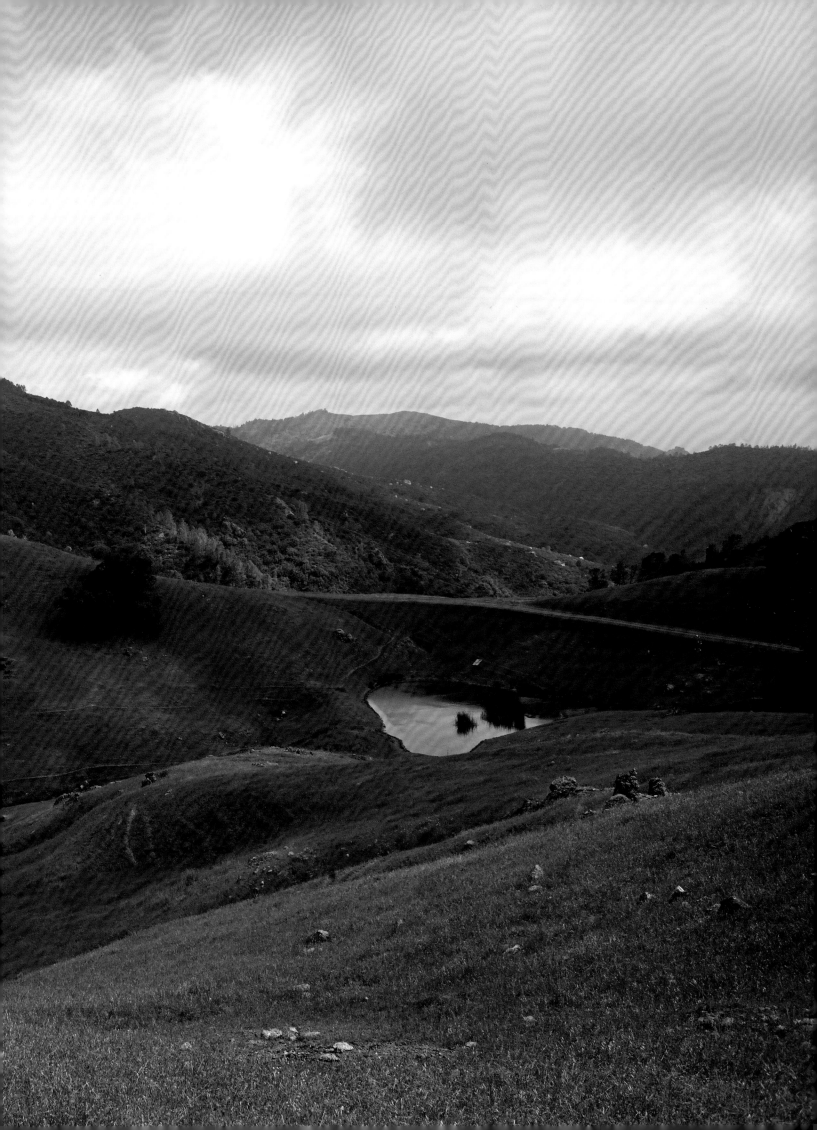

TOP: In 1884, George began buying land in the Sierra Madre mountains of northern Mexico. Because of his friendship with Mexican governor Porfirio Diaz, George was able to acquire nearly one million acres in the state of Chihuahua. George gave Will and Jack Follansbee an adjoining 100,000 acres for their own cattle ranch.

BOTTOM: Artist and family friend Frederic Remington visited Babicora. He drew Jack Follansbee, manager of Babicora, for *Harper's* magazine, identifying him as "El Patron, Don Gilberto of Bavicora."

the next fifty years, using it in the twenties and thirties as the feeder ranch that supplied calves to San Simeon.

On this first trip, Will was eager to impress George with his business skills, urging him to drop everything else and put all his efforts into buying more land in the region. "We are pioneers in Mexico," he wrote. "We have all the opportunities open to us, that ever pioneers in California had and we should improve on them."[6] George gave Will and Jack Follansbee 100,000 acres of Babicora's adjoining land on this visit. Follansbee remained in Mexico and oversaw Babicora as its ranch manager for a decade.[7]

After leaving Harvard, Will also toured George's cattle ranches in New Mexico and visited the Anaconda copper mine in Montana, but neither of these career prospects appealed to him as much as journalism. George was appointed to the U.S. Senate in 1886 (and elected to serve a full six-year term in 1887). He and Phoebe moved to Washington, D.C., residing in a thirty-room mansion at 1400 New Hampshire Avenue. Phoebe became one of the leading hostesses in the city, quite a transformation for a young Missouri farm girl who had dreamed of seeing St. Louis someday. And Will achieved his long-held dream at last when George gave him the *San Francisco Examiner* in 1887.

All three Hearsts were thus pursuing new interests away from San Simeon, which began to decline as a commercial port at this time. George and Phoebe were involved in East Coast politics and society. Will was obsessed with his newspaper, writing George: "I don't suppose I will live more than two or three weeks if this strain keeps up. I don't get to bed until two o'clock, and I wake up at about seven in the morning and can't get to sleep again for I must see the paper and compare it with the *Chronicle*. If we are the best I can turn over and go to sleep with quiet satisfaction, but if the *Chronicle* happens to scoop us, that lets me out of sleep for the day."[8] He hired top writers away from his competitors, slashed the selling price of the paper by half, and filled the *Examiner*'s pages with towering headlines and sensational stories, all techniques he

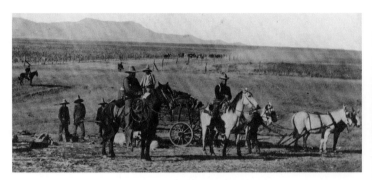

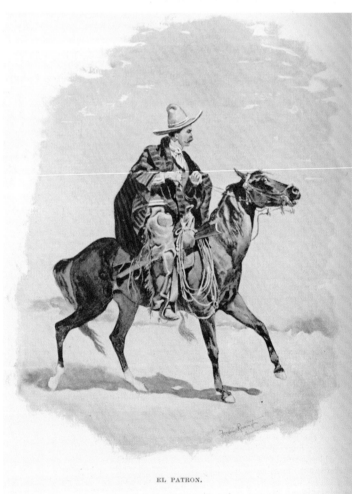

EL PATRON.

practiced in later years to build his newspaper empire of twenty-eight dailies.

During this time, the ranch was very important to George in one way, however. He had raised horses and built a racetrack there in the 1860s. In 1889, he expanded this operation into an elaborate stud farm located south of San Simeon. With two stables, two hay barns, a colt barn, a granary, and 1,500 acres of white-fenced pastureland, it was described as one of the finest stables on the continent. George filled it with racehorses, which he purchased for prices upwards of $15,000 apiece.[9]

Will and Phoebe agreed that George was spending far too much money on horses. His record-breaking purchase of King Thomas for $40,000 incensed them both. Will wrote his father: "Please telegraph me whether or not it is true that you paid forty thousand dollars for a colt. If you have I shall let everything here go to thunder and come East and take care of you. In the meantime you had better get a nurse. I mean this. I shall leave immediately. It is more important to keep you from throwing away your money than to learn to take care of your business when if you keep on like this you won't have any to take care of. If you insist upon squandering all your money I will stop working and see what I can do in that line myself. But you simply want to become notorious, I think. I can suggest cheaper methods & some that will reflect less on your intelligence."[10] Phoebe wanted funds to devote to travel, art, and philanthropy. Will was desperate to construct a new *Examiner* building to outshine his competitor, the *San Francisco Chronicle*. He reiterated to George: "Can't you sell that stable pretty soon. You promised faithfully you would sell it years ago. We figured you could sell it for a hundred thousand while if you didn't sell you would spend a hundred thousand on it—a difference you see between selling it and not selling it of two hundred thousand dollars, enough in itself to start the building with. You owe a good deal of money you know and if we don't begin saving up we never will get anything."[11]

George was serenely unmoved by Will's arguments. The press reported in 1890:

A terse and somewhat personal conversation, says the *New York Sun*, occurred some time ago between Senator George Hearst and his son in the bar room of the Hoffman House. The son, who is a very long youth and rather runs to banged hair, sat solemnly opposite the genial old Senator one day while the latter talked about his racing stock. . . . After the elder Hearst had finished speaking, his son said: "Well, I should think you would learn to keep shy of a thing you know nothing about. Your stable has cost a great amount of money this year." "Well, my son," said the Senator, calmly stroking his gray beard and beaming with apparent amiability on his offspring, "that is good advice. If you had followed it and kept shy of things about which you knew nothing it would have saved me a very much more important source of expense. My stable is not a marker to your paper."[12]

George spent three years developing his San Simeon thoroughbreds. Their formal East Coast debut—with his jockeys wearing their official orange and green Hearst racing silks—was set for the spring of 1891. Instead George became ill in December 1890 with what his doctor termed a "derangement of the bowel." He died two months later, on February 28, 1891. The national press ran long articles praising his generosity, humor, and unpretentiousness. George's life does indeed represent the quintessential American success story—a backwoods miner who became a financial colossus but never abandoned his simple country customs.

George's fortune was estimated at $15 to $20 million (roughly equivalent to $375 million to $475 million today), though the estate also included substantial debts. He left it entirely to Phoebe, to dispense with as she pleased. Will's lifelong friend Orrin Peck wrote her after George's San Francisco funeral: "The detailed accounts . . . we have read &

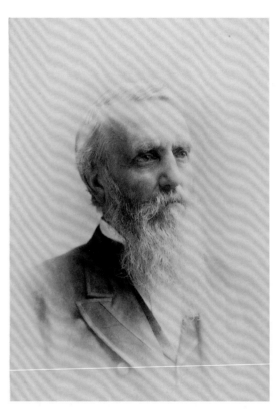

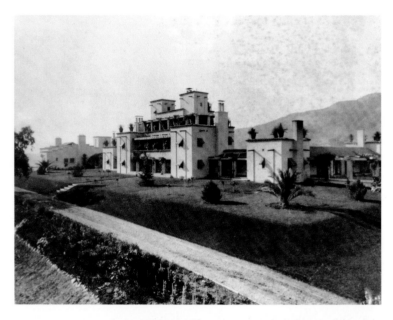

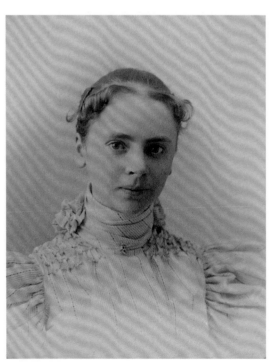

cut out of the papers. Poor Senator, what would he say could he read them! He was so modest as regards outward display and demonstration—I scarcely think he for a moment dreamed in what esteem he was held by his comrades. . . . And I never heard of a man showing more confidence & respect—in a Will for his wife than did he—At the same time he knew what is yours is Will's—& this is right."[13] Will was not so sanguine about the arrangement. Except for the Babicora ranch, Phoebe now owned everything.

There was tension between mother and son at this time in any case. Will separated from Eleanor Calhoun only to take up again with Tessie Powers, a Cambridge waitress he first became involved with during his Harvard days. Will was always open about their relationship, appearing at social events with Tessie on his arm. Phoebe was furious. She apparently felt that George encouraged Will's attachment—or at least did not discourage it sufficiently by shutting off funds for the *Examiner*. Several months before George's illness was discovered, Orrin Peck's mother, Margaret, wrote Phoebe about her vexations with both George and Will: "We all do sympathize with you, and do you know, *I* wish you could manage in some way to have that San Simeon Ranch put in your name. If it is necessary to gain your point by diplomacy, then *use* it. Will has that valuable land in Mexico and it is only fair that you should have something to depend on, for a certainty, and land can not run away. You will always be able to have what money you want for current expenses, and that land or any other you can get hold of will not have to be divided later. It does seem to me that his father can do more to get rid of that thing [Tessie Powers] than anybody if he *will* by refusing to advance another dollar as long as he keeps her. You know . . . how impossible it is for a man to shake such creatures. . . . [They] will work on one's sympathies until one actually feels he is duty bound to protect them."[14]

Phoebe was widowed at forty-eight, with nearly thirty years ahead of her. She became one of the country's leading philanthropists, a tireless supporter of educational pro-grams of every kind. She gave generously to many California causes, including the Sempervirens Fund (later known as the Save the Redwoods League) and funded the complete restoration of California's twenty-one missions. She was the largest donor to the University of California, funding its redesign, classrooms, museum collections, and countless other projects. She was also the first woman to serve on its Board of Regents. In addition to these civic benefactions, Phoebe held the purse strings for Will, involving herself in both his business and his personal affairs, much to his frustration. Soon after George's death, she succeeded in separating Will from Tessie by providing powerful incentives to them both. Tessie was given a large sum and sent packing. Will was able to borrow enough money from Phoebe to purchase his second newspaper, the *New York Journal*, in 1895.

Phoebe spent most of her time on a 4,000-acre ranch George had purchased in Pleasanton, a rural town east of San Francisco Bay. This site had an important connection to San Simeon. In 1894, when Will was seeking a retreat from San Francisco, he apparently asked Phoebe if he could build a home on the property, telegraphing: "Whats money limit for country house."[15] Will hired San Francisco architect A. C. Schweinfurth to build an elaborate old-fashioned California hacienda—with pergolas, balconies, and long horizontal wings—sited on a hilltop dotted with oaks. Will requested that Schweinfurth employ "accessories and decorations of the distinctly Spanish-Californian character."[16] Whatever money limit Phoebe stipulated, Will presumably exceeded it, because by the summer of 1895, Phoebe had moved in herself.

Christened the Hacienda del Pozo de Verona (House of the Wellhead of Verona), it was a smaller, simpler version of La Cuesta Encantada (The Enchanted Hill) constructed at San Simeon twenty-five years later. The Hacienda was named for an Italian Renaissance limestone wellhead Will brought back from Verona for Phoebe. It was converted into a fountain and placed in the center of the Hacienda's

main entrance. From this pastoral setting, Phoebe hosted concerts and entertained such luminaries as Luther Burbank and Henry Ford. She also raised livestock and produce, operating the property as a working ranch. After Schweinfurth died in 1900, Phoebe hired the young and talented architect Julia Morgan to design a swimming pool and several other additions. The exact circumstances of William Randolph Hearst and Julia Morgan's first meeting are unknown, but it is very likely that Phoebe introduced them at the Hacienda.

Hearst and Morgan had many things in common: their love of art and architecture, their devotion to Phoebe, and their affection for the California landscape. Julia Morgan, born in San Francisco on January 29, 1872, was nine years younger than Hearst. Her family moved to Oakland when she was three, when the city was truly an "Oak-land." Its landscape resembled San Simeon, with a level shoreline that gradually ascended to gentle hills punctuated by oaks. Morgan was the second of five children, known even then as an intense and sensitive child. She graduated from Oakland High School in 1890 and considered pursuing a career in music or medicine before deciding to study architecture. Her choice may have been influenced in part by her cousin Lucy's marriage to the East Coast architect Pierre Le Brun. Morgan was the first woman to be admitted into the University of California's civil engineering department. There was no architecture department on campus at that time.

In Morgan's senior year, the gifted architect Bernard Maybeck joined the Berkeley faculty. He quickly recognized her talent and hired her to work in his office after graduation. Maybeck was a visionary designer, an emotional and otherworldly man whose buildings often shared these same qualities. His most remarkable architectural commission came from Phoebe, who hired him in 1899 to design Wyntoon, her home in northern California. An immense stone building of seven stories, it resembled a Bavarian castle and was surrounded by forest on the banks of the rushing McCloud River. Though Wyntoon was as dif-

ferent as can be imagined from Phoebe's Spanish-style hacienda, it shared a similar scale and romantic grandeur.

Maybeck often said "dream big," and his visionary nature stretched beyond the boundaries of his buildings. He convinced Phoebe to fund the Phoebe Apperson Hearst International Competition to redesign the Berkeley campus, transforming it into one of the country's most beautiful academic settings. Maybeck also convinced Julia Morgan to "dream big," encouraging her to apply for admission to the École des Beaux-Arts. This Parisian school of fine arts was world renowned for its rigorous artistic curriculum. Established in 1648—in the reign of Louis XIV—it had never admitted a woman into its architecture department.

Morgan was encouraged in this endeavor by Phoebe, who in fact offered to pay for her tuition. Morgan refused, telling Phoebe that her confidence was enough of a gift. She didn't fear the work itself, as she was "young and strong" and could face the challenge. Her years at the École were indeed challenging. She had to master both the French language and the metric system. She needed to pass the École's traumatic entrance examinations, and once admitted, to gain a place in an atelier or architect's office, where students produced assigned projects. She battled homesickness and endured the difficulties of being a lone American woman in the boisterous company of a hundred young Frenchmen.

The École's curriculum was based on architectural competitions rather than classroom instruction. Students designed elaborate structures based on historic precedents, then submitted them into competitions for points and prizes. Students advanced based on the number of points they accrued. Only a small number of Americans were admitted, and they generally required six years to complete the program. Morgan won sufficient points and prizes to earn her *diplôme* from the École in only three years of study. All students were dismissed when they turned thirty, and she won her final prize just before her thirtieth birthday. Her achievements were covered in the national

In 1903, one day before his fortieth birthday, W. R. married twenty-one-year-old Millicent Veronica Willson. Their honeymoon included a trip through Europe with friends and family. W. R. took this photograph of the party parked beside the Mediterranean, in a setting that strongly resembles San Simeon's rugged coastline.

press. Hearst's own *San Francisco Examiner* declared, "Miss Morgan will . . . return to America with a degree from the École des Beaux-Arts—the first ever attained by a woman, and one which will give her prestige among the leading architects of the United States. The California girl seems destined to win her way in the drama, in literature, and now in the new field open to woman, that of architecture."[17]

While Morgan studied in France, Will poured his energies into the *New York Journal* and into politics. While the *Examiner* had provided a good beginning, he knew that attaining national prominence would require obtaining an East Coast newspaper. He ran successfully for the New York legislature and unsuccessfully for governor of New York state and mayor of New York City. He also made two failed bids for the presidency, once as a Democrat and once as an Independent. He visited San Simeon very seldom in those years, focusing his leisure time instead on art collecting. He haunted the dealers' showrooms and art auction houses of New York, and roamed his way through Europe, writing Phoebe: "I have the art fever terribly. Queer, isn't it? I never thought I would get it this way. I never miss a gallery now and I go and mosey about the pictures and statuary and admire them and wish they were mine."[18]

In 1903, on the eve of his fortieth birthday, Will married a vivacious twenty-one-year-old, Millicent Veronica Willson, whom he had been courting for some time. She and her sister Anita had been vaudeville performers, billed as "The Dancing Willson Sisters." Millicent was a warm and gracious daughter-in-law, eager to win Phoebe's approval, but Phoebe did not attend their wedding, and was very likely unhappy to have a showgirl for a daughter-in-law after all her efforts to steer Will away from unsuitable companions. Phoebe did send Millicent a large emerald brooch as a wedding gift, though she initially kept her distance. The arrival of her first grandchild, George Randolph Hearst, in 1904, improved things considerably. Phoebe eventually became very fond of Millicent.

W. R. and Millicent's five children, all boys, were born

Millicent looks anxiously at Phoebe while visiting the Hacienda with her oldest son George, circa 1908. The arrival of five grandsons from 1904 to 1915 greatly improved Millicent's relationship with her mother-in-law.

between 1904 and 1915. His young and rambunctious family helped entice him back to the ranch. He wrote Phoebe: "I have been down at the ranch for two weeks and have had a great time. The baby gained weight and now weighs thirty-five pounds. He looks very healthy. He has made great friends with [the ranch caretaker] Captain Taylor. He rides a horse, goes down to the beach and goes in wading (the baby I mean, not Captain Taylor) and generally enjoys himself immensely. I don't think he has ever had such a hugely good time. . . . We have had a delightful visit in California and I look like a farm hand and feel fine. The baby is big and strong and healthy. Millie is well and happy."

They stayed briefly in Pleasanton before heading to San Simeon, and apparently their departure had been misunderstood. Will later explained: "Mrs Mc is entirely mistaken about our leaving the Hacienda. We left because I wanted to go to the ranch. I am exceedingly fond of the ranch as you know. We had a glorious time there,—a perfectly splendid time. I wrote you how we camped out and fished and rode horseback. I wish I were there now. . . . I am going to save up and build a cabin down there just big enough for you and Milly and the baby and me. Then I suppose you will go to Abyssinia and stay a year and a half. . . . When are you coming home?"[19]

Phoebe did indeed spend very little time at the ranch during this era, preferring to travel the world or remain at the Hacienda. She was nevertheless very involved in ranch operations and very generous to her employees, as her correspondence attests. Don Francisco "Pancho" Estrada, whose father, Juliano Estrada, sold George his ranchland in 1868, was one of Phoebe's ranch managers. He was a lifelong friend of W. R.'s and a living link to California's vanished Mexican era. Phoebe's cousin Edward Hardy Clark Jr. recalled him:

I remember distinctly one time when I was around the age of ten, down at the old ranch house—long before the house on the hill was built—watching the cattle being put through the dip. Pancho Estrada was directing the operation. The cowboys, Mexican-Californians, all in their special type of sombreros and flat hats. Very picturesque. The cattle moaning and crying [and] the operation going on. And this magnificent man in a commanding position in the last little corral, running the show.

Mrs. Phoebe Hearst came up in her large Alco automobile—American Locomotive Company product. . . . It looked a good deal like a Pullman car itself. . . . As she stepped daintily out of the car, Estrada, seeing that his lady-boss was arriving, put one hand on the rail of the corral, swung clean high out over the rail from the saddle of this magnificent stallion he was on, took one sweep with his hat as he looked to the ground, and bowed low before her.[20]

During three decades of ownership, Phoebe expanded the ranch while steadily shrinking the town. She increased its acreage, bought up the dairy farm leases of her many tenants, and closed down the whaling operation on the Point. By 1910, San Simeon was practically a ghost town. One traveler described staying in the Bay View Hotel: "This once promising little port has dwindled under the caprices of Fortune and local landowners until now only one small coasting steamer calls unpunctually at its wharf. I found myself the only guest in a hotel that would have housed double the whole population, with room to spare."[21] In 1915 the hills overlooking San Simeon Bay were unchanged from when George first started buying land in 1865. The bustling and grimy port town of the 1870s had completely disappeared, however. When William Randolph Hearst began construction on the hilltop in 1919, San Simeon began a new existence as well, as a thriving estate village—a role it fulfills to this day.

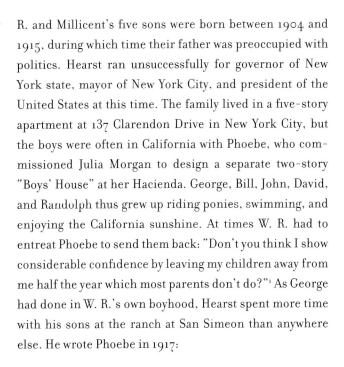

4
BUILDING THE RANCH

W R. and Millicent's five sons were born between 1904 and 1915, during which time their father was preoccupied with politics. Hearst ran unsuccessfully for governor of New York state, mayor of New York City, and president of the United States at this time. The family lived in a five-story apartment at 137 Clarendon Drive in New York City, but the boys were often in California with Phoebe, who commissioned Julia Morgan to design a separate two-story "Boys' House" at her Hacienda. George, Bill, John, David, and Randolph thus grew up riding ponies, swimming, and enjoying the California sunshine. At times W. R. had to entreat Phoebe to send them back: "Don't you think I show considerable confidence by leaving my children away from me half the year which most parents don't do?"[1] As George had done in W. R.'s own boyhood, Hearst spent more time with his sons at the ranch at San Simeon than anywhere else. He wrote Phoebe in 1917:

> We are on the top of the hill at the ranch, and it is wonderfully beautiful and satisfying in every way. I cannot tell you how much better I feel already; I hardly seem to have been ill at all. I am sure that a few weeks here will put me in much better shape than I have been since I was here two years ago.
>
> I think this is the loveliest spot in the world, and I have been about quite a good deal—not as much as you have, but nevertheless enough to be a pretty good judge of localities, climate and scenery. You reproved me for not liking the Hacienda better. I do like the Hacienda and realize that it is a delightful place; but I am out here to jam as much health into my system as possible, and I really feel, Mother, that this is the

After his marriage, W. R. visited San Simeon more frequently. He and Millicent either stayed at the ranch house or camped among the native coast live oaks in the hills overlooking the bay. Hearst was eager for their sons to fish, rope, and ride with Don Francisco "Pancho" Estrada, as he had done in boyhood.

place to do it. I can do so many things here that I cannot do at the Hacienda. I can take long rides over these beautiful hills; I can camp out in the pretty spots beside the creeks, in the valley, or in the little hollows on the mountain tops; I can go fishing in the streams, or fishing and boating on the sea. It seems to me that anything that can be done any where is all assembled and ready to be done on the ranch.

. . . I am sorry that you would not try this hilltop with us just once. I am not sure that you would like things as rough as we have it here, but I think you might, and if you like it at all, you would like it a lot. It is perfect in its way. Of course, we do not try to make it too refined, because that would take away some of the charm of camp life, but if you wanted it more refined, you could easily have it so. We like the all-out-doors part of it. . . . Pancho brought up a bunch of horses, and George and William and John selected the best three, leaving plugs for the rest of us. They are off now on them somewhere. . . . They will come home with fish and fish stories. . . . We all send much love and wish you were here with us.[2]

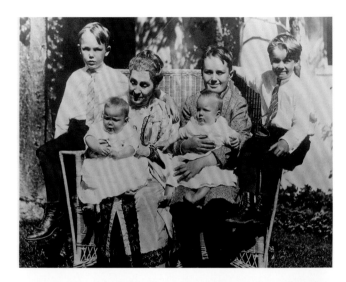

This particular visit lasted for nearly a month, partly in hilltop tents and partly on a camping trip further up the coast:

We have been up to the Sancho Pojo and rode from there up the coast for ten or twelve miles. We went last night up to Pat Garrity's and camped. This morning, the two youngest woke us up at half past four.

We had breakfast and then came down to the Arroyo La Cruz and went in swimming in a big pool, first the children, then the girls and finally the men.

We are back in our regular camp at the top of the hill now, tired and sleepy on account of these kids. I love this ranch. It is wonderful. I love the sea and I love the mountains, and the hollows in the hills and the

shady places in the creeks and the fine old oaks—and even the hot brushy hillsides, full of quail, and the canyons full of deer. I would rather spend a month here than anyplace in the world. It is a wonderful place. And as a sanitarium! Mother, it has Nauheim, Carlsbad, Vichy, Wiesbaden, French Lick, Saratoga and every other so-called health resort beaten a nautical mile.[3]

The following autumn, Phoebe journeyed to New York to spend the holidays with Will, Millicent, and the boys. She caught a fever on the trip home and never completely recovered. By February 1919, it had worsened into Spanish flu, the virulent influenza pandemic that claimed fifty million lives from 1918 to 1919—more victims than all the casualties from World War I. Phoebe was seventy-six when she died at the Hacienda on April 13, 1919, with Will and Millicent at her side. She was eulogized throughout the country for her generous philanthropy, which included building the National Cathedral Girls School in Washington, D.C.; helping to preserve Mount Vernon; constructing free libraries in every Hearst-associated mining town; and co-founding the PTA (Parents and Teachers Association). She never forgot her early days as a poor teacher on a rural farm, and contributed generously to the YWCA, which provided safe housing for young girls seeking jobs and independence in American cities.

Throughout California, flags flew at half-mast and citizens observed a moment of silence in her honor. Phoebe loved her adopted state and contributed more to its improvement than anyone else of her time. She protected its redwoods, missions, and cultural heritage. She ensured it would have a public university of unrivaled beauty and academic excellence. Most important to this story, she cherished the ranch at San Simeon, increasing and improving it throughout her decades of ownership. She also staved off the inevitable forces of commerce and progress that elsewhere erased nearly all of California's once-ubiquitous cattle ranches.

LEFT: Film star Marion Davies, circa 1918. W. R. met Marion in 1915, when she was dancing on Broadway in the Irving Berlin musical *Stop! Look! Listen!* He was fifty-two and she was eighteen. They began a romantic relationship that lasted more than thirty years. One of the first places they visited together was San Simeon.

RIGHT: Julia Morgan circa 1928, at fifty-six. The first female architect of renown, Morgan had already completed more than five hundred projects when she began work at San Simeon in 1919. She designed all its working ranch buildings and employee residences in addition to its hilltop structures.

William Randolph Hearst was fifty-six when he inherited his mother's multimillion-dollar estate. His business and his personal interests were both shifting to the West Coast at the time. His publishing empire had expanded nationwide and could be run from almost anywhere. His political candidacies were nearly all behind him. The budding film industry—in which he had been a major figure since 1913—had begun its westward migration to California in search of year-round sunshine.

Hearst was also drawn to California for a more personal reason: his growing passion for the young, lively, and beautiful actress Marion Davies. They met in 1915 in New York, where Hearst saw Marion in the Irving Berlin musical *Stop! Look! Listen!* He adored her from that moment. He was fifty-two and Marion was eighteen. At first she regarded him as just one of many admirers who crowded around the stage door after the play. But he was persistent, lavishing her and her family with gifts and attention.

Her legal name was Marion Douras. She was the youngest of three sisters, all of whom were brought up to find success on the stage and then find a wealthy admirer. While this certainly must have been her motive at the beginning, Marion was by all accounts uncalculating, sincere, irreverent, and kind. Within a few years, she too was emotionally involved with Hearst, but she remained frustrated by the gap between their ages and also by their inability to marry. Millicent was Catholic, and divorce in that era was unthinkable. She was also a society matron, active in charitable and social pursuits throughout New York. Millicent loved the city, but W. R.'s opinion of the East Coast had not mellowed since his Harvard days.

For a decade, Hearst kept his romance a secret while continuing to reside with Millicent and the boys at the Clarendon. He could spend time with Marion more easily in California, especially after she transitioned from stage to screen roles. Marion's film career began without Hearst's involvement. It wasn't long, however, before his newspapers were extolling her as the successor to America's Sweetheart, Mary Pickford. Hearst made Marion the star of his Cosmopolitan film company and tirelessly promoted her career in his press, often to her embarrassment. For more than thirty years, to the sorrow of his wife and sons, Hearst lived two lives, constructing a separate existence with Marion in California. One of the first places they visited together was the ranch at San Simeon.

When Hearst inherited this land, he had already been planning its improvement for decades. He walked into Julia Morgan's San Francisco office in the spring of 1919 and announced he had grown tired of camping in tents and was "thinking of building a little something" on the hilltop overlooking San Simeon. Morgan knew Hearst well by this time, having designed several projects for him, most recently the elaborate Mission Revival *Los Angeles Examiner* building, completed in 1915. She began San Simeon when her architectural practice was at its height, and continued to manage her firm of approximately ten employees throughout its construction. Astonishingly prolific, Morgan designed more than seven hundred buildings in her long career, and the entire San Simeon project was given the identification number "Job 503" in her records.

This era between the world wars was the golden age for the American country house. A representative example was the Chicago millionaire Marshall Field III's Caumsett, designed by John Russell Pope in Lloyd Neck, Long Island, in 1921. This sprawling Colonial Revival estate featured a model farm typical of the period. Its sparklingly new dovecotes, stables, and barns were decorative features meant to evoke the great eighteenth-century estates of the English gentry and provide a portrait of idyllic country life.

Hearst and Julia Morgan did not have to invent a model farm. The Hearst family had owned and operated the ranch at San Simeon for fifty-five years when ground was broken for the hilltop buildings in February 1920. Construction continued for the next twenty-eight years, during which time Hearst and Morgan focused on the ranch buildings nearly as often as the hilltop ones. Though she had no

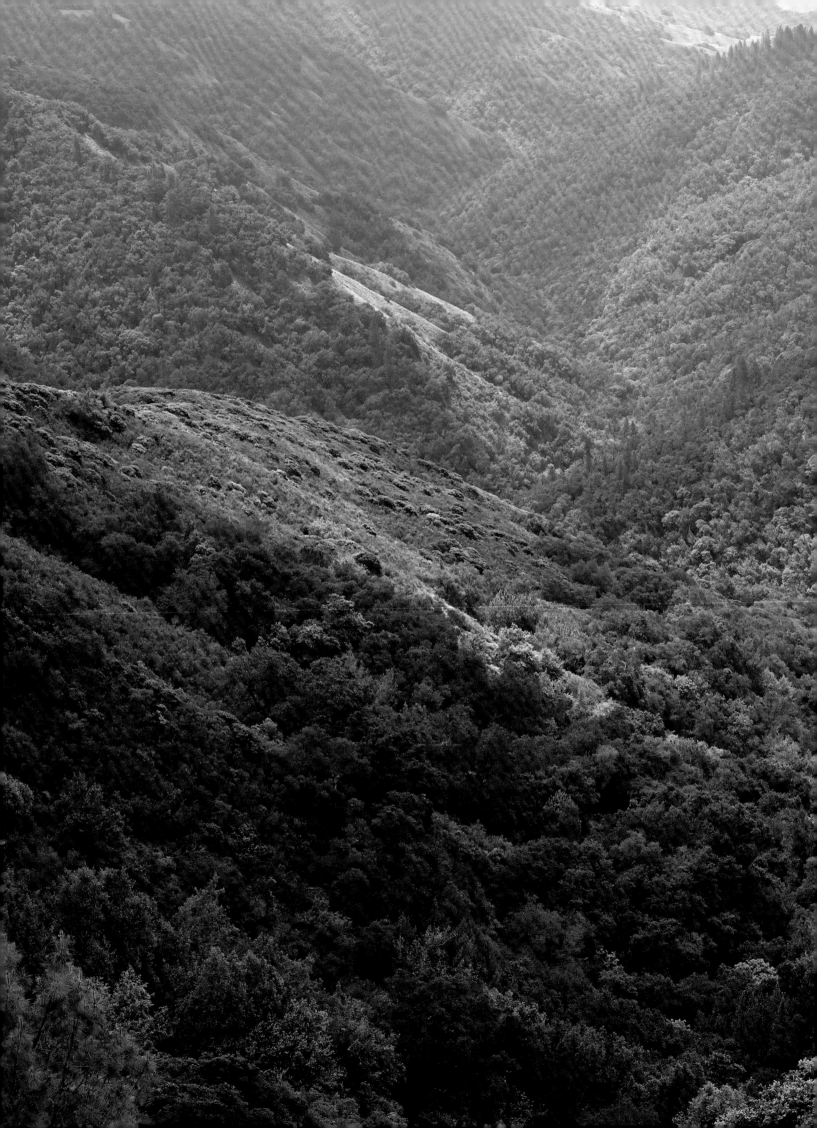

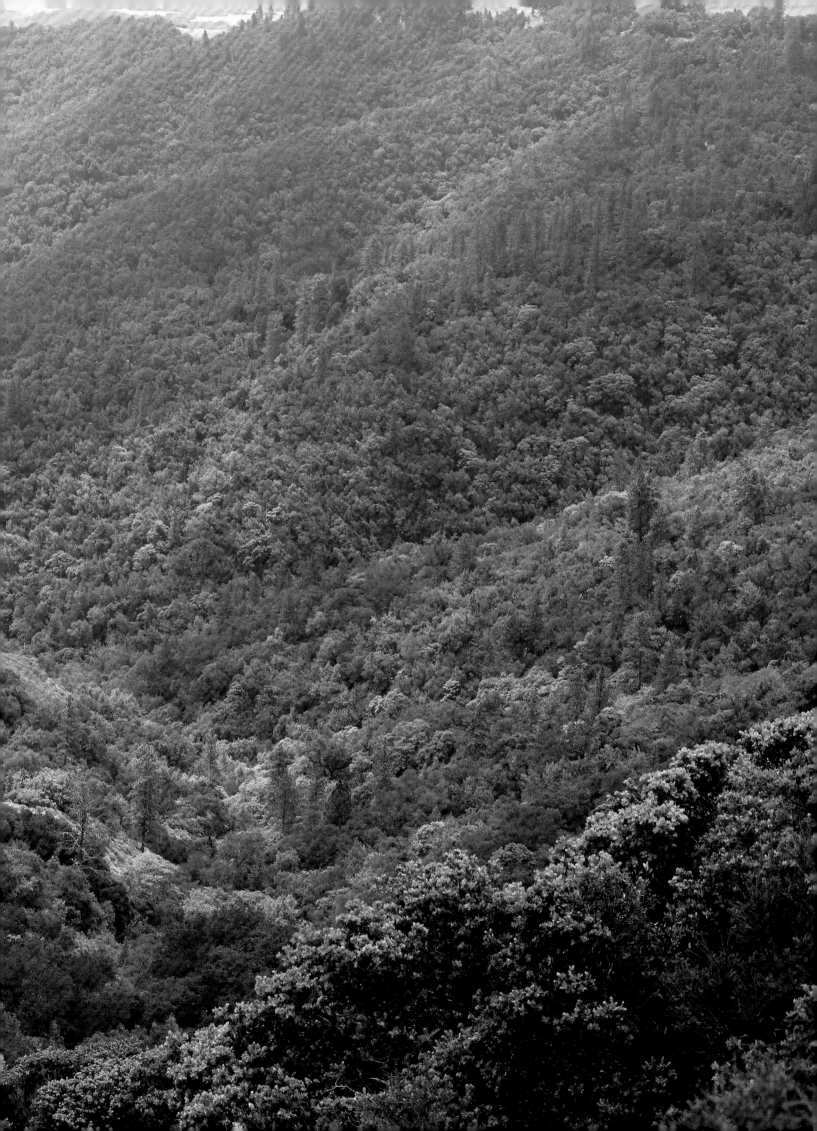

OPPOSITE: Northeast of the Castle lies Burnett Creek, one of many water sources on the ranch. It was named for a nineteenth-century prospector in the region.

BELOW: W. R.'s hilltop buildings overlook San Simeon Bay. The fog burns off slowly there, often wreathing the area in a faint mist.

prior experience in this form, Morgan designed San Simeon's dairies, stables, dovecotes, hay barns, bunkhouses, aviaries, and orchards. She improved existing buildings, making them both more functional and more picturesque. She also oversaw the creation of many new ranch structures, including fish ladders, dams, bridges, reservoirs, rock walls, airplane hangars, landing strips, garages, polo fields, warehouses, and hundreds of miles of back country roads. Hearst was involved in every aspect of the building process, as more than one thousand of their surviving letters and nine thousand architectural drawings attest.

One of Hearst's earliest letters to Morgan emphasized: "The main thing at the ranch is the view."[4] They considered it from both directions—the ocean view seen from the hilltop buildings and the view of the Castle's twin towers from San Simeon below. They hired the San Francisco artist and landscape architect Bruce Porter to review their initial scheme in 1923. He marveled at how quickly the hilltop buildings began to resemble a Mediterranean city. Porter recommended that they build a hotel in San Simeon, and Hearst concurred, writing to Morgan, "I like the idea of a decent Inn at San Simeon and this we will construct."[5] This proposed hotel was in fact never built. Instead, Hearst's guests (seldom numbering more than twenty at one time) were all accommodated in the hilltop structures, either in the main building or in one of its three surrounding cottages.

Employees were also intended to have their own hilltop compound. Hearst wrote Morgan: "Mrs. Hearst is very anxious to have the little town of executive's cottages moved off to a considerable distance from our residence hill . . . where they can all do as they please without the possibility of disturbing anybody. I suggest therefore that you put them . . . on the slopes to the North or Northwest of the hill overlooking the dairy farm."[6] Actually, they did not build a "little town" for employees on a nearby hill. Instead the household staff lived in the South Wing of the Castle, while the construction crew (numbering as many as one hundred men) lived in wooden barracks on the south side of the hilltop. The remaining support staff (gardeners, electricians, etc.) resided in San Simeon itself, or in the little town of Cambria six miles south.

None of this elaborate hilltop construction would have been possible without a water source. Three natural springs—Chisholm Spring, Phelan Spring, and Cole Spring—were located on Pine Mountain, a 3,000-foot-elevation peak east of the Castle (which was itself located at an elevation of 1,600 feet). This gravity-flow system had long provided water to the ranch buildings on the coast. Hearst proposed that they divert it on its way down: "We are to bring the water from the big spring, that now goes to the farmhouse, to the hill first and then to the farmhouse. We must do this by bringing a perfectly good line of four-inch pipe along the crest of the hills."[7] While an excellent idea in theory, in practice there was never sufficient water to adequately supply both the hilltop and the ranch operations.

Adapting to the large number of workers necessary for hilltop construction provided Morgan with another challenge. Previously ranch hands were few and largely confined to the bottom of the hill. When dozens of workers lived on the lonely reaches of the hilltop, rules became necessary. At first, the workmen entertained themselves by hunting deer and using gunpowder to blow up trout in the streams. Hearst was appalled. He telegraphed Morgan: "Impossible to allow men on Hill to wander over the ranch or to fish or hunt. . . . They shall confine themselves to their legitimate business on the property. If you hired a plumber to fix your bathroom you would not expect him to be wandering around your parlor or reading your books in the library. We do not even allow indiscriminate hunting or fishing by guests on [the] ranch." Morgan speedily ended these pastimes, but she sympathized with the men's boredom and provided them with a recreation room and weekly film screenings.[8]

In the early years, Hearst planned to locate the ranch buildings on the hill immediately north of the Castle, cre-

A male sambar deer (*Rusa unicolor*), native to India and Southeast Asia, grazing on the Hearst Ranch. In 1925, W. R. began importing hundreds of exotic species, including sambar, for his private zoo. Their descendants roam the backcountry.

ating a scenic grouping. Morgan was eventually successful in convincing him that the chicken houses, cattle barns, and support buildings would be better at the bottom of the hill. Hearst long held out hope that the Jersey cows—which he regarded as most picturesque of all—could remain on the hilltop, while the Herefords and other beef cattle grazed below. Morgan's suggestions to Hearst for alternative solutions were always carefully phrased, and in this case she won her point by blaming the cattle: "Watching the present experiment with the Jerseys, it is evident that, to even my eye, pastures for fine stock should be fairly level as they do not seem to have as much sense as the range cattle."[9] Hearst wanted his Jerseys to produce fine-quality milk that would yield cheeses like those he had admired in Europe, writing Morgan: "I am also on the lookout for a cheese-maker. There is a man in Petaluma who makes Camenbert [sic] cheese which is sold in New York. . . . I would also like to get somebody who could make the real Swiss cheese, with the holes in it. I have never known of any good Swiss cheese to be made in this country. . . . I would like [to have] an expert man for the Jersey cattle. [I] think I have one of the best herds in California and its reputation should be established; we should have show herds, win prizes, etc., and develop our young stock to best advantage."[10]

San Simeon boasted a feature far more picturesque than Jersey cows: the largest private zoo in America. It began modestly in 1922 with plans for a fenced-in deer and elk park. The impetus for this idea may have been the native deer themselves, as Morgan wrote Hearst: "The deer are so tame this year you can see them in the day time in the 'meadows' and they are determined to sample the orchards ahead of you."[11]

Game parks were often part of large English country houses in the eighteenth century. Hearst's game park was of course meant to be ornamental rather than to supply hunting quarry. By 1925, plans had expanded to include both a deer park near the ranch house and a buffalo and elk park further south. Arriving guests were greeted by the

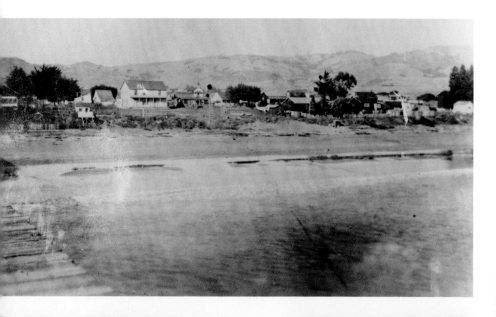

OPPOSITE TOP: Upon Phoebe's death in 1919, Hearst inherited the entire ranch, including San Simeon. This small coastal town contained a one-room schoolhouse, a store, two hotels, numerous homes for workers, and the 1878 warehouse at the base of the long pier. Instead of modernizing in the 1920s, as did most California coastal towns, San Simeon remained a small estate village, occupied almost entirely by Hearst employees.

OPPOSITE BOTTOM: Hearst's poultry ranch at the bottom of the hill raised thousands of birds for the table, including grouse, quail, chickens, pheasants, geese, and turkeys. Poultry ranch manager Gladwin Read also raised several exotic and ornamental species, including this flock of penguins.

BELOW: Among the earliest arrivals at the zoo was a large herd of buffalo (*Bison bison*), pastured in their own field south of the hilltop. These immense animals evoked the enormous herds that had vanished from America's prairies in the nineteenth century. Grazing buffalo were often the first thing guests saw when they arrived at the ranch.

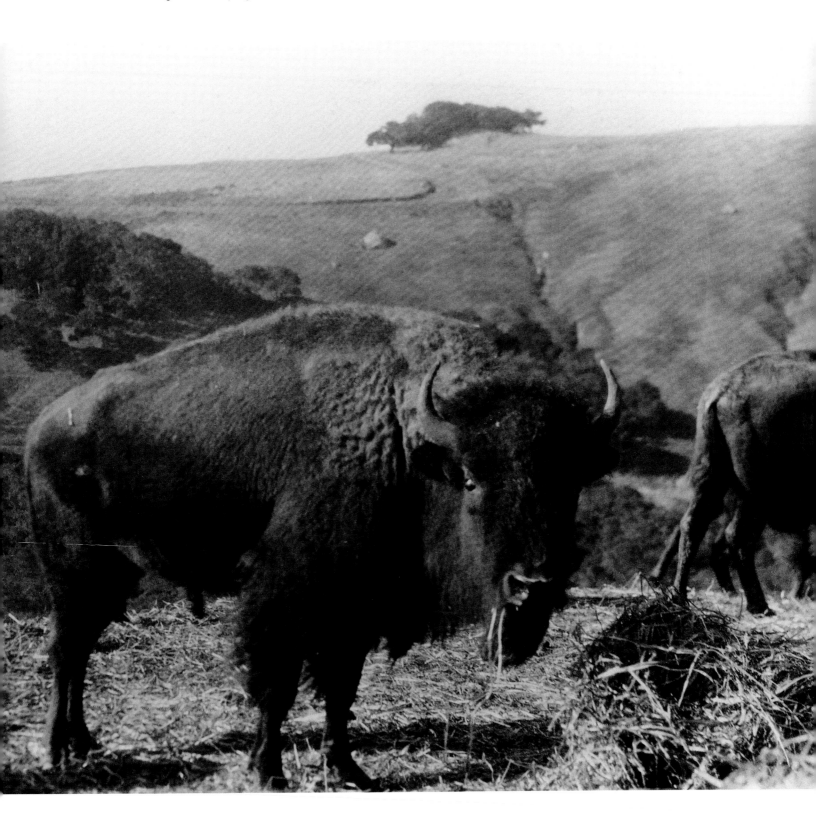

sight of a herd of grazing buffalo, in a romantic re-creation of the nineteenth-century American prairie.

Hearst's animal collection expanded quickly. Morgan wrote him later that year: "The lions are beauties—about the size of St. Bernards and as well kept and groomed as human babies."[12] Exotic species including kangaroos, antelope, zebras, elephants, jaguars, polar bears, and giraffes began arriving in large numbers, eventually totaling approximately three hundred animals. Morgan hired zookeepers and constructed bear pits, pens, and cages for the carnivores. Grazing animals were provided with large fenced-in pastures. To increase the dramatic effect, they mixed many of the grazing species together. Morgan wrote Hearst: "The animals do look very picturesque and interesting as seen unexpectedly grouped here and there."[13] Though picturesque, it was problematic. The animals often failed to mix well together, and it was challenging for Hearst's guests and hilltop employees to drive up a six-mile road through a wild animal park.

In fact, the animals sensibly avoided the roads and traffic, disappearing into the distant reaches of their 2,000-acre compound. Hearst therefore decided to build shelters to keep them near the road:

> I thought at one time that it was desirable to hide the houses in places where they would not be particularly conspicuous, but I find that the animals collect around such feeding places and shelter places, and that if we put the shelters in distant spots we would have our animals where we would never see them. I would suggest, therefore, that we make these shelters exceedingly picturesque log houses and put them in certain picturesque locations not far from the main road—the lowest one where you come into the buffalo field, the second one where you go from the buffalo field to the small animal field, and the third one where you go from the small animal field into the orchard enclosure.

Morgan produced charming and varied designs for six shelters, and considered carefully where the animals would be seen to best advantage above the road bank: "Mr. [Slattery, the ranch manager] had Mr. Addison [the zookeeper] try each one out with a bale of hay and it certainly was a pretty sight coming down to see the way in which the animals grouped themselves—on these natural feeding spots."[14]

Signs were placed along the road to remind everyone that the animals had the right of way, not the drivers. Still there were occasional conflicts. Stanley Heaton, a hilltop gardener from 1924 to 1933, recalled one particular contretemps: "This ostrich, he knew you had to stop to open that gate down there and he was waiting for you. I got tired of that. . . . Just before we stopped, I put my foot out and gave him a big old shove. But I didn't shove him, he shoved me. . . . nearly through the back of the seat. Pretty near crippled me up for a week."[15]

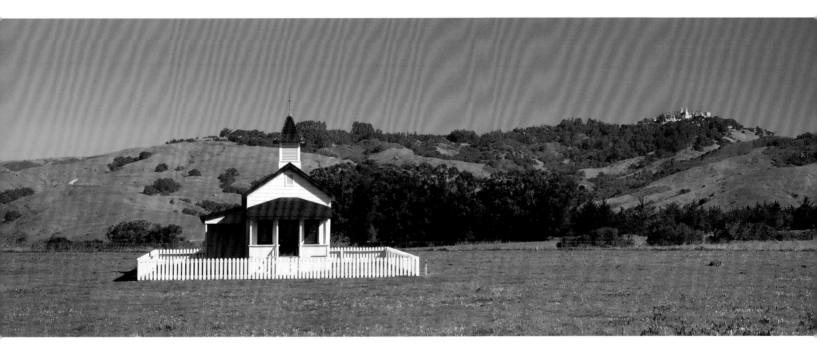

By the mid-1920s, Hearst's vision for both the hilltop buildings and their surrounding acreage had grown far more elaborate. He began to expand his vision of San Simeon's architecture as well. The first structures Hearst and Morgan built were warehouses, which in themselves indicated Hearst's deepening attachment to his estate. He explained to Morgan in 1927: "A great many fine things are coming to the ranch . . . of a much higher grade than we have had heretofore. . . . I see no reason why the Ranch should not be a museum of the best things that I can secure."[16] The first warehouses were galvanized metal sheds, more utilitarian than decorative. These were swiftly filled with Hearst's rapidly expanding collection of Mediterranean art and antiques. In the era between the world wars, American collectors could easily acquire European art, since rising taxes and changing tastes provided strong sales incentives to their owners. Like most of his contemporaries, Hearst purchased very few objects in Europe. Instead he haunted the auction houses and dealers' showrooms of New York City, acquiring the usual items such as paintings and statues, but also the unusual ones, including two twelfth-century Spanish monasteries, dozens of centuries-old stone chimneypieces, and more than one hundred dismantled and crated antique ceilings.

Soon Hearst and Morgan also began to construct spacious Spanish-style houses along the shoreline for ranch employees. Morgan designed four comfortable white stucco homes of steel-reinforced concrete. The picturesque effect of these residences in turn inspired them to elaborate further on their architectural theme. In the center of town, they constructed a large concrete warehouse strongly resembling an early California mission. Hearst wrote to Morgan: "While looking over the plans of the houses at San Simeon, as you advised, it occurred to me that the warehouses can be treated as a group and made an attractive feature."[17]

In the late twenties, when she was in her mid-fif-
ties, Morgan was already remodeling and expanding many
hilltop buildings she had completed only a few years earlier.
Hearst's growing attachment to San Simeon also prompted
him to enlarge the town and create many far-flung struc-
tures on remote parts of the ranch. The Roaring Twenties
era brought him additional capital. It also swelled Julia
Morgan's architectural practice, providing her with more
important outside commissions. Nevertheless, she gener-
ally traveled to San Simeon twice a month. After working a
six-day week in San Francisco, it was her custom to board
the train late Saturday afternoon, taking an upper berth to
allow her to work through the night if necessary. She arrived
in San Luis Obispo early Sunday morning and was driven
fifty miles north to San Simeon, where she often held all-day
meetings with Hearst. Very late Sunday night, she reversed

the arduous journey, arriving in San Francisco early Monday
morning and heading directly to the office.

This punishing schedule took a toll on Morgan's
health. In October 1926 her chief assistant, Thaddeus Joy,
telegraphed Hearst: "Miss Morgan was stricken with a
serious intestinal illness which necessitated an immediate
operation. She was in a dangerous condition until yester-
day. . . . She showed her renewed interest in life by asking
[about] San Simeon. I know you will add your hope to
ours."[18] Hearst entreated her to rest, but then added some-
what less helpfully: "You should organize your office and
do less detail yourself."[19] His concern was sincere, but such
advice was invariably followed by a flood of requests and
ideas for future projects. He did not seem to be aware of
the contradiction.

Morgan was singularly devoted to her life's pas-

In 1926, Hearst and Julia Morgan built three galvanized metal warehouses at San Simeon, two of which are still standing. Great quantities of art and building supplies for La Cuesta Encantada arrived by train and boat over the next two decades, to be stored in these warehouses.

sion of architecture, but if she was pushed by Hearst, she pushed herself more with her own exacting standards and demands. She acknowledged this to be the case while she recuperated, writing Hearst: "Thank you very much for the kind telegram. I will try to heed its admonitions. It is a great pleasure to be able to play at work again."[20] Her revealing final sentence demonstrated what her actions invariably showed: this work—in spite of all its difficulties—was her greatest joy, and she was eager to return.

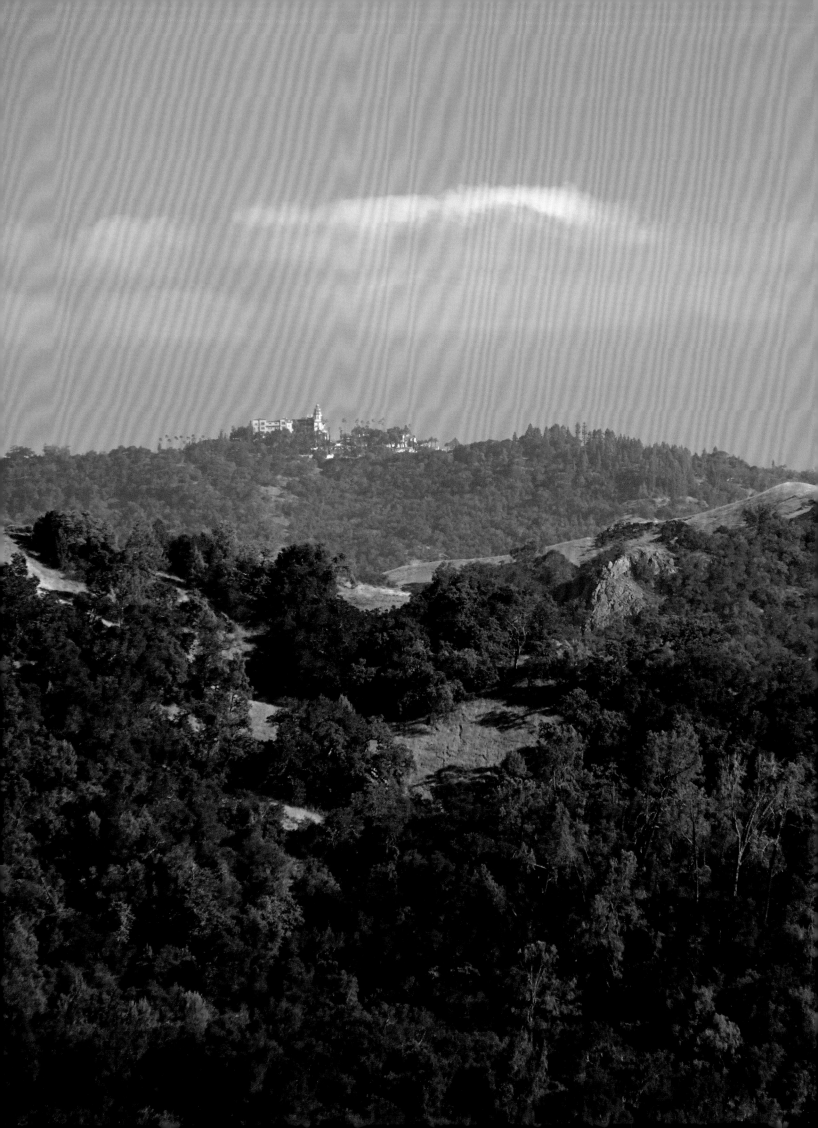

5

AN INVITATION TO THE RANCH

I n 1927, eight years after construction started, the ranch was nowhere near finished. That year alone, Hearst planned to enlarge the poultry ranch, stables, dairy, and airstrip. He wrote Morgan: "I had no idea when we began to build the ranch that I would be here so much or that the construction itself would be so important."[1] In addition to improving its buildings, he wanted to establish its reputation as one of the greatest family ranches in California.

Hearst planned the ranch's public debut much as if he were casting a film. He wrote to his manager, Arch Parks:

> I have agreed to take part in the Santa Barbara Festival next year, sending a contingent of cowboys, good horses, decorative saddles, etc. to represent the ranch. I wish you would make a specialty of getting in the ranch organization some good riding and good looking cowboys. We might as well have that kind, as any other. We might get some who—like Pancho [Estrada] and [Sebastian] Villa—are Spanish, as all that gives a certain atmosphere to the place. I do not mean to let this interfere with business, but please keep an eye out for the picturesque as well as the practical sides of the situation.[2]

Soon after this letter, Hearst purchased several magnificent horses from the estate of silent film star Rudolph Valentino, including Firefly, which Valentino rode in his 1926 film *Son of the Sheik*. Pancho Estrada rode Firefly in the Santa Barbara Festival parade. Several other Hearst cowboys rode Valentino's matched roans and grays. The riders were outfitted with ornate Mexican silver saddles

In 1925, Hearst doubled the size of the ranch when he purchased more than 154,000 contiguous acres to the north, near the inland town of Jolon. At its height, the Hearst Ranch spanned approximately 250,000 acres. This meant Hearst literally owned the view.

In the mid-twenties, Hearst increased the public profile of the ranch by urging his cowboys to enter local festivals. Here they are lining up their spectacular horses for a parade in nearby Cambria. They rode on silver saddles and wore traditional clothing, as one rider recalled: "The dark complexioned men wore Spanish costumes and the light complexioned men wore cowboy outfits."

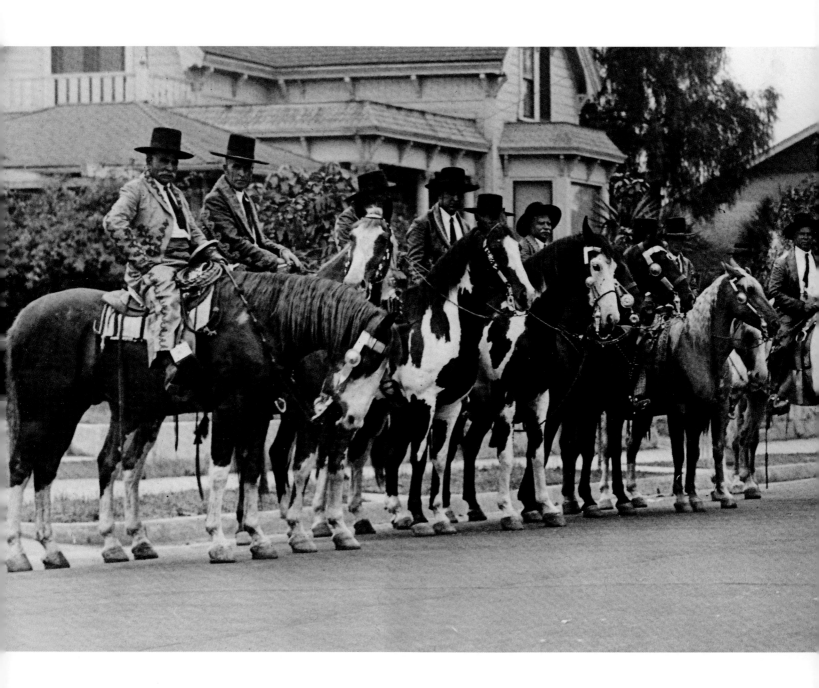

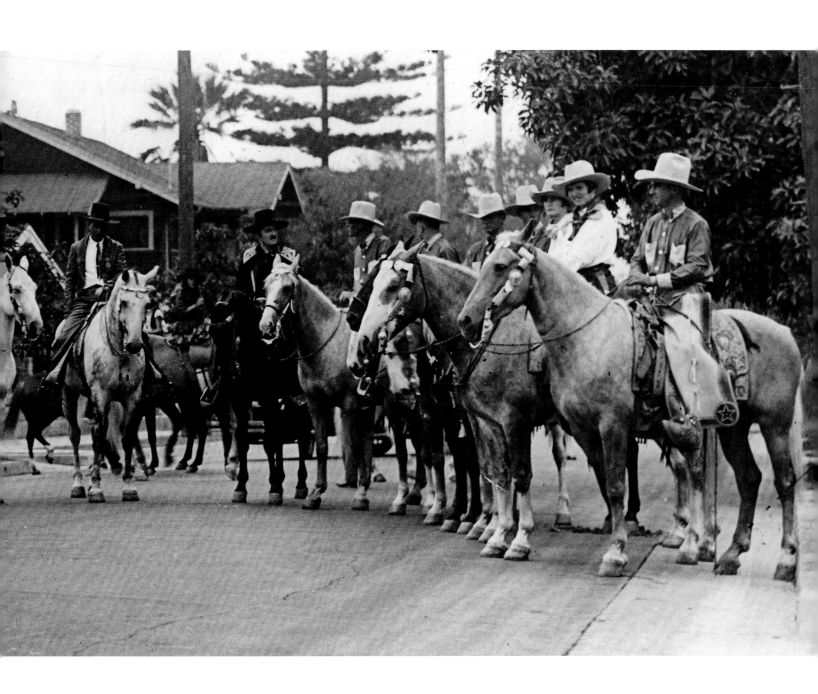

They ran nearly seven thousand head of cattle on the inland portion of the ranch at Jolon, which means "place of dead oaks." They employed twenty cowboys in the winter and forty in the summer, and also dry-farmed wheat and alfalfa.

from Hearst's collection. He instructed Parks: "Please supply the elaborate saddles. I have an enormous number of them, some of them very old and all of them very decorative. I hope you will pick up any showy horses you can find and also, as you say, engage a few spectacular cowboys."[3]

Hearst's Piedra Blanca Rancho was the talk of the 1927 Santa Barbara Festival. His cowboys even consented to remain an extra day so the public could have more time to admire the horses. One of his riders recalled: "The dark complexioned men wore Spanish costumes and the light complexioned men wore cowboy outfits."[4] Cowboys and vaqueros had always ridden together at the Hearst Ranch, in a blending of cultures that reflected the history of the region.

Hearst had particular reason to be proud of the ranch at this time. He had recently purchased enough land to nearly double its size, to approximately 250,000 acres. Employing the same tactics his father had used at San Simeon fifty years earlier, Hearst had quietly and gradually bought up more than 154,000 acres of contiguous inland property near Jolon, on the eastern side of the Santa Lucia mountains. This portion of the Salinas Valley was once grazing land for Mission San Antonio de Padua, founded in 1771 as the third of California's twenty-one missions. After 1835 the region was divided into four ranchos: San Miguelito, Los Ojitos, El Piojo, and Rancho Milpitas. The 43,280-acre Milpitas rancho (which translates to "little gardens") was awarded by the United States courts to San Francisco shipping magnate Faxon Atherton Sr. in 1872. His son, George H. B. Atherton, took over its management in 1877. His wife was writer Gertrude Atherton, who set her 1890 novel *Los Cerritos* on the site. They later sold their property to the James Brown Cattle Company, from whom Hearst bought it. He also purchased many small family ranches, including the nearby Dutton ranch adjoining the town of Jolon (which translates "place of dead oaks"). With two hotels, three saloons, two stores, two blacksmith shops, a jail, and a dance hall, Jolon was larger than San

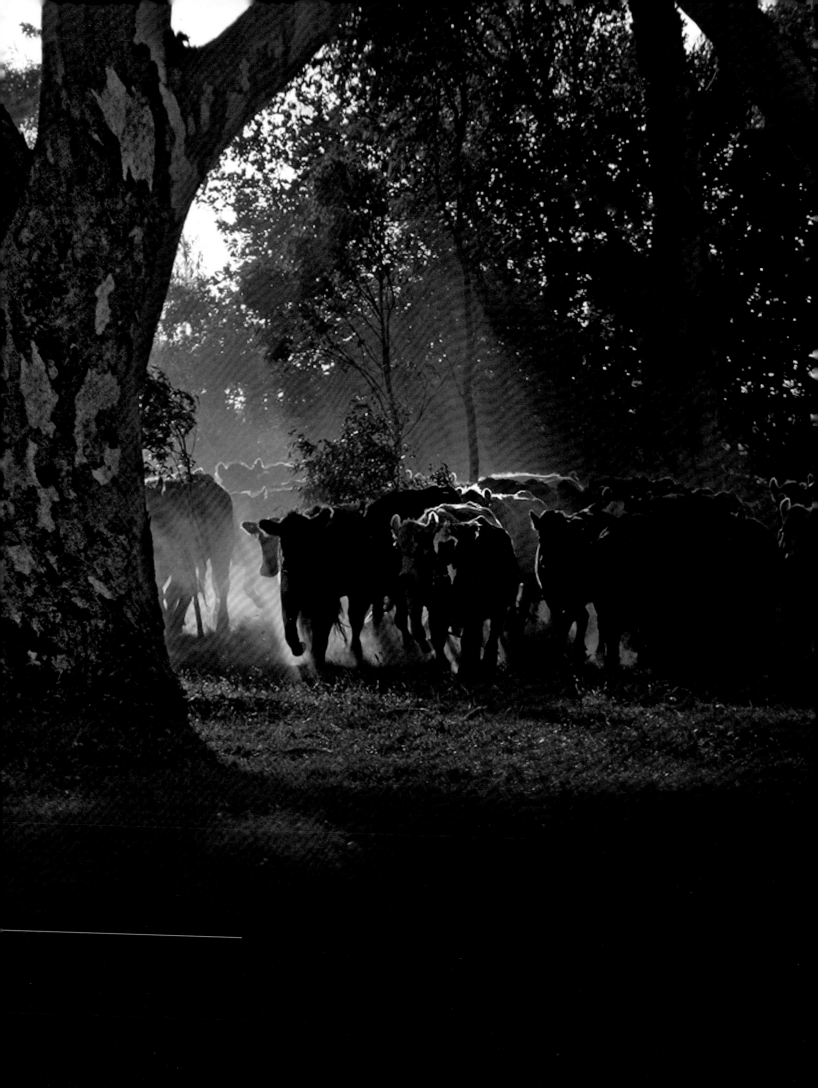

The Jolon barn burned soon after Hearst purchased the property, so he asked Morgan to design the Milpitas Hacienda (meaning "little gardens"). Completed in 1930, it was a large bunkhouse that included two social halls, twenty-five rooms for the cowboys, and a two-story apartment, for Hearst's own use, crowned with a gold-leaf dome.

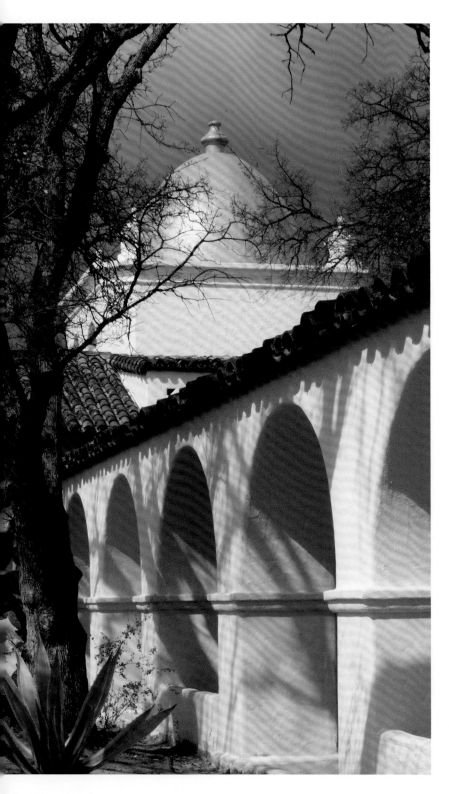

Simeon had been at its height. And similarly, it languished after Hearst's purchase, until little remained of the former stagecoach stop but the general store and the nearly deserted Dutton's Hotel.

With this acquisition, Hearst's ranch at San Simeon stretched as far as the eye could see. He could stand at the Castle's front entrance and look across Burnett Canyon to its northern boundary, Mount Junipero Serra, a 5,862-foot-elevation peak thirty-eight miles in the distance. Hearst had known this spectacular view all his life. Now he owned it, and he could ensure that it would never be altered in any way. Julia Morgan grasped this implication, writing him when she first saw Jolon: "What a wonderful beautiful domain."[5]

The Milpitas ranch allowed Hearst to expand his cattle operation. They ran 5,000–7,000 head on this northeastern outpost, employing twenty cowboys in the winter and double that number in the summer. They also dry-farmed wheat and other grains and raised hogs for market. Immediately before Hearst's purchase, the James Brown Cattle Company's large barn burned to the ground. Hearst's cowboys quickly erected a bunkhouse, kitchen, and dining room on the site for temporary use. Hearst, of course, planned to build something much grander: a large hacienda just south of the original San Antonio Mission. Richard Clark, who oversaw the ranch operations, wrote to Harry Taylor, the newly appointed Milpitas ranch manager, in 1929: "Miss Morgan tells me that Mr. Hearst has in mind a site on level land at the foot of the hill for the main dwelling, as he intends to have it constructed of a Spanish type."[6]

The Milpitas Hacienda was completed in 1930 at a cost of $128,000. Practical as well as decorative, its twenty-seven rooms included two central gathering halls connected by a long corridor of cloister-like bedrooms for the cowboys. This massive structure was entirely built of steel-reinforced concrete, but it resembled an old Spanish mission of whitewashed adobe bricks. Morgan wrote Hearst,

TOP: The Milpitas Hacienda, built in Mission Revival style, was located just south of the historic San Antonio de Padua Mission, founded in 1771. W. R. donated twenty acres of his Jolon ranch to the mission. Both he and Phoebe were generous donors to all twenty-one of California's missions, a family philanthropy still carried on today.

BOTTOM: Julia Morgan designed four graceful Mission Revival stucco houses for Hearst's employees at San Simeon, which Hearst called "our little Spanish village." This spacious home was built for Don Pancho Estrada. It overlooked the beach and featured a large dining room and charming upper-story cupola.

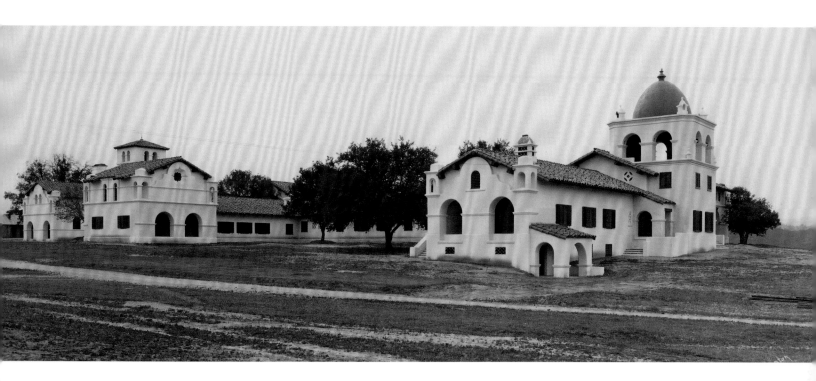

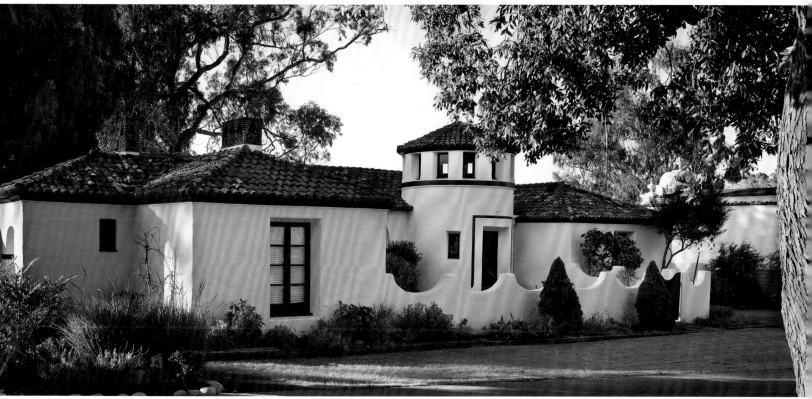

"The Jolon work is progressing well, I will hold back the tower toward the mission until you come. . . . The plastering of the interior was done as agreed, but the weather has been so very hot, no attempt has been made to plaster the exterior. . . . Many tourists are mistaking the new buildings for the Mission—it was really quite amusing this last visit."[7] Their confusion was understandable, because the hacienda's 225-foot-long front facade completely dwarfed the actual mission just up the road. The tower Morgan alluded to was a large gold-leaf dome marking the spacious two-story apartment designed for Hearst's private quarters.

The Hacienda also provided Hearst with a picturesque destination for horseback rides. In 1933, John Steinbeck described the nearby landscape in an unpublished portion of his second novel, *To a God Unknown*: "Jolon is a large bowl in the earth in central California. It is watered in part by two large streams, the Nacimiento and the San Antonio. It lies in the arms of the Coast Range Mountains, of which one rampart guards it from the ocean while a smaller ridge separates it from the long, fertile Salinas Valley."[8] In the summer, the Hacienda's shaded arcades provided a cool respite from the inland valley's intense afternoon heat. Surrounded by open pasture and uninhabited mountains, this vast Mission Revival compound convincingly appeared to be the last surviving remnant of California's great nineteenth-century ranchos, not a modern concrete building constructed a few years before. Here Hearst and his guests created a romanticized version of the Mexican days of the dons.

Hearst often treated the Hacienda like a film set, staging elaborate parties either Anglo or Spanish in theme. Eva Taylor was married to the Hacienda's ranch manager, Harry Taylor. Her job was to create these fetes for Hearst and his guests, as she explained in fairly purple prose:

[Either] the cowboy atmosphere of bandana-neckerchiefed guests eating barbequed beef, salsa, and beans and later dancing the Virginia Reel to the strum of a hillbilly orchestra, [or] . . . a Fiesta with gay caballeros and senoritas enjoying the semi-tropical air, laden with the scent of blue lupins . . . as they strolled along tiled corridors toward the dining room to partake of tamales, tortillas, enchiladas, frijoles, and other fare served by waitresses in mantillas and billowing, shirted dresses, while entertainers on the main floor danced and sang to the stringed strains of a Hollywood, Spanish-costumed orchestra in the balcony.[9]

Hearst was entertaining at the ranch more than ever at this time, after a major change in his personal life. Sometime around 1925, he separated permanently from Millicent, though they never legally divorced. He attempted on at least one occasion to obtain an official divorce, but this was a far more difficult procedure then than it is now, and he was unsuccessful. Therefore, for the next twenty-five years, he lived openly with Marion Davies on the West Coast while Millicent resided in New York City and Long Island, visiting San Simeon only rarely. Marion became San Simeon's official hostess, in what was considered quite a scandalous arrangement at the time. Hearst reporter and frequent guest Adela Rogers St. Johns explained: "Marion was there [at] the dinner, she was the hostess, she met everybody—the presidents, the governors, the ambassadors—everybody. And they accepted her."[10] Hearst's five sons visited often, and in later years, they also brought their wives and families. Though loyal to their mother and often embarrassed at their father's relationship with Marion, they maintained a courteous friendship with her while he was alive.

Marion was a natural comedienne, beloved in the film industry for her generosity and warmth. She was the animating spirit of the ranch, and filled its rooms with her young and exuberant Hollywood friends, including Charlie Chaplin, Gloria Swanson, Douglas Fairbanks, Mary Pickford, Greta Garbo, Louise Brooks, Harpo Marx, Cary Grant,

David Niven, Norma Shearer, Billy Haines, Constance Talmadge, Jimmy Stewart, and Jean Harlow. Marion was known to wryly (and perhaps rightly) refer to some of them on occasion as "The Younger Degeneration."[11]

Typical weekend parties at the ranch included no more than twenty guests, generally drawn from many backgrounds, not only the film industry. One category barred from the guest list was stodgy East Coast society types, whom both Hearst and Marion found extremely boring. Instead they mixed celebrities with business colleagues and prominent newsmakers. Hearst frequently brought his editors to the ranch for meetings, as Marion's close friend and former *Ziegfeld Follies* costar Aileen Pringle recalled: "You would come downstairs and find . . . probably thirty men standing around in blue suits. It would be a surprise for us. They arrived during the night."[12]

Hearst invited prominent politicians and millionaires, including Winston Churchill, Calvin Coolidge, Howard Hughes, Jean Paul Getty, and Bernard Baruch, as well as literary lights such as Aldous Huxley and P. G. Wodehouse. George Bernard Shaw came to the ranch for four nights in 1933, his only visit to a private residence during his entire American tour. Hearst's invitation to Shaw read: "Let me herewith extend you [my] formal and fervent invitation to be my guest and ride the range with me in California."[13] "Riding the range" was indeed a frequent activity, as Alice Head, dignified English editor of Hearst's British *Good Housekeeping*, recalled: "We went up to the Ranch for a few days [and] Leslie and Ruth Howard . . . were among the guests. My principal recollection of this particular weekend is connected with mounting a horse for the first time in my life, stopping to photograph the wild animals (without dismounting), and an emu coming up behind and biting the horse who reared in the air and—No, I did NOT fall off."[14]

One of the more unusual visits was recalled by Bill "Iron Eyes" Cody, an Italian-American who played many Indian roles in the movies. He arrived with Tim McCoy and his wild-west touring company of twenty Arapahoes in full native dress:

Bustling up to Goes-in-Lodge, the six-foot-four Arapahoe chief, [Marion] gave him a punch in the arm and said, "Hi, Chief! Welcome!" Hearst was even more effusive: "Tim! Tim McCoy! How are you, sir? So glad you made it. . . . Now, you must introduce me, I've been anxious to meet these Native Americans for some time." We filed by as if meeting a head of state, Tim making introductions and providing a brief historical anecdote or two. Hearst's reception was enthusiastic and jubilant. He seemed particularly fascinated with the older Indians involved in the Little Big Horn battle, snapping off battle dates and locations as if recalling last week's picnic outing. A lover of history myself, I was impressed.

That night at eleven p.m., the guests gathered in Hearst's private movie theater to view a full-length film and short subject, as was the nightly custom. Iron Eyes recalled that the entire troupe fell asleep as soon as the lights went out: "The cacophony of snorts, wheezes, sighs, grunts, and whistles . . . coming from our quarters must have sounded pretty unsettling to the rest of the guests." The evening actually grew stranger after that, once Hearst and Marion went upstairs to bed after the film: "Here we were in this giant Castle, almost alone! What better place to play Cowboys and Indians? With the older men sitting this one out, we chased [the Hollywood starlets] from room to room, making silly war dance sounds. There was some flirting and kissing, pinching and shrieks, but not, to my knowledge, anything beyond that."[15] Iron Eyes was most impressed by a horseback ride on the ranch:

The ride through what must have been a very small portion of the ranch was wonderful. Hearst, a good horseman, led the pack over land that offered the best

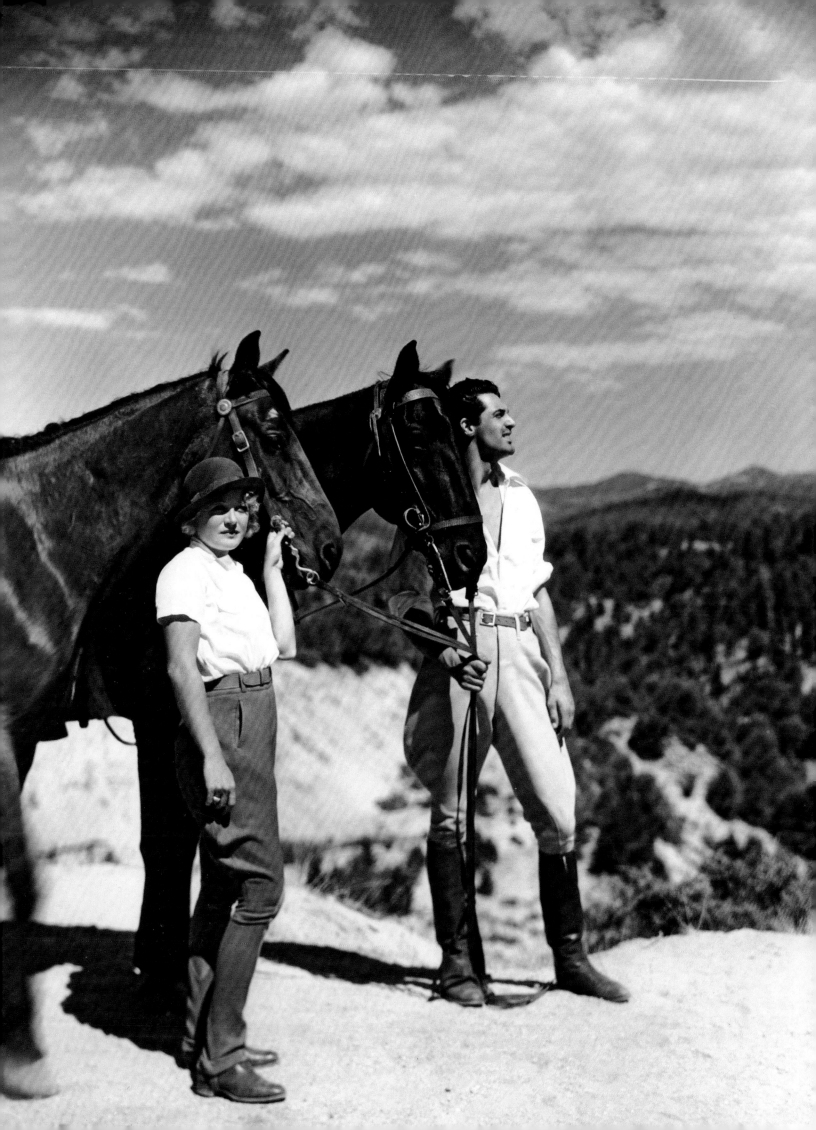

of California geography: rolling hills covered with shaggy golden grass; multicolored rocks, fissures and canyons carved from the earth by streams during the rainy season, cool ocean breezes and bright sunshine. . . . Late in the afternoon we returned, most everyone exhausted except W. R. Of course, I'm used to that kind of riding, but W. R. was in his seventies![16]

Hearst invited a few genuine Hollywood cowboys to the ranch, including Tom Mix, Hoot Gibson, and Will Rogers. The majority of his guests, however, only played cowboys onscreen. Hearst was thirty years older than most of them, which might explain his particular delight in leading them on long rides to the Hacienda. The journey was more than twenty miles, too strenuous for many of the guests. In later years Hearst built a road to the Hacienda and a landing strip at the site. But in the beginning, everyone rode there on horseback. Many must have felt as Clark Gable did, when he reportedly whimpered to Gary Cooper after a long day in the saddle, "When we get to the brow of the next hill, we'll see Los Angeles!"[17]

Marion was not an enthusiastic horsewoman. She wrote: "He knew I was afraid of them, but he adored horses. He said, 'If you love a horse, a horse loves you.' I said, 'That doesn't prevent a horse from getting mad and biting me on the toe.'"[18] Marion's longtime girlfriend Eleanor Boardman agreed with her, remarking: "Marion and I both hated anything that had more legs than we did."[19] Plenty of other guests agreed with them. The Hollywood director King Vidor recalled joining Hearst for a long horseback ride in the company of several guests whom he described as the most "tender-footed cowboys and tender-bottomed women imported from the most comfortable drawing rooms in the world."[20]

San Simeon was an authentic ranch, created in the 1860s by George Hearst for horses first, and cattle second. Will Rogers was an authentic American cowboy and one of its most beloved guests. Rogers was in his twenties when he first saw San Simeon in the 1890s. He got a job ship-

ping a trainload of cattle to the ranch and was struck by its beauty. The Piedra Blanca Rancho was lush and verdant, so different from his family home on the Cherokee Nation land in Indian Territory, the future state of Oklahoma. Rogers and his fellow cowboy Billy Connell considered asking for work on the ranch, but they couldn't communicate with the Spanish-speaking foreman (almost certainly Don Pancho Estrada, who worked for Phoebe for decades). So they headed to San Francisco to see the sights instead. Then Rogers returned to Oklahoma and began his career as a stunt rider and trick roper.

Will Rogers and Hearst first met in New York City, where Rogers was appearing in the *Ziegfeld Frolics* and the *Ziegfeld Follies* with Marion Davies in 1916. Rogers had discovered that his audiences enjoyed his humorous banter as much as his spectacular rope tricks. Florenz Ziegfeld agreed, and hired him as the novelty act for his rooftop show at the New Amsterdam Theater. Rogers's wife, Betty Blake, was skeptical about her husband's career in show business, but he convinced her, her sister Sallie, and his two sisters to attend a midnight show. Sallie wrote her children that they were just stepping into the elevator when "a fine-looking, broad-shouldered man" greeted Will with a handshake and a smile. It was William Randolph Hearst. The Rogers family was impressed by Will's connections. Rogers was famous for interacting with his audience, and the champagne bottle on Hearst's table was apparently a frequent target for Will's lasso. [21]

At San Simeon, Rogers preferred the bunkhouse to the hilltop, according to several accounts. One time Hearst began to worry when Rogers was hours overdue, and finally sent out a search party. They found him down at the ranch in earnest conversation with the cowboys. Rogers helped with the roundups, cracked jokes around the fire, and kept the Hearst cowboys in stitches with his tales and his rope tricks.[22]

Isabelle Orr, a local nurse, was an unlikely observer of one incident at San Simeon. She was on hospital duty in San

BELOW: The scenic landscape the Hearst cowboys ride through today looks almost exactly as it did in the twenties and thirties, when Hearst, Marion, and their guests explored the ranch on horseback.

OPPOSITE: Many of Hearst's guests were surprised by the close friendship between W. R. and Don Pancho, the only person who addressed Hearst as "Willie." Cowboy actor Joel McCrea recalled that Hearst and Don Pancho had the best horses and led the trail rides. As they rode through the ranch, W. R. would ask him, "Now Pancho, do we own that?" and Pancho would answer, "Yes."

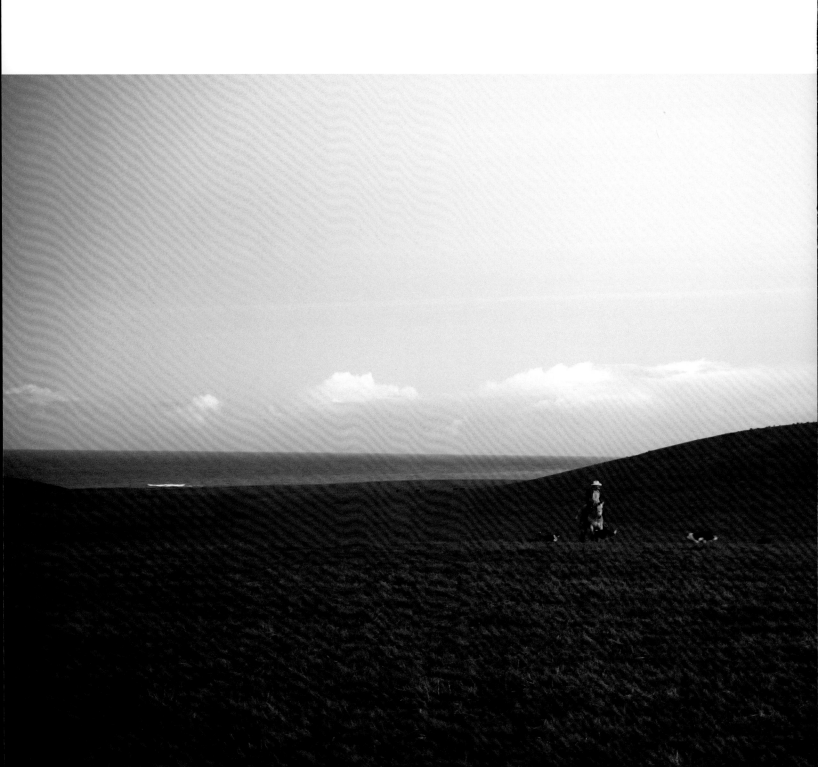

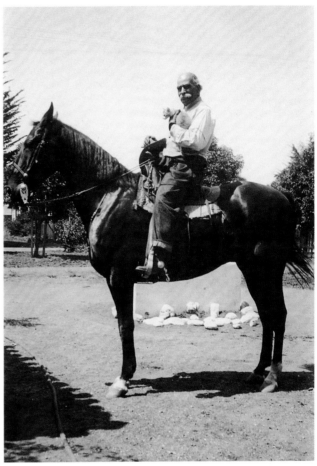

Luis Obispo one night in 1930 when W. R.'s youngest son, Randolph Apperson Hearst, and Rogers's oldest son, Will Rogers Jr., were in an automobile accident. "Bill" Rogers was nineteen and Randy was fifteen. W. R. raced forty miles south and burst into their hospital room, anxious to see the boys. Nurse Orr didn't recognize him at first; she barred his entrance, calling him a "two-bit reporter."

The boys recovered, and Nurse Orr was hired to take care of them at San Simeon while they convalesced. She joined Hearst's guests for dinner each night, and recalled Will Rogers standing up in Hearst's long Gothic dining hall one night to make a toast: "That nurse in uniform down there at the end of the table, she gets by with Will Hearst where we can't get by him, and we've known him for years. She called him a two-bit reporter, right to his face!"[23]

Hearst was a near match with Rogers when it came to riding cross-country. He grew up on horses, learning to ride at the age of two. His son Bill Jr. said: "He was very strong. He was very well-built. Tall [and] not delicate in any sense of the word. And for a fella that you don't think of as being an athlete, he could ride all day. He could ride most other people into the ground."[24] Hearst usually rode his palomino Omaha, and he and his longtime friend Pancho Estrada led the rest of the riders. Their close friendship surprised many of the guests. Actress and frequent guest Colleen Moore recalled:

After lunch that day a group of us ran to the huge sofa in front of the big walk-in fireplace [in the Assembly Room]. We were gossiping and giggling when Mr. Hearst came over saying we must get some fresh air and exercise and to put on our riding habits or blue jeans. The horses were waiting. We had no choice. A little old Mexican hand named Pancho helped us onto our horses, and off we went. A few minutes later I got the shock of my life when Pancho, riding up at the head of the group, turned and called out, "Willie, come up here and ride with me. I want to show you

a pasture." In all the years I knew William Randolph Hearst I never called him anything but Mr. Hearst. We all called him that, except Marion, of course, who called him W.R. Now I couldn't believe my ears. *Willie* to the great Mr. Hearst! I found out that night that Mr. Hearst and Pancho had been raised together on the ranch and had been close friends since childhood. The beautiful Spanish house we had passed that morning in the village below had been built for and given to Pancho by Mr. Hearst.[25]

Pancho's dignity and presence—particularly in the saddle—was remarked on by many. Born on the Santa Rosa Rancho on October 4, 1853, Pancho was twenty-four when George Hearst bought the remainder of the Estrada ranch from Pancho's mother, Nicolasa, in 1876. W. R. was thirteen at the time, and Pancho taught him to rope and to ride. Norma (Bassi) Monson married into the Sebastian family who ran the store in San Simeon. She recalled how proudly Pancho rode around town on a silver saddle. The children "would run up to him and say, 'Hey Pancho!' then he would straighten up even more in his saddle, poised and tall, and ruffle his feathers, saying, 'My name is DON PANCHO ESTRADA!'"[26] Hearst's official biographer, Mrs. Fremont Older, wrote in 1934: "[Hearst] places his dog in his motor, and he himself mounts his horse, and sets forth with Don Pancho Estrada. The caballero of new California and the caballero of the old, lead a house-party up and down mountains, one hour's drive to the picnic grounds by the brook with banks of wild flowers, on the new private road to the far end of the ranch beyond the Mission of San Antonio."[27]

Pancho was seventy-five in 1927, and W. R. began to worry about his health, telegraphing Arch Parks that he "didn't think the horses should be under Pancho . . . because Pancho is too old to look after such matters in necessary detail and I do not want to burden him." Hearst stressed that he did not want Pancho replaced, merely

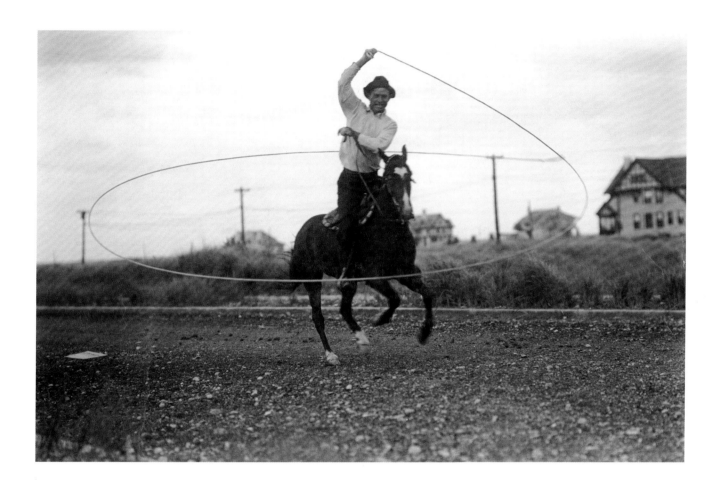

"assisted." It would have to be done with great delicacy. Parks understood, replying that he did indeed need two good men caring for the horses at Pico Creek, "And I think it can be done in a way so as not to hurt Don Pancho's feelings. I know how you feel about Don Pancho."[28]

Don Pancho connected W. R. to old California and their lifetime of shared memories on the ranch at San Simeon. Hearst delighted in bringing these traditions to his guests, most of whom were city slickers who had not spent decades on horseback exploring the backcountry. W. R.'s recently deceased grandson, John Hearst Jr., lived on the hilltop with Hearst for two years in the 1940s. Bunky, as he was nicknamed, was twelve to fourteen years

old at the time, and had an opportunity to closely observe Hearst in his later years. Bunky recalled: "People have said that Grandpop ran the ranch like a huge free hotel, with guests coming and going as they pleased. That wasn't true. The original GH ranch, which had been bought by my great-grandfather, was the last of the old-time Spanish land-grant haciendas and it was run just as the *hacienda-does* had run their places. There was this huge hospitality for everyone under its roof, but at the same time a kind of country simplicity."[29] Those who experienced it never forgot it.

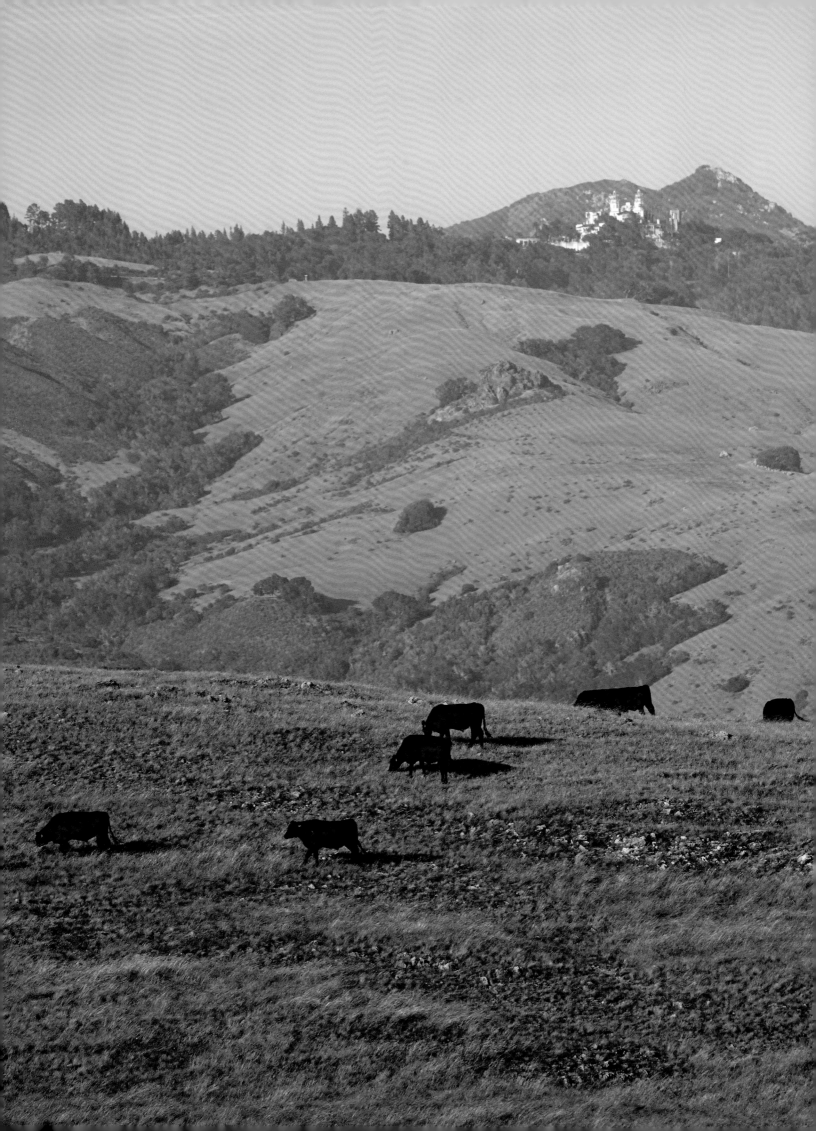

THE PIEDRA BLANCA RANCHO

William Randolph Hearst may have entertained guests in the tradition of the old California rancheros, but when it came to ranching itself, he looked forward, not backward. In this he differed from the gentlemen farmers of the East Coast whose picturesque farms were often adjuncts of their grand country houses. Those operations were meant to be quaint, decorative, and definitely not profitable, as *Country Life in America* explained: "The country house gentleman does not farm for profit. He creates in the city and recreates in the country and his herds and flocks are an investment in healthful diversion."[1] Hearst ran a ranch, not a farm. He ran it as a business, and he was involved in every decision.

Fencing materials were an important early consideration, especially since they were creating pastures for zoo animals as well as livestock. They employed a special type of barbed wire made up of parallel wires with fewer barbs than the conventional kind.[2] Hearst hired orchardist Nigel Keep in 1922, at which time Keep immediately began to fence in their extensive orchards: citrus groves below the cottages, fig trees at a lower elevation, and toward the western hills, a deciduous orchard of cherries, apricots, peaches, nectarines, plums, pears, and apples. Below this, Hearst planned nut trees and an olive grove. He wrote Morgan: "I understand it is well to plant the mulberries with the cherries as the birds prefer them to the cherries and leave the cherries alone."[3]

To obtain sufficient water, Morgan designed their first modern reservoir in 1922. It was a 100,000-gallon steel-reinforced tank at a 1,818-foot elevation, 200 feet above the hilltop buildings. They also improved the pipeline that ran from the Pine Mountain springs and replaced

Hearst was involved in every aspect of ranch operations, as the hundreds of letters he exchanged with his ranch managers attest. Though many East Coast country houses kept livestock for picturesque purposes rather than practical ones, W. R. ran his ranch as a successful business enterprise.

its original redwood boards bound with wire with modern tin-coated brass pipe. Hearst worried that this large water tank would be unsightly, suggesting to Morgan that they plant the hill with evergreens: "The natural foliage of the ranch is almost entirely evergreen, the conifers on the mountains and the live oaks in the gulleys, etc. This gives a beautiful effect, both in the summer and winter, and I would not like to modify that effect by planting any considerable number of deciduous trees."[4] He thought conifers were a better alternative, as long as they did not interfere with good grazing land:

> I think the conifers should be planted on the hill that sustains the reservoir. This hill is barren and not pretty. It would be fine, however, if covered with groves of fir and spruce and deod[a]rs and other attractive evergreens of this variety. They could be watered from the reservoirs while they are young. Deep holes should be blasted and filled with pretty good soil, because, if you remember, the analysis of the water that comes from that hill shows there is rock and mineral there not good for vegetation.[5]

The 100,000-gallon reservoir was insufficient for both the hilltop and the orchards, so within a few years they built a 1.5-million-gallon reservoir directly beneath the first one, using the upper basin as its settling tank. Such immense structures required a huge number of conifers to disguise, as Nigel Keep recalled: "The 6,535 pine trees set out on Reservoir Hill were all in five-gallon cans, and dynamite was detonated in each planting hole to assure penetration of the roots beyond the shallow soil."[6]

They were also planning to build a dam near the ocean for agricultural use, as Morgan wrote to Hearst in 1924: "The dam and lake in the Arroyo Seco [sic, Arroyo de la Cruz] would provide the necessary water for alfalfa, vegetables, canneries, etc., without depleting the Hill water supply. It is certain that any dam built in the canyons

above the camp will be very expensive to build and would impound the water of a comparatively small watershed—, also that a new reservoir will only provide a reserve for fire fighting or to tide over an accident to the main pipe line,— not provide water for garden or orchard use."[7] While they did not ultimately complete the dam on the Arroyo de la Cruz, they did build a large reservoir above the ranch house and the poultry farm in later years. The Hearst Ranch also recently built a sixteen-million-gallon concrete reservoir on a lower pasture near the ocean.[8]

Morgan had finally succeeded in convincing Hearst that the Jersey herd should graze at the bottom of the hill, not at the top. In 1924 they constructed a dairy south of the original ranch house. They rebuilt the dairy further north in 1927, during their general upgrade of the ranch buildings. Former dairy hand Harley Boisen recalled milking 106 cows twice a day, at four a.m. and at two p.m. Occasionally guests came down from the hilltop to watch the milking machines in action. Boisen remembered actress Carole Lombard coming in, wearing so much perfume that the cows wouldn't let their milk down.[9]

In 1928, as an additional part of the ranch expansion, they built a long pergola on Orchard Hill, turning a functioning hilltop orchard into a decorative landscape feature. Hearst had been planning to use small pergolas in the hilltop gardens since 1920. This structure was much more elaborate: a double row of linteled concrete columns stretching more than a mile around the orchard, showcasing dramatic ocean views. Morgan wrote Hearst: "I went over the proposed pergola lines and modified curves etc. to get a more pleasing perspective."[10]

The pergola was built in stages, fully finished only in the late 1930s. Its completed portions were immediately planted with overhanging grapevines and espaliered fruit trees, making a spectacular landscape effect. Norman Rotanzi, hilltop gardener for more than fifty years, recalled: "The pergola was very outstanding in its day . . . with espaliered trees on each side and grapes overhead. Mr. Hearst

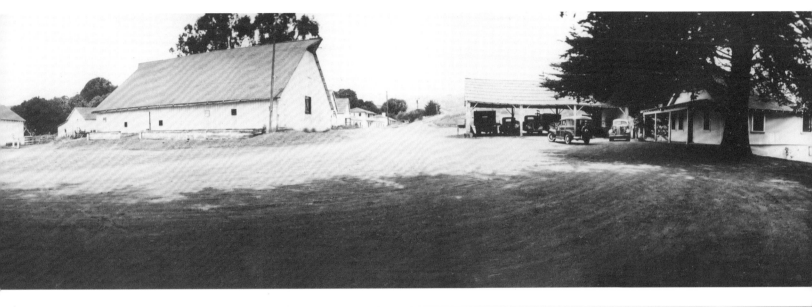

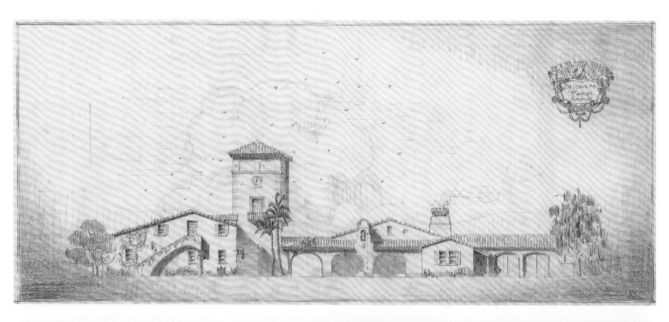

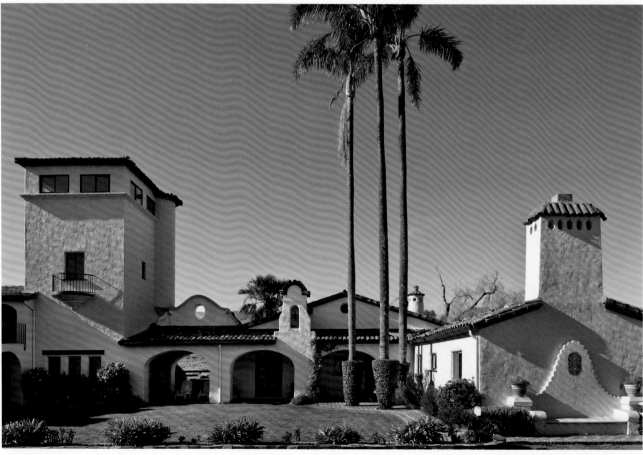

OPPOSITE TOP: Morgan designed a charming residence and office for the poultry ranch manager in 1928. This large building was sited just south of the ranch house, near an alfalfa field. They eventually built a reservoir above it to address the frequent water shortages at the ranch.

OPPOSITE BOTTOM: The east entrance to the poultry ranch manager's house is decorated with dovecotes, towers, archways, and benches, all designed in a picturesque Mission Revival style. The large square tower contains a gravity-fed water storage tank.

would take a weekly walk through the pergola."[11] Orchardist Brayton Laird was in charge of grafting the apple trees:

> One time we took one whole orchard of red delicious and cut those right off. We regrafted golden delicious and had the golden delicious apples growing [alongside them] by the next year. Mr. Keep was very very strict on not hurting the tree. They were all like little children to him. On the cold mornings he liked the lizards that protected the trees and ate the bugs and everything. So he'd keep them warm . . . in his shirt [and place them on the trees with bug infestations]. He was after gophers all the time and if we ever killed a gopher snake, that was curtains for us. . . . [The fruit] was shipped as a gift to remind some of [Mr. Hearst's] people [of the ranch].[12]

Hearst initially intended for the poultry farm to be located on the hilltop near the orchard, but he eventually agreed to build it at the bottom of the hill, just above the original ranch house. He decided not to make it a large commercial operation, because "this takes a good deal of money, and I am afraid if we contemplate any such large expenditure we will not do anything at all."[13] Morgan lavished the poultry ranch with architectural detail, and its five-room bungalow was the most delightful employee residence on the entire estate.

The poultry ranch manager in the thirties was Gladwin B. Read. He raised thousands of birds in pens behind the house, including prize chickens, ducks, geese, turkeys, guinea fowl, pheasants, partridges, grouse, and squab for the table, and many rare birds for display, including peacocks, pelicans, and penguins. There were occasional problems with the poultry, as when Hearst wrote, "Nearly all the poultry is so tough that I am ashamed to give it to our guests. I cannot understand it. Haven't we any *young* chickens?"[14] Read recalled making a living Easter display on the hilltop one year:

> At Easter . . . I had suggested a little display of baby chicks and ducklings in the Refectory . . . as very appropriate during the Sunday dinner. Mr. Hearst agreed that would be fine—if I was certain that it wouldn't harm the birds—and if I would personally see that they were brought back to the farm right after the meal. No pets ever had it so good! [We] constructed a little pen on top of a card table, in the center of which was a gaily colored house, heated with an electric bulb, while out in the "yard" there was food and water.[15]

Hearst also raised hogs, an operation he planned to improve as part of the 1927 ranch upgrade. He wrote ranch manager Arch Parks: "I am inclined to believe in pure-bred hogs, just as I believe in pure-bred cattle."[16] The ranch conditions were a factor, and Hearst realized this, writing Parks soon after: "There is still the question of what kind of animal takes care of itself best under those semi-wild conditions that prevail on the ranches."[17]

The main focus at the Piedra Blanca Rancho was beef cattle, just as it is now. Hearst's cattle were grass-fed then, as they are today. A visiting landscape expert described the pastures: "The grazing lands lie between the sea and the mountains, averaging about a mile and a half wide. Wild oats grow freely everywhere. . . . There are about 7,000 cattle (Herefords and Durhams). . . . The wild oats and other native grasses are rarely mowed down for hay. It cures in the hot sun and the cattle live upon it till the fall rains begin, in October as a rule."[18]

Hearst wanted only purebred Herefords, raised partly on his coastal ranch and partly on his inland one: "I want to continue to do our own farming and not lease and I think we could possibly make a road connecting the two ranches and bring all the feed necessary over here and store it in barns. If not, it's easy to truck through San Luis Obispo."[19] Longtime Hearst cowboy Durward Ward recalled the trek: "We worked cattle all over the ranch, movin' stock between

the coast place and the Santa Margarita ranch over here where Hunter Liggett [Hearst's former Milpitas ranch, purchased in 1925] is now. We'd drive 'em up San Miguel Canyon, over the hills, and come out at the back end of Pacific Valley [the coastal bluffs north of San Simeon]. Some places the trails was so narrow, we'd have to string them cattle out for miles. Because if they piled up, some was sure to get shoved over the bank an' you'd lose them down the steep canyons."[20]

Hearst asked Morgan to build or improve several cabins along the trails, so the cowboys would have good shelter for the roundups. A rebuilt Burnett Cabin, located on a spring near Burnett Creek northeast of the Castle, is still in use today. Local homesteader Clifford Harris built the original cabin in 1918 and sold it to Hearst in 1926. It was a good investment, since he paid $1.25 an acre in 1915 and sold it for $12.50 an acre eleven years later. The cabin at Burnett is emblematic of what occurred in the region countless times, as the Hearst family bought up homestead after homestead. Hearst wrote Morgan: "I want to speak to you about a plan for a shack up at Burnett. I think it is desirable to have shacks at two or three such points on the ranch so that we can ride a distance and have an overnight headquarters."[21] Two of these small cabins—at Burnett and to the southeast, at a site called Tobacco—served as lodgings on their cattle drives. "It took a week or ten days to take care of the cattle during branding and weaning time," dairy hand Harley Boisen recalled. All the ranch hands joined in to help. They each had three horses, "and we'd put hobbles on them at night so they wouldn't run away."[22]

Hearst also landscaped the area around the Burnett cabin. Norman Rotanzi recalled transporting large redwood trees (*Sequoia sempervirens*) several miles out to Burnett in 1934. He placed them next to Burnett Creek where they received sufficient moisture to flourish. Many of those trees are still alive today.[23]

In the mid-1920s, Hearst's newly purchased Milpitas ranch and his San Simeon Ranch were not the extent of his cattle operations. Hearst owned several other ranches in the southwest, the largest of which was Babicora in northern Mexico, purchased by George Hearst in 1884. This ranch in the high mountains of Chihuahua was described in 1908, nearly a decade after George's death:

> With over a million acres of agricultural and grazing land, with large herds of blooded cattle, horses, and sheep roaming over this vast domain, the big Hearst cattle ranch and farm in Chihuahua is the peer of any such estate in the world. . . . Two hundred and fifty miles of barbed wire fence enclose a portion . . . and within the enclosure graze 60,000 thoroughbred Herefords, 125,000 fine sheep, and many thousand head of horses and hogs.[24]

In 1915, during the Mexican Revolution, Pancho Villa appropriated much of Babicora and returned it to the locals. It was reported that Villa's men treated the Hearst ranch hands at Babicora better than those at many other ranches, for two reasons: ranch manager Maximilian Marquez was a friend of Pancho Villa's, and Phoebe Hearst was renowned for her generosity to the locals.[25] Though it had much diminished in size, Hearst maintained Babicora and shipped cattle back and forth to San Simeon in the 1920s and 1930s. By 1928, Babicora was branding 10,000 calves each year.

As was the case in all ranch operations, Hearst followed Babicora closely. For instance, in 1929 Hearst arranged with an outside supplier to buy 130 Hereford bulls to replace his seven-year-old bulls that were past service. He was disappointed that Babicora had not raised more calves: "The number of cows had greatly increased but the number of calves branded did not increase in proportion." Hearst told the seller that he did his breeding with seven bulls, one to each hundred cows.[26]

The Babicora ranch expanded into Texas in the 1930s, as the ranch manager explained: "We are planning to feed

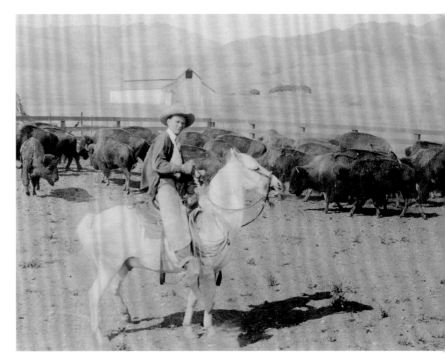

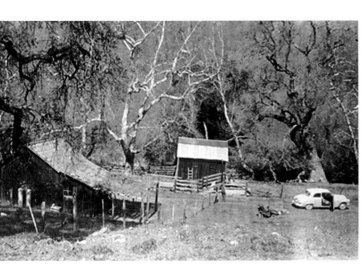

all the cattle we will bring out of Mexico this year in Texas. We have established our own feed yards there, and find it more advantageous to feed than to pasture, particularly as we bring out cattle out of Mexico as yearlings, and wish to push them to market at the earliest age possible."[27]

There were usually five or six year-round cowboys on the Hearst ranch at San Simeon, with extras brought in for the busy seasons. Longtime cowboy Archie Soto recalled:

> There was about six of us riding with the cattle, working the cattle all the time, just here at the Piedras Blancas ranch. . . [Mr. Hearst] paid top wages for that kind of work. . . . It was an awful good place to work. Everybody had a good time. We had good cooks. . . There wasn't many hands changed. You knew you got a job there and you stayed.[28]

They didn't just rope cattle—they roped buffalo and other zoo animals as necessary. Ken Winsor was a dude wrangler, living on the hilltop near the stables and caring for twenty quarter horses, as well as taking guests out on trail rides. He recalled how hard the buffalo were to handle. Sometimes they simply could not coerce them into the corrals.[29]

In addition to the quarter-horse stables on the hilltop, the Hearst Ranch had stables near the old ranch house for the cowboys, as well as the Pico Creek Stables, improved by Hearst in the late 1920s. Hearst's best horses were raised there, including many Arabians, which he began breeding in 1919. The finest among all light breeds, Arabians are renowned for their stamina and beauty. Their small head and narrow muzzle, high tail carriage, wide-set eyes, and prepotency as sires make them the finest of breeding horses. Hearst wrote William Robinson Brown, president of the Arabian Horse Club, in 1930, stating his goal was to "improve Arabians in America, to supply other breeders with superior stock, and to perpetuate the pure Arabian blood."[30]

Hearst also raised many other breeds, but specialized

in Morgans. Every Morgan horse is derived from a single sire—Figure (later renamed Justin Morgan), foaled in 1789 in Massachusetts—making them one of the first horse breeds developed in America. Though smaller, Morgans resemble Arabians with their substantial necks, hindquarters and barrel, and a refined head.[31] Robert Combs and his father were trainers who brought stud horses to San Simeon, making regular visits through the 1930s and the early 1940s:

> While we were at San Simeon, a couple of the guests were Tom Mix and Hoot Gibson. . . . Mr. Hearst had some of the most gorgeous Morgan horses you ever laid your eyes on. . . . They would have manes on them that . . . would hang four feet down the side of their neck. Their tails—you'd brush them with a brush and they would hit the ground.[32]

Hearst bought fourteen Morgan mares in 1929 and bred them to one of his greatest horses, Uhlan, a bay stallion bred by the U.S. Morgan Horse Farm. From 1932 to 1939, 110 Morgan foals were registered to the Hearst stables. Among these were eighteen Morabs, a Morgan-Arabian cross, the beginning of this important breed, which now has its own registry, known as the Hearst Memorial Morab Registry. Hearst is credited not only with originating the breed, but with originating its name.[33]

Only a few years after his efforts to expand the ranch in the late 1920s, Hearst had to retrench. There was not enough money to go around, even before the Depression. Morgan had not been able to meet the bills, and when she was supplied with stopgap funds, thanked Hearst: "If we can have the money you propose for February and March, we will be paid up fairly to normal, and from then on can work on any amount you set. I do not want, or mean, to be greedy."[34] There were many financial shortages ahead, but Hearst tried not to penalize his employees. He wrote Arch Parks: "I am much disturbed by the cuts that you have made

STORE SCHOOL HALL CHURCH
 —PLAZA—

in wages in departments relating to the hill. . . . I have never been in the habit of reducing wages. It is much better to undertake less operations than it is to deprive people of liberal compensation."[35] He asked Parks to meet with him to discuss reinstating their wages.

When personnel problems did occur, they were usually related to disputes about divisions of labor in different departments. Engineer Camille Rossi was the construction superintendent from 1922 to 1932, and he was often the source of the conflicts. A productive and talented worker, he nevertheless had a very difficult personality. Hearst was aware of this, writing Morgan: "I don't think Mr. Rossi gets along with people." Hearst continued: "He seems sufficiently satisfactory on construction matters but I think he is more of a hindrance than a help in other matters."[36] It was easier for Hearst to be philosophical about Rossi's defects, because he didn't have to deal with him every day. Furthermore, Rossi ensured his employer's approbation by aligning himself with Hearst, even when their decisions went against one of Morgan's directives.

Rossi was involved with all hilltop and ranch construction, including the barns, animal shelters, poultry ranch, warehouses, Milpitas Hacienda, stables, and employee residences. In 1932, when he defied Morgan's authority by dynamiting on the hilltop against her specific instructions, it seemed Hearst was ready to fire him at last. But when Rossi pleaded, Hearst began to waver, writing Morgan: "Mr. Rossi seems to be in such desperate straits that I am repenting letting him go. What do you say? Shall we try him another year?"[37] Morgan responded: "Any decision you come to in regard to Mr. Rossi, I will, of course, fall in with cheerfully, but [I] believe that not carrying through will make him doubly hard to work with. . . . I may be unreasonably tired of operating with a constant sense of contrary purpose, and not see conditions fairly or clearly as your fresh eye can."[38] Morgan finally gained her point, and Rossi left for good. She suggested his replacement: George Loorz, the best-loved and most competent manager they ever had.

TOP: In 1923 Hearst wrote Julia Morgan: "I want an inn at San Simeon, and this we will construct." Though planned, it was never built. Morgan's elevation drawing, circa 1929, shows a school, church, inn, and employee residence along San Simeon's main street.

BOTTOM: Many miles of ranch roads still provide access to the backcountry. This view looks east over Burnett Canyon, with a reddish butte known as Burnett Peak in the distance.

INN COURT GARAGE 2. HOUSES

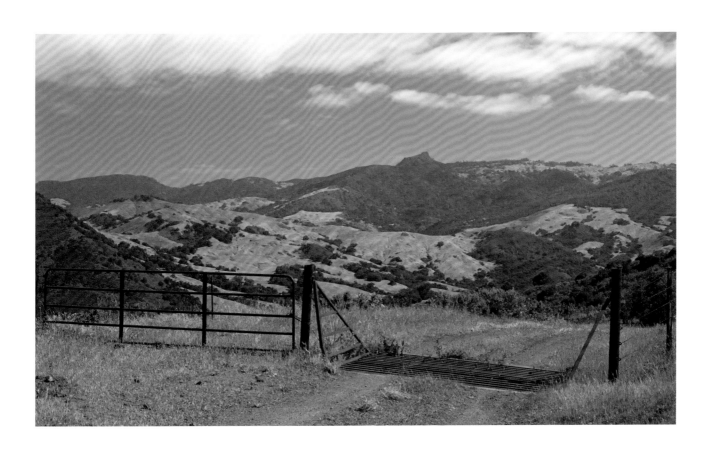

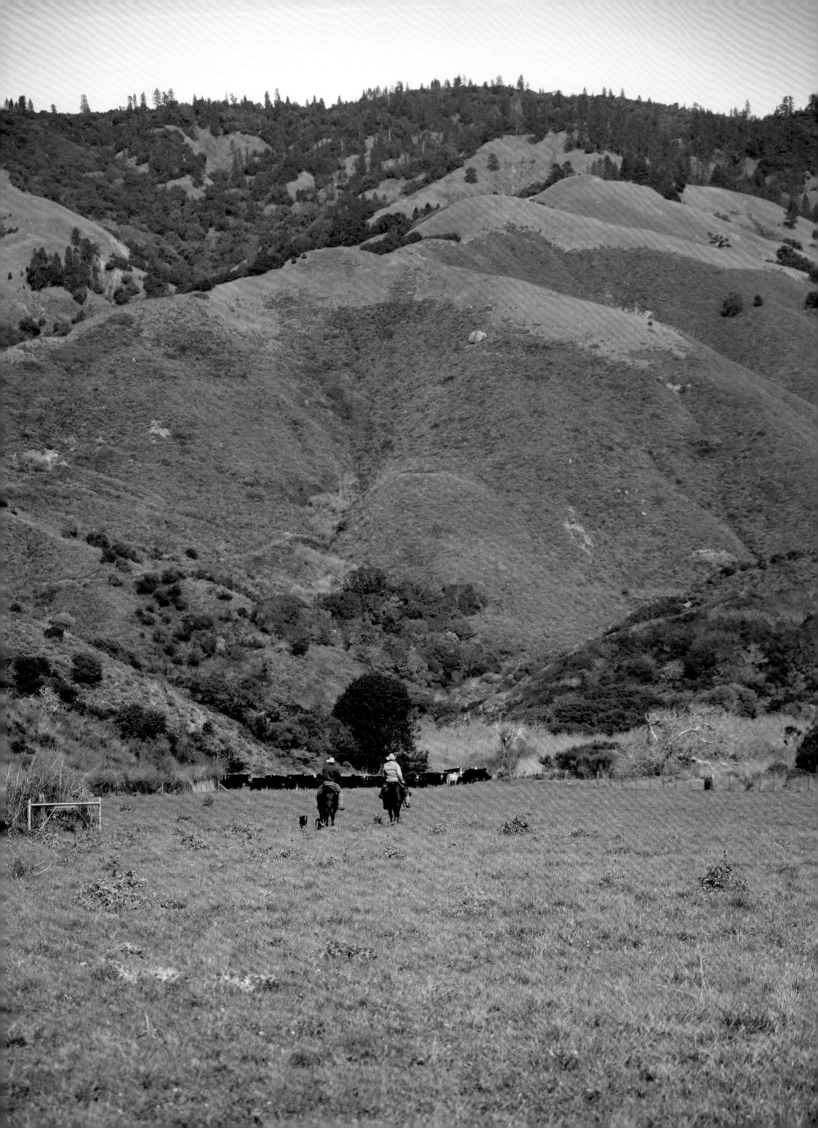

7

STORIES FROM THE RANCH

he author and bibliophile A. E. Newton described driving to the Hearst Ranch in the mid-1930s:

> John Henry Nash, the great San Francisco printer, had met me according to arrangement at San Luis Obispo in a high-powered car, and after motoring for several hours said to me, "We are now on Mr. Hearst's ranch." We had entered no gates and there was nothing to suggest that we were in a private estate; we were just speeding along a country road. "That is the port of San Simeon . . . When Mr. Hearst sees anything he wants, he buys it and sends it here. If it fits into his scheme he uses it; if it doesn't, he puts it in storage. Those are his warehouses."
>
> Presently we came to a wooden gate, one of those "grasshopper gates" which leap sideways into the air by the pulling of a rope. I did the pulling, taking the opportunity to read a sign on the gate, "Beware of the wild animals." I didn't see any, but knowing where I was, I promptly bewared, and, quickly closing the gate, hurried into the motor. After a mile or two we came to another gate with a similar sign, and then another gate, this time guarded by a man who came out from a small cabin. "Are you expected?" he said. "What name?" I saw wires leading from the cabin and no doubt our names were telephoned to the mansion. Permission to enter was soon accorded.
>
> A few moments more, and high up on a mountainside, we saw a huge pile of superb buildings which seemed to be dominated by a Spanish cathedral. "That is La Casa Grande and believe me, that is what

Driving the cattle out to pasture in the eastern hills.

119

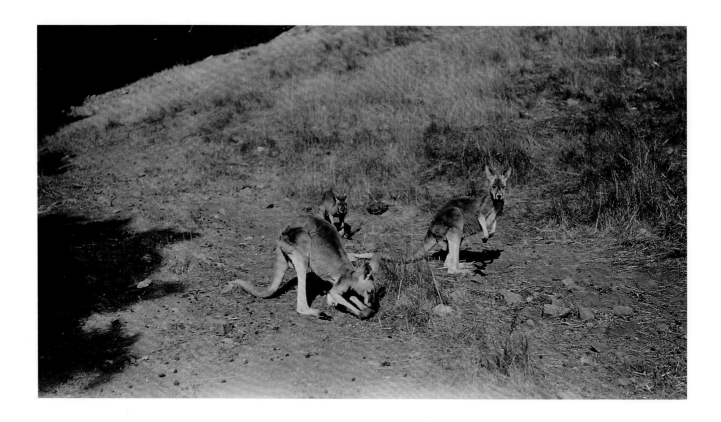

it is," said Nash. "Do you see that black mass down there? Buffalo." The deer, zebra, and giraffe seemed to be living on intimate terms with herds of cattle and the Arabian horses.[1]

Frances Marion was a screenwriter who wrote many of Marion Davies's films. She came frequently to the ranch, and also knew her way around the wilds of Hollywood. She mentions both when describing the fencing for the zoo animals:

We drove along the coast, often veiled in fog, until we arrived at the outer perimeter of Mr. Hearst's domain—several hundred thousand acres of wooded land, vast meadows, and towering hilltops. On the peak of one of these rose a feudal castle right out of the Arabian nights. To reach it one climbed for miles on a winding road where deer, antelope, bison, giraffe, and zebra roamed. Wire fences had been built, not to protect the guests from the wild animals, but to protect the wild animals from the guests; the highly civilized influence of Hollywood being considered most contaminating.[2]

Charlie Mitchell held many jobs on the ranch, including night watchman and cattle transporter. Raised largely in Cambria, six miles south of San Simeon, he recalled watching William Randolph Hearst drive through the town:

I moved to the area when I was six, in 1937, and Hearst was a big deal around here. I remember seeing Bing Crosby and Cary Grant in Cambria, going into a bar called Reales, or watching the Pinedorado Festival. And we'd see Mr. Hearst, because the road went right

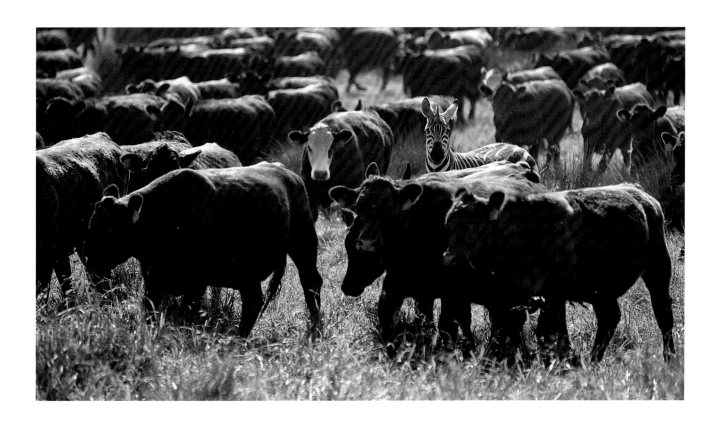

through Cambria and Steve Zegar, his taxi driver, used to pick him up at the train station. Mr. Hearst would sit right in the middle of the back seat, and he was a big man, and you could see him and you'd know when he was at the ranch.[3]

Many guests were surprised by the ketchup and other bottled condiments placed on the tables in the Refectory, Hearst's medieval-style dining room. It's generally thought that Hearst wanted to recapture the simplicity of his camping days on the hilltop and remind his guests that this was the ranch at San Simeon, however grand their surroundings appeared. Socialite Slim Keith recalled:

When dinner was announced, we would file into the long, high-ceilinged dining room, with its narrow refectory table. . . . I was so dazzled by the grandeur of

the set-up that I wouldn't have been at all surprised to have been seated next to an armored knight or two, or to have had a conversation with Cardinal Wolsey across that venerable table. We would, however, have been forced to converse over tomato ketchup bottles, A-1 sauce, and glass containers of paper napkins, which were placed at intervals down the length of the table and were the permanent and incongruous centerpiece of the noble board.[4]

Even on the hilltop, many informal ranch traditions were maintained. Tennis star and frequent guest Alice Marble occasionally sang during dinner: "Dinner was suddenly announced by Marion ringing a great big cow-bell (Hearst himself often rang it, as well). . . . Mr. Hearst had novel ideas about dinnertime entertainment. Sometimes he would ask me to sing, or Chaplin to play the violin [which

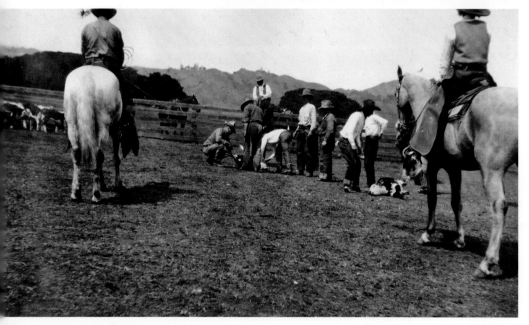

OPPOSITE TOP: This grasshopper gate swung open when tripped by a hinge.

OPPOSITE BOTTOM: At the Piedra Blanca Rancho, roundups and brandings were often attended by Hearst's guests.

BELOW: The sun sets above the late-afternoon fog that frequently veils San Simeon's coastline.

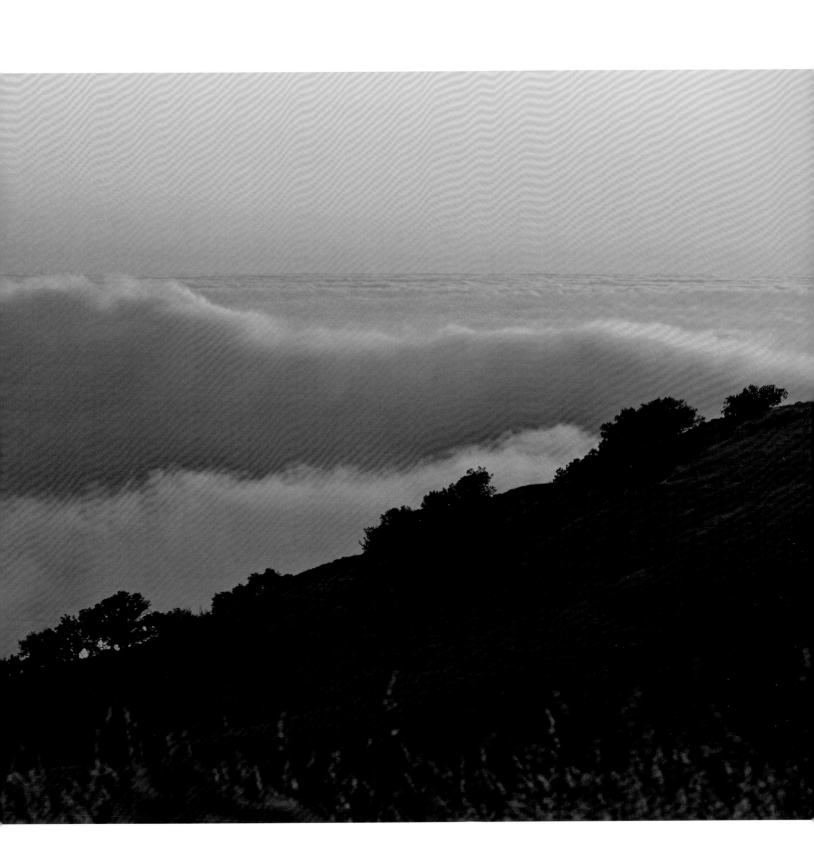

Chaplin hilariously did left-handed], or other guests to perform. Our host's contribution was yodeling, which he did very well."[5]

Roy Rogers came to the ranch with his band, the Sons of the Pioneers:

[Mr. Hearst] was an avid western music fan and his very favorite song was the classic *Tumbling Tumbleweeds* as done by our group. For several years in a row, in the mid-thirties, we were invited to the Castle to entertain at Mr. Hearst's birthday celebrations. . . . Mr. Hearst would ask us to go on playing and singing long after the other guests had retired. He would listen just as long as we would play and would ask for *Tumbling Tumbleweeds* again and again. He just never tired of hearing it and would join us in singing it.[6]

Hearst crusaded in his newspapers against various forms of animal abuse: the use of rare bird feathers in women's hats, the abuse of horses in cowboy westerns, bullfights of any type, and particularly vivisection—the practice of conducting laboratory experiments on animals. Marion Davies opposed it as well:

They brought my name into the vivisection thing. They said that people who were against it were not humanitarians. They didn't care about human lives, only dogs. Well, that was no argument. That was too ridiculous. I said that the way I felt about dogs also went for rats and mice and even as far as cockroaches. . . . Everything has nerves in its body, even the fish that you catch. . . . I had an agreement with the [UCLA Marion Davies Children's] Hospital to cut vivisection out. . . . Nothing. Not even a mouse or a rat. We won't do it.[7]

Author and illustrator Ludwig Bemelmans visited the ranch in the late thirties. His artist's eye was particularly attuned to the landscape, and he captured its beauty in his account of a horseback ride:

I got a horse . . . with one of the cowboys to ride with me. He brought the horse into a wide courtyard whose walls were unfinished, with the cement again bare, and the plain surfaces broken only in one place where an exquisite Florentine loggia was installed. . . . The paths go along ridges. To the west is the view down to the ocean, and to the east, always in a contrasting light, is an immense valley that reaches to the next ridge of mountains.[8]

Gossip columnist Louella Parsons was frustrated when the zoo animals had the right of way:

The Chief originally called his beautiful palace "La Cuesta Encantada," meaning "Enchanted Hill"—but he has always referred to San Simeon as "the ranch." This is not as much of a misnomer as it seems. . . . Buffalo, zebras, deer. . . . Herds of cattle, riding horses for the guests, chickens, wonderful dog kennels, acres of vegetables, fruit groves, and wide grazing valleys are an integral part of the color and scope of the property. For next to beauty, Mr. Hearst loves animals. Heaven help any guest who, by chance, should run over one of the roaming deer, or llamas, or kangaroos.

One night, I remember, a party of us, including Bebe Daniels, were being driven up the hill by one of the Hearst chauffeurs. It was very late and we were weary after a ride on the midnight special from Los Angeles. A very defiant and bossy moose parked himself in the middle of the road and refused to move. We honked the horn. We yelled at him. We made horrendous noises—but he merely gave us a wicked look. Bebe was all for jumping out and shooing him away.

BELOW: Cowboys encountered many exotic zoo animals, including llamas and ibexes.

OVERLEAF: San Simeon Point frames the bay at sunset. W. R. planted Monterey pine, Monterey cypress, and eucalyptus trees to cover what had formerly been a bare stretch of land.

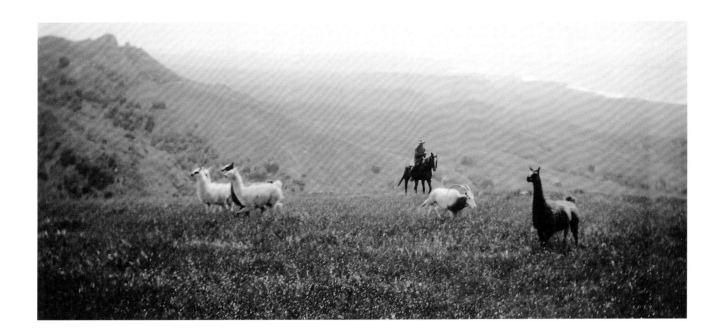

But the chauffeur refused to budge! He said Mr. Hearst would not like it if we did anything to frighten one of the animals.

So we sat—and after an hour's wait, the moose moved nonchalantly out of the way.[9]

Guests did not need to bring riding clothes to the ranch. The necessary outfits were available in all sizes, as the actor and director Ray Milland recalls:

Our rehearsals [for Marion Davies's 1931 film *Bachelor Father*] took place in Hearst's private theater, but they never lasted more than an hour each morning, so there was plenty of time for swimming, tennis, or riding. Most of my time was spent at the stables trying to master the restrictive Western saddle and trying not to castrate myself in the process. . . . We were told that if we needed riding clothes the housekeeper would outfit us completely. We were taken down to a room that looked like . . . Western Costume. Everything was there, and in all sizes. . . . And all of it immaculate. Mind boggling.[10]

Arthur Lake (who played Dagwood Bumstead in the *Blondie* films, based on the popular comic strip) and his wife, Patricia Lake, were frequent guests, since Pat was Marion Davies's niece. Pat was an experienced rider and enjoyed showing off:

Arthur: Jack Hearst [John Hearst, third of W. R. and Millicent's five sons] invited me there the first time, and I heard about this little gal from back East, Marion's niece, and she was a quick fourteen or fifteen. She was something. Everybody would come out in the jodhpurs and these sleek, slick riding boots, and this one would come out with the riding party. She had tennies on, an old sweat shirt, blue jeans, and no saddle. Half the time, she'd be bare back.

Pat: I rode a cow pony, like a pinto, and they all kind of hated me, because they were all very grand, and the brat would start the horses all running. I would start running and then the horses would try and race. You know how little brats, punk teenagers, are.[11]

Hearst was an accomplished horseman who apparently received secret
pleasure from outriding his younger guests, many of whom were
robust film stars, and some of whom had portrayed cowboys onscreen.

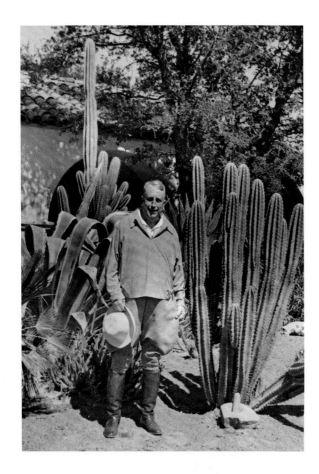

John Hearst Jr., who was nicknamed Bunky, lived on the hilltop with his grandfather from 1946 to 1947. Bunky observed Hearst's habits very closely:

> We used to take a long walk nearly every day. Helena, his dachshund, always came along. She and I would go on ahead, she sniffing everything and I just exploring. But when Grandpop thought we had gone too far he would put two fingers in his mouth and blow a whistle you could have heard clear to San Luis Obispo, forty-three miles away. It was the shrillest sound I have ever heard a human being make.[12]

Bunky rode a motor scooter down the hill to San Simeon's one-room schoolhouse each morning:

> My trip to school . . . [went] through Grandpop's wild animal enclosure. Usually the zebras and the bison kept grazing and paid no attention. Then Grandpop gave me a motor scooter, and a . . . water buffalo began to take an interest in me. Every morning when he saw me coming he would move a little closer and sniff the air. Finally one morning I saw him, head lowered, pawing the ground right in my path. He charged, and I took off cross-country—becoming, I suppose, the only eighth grader in the United States ever chased to school by an irritated water buffalo.[13]

The Castle had forty working fireplaces, nearly all of which were at least three hundred years old. Maurice McClure's first part-time job was hauling the wood upstairs to each one:

> Firewood was purchased from local ranches and farmers there, up in the hills above Cambria [six miles south of the Castle]. . . . So far as I know, little or none of [Hearst's trees] was ever used for firewood. Mr. Hearst did not want a tree cut down and burned.[14]

Harley Boisen worked in the dairy at the bottom of the hill from 1935 to 1937. Ranch employees were invited to watch films with Hearst, Marion, and their guests in the Castle's lavish movie theater, as he recalled:

> Every night there would be a [film] shown, and you never knew when. All we were asked to do was come in clean clothes. Don't come up with manure on your shoes, you know.[15]

Wilfred Lyon was twenty years old in 1934, when he was hired as a houseboy at the ranch. He didn't realize how well W. R. could ride a horse:

> The darn Depression in Cambria was just like anywhere else. It was hard hit, there weren't many jobs,

and the young fellows were getting out of school and not able to find anything to do. . . . I spent two years in the [ranch] commissary, down where the gardeners and the orchard men and the animal men all lived. But one Saturday I was called by Pancho Estrada. [He] was an old-timer. His family had a Spanish grant and Mr. Hearst's family had bought it.

Pancho said he needed some help to take three head of horses to Burnett where Mr. Hearst and a group were going to have a picnic along the creek. He said, "You'll ride one horse and lead one and I'll ride one and lead two." We had a brush-axe which was like a machete, a long wooden-handled one with a knife on the end, that we had to cut the trail out because the limbs would hit people in the face. We had about four gates to open and we cleared the way and got down to where the picnic was. The help, the waiters and all after they served the guests, would sit to the side and have their meal. It was the same food the guests were eating but you sat separately from the guests.

Well, when it was time to go back there were three people who were going to ride back to the Castle . . . Mr. Hearst, [Hearst newspaper reporter] Adela Rogers St. John, and . . . an Italian prizefighter by the name of Enzo Fermante. . . . Instead of taking the trail that Mr. Estrada and I cut out, Mr. Hearst decided to go way down toward the orchard and up the pergola . . . and come out at the eagle's cage . . . above the polar bear pits.

They always kept eight or ten head of horses down near the mold shop. . . . There was a barn down there . . . and I didn't know it at the time but they [usually] just threw the reins over the saddle horn and the horses would run on down. So when we got to the eagle's cage Mr. Hearst's horse was doing a lot of rearing round and acting awful nervous and I thought, "Well, he's going to have a problem here."

So I got off my horse. . . . and I grabbed Mr. Hearst's bridle thinking it would kind of quiet his horse down. That upset Mr. Hearst and he said, "Let him go! Let him go! He knows where he's going!" Here I thought I was being the hero, but it was very embarrassing for me. But anyway, it passed by and nothing more was said about it.[16]

Many former staff members recall the rules against picking flowers or fruit in the gardens. Construction worker Guido Minetti explained:

If you got caught picking any fruit up there it might have meant your job. But we always had fruit where we ate. . . . Nigel Keep, who was the head of the orchard . . . would bring it and put it in the kitchen where the people could get it. . . . There were 125 [working] on construction and about twenty-five to thirty [staff] at the Castle. If everyone went down and picked an orange, when he brought his guests, there would be no oranges, no fruit.[17]

From 1941 to 1942 a mercury mine was in operation on the ranch, in an attempt to find minerals to assist in the country's war effort. The Polar Star Mine was located near San Carpoforo Creek, northwest of the Castle. Jim and Marjorie Collard worked it under lease with the Combined Metals Company:

We hired a drilling company, and they drilled a number of holes to outline the ore body on the hillside. After these holes showed value . . . we built a road on the south side of the creek, all the way. In doing so, the . . . Hearst [Corporation] told us that we had to cover any tree that we knocked over. Cover it, so Mr. Hearst wouldn't see it. Because he didn't want anybody cutting trees on his ranch.[18]

SKETCH · FOR · GATE · AT · SAN · SIMEON

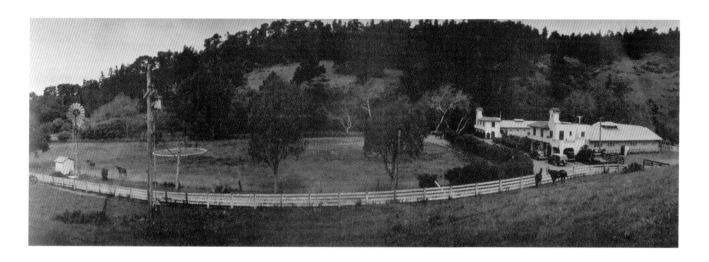

W. R. and Julia Morgan moved at least four fully grown, centuries-old native oak trees on the hilltop. The last oak tree was moved by a local contractor and builder, Alex Madonna:

> This tree [moving] thing came up and they couldn't get anyone to bid on it. So they wanted me to look at it. I'll never forget [it]. That tree had a box around it . . . a wooden box. They took it and jacked it up and had it so you could move it. I looked at the thing and I thought, well, I had a little tractor I'd just bought and it only weighed five and a half tons. And . . . I didn't realize this, but that tree in total probably weighed 100 to 200 tons. So I hooked onto it with this little tractor. I just sat there and spun my tracks and I couldn't even budge it. . . . I had a contract to move that tree for, I think, $400. . . . Everyone else passed it up. . . . So I decided, well I gotta do something and get that tree moved or I'm not going to make any money. So I went out and I got some pulleys . . . and some cable and I kind of made a cable thing by just going around each one of those pulleys and I could take my little tractor [and] move twenty feet. I probably moved the tree two or three inches [at a time]. I'd back up and take another bite and so inch by inch . . . in a couple of days, I got that tree moved. People couldn't believe it. Neither could I.[19]

Richard "Dick" Lynch was the manager of the San Simeon Stables (located south of San Simeon, near Pico Creek) from 1946 to 1952:

> We had mostly Arabians, but there were also Palominos, Appaloosa, Morgans, and Morabs (which were an Arabian and Morgan cross). . . . There were six or seven men working at the stables. Fred Ponder was the head stallion man, whose only responsibility was to take care of the stallions and the silver Mexican saddles. Just to go in the tack room was quite a show. People would come by just to see the Mexican saddles kept in immaculate condition. . . . They also grew 300 acres of feed hay for the horses.[20]

Charlie Parlet started work as a cowboy in 1921 and stayed for fifty-six years. He was equally skilled with cows and horses and he recalled every inch of the land:

> I was raised near the Hearst Ranch. I just came over the hill and asked for a job. I knew what to do because I was raised in it. What keeps a cowhand on is being

BELOW: A picturesque duplex residence Morgan designed for ranch employees in the late 1920s.

OVERLEAF: A breeding program has recently been developed to produce the cowboys' quarter horses, preserving the bloodline and legacy of the Hearst Ranch's working horses.

willing to do anything. I've had a good life, outdoors with horses and cattle. Never owned a pair of shoes. Spurs, boots, broad-brimmed hats and blue jeans, they're my work uniform. Been riding for seventy years. Ridden more miles on horseback than in a car. Four-wheel drive can't replace the horse in our country. Too rough. Too brushy. We must have horses to find, gather, and pen our cattle.

We handled about 5,000 head of cattle on the ranch. They had the same brand that we're using now: G with a hanging H. When I first came here we'd drive all our beef to San Luis Obispo, to a place we called Gold Tree.... We had a round-up every year and quite a few of the guests would come down and watch the branding and the boys ropin' the calves.[21]

Byron Hanchett worked on the hilltop as an electrician in the late 1940s. One of his responsibilities was setting up telephones:

Mr. Hearst often took his guests into the back country for a picnic.... He would call about a week ahead and tell us where he wanted a phone installed.... We spent two days installing it. We hung the phone under the shade of a tree, so the overhanging branches would protect it from the sun and weather....

There is a story told that on one picnic, while the guests were sitting in the shade, one of them commented, "I wonder how the Dodgers are doing today." Mr. Hearst got up and said "I'll go find out." He walked into a grove of trees to the phone and called one of his newspapers. He came back to his guests, gave them the score, the inning, and told them who had hit home runs. The guests wondered where he got his information out there. He loved to entertain and surprise his guests.[22]

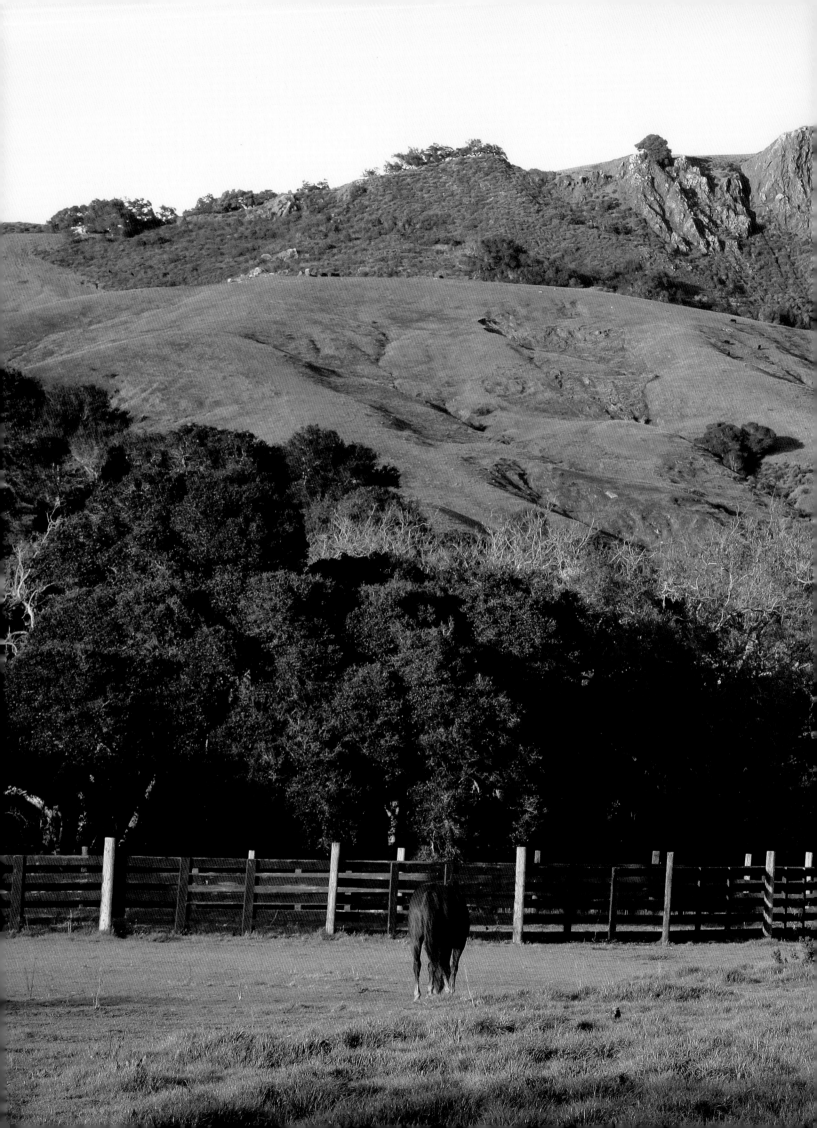

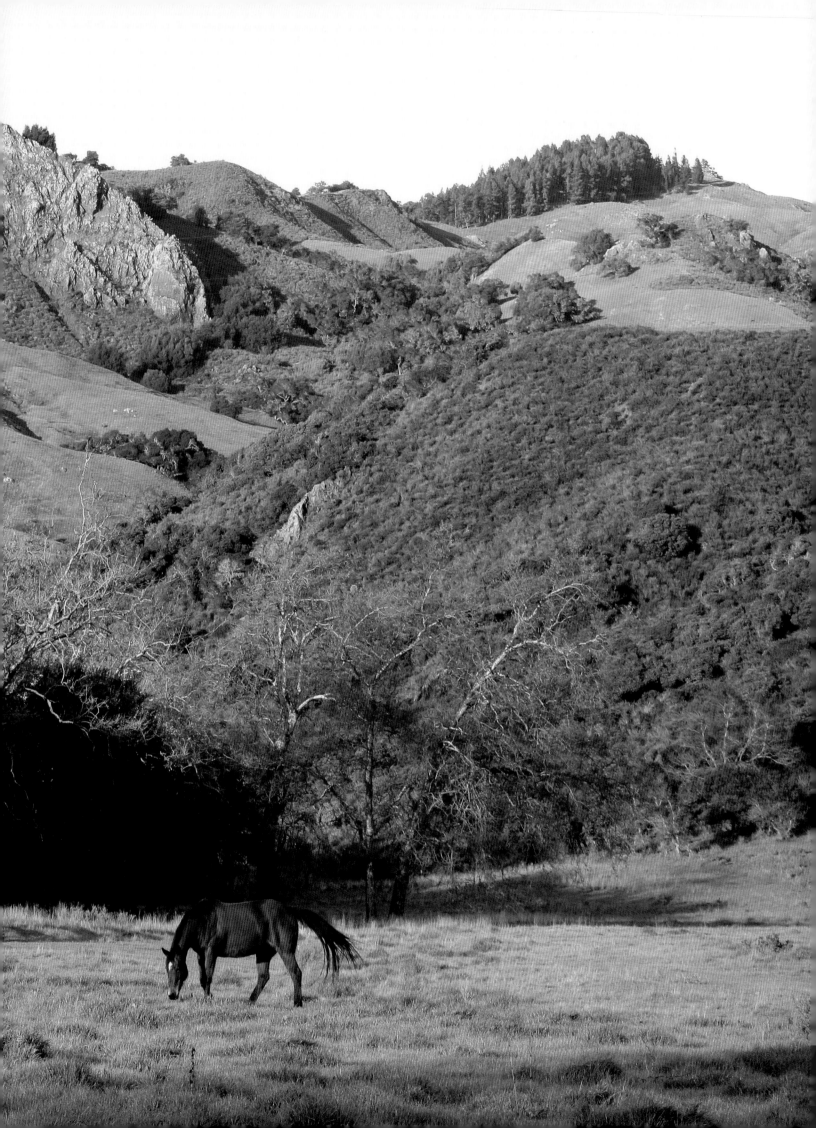

Carey Baldwin was hired as the zookeeper in 1926, soon after the lions arrived. He decided to go into the lion cages by himself, in spite of having no idea how to go about it:

> Although I know now that nothing will infuriate an animal quicker than to stare at him, [on my second day of work] I walked in [to the hilltop lion cages] with my shoulders back and glared brazenly at the two lions. The big cats were confused. . . . All they seemed to want to do was to keep out of my way. . . . I came out of the arena feeling very much a man.
>
> The trouble came the following day. . . . I was feeling quite competent. I had turned the lions out of their quarters,—or thought I had—but after climbing down off the roof, I discovered that Leo was in the arena, but the lioness was in her pen. . . . I knew I could go into the arena and open the shutter with the lion there, for had I not been with the cats the day before?
>
> I strolled up beside the sleeping lion and started to lift the shutter to the lioness pen. The noise woke Leo, and when he opened his eyes, the first thing he saw was me standing between him and his mate. He let out a horrible coughing bark and lunged—right in my face. It seemed slightly louder than the explosion of a double-barreled shotgun. . . . I dodged his first leap, warded him off with my stick on the second charge, and finally moved backward far enough and fast enough to get out of the gate. I've never forgotten how Leo looked when he came after me. He lost the confused expression of the day before. . . . His mane and scalp appeared to slip back, which made him look terribly long and slim. His big yellow eyes bulged in a dreadful way. . . . I learned three things that morning at the Hearst Zoo, mostly about lions. One was, awaken a lion gently. Another was, a small stick may ward off a charging lion. And the third and most important thing was, it's a good idea not to go in with the lions.[23]

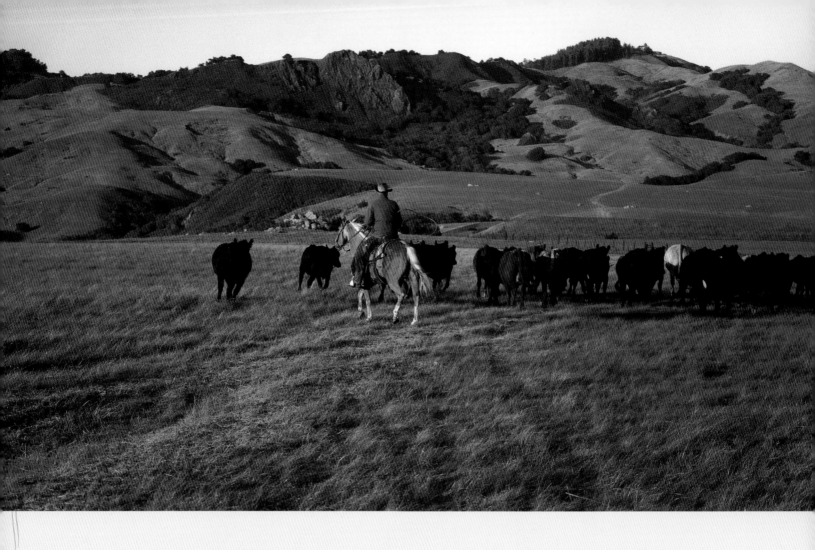

A COWBOY'S LIFE AT THE RANCH

C̶H H̀

Charlie Parlet was a cowboy on the Hearst Ranch from 1921 to 1977, an astonishing fifty-six years, beginning when he was nineteen:

> When I first came here, we had breakfast at 5:30 and supper at 6:00. After breakfast, you'd saddle your horses and go to work. We'd drive all our beef to San Luis Obispo, [to] a place they called Gold Tree [to load them onto trains]. Ranch hands used to get $60 a month and food; that was room and board. It was a little bit more than [at] most ranches. An average meal was usually beef, beans, and potatoes. After work, we usually played poker. We'd go into [the bars in] Cambria every Saturday night. It was all pretty good for us at the ranch. We didn't really realize there was a Depression.

This was really a peaceful place until they gave the state the Castle, then everything changed overnight. [Millions come to see it] and I guess that's what Hearst built it for, really.[1]

From 1976 to 1999, Harlan Brown was the ranch manager, during which time it underwent many improvements. Harlan completely restored the old dairy barn, transforming it into a public events venue without altering its character as one of Julia Morgan's original ranch buildings. Charitable events held in this room have currently raised more than $45 million:

It's not really a job out here; it's a way of life. It's something you've got to love. You've got to love the land and the animals. You're not doing the same thing all the time. Sometimes you're branding cattle or fixing fences, and other times you're clearing roads or fixing water pipelines.[2]

Ranch cowboys can be tough characters. William Randolph Hearst's great-grandson Steve, the current vice president of the Hearst Corporation's Western Land Division, recalled Jake Villa, another cowboy who spent decades on the ranch:

I used to call him "Billy Goat Gruff," because that's exactly how he was. Someone would say to him, "Steve's on the phone." And he would walk over, just pick up the phone, and hang it up! And I would have something important to say! But that's okay—he was a fabulous character, and I loved him.

We gave Jake a new truck once, and we bumped his truck down to be used on the Ranch. So I saw Jake two weeks later and I said, "Jake, your truck already has a big dent in the door!" Jake said, "Hey, sometimes things just get in my way." And I said, "Is there any way that I can convince you to be a little easier on the equip-

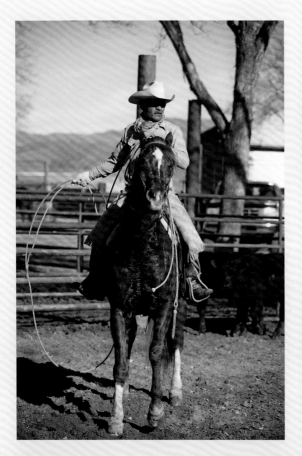

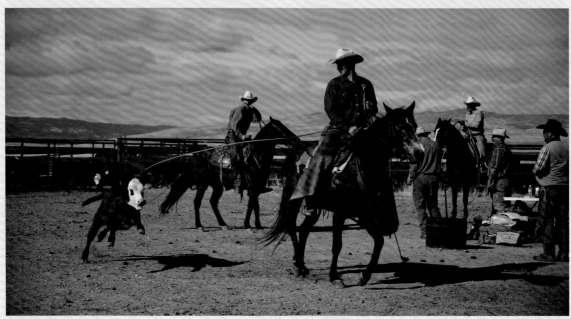

OPPOSITE, TOP LEFT: Good roping skills are vital. If cattle stray on the trail, a cowboy must be able to rope them and return them to the herd.

OPPOSITE, TOP RIGHT: The cowboys also walk among the cattle, to accustom them to human contact.

OPPOSITE, BOTTOM: At the Piedra Blanca Rancho, branding has been done the same way for the last 150 years.

TOP: Both cowboys and cowgirls work on the Hearst Ranch.

BOTTOM: The cowboy life is often a solitary one.

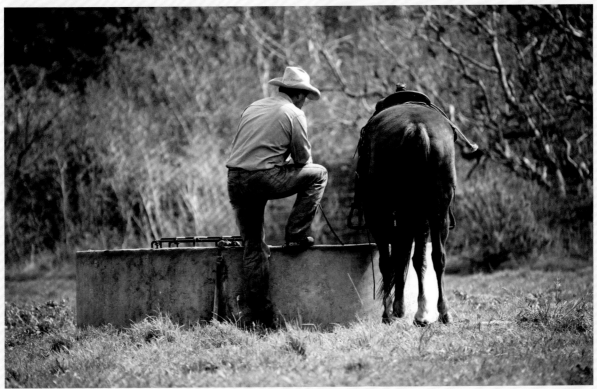

ment?" And he said, "Well, I'll give that a shot. But I'm going to give you some personal advice. I'm going to be coming back by here in about ten minutes. If I were you, I'd stand clear!" And I just backed away from the road. Nobody gave Jake any backtalk around here.[3]

Steve also remembered a cowboy named Buster Speer, who favored a local saloon:

Buster Speer was small—five foot three, 120 pounds, so small he had to run around the shower to get wet. He said, "You know, we used to start early at the ranch, around 6:30 a.m. and that meant we'd get off around 3:00. And we used to run down to this little bar [nearby, named] Camozzi's. The floor was all bumpy and slanted down towards the bar. By god, you could get to it, but you couldn't get away from it!"[4]

Longtime cowboy Carl Negranti worked for Charlie Parlet when he was the ranch manager. Carl learned how to second-guess Charlie:

I got used to workin' with Charlie. There's always tricks to the game. Parlet would tell the cowboys, catch your horse. We're going to do some work today. And the guys would get their horses all saddled and this and that, but I wouldn't saddle mine. I'd wait till Parlet caught his—and I could tell what we'd be doing by the horse he caught. If we were going on a rough deal, he'd ride a different horse. I'd wait till he picked his horse, then I picked the horse I could do the best good on. And all the other guys were stuck with theirs.[5]

Buster Speer's son, Flint, still works for the Hearst Ranch, as he has for most of his life:

In the early sixties, I went into the back country with my dad, and Jake Villa, and Charlie Willoughby, and

a bunch more cowboys. We were holding up some gentle cows and the other guys would bring in some of the cows that weren't so gentle, and the gentle ones would kind of slow them up. Then we'd take them to a holding pen.

We got some that weren't slowing down very good. There were seven of us in a circle around those cows. And old Jake says to me, "Okay now, take it easy, Flint. Just take it easy." So I'm standing there thinking, "Well, you know, I can't let them sons-of-bitches get by me!"

We started down the hill, and we've got these cows surrounded. And I had one that comes over to where I'm standing. I was in the seventh grade, and I guess I made too much noise. That son-of-a-bitch didn't get by me—but it did go right through about three of them other guys.

Nobody yelled at me or said anything about it. But I still remember how I felt.[6]

The current ranch manager, Cliff Garrison, has worked on the ranch for more than two decades. He is a dedicated horseman, and is also devoted to his dogs: "Every cowboy has his own dogs, raises and trains his own dogs. A dog can go places a horse can't, and a dog is usually the first one to reach the cattle, not the cowboy on his horse." Cliff's dogs are all border collies, though other cowboys also use McNabs and Kelpies. Cliff explained: "They have natural herding tendencies. You have to train them with commands so you can control them. It's kind of like flying a remote model airplane. It'll fly, but you have to make it do what you want it to do. You need to have a good set of cows that are dog-broke and respect the dogs. Cow dogs fit well with the low-stress environment we promote with our cattle. It's not just the cowboy. It also comes down to the dogs and how they respect the cattle, and vice versa. We would need a lot more cowboys if we didn't have good dogs."

A YEAR AT THE HEARST RANCH

In the winter, the bulls are turned out with the cows for breeding. In the summer, they are pregnancy-tested. In the fall, the calves conceived the previous winter are born.

The next winter, the young calves are rounded up, processed with vaccinations, and branded to provide permanent identification. They are also given a RFID (radio frequency identification) tag and a color-coded number tag, which makes it easier to identify a specific animal from a distance in a field. While the calves are separated from their mothers, the cowboys make a point of imprinting the calves to humans by walking slowly through the herd.

After branding, the calves are immediately reunited with their mothers. From then on, they are moved throughout the ranch in a low-stress method of pasture rotation. They graze on the inland pastures first, allowing the coastal pastures time to store up forage for summer and fall.

The calves are weaned in the summer, at an age when they wean themselves naturally. Calves and cows are separated by a wire fence, so they can still smell and see each other. Again the cowboys walk through the calves to accustom them to people.

Once weaned, the steers and heifers are pastured together on the land with the strongest feed, which has been reserved for use in the post-weaning stage.

Late-fall rains and some residual dry matter are the key to getting green grass early in the rainy season (the time when conventionally raised cattle are taken to the feedlot for corn feeding). When the cattle reach 1,080-1,200 pounds, at approximately eighteen months, they are taken to harvest in a facility that is certified as following humane animal protocols. The Hearst Ranch's grass-fed and grass-finished beef operation still follows the methods that have been used on this family ranch for most of the last 150 years.

The ranch will always need cowboys, as current ranch manager Cliff Garrison explains:

I love cowboyin'. I will do anything to preserve the lifestyle we cherish and raise our families in. The cowboy is an icon, a true American creation. There's not a whole lot of big ranches like this where cowboys still get to be cowboys, and learn the skills to do the job well. It's not for wannabe cowboys. It's for guys that are darn sure cowboys and have maybe some DNA in their blood to do this kind of work. It's still a big important job to be a cowboy out here, because cattle don't see a man too often in this big rugged country, and they can turn wild on you pretty easy if you don't treat them right.[8]

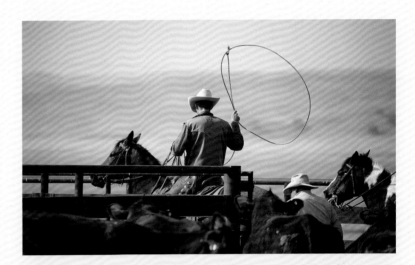

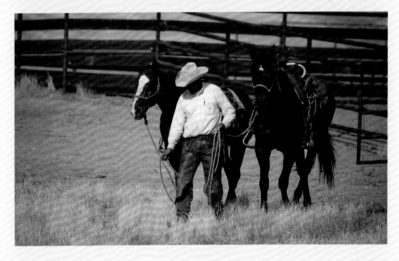

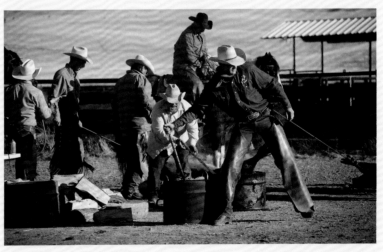

TOP: Cowboys need to be versatile enough to work alone for long periods, and also to work closely with a team when necessary.

BOTTOM: Even when cowboys gallop through the creek beds, their cow dogs are not far behind.

OPPOSITE: Hearst Ranch cowboys are not armchair or weekend cowboys—they are the genuine article, carrying on an iconic tradition that was born in the American West.

OVERLEAF: Hearst Ranch cowboys know every detail of this land, on which they ride from dawn to dusk, through all the passing seasons of the year.

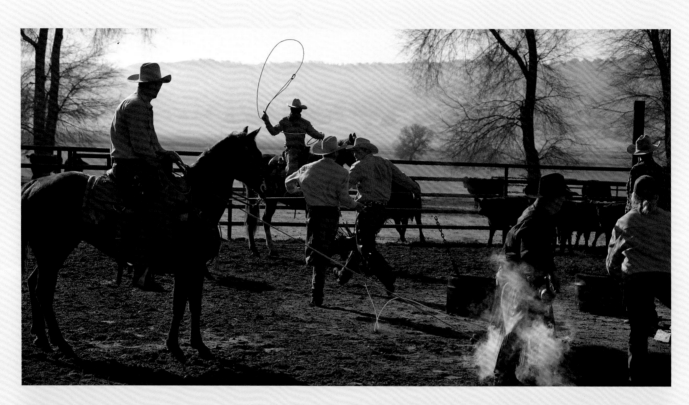

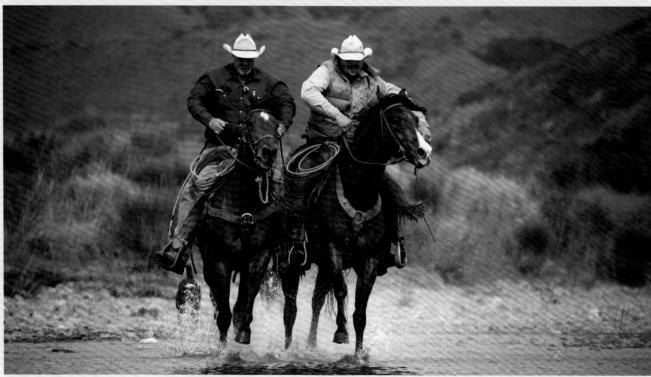

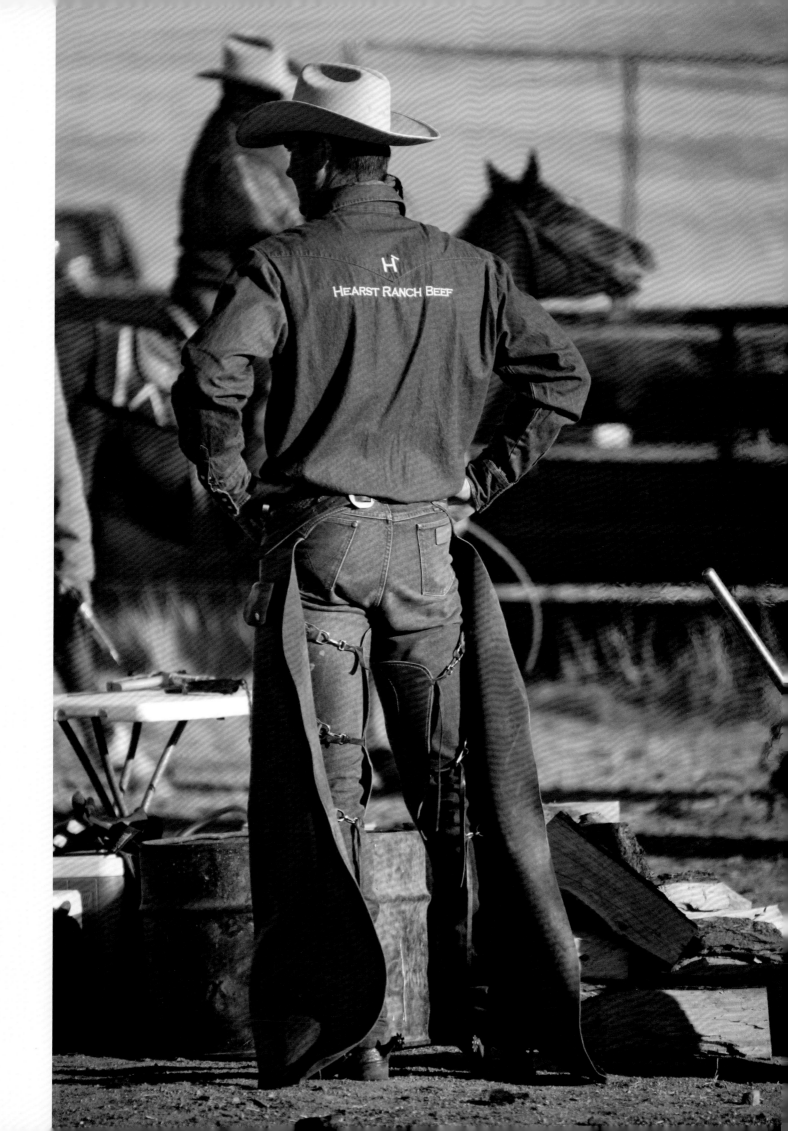

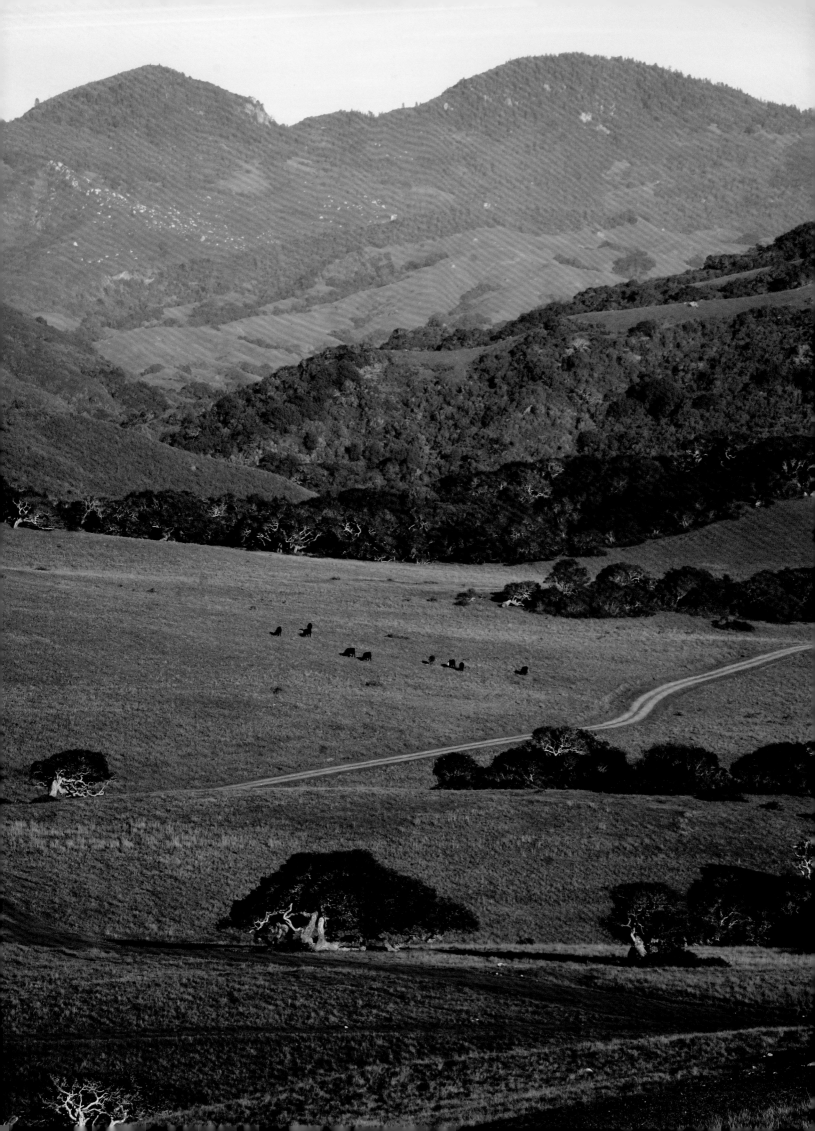

8
ENTER GEORGE LOORZ

hen Julia Morgan recommended George Loorz to replace Camille Rossi as construction superintendent in 1932, she chose someone whose sunny personality was Rossi's direct opposite, but who equaled him in efficiency and skill. Loorz was a beloved and inspiring figure to both his employees at the Hearst Ranch and his neighbors in San Simeon. One of the hilltop gatekeepers, Ray Swartley, wrote: "George Loorz's success as a leader of men lies in his perennial cheerfulness and kind disposition; in his humility and his charity; in his generous appreciation of others; and in his modest opinion of himself. . . . He studies hard, thinks quietly, talks gently, and acts frankly."[1]

Loorz was a tireless correspondent who saved all his files, resulting in the most detailed construction record in San Simeon's history. Soon after his arrival, Loorz told hilltop plumber James Rankin that Hearst had already asked him to build a bridge across the ravine; extend the Burnett Road into the backcountry; construct partitions in the animal pens; pave the bear grotto, dog kennels, and birdhouses; and transport several full-grown cypresses and palm trees to the Castle gardens. These tasks were in addition to his hilltop responsibilities, which included completing several bedroom suites in the Castle, overseeing the mounting of thirty-six carillon bells in its twin towers, and constructing two lavish swimming pools. Loorz concluded: "All I need is money and I'll have plenty to do."[2]

All this activity was even more challenging because Morgan was absent for several months. Hearst noticed that she wasn't feeling well, and queried Loorz worriedly about it in the summer of 1932. Morgan had been plagued with ear infections since childhood, and underwent an operation to correct the problem. At first she seemed to be healing well,

In 1932, Hearst fired his longtime construction superintendent, Camille Rossi, whose contentiousness had frustrated Morgan for years. She picked his replacement, George Loorz, whose cheerfulness and skill endeared him to everyone. Loorz constructed several ranch buildings, as well as dams, bridges, and miles of backcountry roads.

and asked Hearst to arrange a plane flight for her to the ranch, writing: "It will be mighty good to see San Simeon again."[3] Hearst responded: "I think if you drank a bottle of English or rather Irish stout every day it would do you a lot of good. You eat so little, the porter would give you strength."[4]

Hearst was sincerely concerned about Morgan's health, but also eager to move ahead on projects without her assistance. Loorz was steadfast, however, writing Morgan that he was afraid Hearst was getting irritated, because "I do not do what he requests immediately and say 'Yes' like a parrot. I do it for your sake and for the good of the job for he really asks for more things done than we could do with double the crew. If I kept jumping from job to job as fast as he requested, just to make an impression, I would never get anything finished, and he repeatedly remarks that he likes to get things finished. . . . You see I need either your moral support or advice."[5] Morgan replied: "I am not worrying and thank you very much for that."[6]

Morgan continued to work while she convalesced, drawing up plans for the elephant house, enclosure, and pond to be built near the animal pens east of the Castle. She wrote Loorz: "I will have a scale drawing of doors [and] pool . . . in Monday's mail—as I did not want to risk ordering [it built] without [Hearst's] approval, he cares so much." Only after settling those details did Morgan tell Loorz about her serious health problems: "I had to go back to the hospital for a second siege of the nature of the 1st only deeper in. If it had to happen, it's as convenient as at any time. The 1st one was a chance anyway, & this is another. You are a great comfort, George, for I know you will keep the needed balance."[7]

In an attempt to heal an infection that resulted from the first operation, Morgan's surgeon removed her entire inner ear in a second procedure. He also accidentally severed a facial muscle. Both procedures caused devastating damage: her equilibrium was gone, causing her to frequently stagger and fall; furthermore, her face was deformed into a twisted smile that took years to dissipate.

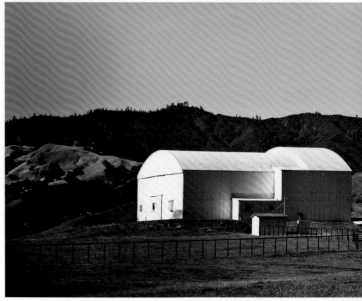

Morgan's nephew recalled: "The doctor never sent her a bill and she realized that in some respects he was more hurt than she was. . . . She used to send a present to him every Christmastime."[8]

Loorz did indeed keep "the needed balance" as Morgan healed, reporting to her later that year that Hearst was in a splendid humor. He continued: "I cannot but lament because of the little real help I can give you there where you need it most. I hope it is just a little comforting to you to know of the deep personal regard we (The Loorz's) have for you. . . . The kiddies have been inquisitive about your whereabouts and have wondered if you have returned to the hospital. How those little aeroplanes have flown straight to their little bosoms."[9]

Morgan was back on the job by April 1933, when Hearst's economic shortages were becoming more frequent. Furthermore, Wyntoon—the grand Bavarian castle Bernard Maybeck had constructed for Phoebe—burned completely in 1930, providing insurance money and a new project to draw away both Hearst and Morgan's attentions. Loorz knew that Morgan (who paid all San Simeon's bills

from an allowance Hearst provided) had been running so short that she had not paid herself in quite a while. He wrote her that he hoped she could begin working on the Wyntoon drawings (and presumably be paid by the fire insurance funds) so "you can at least collect for some of the efforts you are extending. This may sound monetary and cold blooded, but there are hundreds of us who do receive compensation for our efforts, so why shouldn't you?"[10]

In spite of the money shortages, Loorz was still enthusiastic about his job, writing: "This is what I sleep, eat, and write. I like it. . . . Think of me here now building a road, a dam, an airport, a building, and moving a tremendously large oak tree with all its roots."[11] Loorz admitted that the continuous responsibility of his position was "a good deal like being in the army, on duty from 'now till then,' off only when you take time off and [still] wonder what will happen while you're gone that will give you trouble when you return," but he was proud of the confidence both Hearst and Morgan had in him, saying they were "splendid to work for."[12] Loorz wrote: "[Though most] of the crew likes it better when he is away for they can swim

in his pools, ride some of his horses. . . . I like it better while he is here, for everybody seems to take his business more seriously."[13]

One of Loorz's most complicated jobs was building the Burnett Road. This grading project had been undertaken by outside contractors in 1928, and by 1932 a dirt road stretched eight miles from the hilltop to the Burnett cabin. There was still much for Loorz to do, however. He wrote his business partner, Fred Stolte: "Wish I had time to tell you about my hike over thru the mountains to Jolon the other ranch . . . and my visit to the ruins of the old San Antonio Mission. . . . I enjoyed it immensely although the purpose of the trip was to locate a new road course."[14] The work proceeded slowly, as it involved not only grading, but building bridges, a dam, and a fish ladder for the steelhead trout. Hearst was eager to drive all the way to Jolon, but they were far from ready for this, as Loorz ruefully told his colleague Warren "Mac" McClure in 1933:

> Spent a most uncomfortable Saturday afternoon accompanying the party on a picnic to the end of the new road and thence over a very rough trail on horse-back to the Nacimiento River. They complained so much about the rough road (quite unfinished) and the hazardous, steep, rough, narrow trail, that I felt sick when we reached the other side. Did Marion kid W. R. about his fine trail. You might know that she was persuaded to take the trip after long and lengthy teasing and coaxing by Mr. Hearst.[15]

The road was completed in 1934, and included a wooden trussed bridge one hundred feet long that spanned the Nacimiento River. Loorz proudly wrote Stolte: "I just wanted to tell you that it would be a lot closer for you to come down by way of our new road thru to Jolon. It is rough and very dusty and will be until the first rain when we can grade it properly. However, it is an interesting ride. . . . It saves 80 miles but not a lot of time as it is a slow road."[16]

After 1934, Hearst usually drove guests to the Milpitas Hacienda and flew them back. There was a 3,000-foot-long, 100-yard-wide airstrip at the ranch as early as 1926, which was expanded into a combination polo field and landing strip the following year. Hearst wrote: "I think the polo and flying fields should be as convenient to the hill as possible. . . . They must be on the flat lands below the hill, but I think along side the road to the town of San Simeon."[17] A landing strip had been graded at Jolon by 1930, and Loorz wrote Morgan that Hearst wanted to build a large airplane hangar at San Simeon: "After a flight to Jolon and back yesterday, [Mr. Hearst] became an aviation enthusiast."[18] In fact, Hearst owned several airplanes in the late 1920s, including three Vultee V-1As, a Ford Trimotor, and a Stinson.[19]

Morgan also enjoyed flying, particularly because it provided the opportunity to see San Simeon from the air. She told Hearst about a flight she took with his oldest son, George, as her pilot: "After getting that long coveted airplane picture first hand around the hilltop, [we] landed in your San Simeon airport *just 23 minutes* later. It seems incredible! The plane passed directly over the Red Butte, and circled over the new chicken layout which looked very neat and trim. After putting in an intensive afternoon on the Hill, the taxi dropped me at the San Francisco field at 8:15 p.m. It made a full day—I am not quite sure as to the wisdom of repeating it—but it was well worth while this once."[20]

Loorz made improvements to San Simeon's landing strip, which they knew was inadequate. Morgan asked him to move a row of power poles further away, writing: "I've gritted my teeth several times thinking we would crash through the fence."[21] He also constructed a large hangar and installed lights, reporting: "W. R. lands after dark every time he comes now, so none of the lighting expense was in vain. They came up last week for a couple of days, landing at 8 p.m. with one plane and Joe [Willicombe, Hearst's personal secretary] and Julia [arriving] at 9 p.m. in the small four-place job. Both planes fit nicely in the hangar and everyone concerned seemed very well pleased."[22]

TOP: Hearst Castle from the air, mid-1930s. The kennel area, large cat cages (tigers, jaquars, etc.), and stables are visible at far right.

BOTTOM: George Hearst purchased land at San Simeon in 1865 because he was convinced the railroad would soon be built along the coast. This did not occur, nor was any road built as a throughway for automobiles. It remained impossible to travel from San Simeon to Monterey by land until 1937, the year Highway 1 officially opened.

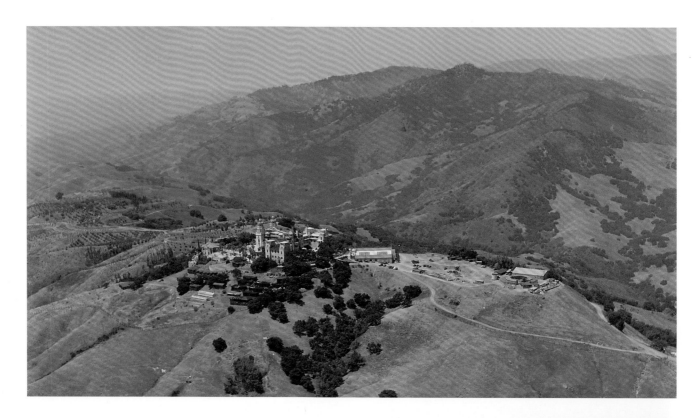

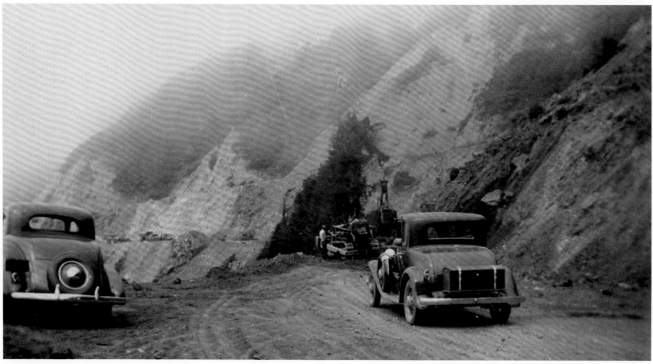

Another efficient means of reaching San Simeon
was nearing completion at this time. Highway 1, which
connected San Simeon to Monterey, officially opened in
June 1937. Its eighty-five miles of coastal roads—much
of it carved out of solid rock hundreds of feet above the
ocean—and its thirty-nine bridges took years to complete;
it had been under construction since 1922. Hearst wrote
Morgan in 1931:"The Coast Highway people are going to
put a bridge over the Arroyo del Puerto and they are going
to build it and pay for it; but they thought we might want
to design something which would be in keeping with the
character of our little Spanish village. If you do anything,
it should be simple, of course, but something that would
harmonize."[23]

The highway brought commerce and progress to San
Simeon. Sebastian's store was built on San Simeon Point in
1852, moving into town in 1878, when George Hearst com-
pleted his wharf and warehouse across the street. Manuel
Sebastian bought it in 1914, and it remained a place that,
according to Loorz, "has 1 copy of everything from a can
of corn to a Blue-Jay corn plaster. That is, everything but
what you want."[24] Loorz wrote: "Tomorrow the coast high-
way opens up and a good crowd is expected. They have
asked Randy [Apperson, Hearst's first cousin and the ranch
manager] to be there at the opening ceremony and he
has asked me to come along with him. . . . The Sebastians
have been rushing a lot of things including new refriger-
ating units together so they will be properly stocked for
the anticipated crowd. I think it will help their business a
lot. . . ."[25] San Simeon was owned in its entirety by Hearst,
save for the two small lots devoted to Sebastian's store.
Manuel Sebastian's granddaughter, Nora Monson, recalled,
"My grandfather, when he was older, would sit on a bench in
front of the store. Tourists driving by would stop to ask him,
'Who owns all the land around here?' My grandfather just
loved to reply, 'Will and I! We own all the land around here!'"[26]

In those days a dozen wooden houses and a community
hall augmented the attractive employee residences. Loorz,

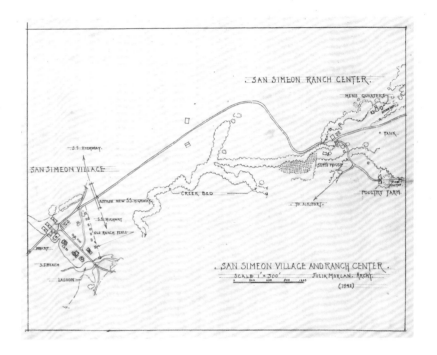

his wife Grace, and their three sons lived in the middle
stucco house on the shoreline. Their three boys attended
the one-room Pacific School, where nearly all the students
were children of ranch employees. Loorz was at the center
of activities in the town, serving on the school board and as
an informal adviser in many matters. He and Grace hosted
frequent cheerful dinner parties for the hilltop workers in
their dining room, which Loorz described as "more of the
same old thing, you know, wine and song."[27]

The ranch project most important to Loorz was the
men's bunkhouse across from the old ranch house. Hearst
had planned to replace the old bunkhouse for years, finally
saying to Loorz: "I want the men to have their house. We
have so much house here that we can wait."[28] It was to be
built in an "Old California style," with twenty rooms for
the men, a separate bathhouse, a dining room and living
room, and recreation rooms, as well as a spacious open
courtyard.[29]

Loorz was excited by the prospect, writing: "It looks
dandy to me. So does the cost. . . . Just to show my clever-

ness I'll sketch below what I remember of it as I glanced at it for a minute or two yesterday when Mr. Hearst and Miss Morgan had been mulling over it."[30]

Loorz was delighted with the bunkhouse, writing to a friend: "Even the poor slaves (help) at the Ranch are going to get a really nice Spanish Bunkhouse with individual rooms and steam heat."[31] Morgan wanted to be sure that it blended with the other buildings, telling Loorz she wanted it to look like the Mission Revival–style warehouse in San Simeon. In fact, with its square towers and narrow wooden balconies, it more resembles the Monterey Revival style. She offered to come to the ranch to consult with Loorz, saying: "It will be my fault if the result is not attained—& [it] is a very Prominent Building! Which one does not naturally think it, & difficult."[32] Loorz was justly proud of this practical and yet very ornamental structure, which still dominates the ranch buildings: "It is real nice looking and I am proud to have had so much to do with it. In other words . . . there is more of me in this house than in the big one on the hill."[33]

By the time the bunkhouse was under construction, Hearst's indebtedness was severe. Loorz had experienced building shutdowns every year since 1932, but this was different. He wrote: "[Mr. Hearst has] become more confident and personal in all our conversations. He would josh with me and occasionally go so far as to laugh and tap me on the shoulder. . . . However, Mr. Hearst and money seem to have parted company. . . . The fact is that the construction on the hilltop will shut down entirely for the first time. . . . He said it was possible that we would start up again in three months but Miss Morgan says no—not this year again. . . . The household is reduced to nearly half. The garden department is cut to half. The orchard crew is trimmed. Two watchmen are laid off. . . . [I am] deeply grieved for such men as Gyorgy [a decorative painter], Frandolich [a stonecutter], etc."[34]

The bunkhouse was the final project completed before the shutdown. Hearst requested that Loorz take his

best men and finish its construction in the most economical way possible. At seventy-four years of age, Hearst was an astonishing $87 million in debt in 1937. His creditors began to take control of his finances. Loorz wrote: "From Randy [Apperson] I learned that Mr. Hearst is a pathetic, broken man. . . . Apparently his creditors are quite anxious to hurt him if they can. Further a government tax investigation seems eminently possible."[35] Loorz moved his family to Pacific Grove, a small community south of Monterey, where he continued to run his construction firm. He was still technically working for Hearst and Morgan, but there was nothing to do. In San Simeon, many of the locals were also out of a job. In New York, the liquidations began. Much of Hearst's enormous art collection was put up for sale in the incongruous setting of Gimbel's department store. At San Simeon, most of the exotic animals were sent to other zoos in California, though many grazing animals (including zebras and Barbary sheep) remained. Their descendants still graze the hills today. Hearst also sold several of his finest Arabian horses.[36] And in December 1940, Hearst

TOP: San Simeon was owned entirely by W. R., except for two lots where Sebastian's store was located. Manuel Sebastian's granddaughter recalled his delight when tourists driving up the highway would ask him who owned all this land. He would reply, "Will and I! We own all the land around here!"

BOTTOM: The Roosevelt Highway, as Highway 1 was known, ran through the ranch and brought the world to San Simeon. Hearst's ranch and hilltop buildings were suddenly visible to every passing motorist.

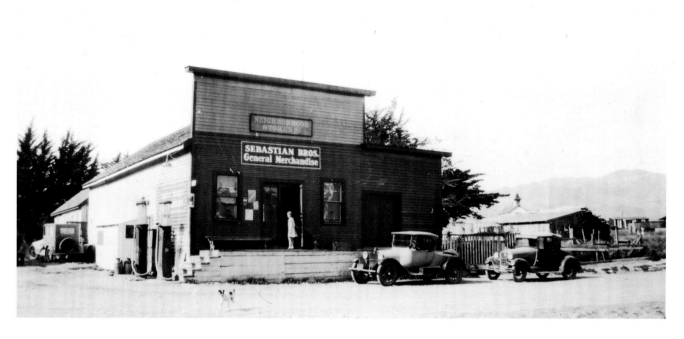

BELOW: Loorz oversaw every aspect of the bunkhouse's construction, writing, "I am proud to have had so much to do with it. . . . There is more of me in this house than in the big one on the hill."

OPPOSITE: Morgan designed the bunkhouse in a Monterey Revival style, characterized by its wooden balconies and horizontal lines. She wrote Loorz: "It will be my fault if the result is not attained—[it] is a very prominent building! Which one does not think it, & difficult."

ELEVATION TOWARD ROAD
SCALE 1/8" = 1'-0"

In the late 1930s, Hearst was $87 million in debt, a staggering sum that required considerable liquidations. In December 1940, he sold nearly 154,000 acres of his northern Milpitas ranch to the United States Army, which built a training base on the site. The hacienda became the Fort Hunter Liggett Officers' Club, which it remains today.

sold the Milpitas Hacienda and 153,865 acres of the northern ranch to the United States government, which built an army base, Fort Hunter Liggett Military Reservation, on the site.

Liquidating much of what he had built took a tremendous toll on Hearst. He also felt betrayed by his closest advisers, who stepped in and took financial control of his empire in 1937. Marion Davies said: "W. R. was going to be sold down the river by the people he had placed his great faith in. He always misjudged people. They were trying to get the control, but he didn't know it until it happened, and he was shocked. He was a broken man. He couldn't believe that the people he had practically made would ever do a lousy trick like that to him."[37] During this time of loss and uncertainty, San Simeon experienced its worst tragedy: a fatal plane crash on February 24, 1938. Arriving guests Lord and Lady Plunket and Hearst's substitute pilot, Tex Phillips, all died, and the remaining passenger, bobsled champion James Lawrence, was severely injured. They had arrived late, when the fog was moving in, obscuring the airstrip. Phillips tried unsuccessfully to land, then pulled up too quickly, and the plane burst into flames on the runway. It was a tremendous shock. Both Hearst and Marion grieved deeply. Hearst chauffeur Jud Smelser wrote to Loorz:

M. D. [Marion Davies] fainted in the picture show last night, or passed out, I'm not sure which. She has really taken the crack up of the plane quite severely and has been in semi-hysterics on and off but then all of the Douras family are good at dramatics but I really feel she is genuinely upset and hasn't the ability to control her emotions as we of the sturdy pioneer stock can do. It is rumored that W. R. plans to fly south for the funeral of the Plunkets and it is also rumored that he has grounded the rest of the planes for some time but I won't be able to verify these rumors until Monday when I go after the mail and can talk it over with Pete Sebastian.[38]

Throughout this challenging time, Hearst continued to visit San Simeon and plan more construction, although there were no funds to pay for it. Loorz wrote Morgan:

I just returned this noon from two days on the Hilltop. I went down in answer to a request from Mr. Hearst thru Mr. Keep. He wanted me to run a survey of China Hill [the hill just north of the Castle, where they had planned to erect a Chinese-style zoo that was never built] and lay out a narrow Pergola Pathway around the hill. It is too far for him to walk to the present one and walking on China Hill now is nearly impossible. He always walks around the hill now on the road which is both dangerous and not too pleasant. I'm certain it was just another air castle but enjoyed the two days in the sunshine.[39]

Even before the United States entered the war in 1941, Hearst left San Simeon—in part due to his continuing financial challenges, and in part due to the growing danger of Japanese invasion from the coastline. Early in 1940, the hilltop timekeeper Ray Van Gorden wrote Loorz: "Mr. Hearst sort of made a cleaning up to Camp, they say. [He] let Mr. Williams [the warehouse manager] and all his force go but [kept] Nick Yost and Marks [Yost worked as a warehouseman and Marks Eubanks was the electrician]. He figures on staying in Santa Monica, where he now is."[40]

Morgan filled this hiatus in her work by departing on a freighter trip through southern Europe in the fall of 1938 that lasted through the spring of 1939. She kept a travel diary in which she often compared European features she admired to San Simeon's—and the latter generally won the contest, in her opinion. While she seemed to enjoy the trip, her family called it a stopgap, saying, "She only traveled when she couldn't build."[41]

Morgan occasionally returned to San Simeon. Loorz wrote her in the spring of 1940 that he was sorry her illness had prevented a visit, as they had planned to drive her into

BELOW: In 1936, Don Pancho Estrada died. Pancho had known W. R. from boyhood and represented a living link with old California. Here Don Pancho is surrounded by his family circa 1934. Back row from left: Mary Estrada, Pancho with his cat Gatito, Tom Lynch, and Pancho and Mary's daughters Mabel Summers and Julia Lee. Front row: granddaughters Frances and Mary, with Cindy the dog.

OPPOSITE: An empty window seat in Don Pancho's spacious home, which was designed by Julia Morgan. Hearst was very involved in its construction, and asked Morgan to increase its size and add a dining room.

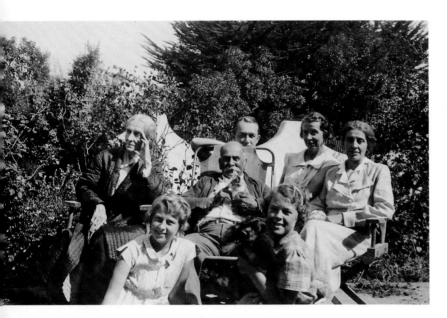

the backcountry to see the wildflowers. He continued: "I know also Miss Morgan that you come down here for relaxation and that dinners and such interrupt that restfulness you get otherwise. . . . We want you only when it will really be enjoyable to you."[42]

Though the story of William Randolph Hearst and his ranch at San Simeon does not end here, these were certainly years of great hardship. Orson Welles's *Citizen Kane* came out in 1941, when Hearst was already at his nadir. It painted a very unflattering portrait of him as a greedy and arrogant press lord, and though the film was fictional, the public largely accepted it as fact. Charles Foster Kane's second wife was a boozy, talentless opera singer, for whom he bought a career. The public assumed this was a thinly veiled portrait of Marion Davies, who did indeed have a drinking problem, but was nothing like the film's shrewish Susan Alexander Kane. San Simeon, too, was no dark and brooding Xanadu, but Welles's celluloid images endured for many decades.

One of the earliest losses of this period was one of Hearst's hardest: Don Pancho Estrada died in 1936. Hearst lost not only the employee who had worked for his family for nearly sixty years but also the man who had been his close friend since childhood. Charlie Parlet was a laconic cowboy who knew Pancho well. Parlet was second only to Pancho in his number of years at the ranch, and he described Pancho with the most important attribute first: "A fine horseman, and a fine man."[43] When actor William S. Hart sent Hearst his condolences, he replied: "Thank you for your thoughtful telegram. It is a great grief to lose Pancho, whom I have known since early childhood. It makes us realize that the journey is nearing its end. But I guess by the time we get there, Pancho will have the campfires burning and be ready to welcome us, as always."[44]

9
LAST DAYS AT THE RANCH

I n 1937, when Hearst halted construction completely at San Simeon, things were even worse than George Loorz realized. Four years before, in order to finance his expanding projects amid mounting debts, Hearst had mortgaged San Simeon to his chief competitor, Harry Chandler, the publisher of the *Los Angeles Times*. Chandler agreed to extend the mortgage, but Hearst was in the horrible position of potentially losing his beloved ranch to his chief business rival. Marion Davies stepped in at this critical juncture and loaned Hearst a million dollars from her own fortune. She also arranged an additional million-dollar loan from Cissy Patterson, the publisher of Hearst's *Washington Herald*. It was a sufficient intervention to forestall disaster.

Hearst spent little time at San Simeon during the war years. It was considered vulnerable to Japanese invasion on the coast—particularly after the oil tanker SS *Montebello* was sunk by a Japanese submarine six miles off San Simeon on December 23, 1941. Hearst and Marion spent most of the war holed up at Wyntoon. He was on a very tight allowance from the corporation, which had slashed his annual salary by eighty percent. Nevertheless, he devised a construction project.

Hearst set about improving the Babicora ranch in Mexico. It was located in a region less affected by the war than San Simeon, and could still be justified as a company investment. Hearst asked Morgan to design an enormous adobe to serve as its ranch headquarters. Morgan had almost entirely closed down her architectural office by this time, and she had not designed anything at San Simeon for the past few years. Nevertheless, she traveled to Babicora in the winter of 1943. She wrote about the trip to friends in San Francisco:

Hearst Castle lit up at twilight. Construction was at a near standstill during the war. Hearst and Marion spent most of their time at Wyntoon, which Morgan had redesigned after a 1930 fire destroyed the original Maybeck building. By this time, Morgan had largely closed down her architectural office in San Francisco.

The place I was in was miles & miles away from traveled roads, some 160 to be exact, so one was not free to go and come individually, and life there was much as it must have been 100 years ago—The women folks still washed their familys & cloths down on the creek banks & ground their meal, corn, wheat, & oats, down on the creek beds, & cooked on open fires,—owned their own cows & horses, & dressed as in the Mexican pictures we are used to seeing—Speak Spanish only— As I do *not*, sign language & *grins* were in order. When in a foreign language country one picks up a lot of main words quickly, particularly if one has had Latin in school. Every one could have horses, *guns*, galore, & the hunters had a fine time—for the North American birds are still on trek south, great flocks always winging their way over this high table land of heron, black birds, every variety of duck, wild geese & turkey as well as the tiniest of birds,—all flying in their own shape of formation & evidently obeying orders—I went on some special work, which has to be reported on & drawn up, here—probably two or more busy weeks.[1]

When Morgan returned from Mexico and thanked Hearst for her visit, he must have suspected it was an arduous one, because he replied: "I am glad the trip was not a trial to you—IF it was not. I 'sort of' suspect it was in part, at least."[2] In fact, the journey had been cut short because two members of the party had become ill. Morgan herself was seventy-one and charged with building a massive adobe far in the countryside of mountainous northern Mexico—work almost anyone would regard as a trial.

She was assisted by a Spanish-speaking engineer, Edward Ardouin, whose letters make clear the complications of the project. They were plagued by building delays, communication difficulties, and weather problems —including an enormous storm that occurred while the adobe bricks were being dried in the sun, transforming their building materials into a river of mud. In the meantime,

far away at Wyntoon, Hearst was eagerly adding so many features to Babicora that its projected costs increased fivefold. The corporation's accountants were adamant that Hearst stay within the allotted budget. Ardouin's frustration was increasing as well, as he wrote Morgan: "If Mr. Hearst would only wait until this war is over, we could duplicate what he wants built for at least half of the price and do a better job." Hearst's reply was blunt: "We do not know how long the war is going to last. We do not know how long I am going to last."[3] He insisted that the project proceed. Morgan returned to Mexico for two months in 1944, and vainly attempted to get construction restarted. Ardouin was not even answering her letters by this time. Ultimately little was built of Hearst's planned adobe except the foundations.

In 1944, while construction at both San Simeon and Babicora languished, the corporation asked Julia Morgan to create a record of San Simeon's total cost. They gave her a final sum of $4.7 million dollars, asking that she present figures to reach that amount. It took Morgan several drafts to accomplish this, in what was obviously a backward calculation. Still it gives a good indication of the general expenditures for the project. The animal cages and shelters were listed at $75,000. The warehouses and structures in the town of San Simeon were listed at $110,000. The general ranch buildings and support systems (septic system, reservoirs, etc.) totaled nearly $150,000. Ultimately, including the postwar projects, the estimated expenditures for the built-in antiques (ceilings, fireplaces, etc.), and the costs of all Hearst's other art purchases, the approximate total to build and furnish the entire hilltop and ranch came to between $7.5 and $8.5 million (roughly equivalent to $100–150 million today), an enormous sum for 1919–47.

This recordkeeping was done during the war. When the war ended in the fall of 1945, Babicora suddenly became an unnecessary diversion. Hearst returned to San Simeon in September with much to celebrate. The company's liquidations, downsizings, and retrenchments had been suc-

In 1943, Hearst decided to build an enormous adobe at Babicora, his remote and primitive ranch in northern Mexico. Morgan journeyed twice to the site, attempting at age seventy-one to complete a project that was beset with delays, cost overruns, and war shortages. Babicora was never finished.

cessful, helping to bring him out of debt. The American economy itself had further boosted the profitability of journalism during the war years. Hearst was solvent again, and he immediately hired a crew of one hundred men and recommenced construction at San Simeon. Morgan did not join him. Though she still kept in touch with her staff and no doubt was closely aware of the proceedings, her health had deteriorated and she was no longer able to travel to the hilltop. George Loorz continued to oversee the work from afar as well. The onsite construction superintendent during these final years was Loorz's close friend and longtime colleague, Warren "Mac" McClure, who had worked as a draftsman with Morgan for many years.

One of Hearst's first actions was to purchase an enormous Douglas DC-3C airplane specially equipped with a cargo-type entrance door, so he did not have to remove his hat while entering. It required a much larger airstrip,

which they built on a site northeast of the previous one. This long flat piece of land was suitable in every way but one: the dairy barn was located on the spot. Therefore it was also moved a few miles north, and placed on a small rise, facing west.

One of Hearst's last investments in the ranch may have had the most far-reaching implications. In the late 1940s, he imported Arabian horses from the Middle East to improve their bloodline in America, thus strengthening the breed in this country. Hearst financed an expedition led by the renowned horse breeder Preston Dyer, who enlisted Prince Fouaz of the Rualla Bedouin tribe in Saudi Arabia to assist him in locating horses. A contingent of specialists, including a veterinarian and a photographer, traveled for two years and examined three thousand horses. They purchased fourteen—six stallions and eight broodmares—to bring back to the Pico Creek Stables at the Hearst Ranch.

TOP: In 1947, Hearst financed a trip to the Middle East, where his team acquired Arabian horses to strengthen the bloodline in America. His buyers and veterinarians examined three thousand horses and purchased fourteen, which were shipped to Pico Creek Stables in 1948.

BOTTOM: During the money shortages, Marion stepped in to assist Hearst with a substantial loan. By the end of World War II, his wealth had largely recovered. Hearst returned to the ranch and busily launched additional construction projects, including lengthening the airstrip and moving the site of the dairy barn, shown here at the far right, to a hillside two miles north.

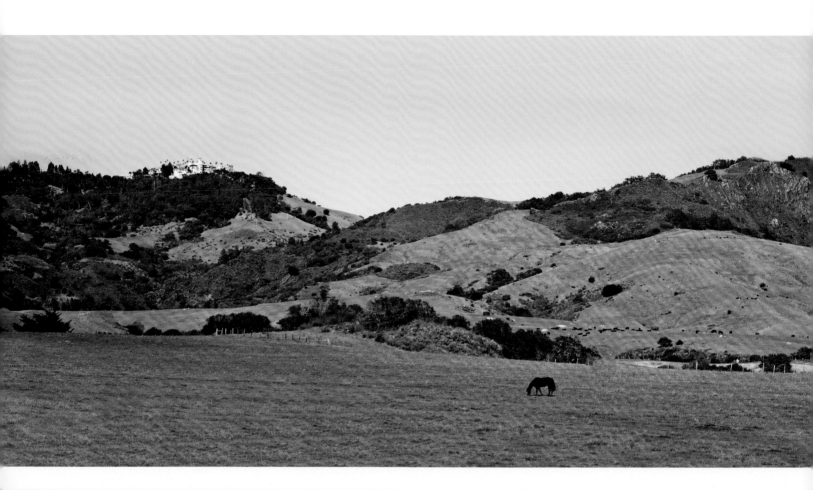

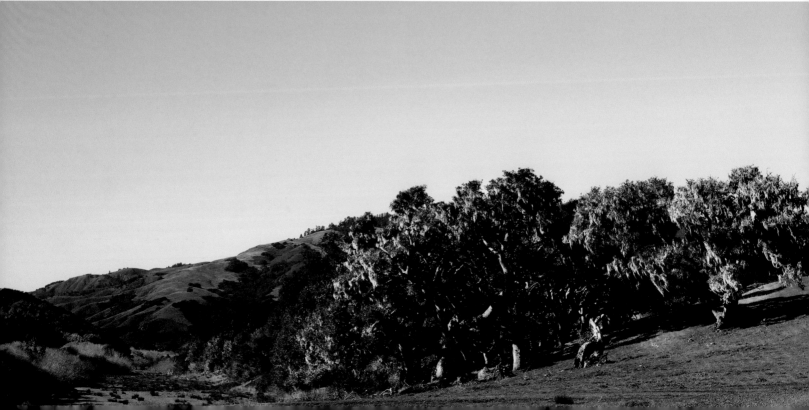

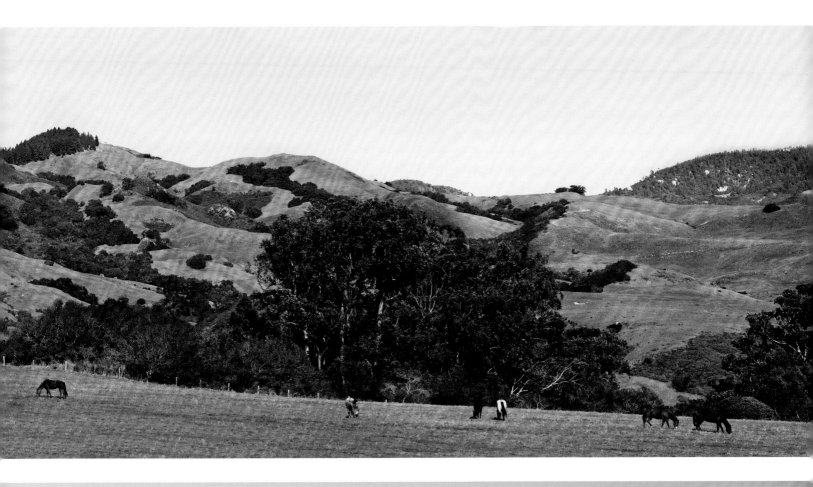

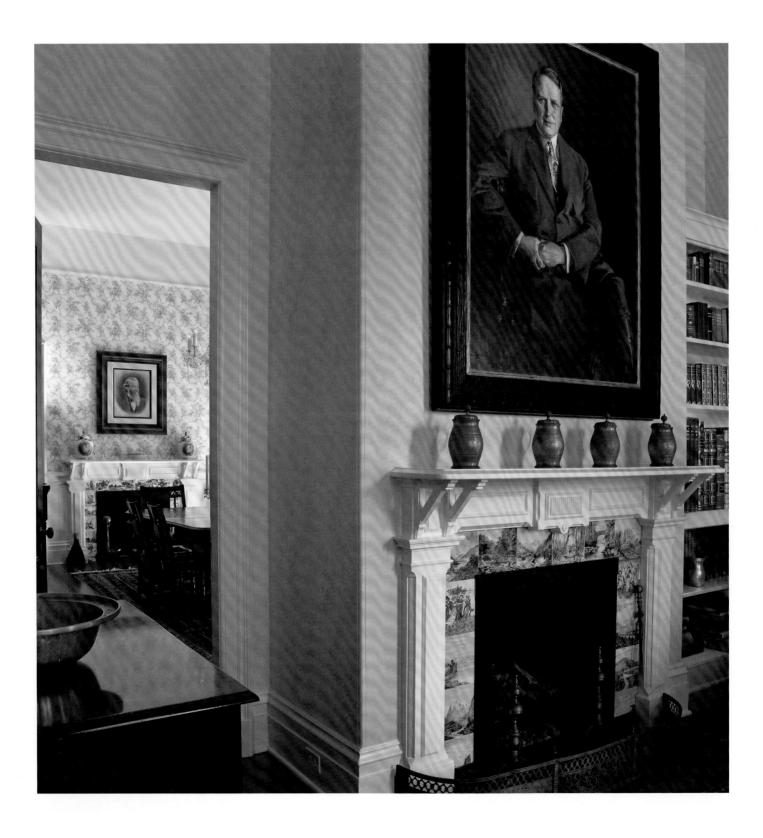

The trip home was filled with disasters. They found themselves caught in a cholera epidemic as they attempted to leave the Middle East, and their twenty-eight days at sea—with the Arabians in specially designed stalls—included a two-day hurricane that nearly wrecked the ship. Once they landed in America, they made the cross-country journey by train, arriving in California in 1948. The expedition was described as:

> [o]ne of the greatest shipments of Arabian horses ever to reach America from Arabia. . . . The trip in search of the equine aristocracy took them approximately 25,000 miles to England, France, Italy, Tripoli, Egypt, Syria, Mesopotamia, Iraq, the northern Arabian desert, and Lebanon. . . . Horsemen everywhere will rejoice to know that in America there reposes a goodly supply of that "eternal yeast—the Arabian horse," not only a good horse breed in himself, but one whose blood has made other breeds great. America and the world owe a debt of gratitude to the owners and management of the San Simeon Stables.[4]

By the time the Arabians reached San Simeon in 1948, Hearst was no longer there to receive them. A series of auricular fibrillations (irregular heartbeats) had caused his doctors to insist that he leave the isolation of the hilltop. He was so unwilling to go that he attempted to convince a leading heart surgeon to move into the lavish hilltop cottage beside his own. The surgeon wouldn't relocate, so Hearst departed in May 1947. "We'll come back, W. R., you'll see," Marion said, when they left the hilltop. He cried silently as they journeyed down the hill for what turned out to be the last time.[5]

Hearst's final four years were spent with Marion at "the Beverly House," a large Mediterranean-style estate in Beverly Hills at 1007 Beverly Drive. Each week, a shipment of beef, poultry, and produce from San Simeon arrived so Hearst could always eat the food from the ranch. He never lost his mental strength, but his body grew increasingly frail. Marion tended him lovingly but was drinking very heavily at this time.

When William Randolph Hearst died of a cerebral thrombosis on August 14, 1951, all five Hearst sons had gathered at the house. Marion was not present at the moment of his death. She was sleeping or sedated in another room, and Hearst's body was removed before she awoke. Bill Hearst Jr. wrote many years later: "If Marion had walked into any of the numerous rooms we were using, she would have heard everything. She didn't. That was clearly because she had been sedated, was exhausted, and was hung over. Our plane to San Francisco didn't take off until about four o'clock, some six hours after my father passed away."[6] Marion said, "I asked where he was and the nurse said he was dead. His body was gone, whoosh, like that. Old W. R. was gone, the boys were gone. I was alone. . . . I had loved him for 32 years and now he was gone. I couldn't even say good-bye."[7] These competing narratives are a sad testament to the fragility of the family circumstances Hearst had tried unsuccessfully to weave together for more than thirty years. His sons were understandably loyal to their

BELOW: Marion Davies did not attend Hearst's funeral. She returned a large inheritance of corporation stock Hearst had bequeathed to her—selling it to Millicent Hearst for one dollar—and married a former stuntman named Horace Brown ten weeks after Hearst's death. Marion had created San Simeon's informal social atmosphere with her warmth and wit, but she never returned to the ranch. She died of cancer in 1961, at age sixty-three.

BOTTOM: From 1887 to 1951, William Randolph Hearst built a media empire that at its height consisted of twenty-eight daily newspapers, fourteen magazines, eight radio stations, a wire service, and two film companies. Pictured here is the Hearst Corporation's first board meeting after the death of the Chief, as Hearst was known by his employees.

mother, and their affection for Marion evaporated when their father was gone.

Hearst was eulogized as the country's most powerful press lord, an unsuccessful politician who nevertheless permanently changed society. His vast media empire brought popular culture—its vulgarities as well as its democracies—to a central position in American life, one it has never abandoned. He was also recognized for building mansions and buying art on a scale worthy of a Roman emperor. Hearst lived long enough to recover the fortune he had lost. His estate was valued at approximately $160 million in 1951, fourteen years after he was $87 million in debt. But as far as posterity is concerned, the most durable portrait of this man was provided by *Citizen Kane*, Orson Welles's brilliant but inaccurate film, which Hearst reportedly claimed never to have seen.

What all these eulogies missed was the central aspect of Hearst's character: his identity as a California rancher at his beloved Piedra Blanca Rancho at San Simeon. This attachment was the longest one of his life, and grew dearer to him with every year. As his parents passed their love of this landscape to him, he passed it on to his five sons and to his grandchildren. Their love for the land has been passed along through seven generations of the Hearst family, who will doubtless share their devotion to the ranch with countless generations to come.

Marion Davies never returned to San Simeon, but she continued to have an impact on its fate. She remained in Southern California and did not attend the grand funeral held at Grace Cathedral in San Francisco, the same church where George and Phoebe's memorials had occurred. Millicent and all five sons were there, but Marion said, "I'll just stay here. He knew how I felt about him, and I know how he felt about me. There's no need for dramatics."[8] However, she had a dramatic surprise of her own in store. Soon after Hearst's death, she provided a scoop to the gossip columnist Hedda Hopper (who was not a Hearst employee but had been a frequent guest at San Simeon). Hearst's will had

been drawn up in 1947 when he was eighty-four, establishing separate trusts for Millicent; his five sons; and two very large philanthropic foundations (the Hearst Foundation, Inc., and the William Randolph Hearst Foundation), still in existence today. Hedda Hopper reported in her column that late in 1950, Hearst had drawn up a separate trust agreement that gave Marion Davies control over his publishing empire. Marion inherited 30,000 shares of Hearst Corporation preferred stock and voting rights to all the corporate stock, which made her the primary shareholder of the company.

In this codicil, Hearst mentioned the tremendous assistance he had received from his "great friend Marion Douras" (Marion's legal surname) when she stepped forward in 1937 with the loan that saved his empire. He clearly wanted to acknowledge the tremendous role she had played in his life, and cushion her, if possible, from the acrimonies he must have anticipated would follow after his death. However, with California's community property laws, and most certainly Marion's proud devotion to Hearst, these arrangements were destined not to remain permanent. A series of negotiations ensued and attorneys from both sides drew up an agreement. On October 30, ten weeks after Hearst's death, Marion announced she had relinquished her voting rights to Millicent Hearst for a token payment of one dollar. She was also granted the ceremonial right to remain a Hearst Corporation adviser, a right she never exercised.

As if this news wasn't amazing enough, it was followed the next day by another announcement: On October 31, 1951, Marion married for the first time, at the age of fifty-four. The groom was Horace Brown, who was known (as a courtesy) as Captain Brown, because he had once served in the Merchant Marines. Horace had been a Hollywood stuntman and hanger-on who briefly dated Marion's sister, and who caught Marion up in a brief, whirlwind romance. There was one thing about him everyone noticed: He looked like a younger William Randolph Hearst. Their

marriage was not particularly happy, and Marion petitioned for divorce more than once.

Marion lived in Southern California for another decade, dying of cancer of the jaw in the summer of 1961 at age sixty-three. *Citizen Kane* had done its damage, and she had been written off as a talentless actress (disguised in the film as an opera singer who couldn't sing) for whom Hearst had purchased a career. She believed this dismissive verdict. For a brief time after Hearst's death, she began taping her memoirs. Marion claimed they had never watched the film: "But plenty of people talked about *Citizen Kane*. They would say that it was terrible and I had to go see it. . . . Who was I to say I didn't like the way he [Orson Welles] did his picture? I was not built that way. I liked to keep the waters calm." Before she gave up taping, she concluded, touchingly, "W. R. argued with millions of people. He thought I could do anything—Shakespeare's plays, any sort of part. He thought I'd be the best."[9]

This was a very sad self-evaluation, and an inaccurate one as well. Film historians have rediscovered Marion, particularly in her delightful comedies with director King Vidor: *Show People*, *The Patsy*, and *Polly of the Circus*. Marion has been recognized as the first screwball film comedienne, the talented predecessor to Carole Lombard, who had previously been credited with inventing the genre. Orson Welles attempted to repair the damage he had done to her career by writing the introduction to *The Times We Had*, a book that reproduced Marion's unfinished memoirs, published in 1975, fourteen years after her death. Welles wrote that Marion was "one of the most delightfully accomplished comediennes in the whole history of the screen," who was "the precious treasure of [Hearst's] heart for more than thirty years, until his last breath of life." Welles concluded: "Theirs is truly a love story. Love is not the subject of *Citizen Kane*."

Another unacknowledged aspect of Marion's contributions is the important role she played in creating San Simeon's unique social atmosphere. Her warmth and

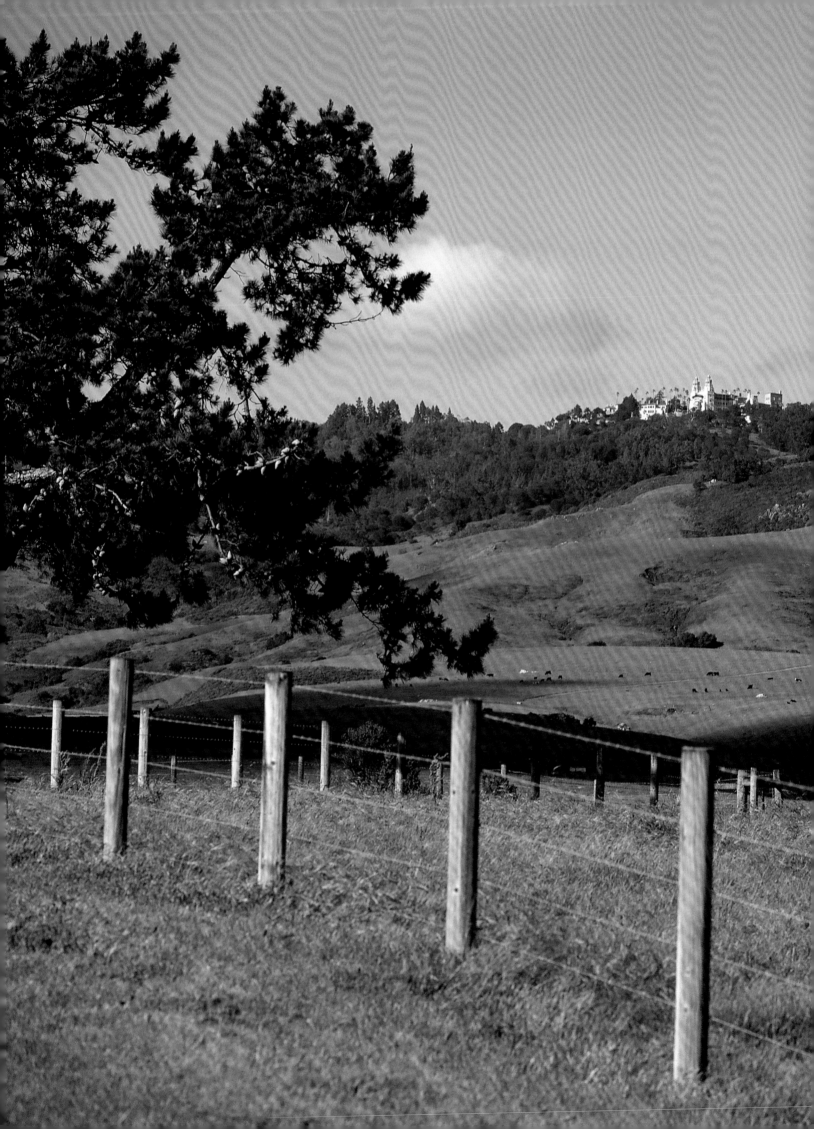

unaffected charm broke down barriers, and she enchanted Shaw, Churchill, and Coolidge alike. As hostess of the Hearst Ranch at San Simeon, Marion was uniquely able to project what Hearst's grandson John Jr. called the old California hacienda tradition: "a huge hospitality for everyone under its roof, but at the same time a kind of country simplicity." This was the essence of Marion's personality.

There were no specific instructions about what was to happen to San Simeon, though as Bill Jr. recalled, his father had made it clear to him that he hoped the hilltop buildings would be donated to Berkeley's University of California. Bill explained: "Pop had known that the state would probably become the eventual owners.... Neither of us related these thoughts to anyone because it was not time to suggest he might be leaving. He was very serene about it. I remember rising from the conversation and being a little weak at the knees. He was smiling, however, and I knew that he had long reconciled himself and was pleased that so many people would one day enjoy the place."[10]

In fact, when Robert Gordon Sproul, chancellor of the university, was approached about the donation, he refused it. At the time there was only a single campus for the university, and San Simeon was a four-hour drive south. There was no endowment for its upkeep being offered with the gift. Furthermore, Hearst was a very controversial figure and La Cuesta Encantada's architectural style was considered excessive and outmoded in 1951, the era that celebrated spare, modernist concrete buildings then known as the International Style.

Several possibilities were considered, including turning it into a western White House or a private hotel. The oil billionaire and former guest Jean Paul Getty considered buying it, as he wrote in his autobiography: "If San Simeon had been closer to a city, I would have offered to buy it in the 1950s. I think the house and 1,000 acres around it might have been purchasable in 1952 for one-tenth its cost. It would have been a marvelous investment, considering the appreciation of property values in the

years that followed."[11] There was even some interest from the United States Army, but Bill Jr. was very opposed to the prospect of an Army purchase. He called the Secretary of State, telling him to abandon the idea or he would launch a campaign in the Hearst press, since he felt government funds should be devoted to other purposes than building a "plush officer's club."[12]

Among the dispersals of this time were most of Hearst's Arabian horses. As a young man, W. R. had railed at his father when George spent huge sums on racehorses in his final years. They brought him tremendous pleasure,

though he only had three years to enjoy them. Ironically, W. R. spent enormous sums to acquire those magnificent Arabians at the end of his life. They brought him great pleasure, but he only had three years to enjoy them as well, before his death at age eighty-eight. Not all were sold. Both Bill Jr. and his younger brother Randy chose the horses they wanted to keep, among them the spectacular Mounigha, a desert-American cross.

Bill Hearst and his wife, Austine, carried on W. R.'s dream by continuing and expanding the breeding program. They hired Lloyd Junge, who managed the Arabian

OPPOSITE: All five Hearst sons continued to work at the Hearst Corporation. Back row from left: Randolph Apperson Hearst, David Whitmire Hearst. Front row from left: William Randolph Hearst Jr., George Randolph Hearst, John Randolph Hearst.

BELOW: In 1953, the Hearst Corporation donated the beach south of San Simeon for use as a public park, christened William Randolph Hearst State Beach. At this time the thousand-foot pier George built in 1878 had been torn down due to old age. It was later reconstructed.

stable for fifteen years. Austine was an accomplished horsewoman who was central to the operation. She also wrote *The Horses of San Simeon*, an unrivaled account of the history of San Simeon's stables. In it, she explained her breeding philosophy:

> I like calm, kind, sensible horses and, of course, I believe that conformation does not mean good performance. A horse can move and do the job he is asked to do if he is built right. The standards established for Arabian horses perfectly describe a horse that will be useful for trail riding, showing, jumping, and traveling long distances, and yet will remain sound. I also feel that size matters. All things being equal, I have found for my purposes that a good, big Arabian is preferable to a good, small one. And so we will continue to breed for disposition, conformation, and size, in that order. At San Simeon we will probably always breed Arabians, the oldest, purest-blooded, most beautiful breed in the world.[13]

Other important parts of Hearst's collection were also sold. In the late 1950s and through the 1960s, many of the items in the San Simeon warehouses were available for purchase. Sometimes people drove up to the warehouses directly to buy things on their own. More often, though, these acquisitions were handled through New York, where appointments were set up for various art dealers to inspect and purchase the pieces. A great deal of Hearst's art collection was dispersed in this way, from small decorative art items, to paintings, to entire antique ceilings and massive chimneypieces. Thousands of objects remained unsold, however—a testament to the vast number of Hearst's acquisitions, even after countless liquidations in New York and California. James Evans worked from 1955 to 1958 as an assistant to Marguerite Brunner, who ran the warehouses. He recalled that the sales at that time were handled through New York, under the supervision

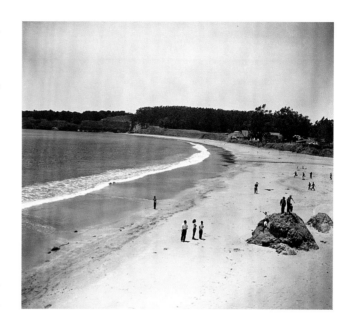

of Charles C. Rounds, who ran the International Studio Art Corporation, the division of the company devoted to Hearst's art collections: "People contacted Mr. Rounds in New York at the warehouses there and then word would come out that somebody was coming to look at things. . . . It was a different time. You know, you look back now, and it's like they were being given away."[14]

After the university turned the Castle down, the Hearst Corporation and Hearst family began discussions with the State of California and its Department of Beaches and Parks (as the California State Parks division was then called). In 1953, the corporation donated a park that became known as the William Randolph Hearst State Beach, to allow visitors to picnic and stroll on the beach. An ensuing plan for their much larger donation stipulated that the corporation would receive a series of tax deductions for donating the hilltop to the people of California as a public monument. There had been concern within the corporation about the high cost of maintaining the estate in any private capacity, and the Hearst family was eager to give it to the public, as

During the late 1950s and early 1960s, many art objects were sold from San Simeon's warehouses. Sometimes buyers drove up and purchased pieces by appointment, but usually the dispersals were overseen by the International Studio Art Corporation, a subsidiary of the Hearst Corporation.

W. R. had wished. At first the area of Orchard Hill, including the pergola, was included in the acreage mentioned in the gift donation. Randy Hearst objected as a spokesman for the family, stating that they did not feel the transfer of so much land was a necessary part of the gift. So the pergola area was removed from the deed. On May 21, 1957, Hearst Corporation President Richard Berlin and Vice President Bill Hearst Jr. sent California Governor Goodwin Knight a telegram, stating:

> The Hearst Corporation has decided to initiate a series of gifts to the State of California, for exclusively public purposes, consisting of the buildings and structures at San Simeon, in San Luis Obispo County, California, known as La Cuesta Encantada, with its grounds of approximately one hundred twenty acres and its furnishings and works of art and with a lower staging area near State Highway No. 1 which is needed primarily for automobile parking, together with access and water easements.
>
> The property is to be preserved intact and operated by the State as a State Historical Monument as part of the California State Park system. It is to be a memorial to William Randolph Hearst, who was responsible for its creation, and whose hope it was that the State of California receive it in the name of his Mother, Phoebe Apperson Hearst.
>
> It is our intent, as we know it is yours, that this property will be operated in a manner consistent with its historical, aesthetic, and cultural character, with no commercialism or other activities that would detract from its dignity and impressiveness.
>
> If you approve our doing so, we will confer with the California State Park Commission as to all matters relevant to the proposed gifts and we will submit to the Park Commission at an early date drafts of papers to give effect to the gift we contemplate making to the State at this time.

These structures are of great beauty with their remarkable collection of works of art and furnishings and will be one of California's outstanding attractions and will be a source of pleasure and education to the people of California and the visitors to the great state of California.[15]

Hearst Castle opened for public tours on June 2, 1958. More than double the expected number of visitors appeared, and those numbers kept growing. Few changes were made, except for building a parking lot and a small visitors' center directly across from William Randolph Hearst State Beach, and building a short bypass road south of the Hearst Ranch entrance, to allow the buses to travel up the hill without disturbing the occupants. Ranch operations went on as before, but not really: for the first time, the bottom of the hill and the top of the hill were in separate ownership.

The night before tours began, all five sons and their families and friends held a small private party on the hilltop for the last time. Actor David Niven was among the guests: "For a few days we explored . . . and hiked and pretended we enjoyed ourselves, but Bill was obviously weighed down with a deep sadness which affected us all. . . . In silence, William Randolph Hearst Jr. drove us down the road from the Enchanted Hill."[16] The Hearst Ranch would never be the same again.

IO
A GIFT TO THE FUTURE

OPPOSITE ABOVE: In the years after Hearst Castle opened to the public, the corporation contemplated various development schemes for the area. One project envisioned an extensive resort with a twenty-seven-hole golf course and a large hotel. At the center of this drawing is Highway 1, which was rebuilt to bypass San Simeon at this time.

OPPOSITE BELOW: This resort plan was modified over several decades, and was intended to turn the region into "the next Pebble Beach." There was insufficient water in the area and construction never commenced, in spite of the corporation having received approval from the county board of supervisors and later from the California Coastal Commission.

OVERLEAF: Even after Hearst sold the northern 154,000 acres of his ranch to the government in 1940 to use as an army base, the Piedra Blanca Rancho encompassed 82,000 acres of coastal pasture and thirteen miles of shoreline.

his chapter is dedicated to the memory of Roger C. Lyon (1949–2010), who was instrumental in bringing about the conservation solution for the Hearst Ranch. Its story begins on June 2, 1958, when Hearst Castle opened to the public as a state park. For the first time, the Castle's lavish hilltop buildings were separated from the rest of the ranch. From 1958 through the mid-1970s, the Hearst family continued to stay on occasion in the most elaborate of Hearst's three cottages, known formally as Casa del Mar (House of the Sea) and informally as A House. The other two cottages and the large formal rooms of the Main Building were shown to the public on guided tours.

The donation of Hearst Castle to the people of California was remarkable for reasons beyond the estate's outstanding beauty and historic significance. Most house museums do not retain their original objects. Instead they are often furnished with a mixture of period pieces intended to supply the appropriate atmosphere. Nearly all of Hearst Castle's contents were included in the gift—English silver, panel paintings, Persian carpets, Flemish tapestries, and thousands of other items, all in their original locations—constituting not only a superb art museum but also a window into a vanished past.

The buildings, grounds, and fixed objects (antique wooden ceilings, stone fireplaces, etc.) were donated in the 1957 deed of gift. All other items (Greek vases, bronze statues, paintings, sculptures, and dozens more categories of decorative arts) remained in place, but their title was gradually transferred from the Hearst Corporation to the State of California, providing continued modest tax benefits. For nearly two decades, while portions of the Castle remained in private ownership, the Hearsts stayed in A

House at various times of the year. Visitors were intrigued to learn that family members might still be in residence, perhaps strolling in the gardens or swimming in the pools after closing time. By the mid-1970s, all hilltop objects had been donated to the State of California, at which time the Hearst family departed from A House, occupying instead various ranch buildings near the coast. Since 1958, more than forty-five million visitors have viewed the Castle, which is in constant use, as Hearst intended. But it is no longer a private home, a circumstance his descendants might understandably have cause to regret.

Another loss came in 1957, when Julia Morgan died on February 2, at eighty-five, after a long illness. Having cared for both her brother and her mother when they suffered extreme memory loss, she doubtless recognized the implications when she herself became increasingly forgetful. Her response was yet another example of her thoughtful self-effacement. Morgan dismissed her long-time housemaid, Sachi Oka, and hired a stranger. She withdrew from her nephew, Morgan North, his wife Flora, and their family—all of whom were preoccupied with their own concerns at the time. She caused as little fuss as possible. They recalled her having once said, "Just give me a quick tuck-in, with my own."[1] Julia Morgan was buried at Mountain View Cemetery in Oakland, among the rolling hills and sheltering oaks she had known since childhood. Her gravesite is now one of the most visited in the cemetery, but her seven hundred buildings—from the magnificent Hearst Ranch at San Simeon to the smallest private home—are her true monument.

At the Hearst Ranch, life went on much as before. Randolph Apperson succeeded Arch Parks as ranch manager in 1934 and remained on the job for nearly thirty years. Apperson and W. R. were first cousins (on Phoebe's side—Randolph was her brother Elbert's son), who referred to each other both in writing and in conversation as Cousin Will and Cousin Randolph. Apperson had a difficult personality, according to many. He was a hard worker but apparently inflexible and ill-tempered, and he frequently locked horns with ranch employees and family members alike. Apperson was ranch manager during many times of transition: Hearst's financial crisis in 1937, his death in 1951, and the opening of the Castle in 1958. Austine Hearst spoke warmly of Apperson, whom she recalled having boasted to her once: "I often had to send out a crew to take rocks out of the trails and cut down limbs so they [Hearst's guests] wouldn't bump their famous domes. Difficult bulls had to be removed too. But in all those years, we had no casualties."[2]

Apperson was succeeded in 1963 by Charlie Parlet, who started cowboying at the Hearst ranch in 1920. Austine recalled him saying:

Cowboys never carry handguns like you see in the movies or on TV. We may shoot a rifle during deer-hunting season, but very seldom does anyone shoot from a horse. I never carried a sidearm and I am an awful poor shot with a handgun. Another thing, we get home early. We run over five thousand head of cattle. We brand a couple thousand calves a year. When you're in the saddle, outdoors ten hours, you're ready and glad to sit down and watch a western film on TV.[3]

Austine admired Charlie's knowledge, skill, and leadership:

No one will ever know the ranch better than he did. He remembered every foot of ground, every tree, every spring, every gully, every fenceline. . . . He had a lust for good food, good drink, good horses, good cattle, good friends, good family ties, all priceless attributes in a leader. Leadership counts as much as experience, knowledge, and courage to run a ranch as immense as San Simeon. Charlie's men and his horses always cooperated with him perfectly. They loved him and he loved them. But of all his deep loves, he loved most

the ranch where he spent sixty years working, teaching cow lore to green young men, and teaching green, young horses to stop when the loop is thrown, to face the steer or calf, to keep a tight rope. Charlie understood cows and horses as well as he understood men. He had character, proving true what that other great roper, Will Rogers, said, "The outside of a horse is good for the inside of a man."[4]

When Charlie began as ranch manager, the land south of San Simeon was being rapidly and haphazardly transformed into San Simeon Acres, a motel row on both sides of Highway 1. W. R. had sold this portion of the ranch in the 1940s. The undistinguished buildings constructed on the site in later years almost certainly indicate how San Simeon itself would have looked had it been subdivided.

Eager to profit from the tourist boom at the Castle, Cambria created an entirely new business district on its northern boundary. The State of California sought to maximize its investment by constructing an elaborate restaurant and gift shop at the Visitor Center. Cambria merchants were incensed, claiming unfair competition. The Hearst Corporation shared their view, as Vice President William Murray explained: "The grantor wanted no large scale commercial establishment of any kind. . . . We never envisioned [the] installation the state now contemplates." When the courts sided with the merchants, the State appealed to the Supreme Court and lost again.[5] As a result, the Visitor Center initially consisted of temporary structures. A modestly utilitarian building was eventually constructed in the 1970s; it was expanded in the 1980s and remodeled in the 1990s.

The Hearst Corporation itself was in fact eager to build in the area. In 1964, Vice President Jack Cooke announced plans for a $340 million development of eight separate villages spread over fifteen miles of coastline with an estimated 65,000 residents. The plan featured a yacht harbor, convention center, airport, hospital, and eighteen-hole golf course, as well as twenty churches, eleven elementary schools, three junior high schools, three high schools, and a college. Sixty thousand acres of the ranch were to be designated as a wildlife preserve with access to backcountry lodges via pack train or helicopter. The County Planning Commission gave it their tentative approval.[6] Even then, however, doubts were expressed about a sufficient water supply. The corporation did not act on the project.

Jack Cooke (the vice president of the corporation's Western Land Division), along with his brother-in-law George Hearst Jr. (publisher of the *Los Angeles Herald-Examiner*) together spearheaded the purchase of the 73,000-acre Jack Ranch in 1966. An inland cattle ranch of open pastures in the northeast corner of the county, this acquisition nearly doubled the Hearst Ranch's acreage, twenty-five years after W. R. had been forced to sell the Milpitas cattle ranch to pay his debts. Like the Hearst land at Jolon, the Jack Ranch was arid, open country with a long history. Its circle C brand Ⓒ is the oldest registered brand being used in the state today. Originally part of the Cholame Rancho, a 26,621-acre land grant awarded to Mauricio Gonzalez in 1844, the Cholame Ranch was purchased in 1867 by W. W. Hollister, who sold portions of it to rancher J. Edgar Jack in 1869. Though the Jack Ranch is not contiguous with the Hearst Ranch, it provides the same function as the former Milpitas Rancho—calves can be taken from the coast earlier and allowed to graze in the inland valley on its more abundant pastures.

Throughout the 1970s, the Hearst Corporation's San Simeon development plan remained in place, though apparently little was done to advance the project. When the California Coastal Commission was created in 1972 to oversee the entire coastline (and an inland border generally extending for one thousand feet), all construction projects in the state faced stronger scrutiny and opposition. In the case of the Hearst Ranch's proposed development, the Coastal Commission changed its one-thousand-foot jurisdiction, stipulating that the inland border should extend five miles east, in an attempt to control approximately two-thirds of the property.

In 1983, the corporation introduced its resort plan for San Simeon. This eventually included three hotels totaling 650 units plus several restaurants and retail outlets, to be built on 300 coastal acres, including one 250-unit hotel and an eighteen-hole golf course located directly on San Simeon Point. By 1988, this proposed Hearst development had been accepted into the Local Coastal Plan for the region. Though public opposition to the project had grown considerably, the Board of Supervisors and the Coastal Commission promised approval under certain conditions. The *Los Angeles Times* reported: "The Coastal Commission has repeatedly said it will only approve the project if Hearst accepts an easement guaranteeing that the remaining 76,650 acres it owns will be used for agricultural purposes only. . . . Hearst officials say the company doesn't intend to develop the remaining land, but they oppose the creation of any legal instrument—such as an easement—that officially prevents the company or future buyer from building on the property."[7]

From 1983 to 1988, there were numerous discussions and compromises between the corporation and public agencies, in an attempt to approve a development plan within the guidelines of the 1988 Local Coastal Plan. The Hearst Corporation continued to lobby during this interval, arguing that their proposed resort would add $3 million in annual tax revenues and become "the next Pebble Beach." Longtime Hearst attorney Phil Battaglia pointed out that the development would only occupy a small fraction of the ranch: "As long as this land has been in the family, the Hearsts have been committed to keeping

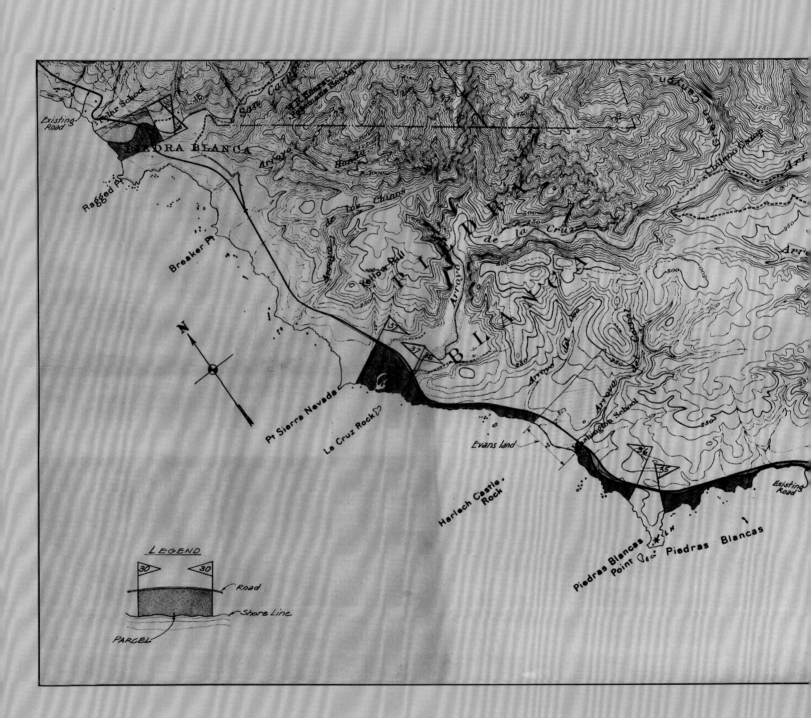

PIEDRA BLANCA

Existing
Road

Pillar School

Ragged Pt

Breaker Pt

N

P⁺ Sierra Nevada

La Cruz Rock

San Carp...

Arroyo

de los Chinos

Arroyo

de la Cruz

P I E D R A

B L A N C A

Chileno Range

Arr

Arroyo

Washington School

Evans land

Harlech Castle Rock

Existing Road

Piedras Blancas Point

Piedras Blancas

LEGEND

30 30

Road

Shore Line

PARCEL

In 1959, the Hearst Corporation acquired the coastal rocks lying just off San Simeon Beach. By 1966, the corporation had received tentative approval to build a $360 million development of eight separate villages for 65,000 residents along fifteen miles of San Simeon's coast. Planned amenities included a yacht harbor, convention center, airport, hospital, and college. The project was never executed.

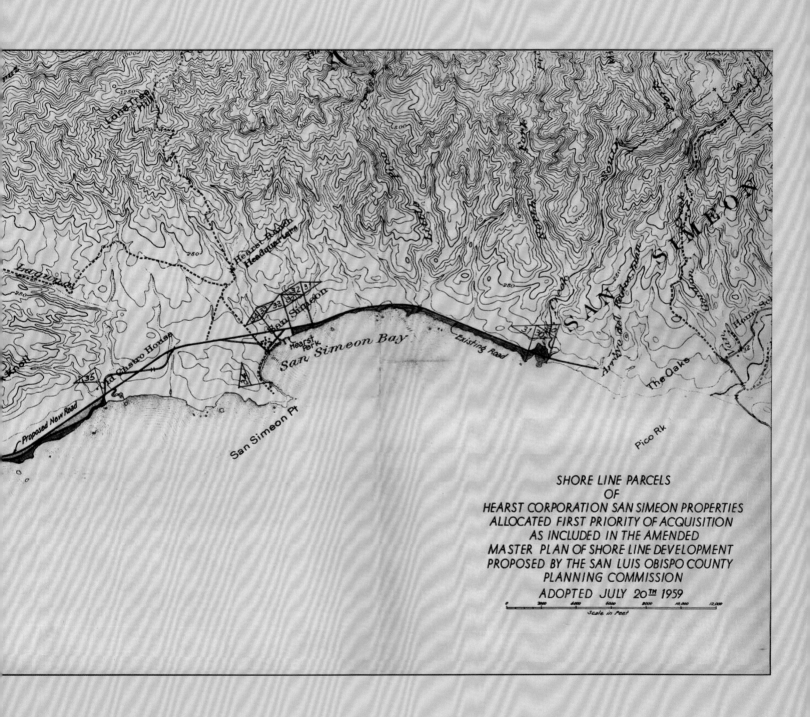

SHORE LINE PARCELS
OF
HEARST CORPORATION SAN SIMEON PROPERTIES
ALLOCATED FIRST PRIORITY OF ACQUISITION
AS INCLUDED IN THE AMENDED
MASTER PLAN OF SHORE LINE DEVELOPMENT
PROPOSED BY THE SAN LUIS OBISPO COUNTY
PLANNING COMMISSION
ADOPTED JULY 20TH 1959

Scale in Feet

BELOW AND OPPOSITE: In 1966, under the direction of Vice President Jack Cooke and George R. Hearst Jr., the corporation purchased the 73,000-acre Jack Ranch. Its Circle C brand is the oldest registered brand in use in California. The Jack Ranch began in 1844 as a Mexican land grant awarded to Mauricio Gonzalez. It was then known as the Cholame Ranch. W. W. Hollister purchased it in 1867 and sold portions of it to rancher Edgar Jack in 1869.

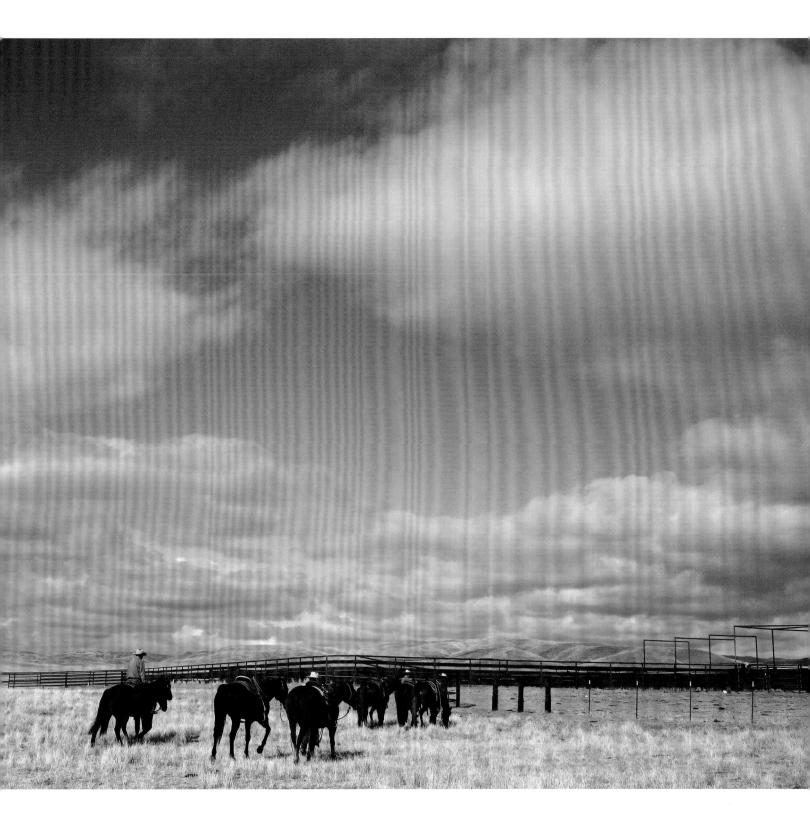

BELOW: The Jack Ranch played the same role that the Milpitas Ranch had in Hearst's era. Its inland valleys allowed the calves to be taken from the coast earlier and quartered on more abundant pasture.

OPPOSITE: Weaning at the Jack Ranch involves separating the cows from their calves. They are divided by a fence, but are still able to see and smell each other to minimize stress.

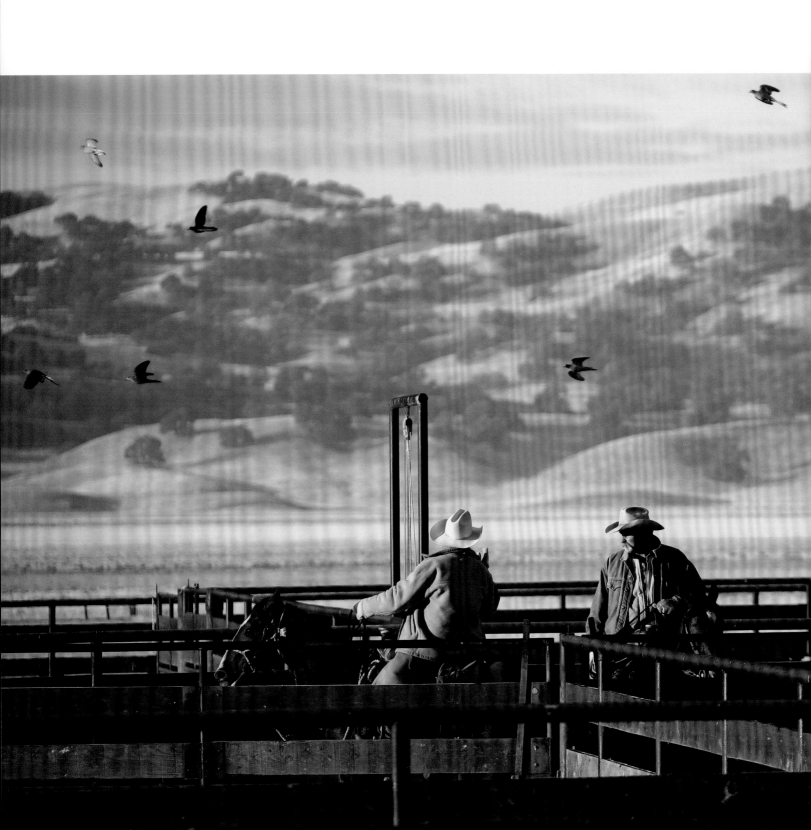

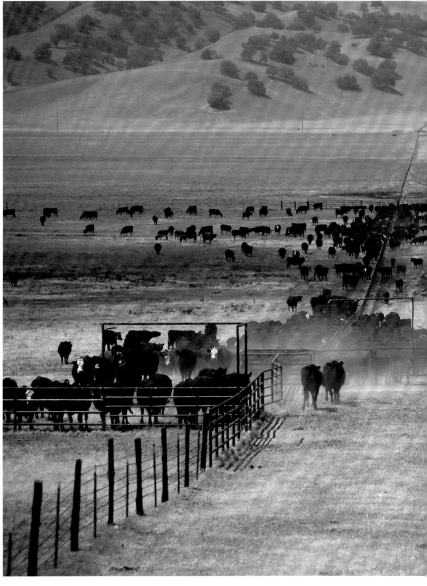

the vast bulk of it in agriculture. There is no reason to believe that commitment is waning."[8]

While the corporation was finalizing its resort plan proposal, the Hearst Ranch hired its new manager, Harlan Brown. In his twenty-three years on the job, Harlan made many improvements, including rebuilding the old dairy barn, improving roads, crossbreeding White-Faced Hereford cows with Angus and Brahman bulls, and introducing dogs on the ranch. "We use dogs to help us gather the cattle," Harlan explained. "The dogs move the cows to men on horseback. But they move them slowly. Herding cows requires a rider to be alert. Anything can spook the bunch, and off they go. If *your* attention wanders, they'll wander."[9] Under Harlan's management, the Hearst Ranch continued to run more than three thousand head of cattle, grazing them on pasture and then selling them to feed lot cattle buyers for finishing.

In 1996, George Randolph Hearst Jr. was appointed chairman of the board of the Hearst Corporation, succeeding W. R.'s youngest and last-surviving son, Randolph Apperson Hearst, who was retiring from the position. George Jr. was William Randolph Hearst's eldest grandson and represented not only the next generation, but also

a different perspective. All five Hearst sons were accomplished horsemen who knew and loved the ranch. George was a fine horseman as well, and active in the renowned Santa Ynez riding club Rancheros Visitadores, whose seven-day horseback ride during the first week of May he attended for forty-five years, never once missing a ride. But George was also a cattle rancher, the first in the family since his grandfather William Randolph Hearst. George ran his own cattle operations for forty-three years, and also flew to the Hearst Ranch many weekends to work: "They'd leave a horse for me at the barn," he said. "When I'd fly up, I'd see where they were and go park the plane, get on the horse, and join 'em."[10] He helped with the branding, gathered wild cattle in the backcountry, and worked the roundups.

Many admired George's ability to embrace both the corporate and the ranching life. His older son, George Hearst III, described his father's constant uniform, which included boots and a Stetson: "It's always great to see him coming up into the [New York] Hearst Tower . . . and he had that Stetson on, and everybody knew the Chairman was in the house."[11] Hearst Corporation CEO Frank Bennack Jr. described George's ability to balance these different worlds as being "like a lasso in the hands of a very skilled cowboy, stylishly and perfectly on key, at any and all times."[12] George provided a steadying presence in the years ahead, when the future of the ranch was a matter of much discussion within the corporation.

In 1998, the Coastal Commission recommended that the resort plan be scaled down to a 375-room hotel, a 60-bed hostel, a 50-bed campground, and various restaurants and retail outlets. The commission created and approved this plan and sent it back to the county, which had six months to review it. During this interval, the corporation vowed not to accept the Coastal Commission's proposal. While some Hearst family members agreed that the goal should primarily be preserving the value of the asset, a small number dissented from this view and spoke

OPPOSITE: In the mid-1970s, dogs were reintroduced on the ranch in a tradition that predated William Randolph Hearst's era. Though some were Australian shepherds, the Hearst cowboys have most often used Kelpies or McNabs, like these two puppies.

BELOW: Dogs can go places a man cannot, and they are almost always the first ones to reach the cattle. These highly intelligent working animals learn to move the cattle slowly and to keep them calm.

OVERLEAF: In the 1970s, ranch manager Harlan Brown renovated the interior of the old Hearst dairy barn using materials found on the ranch. It became a private event center where more than $45 million has been raised for various charities.

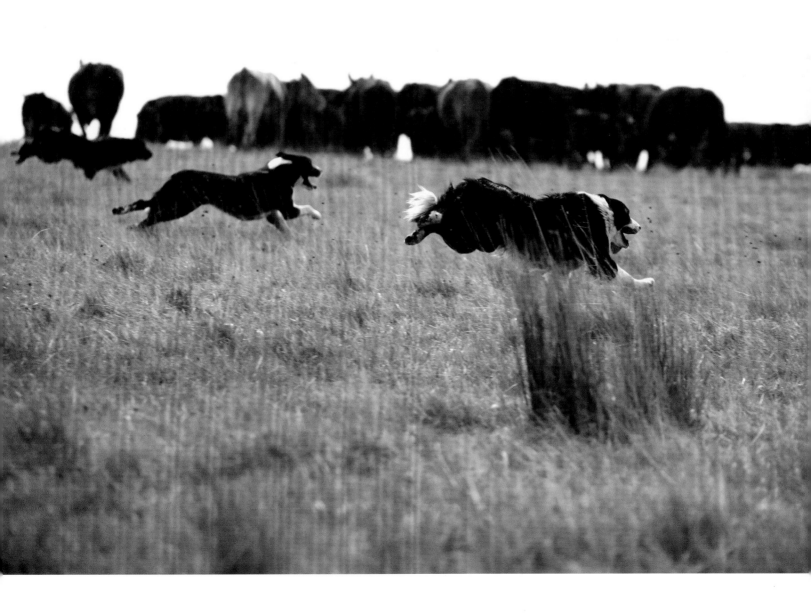

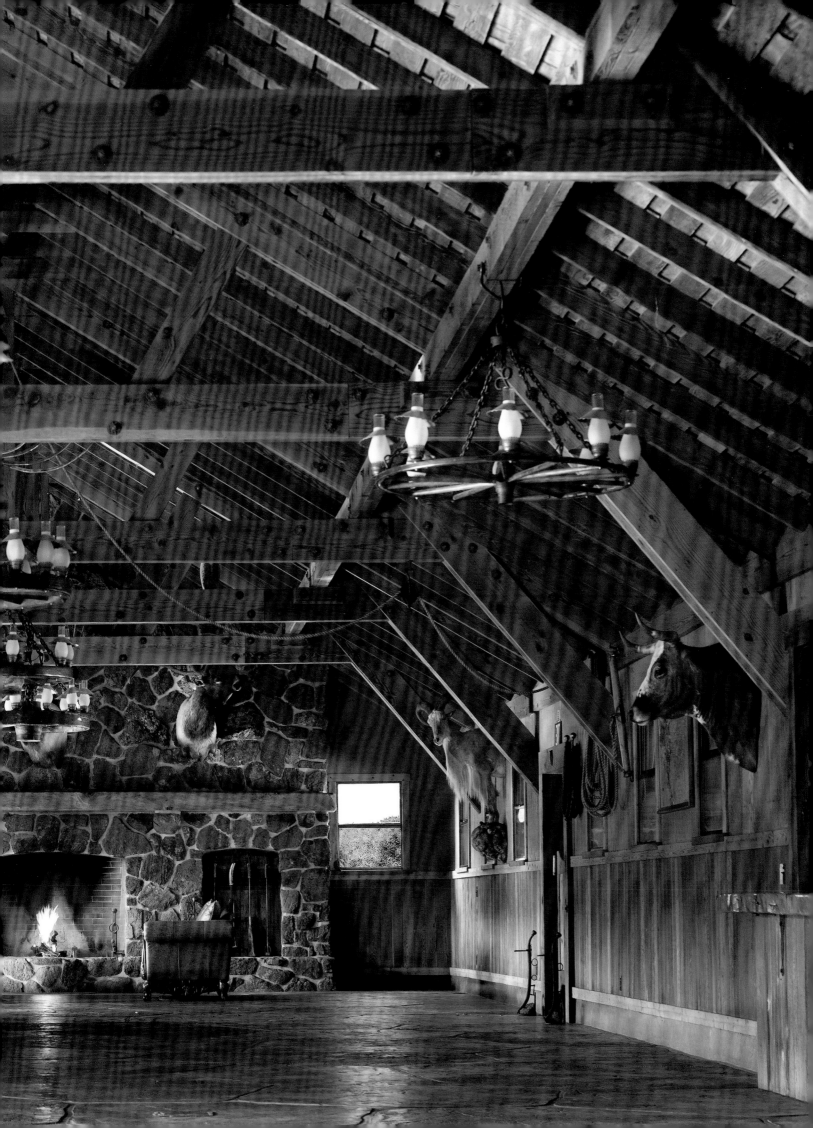

out about their desire to have the ranch remain unaltered. The *Los Angeles Times* wrote: "What is clear is that the San Simeon issue has opened a rare window into a family's internal disagreements."[13] Because the corporation did not accept the Coastal Commission's proposal for a scaled-down project, the 1988 plan for a 650-unit golf course and resort remained in place.

During this period of impasse, William Randolph Hearst's great-grandson Stephen T. Hearst entered the story. He too was a part of both worlds. As George Jr.'s younger son, he had grown up on the ranch and loved it deeply. Steve had also worked for the Hearst Corporation's newspaper division for twenty-five years, in various vice-presidential positions. He understood the corporation's perspective as well. Steve recalled, "I heard my Uncle Jack [Cooke] was retiring [as vice president and general manager of the Western Properties division]. I called my father and let him know I wanted to move from the newspaper division to the real estate division." Steve found himself very quickly sitting in CEO Frank A. Bennack Jr.'s New York office. Discussing his new position, Steve told him, "I want to put all the development plans for San Simeon on hold, and I want to place the property under a conservation easement." Steve replaced Jack Cooke and began meeting with various stakeholders. By this time, anti-Hearst sentiment was so strong that numerous environmentalists remained hostile. Many would not agree to speak with Steve at all.[14]

Steve's first step was to assemble a team, of whom the most influential members were local San Luis Obispo land attorney Roger Lyon and Marty Cepkauskas, Director of Western Real Estate for the Hearst Corporation. Roger Lyon had already successfully established the Cayucos Land Conservancy, preserving four miles of Highway 1's coastline south of Cambria. Marty Cepkauskas's role was to gather and assimilate an ever-growing mass of data and manage the day-to-day details of the project. The team also included additional consultants and land advisers. The group began by reviewing the Hearst Ranch original deeds

and parcels, many of which dated back to the nineteenth century. Ultimately the corporation moved to finalize these rights by certifying 272 legal lots. After receiving Certificates of Compliance on these properties, the appraisal process began. At its completion, the total value with existing property rights was $350 million. By giving up the majority of these development rights and placing a conservation easement on the ranch property, the team arrived at an easement value of $230 million. This sum helped support their position that the potential land value of a conservation solution—including tax benefits and the retention of the working cattle ranch—would provide a sufficient monetary return to justify leaving the ranch largely untouched. Steve Hearst had been the earliest champion of this idea, and he was very pleased with these findings.

While the land valuation process was underway, Cliff Garrison replaced Harlan Brown as ranch manager. Cliff had been a cowboy all his life. He studied agricultural business management in college and started working at the Hearst Ranch in 1986. Cliff and Steve soon began discussing the possibility of switching from the conventional cow/calf ranching operation to a branded grass-fed beef

OVERLEAF: Hearst Ranch cattle forage and graze the same way they have done for millennia. They fertilize the land naturally, and their grazing activity encourages a wide distribution of native grasslands.

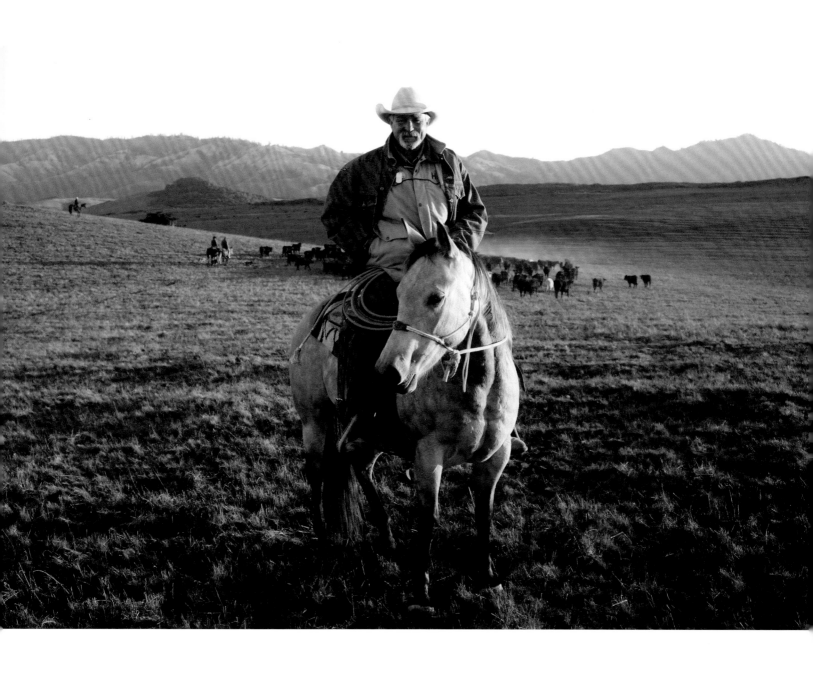

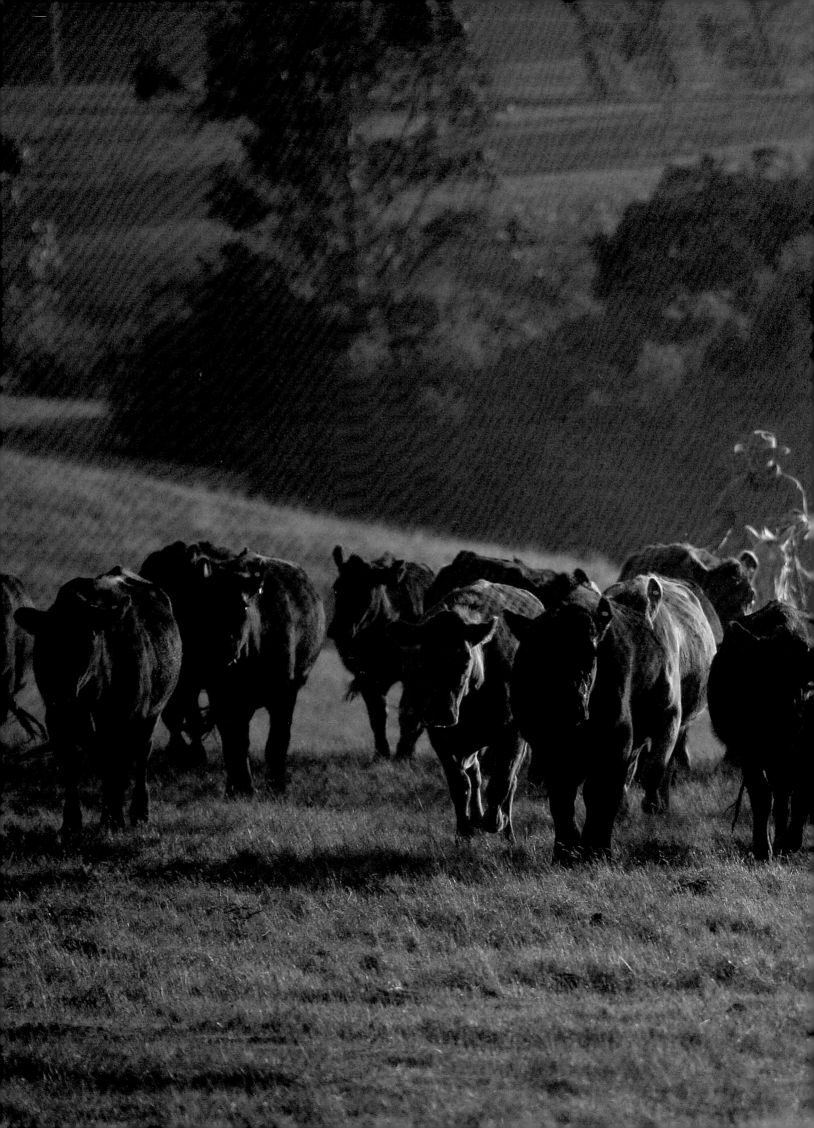

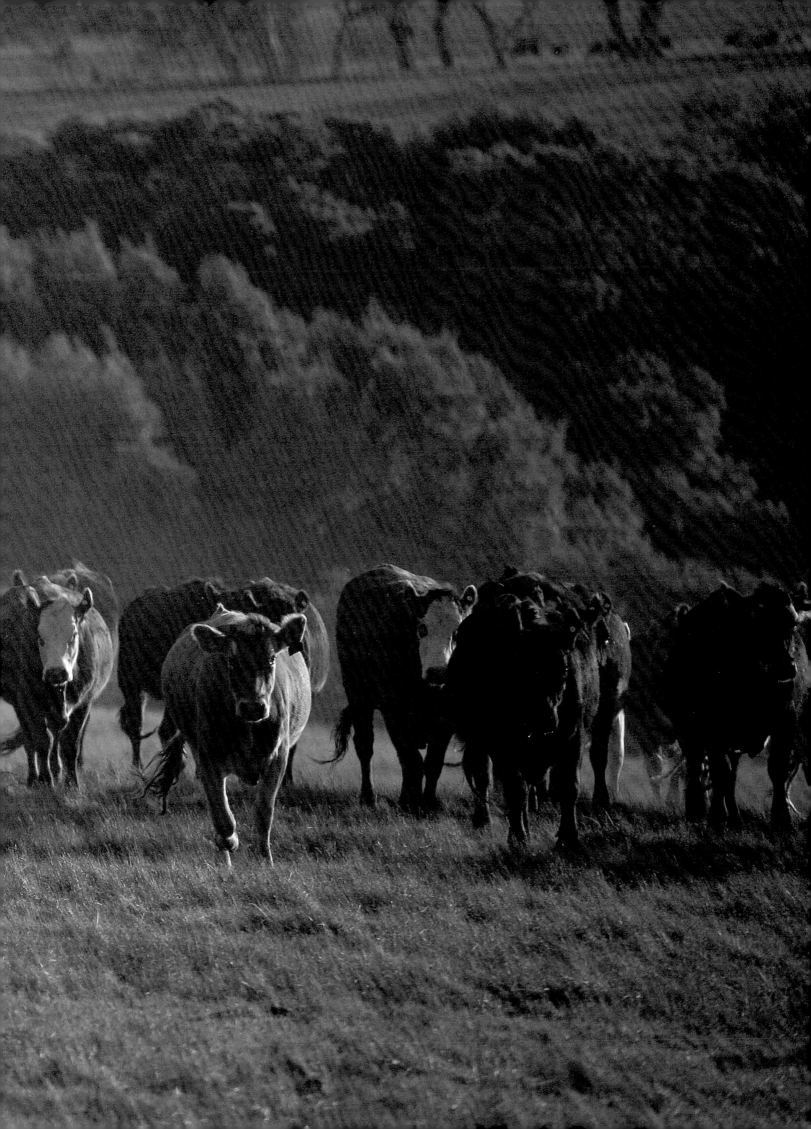

operation. Very few ranches were raising and selling grass-fed beef in 1999. It was environmentally sustainable and yielded beef that was superior in nutrition and taste, but grass-fed, grass-finished beef was difficult to produce and market. Cliff recalled: "The thing about being here for so long, I knew the ranch like the back of my hand so I was able to design a succession in grazing [pastures] that made sense to achieve the goals in a finished piece of meat. To put enough pounds on [with only] grass is not easy to do. It is a heritage practice that takes us back to how cattle were raised before feed lots, which developed after World War II."

Cliff also revived the horse-breeding program, purchasing Jack and Phoebe Cooke's six broodmares and five two-year-olds after Jack Cooke's retirement as vice president of the corporation. The Hearst Ranch once again began raising many of its cowboys' horses, which are designated with the original H slash brand on their hip.[15]

Ranch operations like these were very familiar to lawyer Roger Lyon, who was also a local rancher. Both Marty and Steve credit Roger for keeping the conservation effort going, in spite of numerous setbacks. Many environmentalists remained suspicious of the corporation's motives after decades of acrimony. Within the company and Hearst family, many were skeptical about the likelihood of a positive outcome to a preservation-based solution. They were concerned that the corporation's reputation was suffering after decades of public hostility, but they also believed that the resort development was necessary, in order to preserve the value of this trust asset. "If Steve or his dad had been golfers, things might have turned out differently," Marty joked. "The Conservation Agreement was only possible because Steve came over to the Real Estate division with fresh eyes and a clean slate."[16] There were occasional bright spots, including the serendipitous discovery of a set of plans Julia Morgan had drawn in 1929 for a small Spanish-style hotel in San Simeon. More often there were setbacks, including the breakdown of negotiations with the Nature Conservancy in 2002, and the continuing objections to the corporation's plan to retain ownership of a small amount of coastal acreage and to deny public access to the working ranchlands located east of Highway 1.

Late in 2002, the Hearst Ranch began working with American Land Conservancy (ALC). Together they produced a conservation framework: "Conserve the extraordinary natural, cultural, and scenic resources of the ranch; maintain the viability of the ranch as a working landscape; and provide public access to one of the most stunning and pristine stretches of California coastline."[17] With these goals in mind, the Hearst Corporation and ALC worked toward finalizing what the *New York Times* described as the largest and most complex conservation deal in the United States. Steve Hearst recalled, "I remember the day we announced our alliance with ALC, and presented our conservation framework to the public for the first time. That evening, we all sat in front of the television and waited for the evening news, hoping that the press finally understood our intentions. To our great satisfaction, the news broadcast began with the words 'The Hearst Ranch, a conservation solution beyond everyone's expectations.'"[18] Kara Blakeslee, an ALC manager and important member of the team, recalled: "With the preservation stakes this high, we knew we could not afford to fail."[19]

On February 18, 2005, the Hearst Ranch Conservation Project finally closed escrow. Steve Hearst recalled: "That day, a group of us left the San Luis Obispo County Recorder's Office and went out to lunch to celebrate. During lunch, I received a call from corporate headquarters, informing me that they had just been wired a payment of $80 million. I said, I know. I just sent it to you. The deal is closed. The following day, the headline in the local press read 'HEARST DEAL OUT OF ESCROW INTO HISTORY.' This conservation solution took an unbelievable amount of effort and resources, but it was without question the right thing to do. If it weren't for Roger Lyon's level-headed and wise counsel, I would have thought about throwing in the towel several times."[20]

BELOW: Sebastian's store was founded in 1852 to provision the shore-whaling operation on San Simeon Point. After George Hearst built the warehouse and pier in 1878, the store was towed into town using horses and skids. After several owners, Manuel Sebastian purchased it in 1914. He and his family steadily resisted efforts by the Hearsts to purchase the store. The Hearst Corporation finally acquired Sebastian's in 2009 and has turned it into a wine-tasting bar, while retaining its historic character.

OVERLEAF: The landscape of the Piedra Blanca Rancho has changed very little since George Hearst's first purchase in 1865.

PAGES 210–211: The Saunders Vineyard in Paso Robles, thirty miles east of the Hearst Ranch, is the current site of the Hearst Ranch Winery, begun in 2010. W. R. wrote to Julia Morgan in the 1920s: "There's money in wine grapes. We ought to plant 'em." His intention to have a vineyard has finally become a reality.

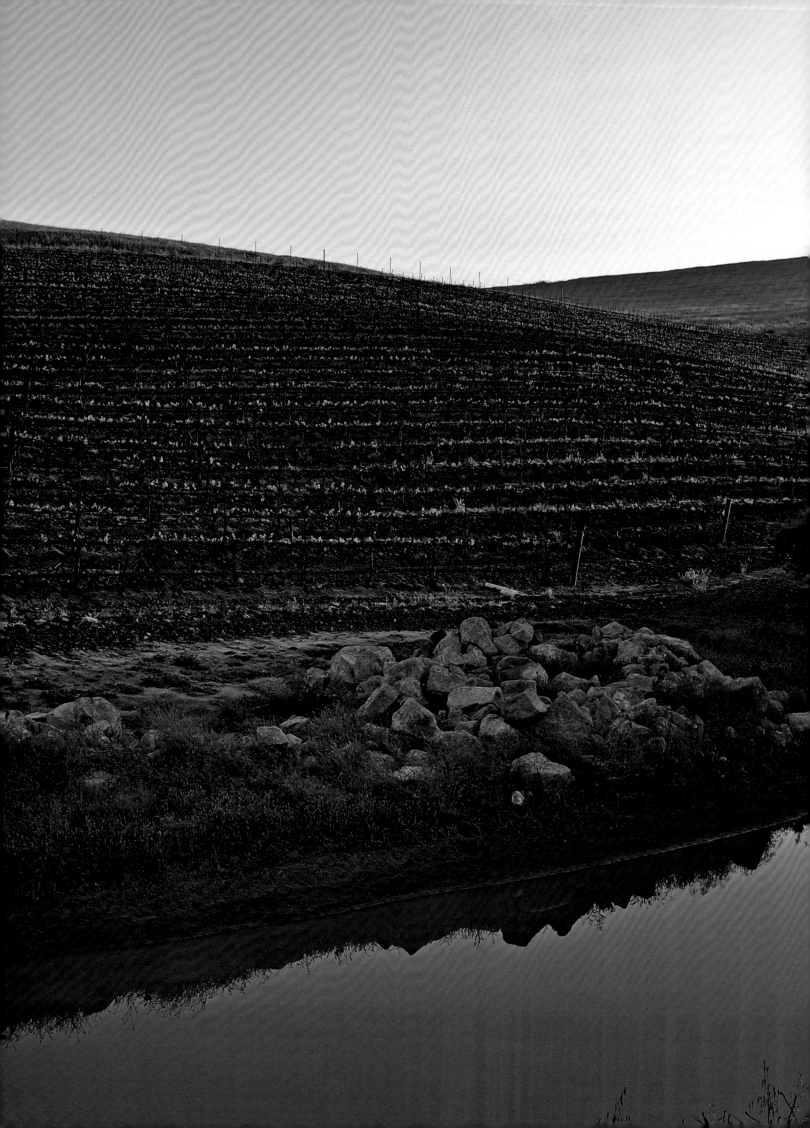

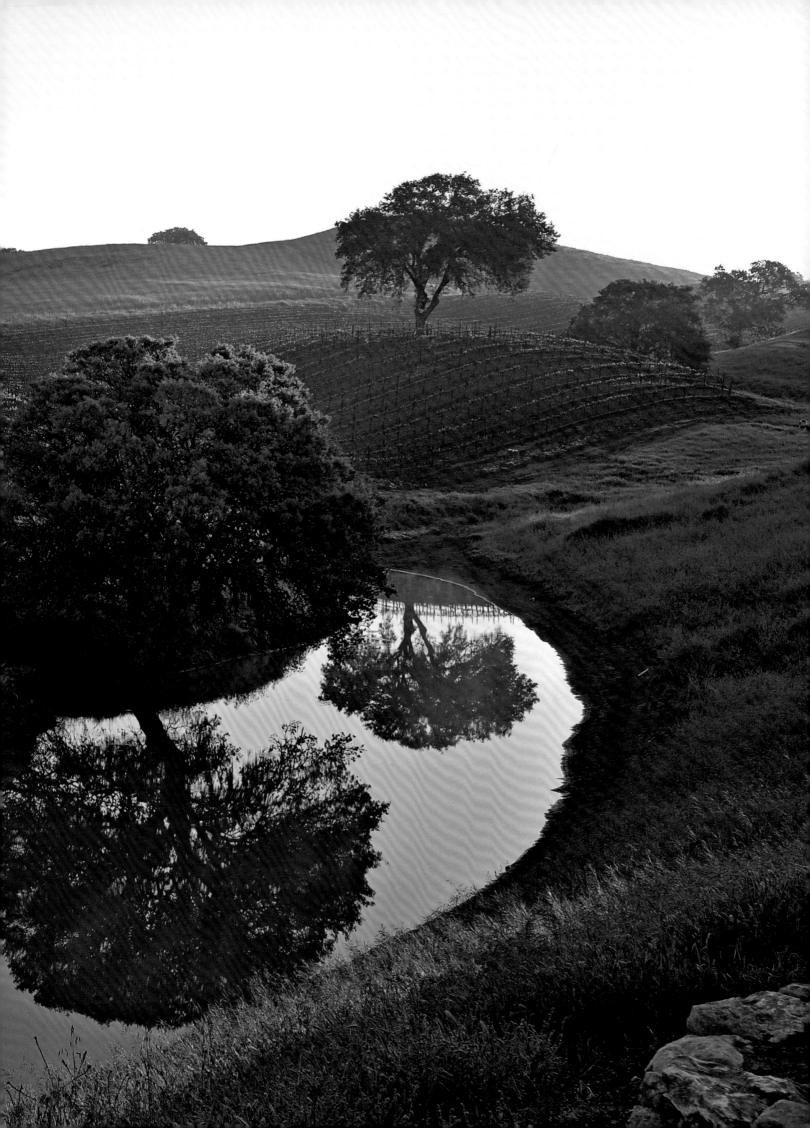

The Hearst Ranch Conservation Agreement is a complex arrangement involving four agencies: the Hearst Corporation, State of California, American Land Conservancy, and California Rangeland Trust. The Hearst Corporation received $95 million from the State of California, $80 million of it in cash and $15 million in tax credits. This was one-third of the land's actual value; the remaining two-thirds was a gift from the corporation.

On the west side of Highway 1, the Hearst Corporation donated 1,500 acres of land to the State of California. This included 949 acres of public parkland made up of thirty beaches and thirteen miles of coastline, to be administered by California State Parks. The remaining acreage allowed Caltrans to realign Highway 1 to reduce coastal erosion. The Hearst Corporation retained ownership of 719 acres, including land at San Simeon Point, San Simeon Village, San Carpoforo Creek, and Pico Point. Public access provisions are permitted to all four of these sites. In addition, these combined public access rights and land donations added eighteen miles to the statewide California Coastal Trail Project.

On the east side of Highway 1, the 82,000-acre, 130-square-mile Hearst Ranch was placed under a conservation easement overseen by the California Rangeland Trust. This ensures that it will remain a working cattle ranch in perpetuity. Virtually no development is permitted, though twenty-seven homesites (each a maximum of five acres) may be constructed in the future, in compliance with conservation and viewshed restrictions, and with the provision that they receive the appropriate approvals from all regulating agencies.

The conservation easement stretches over land little changed from George Hearst's day. It is still a richly diverse environment, including 30,000 acres of oak woodlands; 25,000 acres of grassland and coastal prairie; 20,000 acres of wetlands; 15,000 acres of chaparral; and seven major watersheds. The cattle graze these pastures just as they did in 1865. Kara Blakeslee explained:

More than one thousand plant and animal species have been observed on the property, including rare and threatened species like the red-legged frog, the southwestern pond turtle, and the California condor. It contains nearly every type of ecosystem in California—savannah, pine forest, oak woodlands, coastal environments. The normal animals like mountain lions live there, along with many exotic escapees [from W. R. Hearst's former zoo]. You expect bobcats, but you also see zebras. It has all the things that people love about the natural world. . . . We owe a debt of thanks to the Hearst family for their excellent stewardship of the ranch. Their efforts to maintain the biological diversity and ecological health of the ranch over several generations have made it invaluable to the State of California.[21]

Since its completion in 2005, the Hearst Ranch Conservation Project has won a number of prestigious environmental awards. Local opposition to the plan dwindled quickly after its adoption. It is now looked to both locally and internationally as a model for future land-protection agreements. Steve Hearst said: "Seven generations of my family have stood on this dirt, and been privileged to do so. . . . We value our relationship with the community, and I know they value the natural landscape that we protect. [In] everything we do, we put it back the way it was, or we refurbish it the way it stands."[22]

Five years after the agreement was signed, Roger Lyon died in an airplane crash at age sixty-one. At his memorial service, Chopper (which was his nickname since childhood) was described as a family man, an athlete, a prankster, a rancher, a surfer, an optimist, and a doer, brimming with energy and life. He loved the coastal lands of Central California and he devoted himself to preserving them forever. Roger said of the Hearst Ranch conservation deal: "People are going to appreciate it more and more as time goes by. In all of the public meetings, what [we've heard]

is that they want things left pretty well alone, and that's what's happening."[23] Roger was right. People appreciate this conservation agreement more fully with every passing year. They also appreciate the crucial part Roger played in bringing it to fruition. His many friends often think of Roger when they see the peaceful hills of the Hearst Ranch, or stand on the shore nearby and listen to the waves.

William Randolph Hearst's eldest grandchildren, twins George Randolph Hearst Jr. and Phoebe Hearst Cooke, both died in 2012 within months of each other, George at eighty-four and Phoebe at eighty-five. They both loved the Hearst Ranch and spent thousands of hours exploring it on horseback. George and Phoebe first came to San Simeon to visit their grandfather in the 1930s and 1940s, when the ranch was in its heyday. It is unnecessary for us to imagine how it looked to them in the thirties—because the Hearst Ranch looks almost exactly the same today. Unlike most family ranches, it was not broken up and sold by later generations, or mechanized to increase profits. Its coastline remains as lovely today as it was in the thirties. After 150 years of family ownership, the buildings of George Hearst's and Phoebe Apperson Hearst's era—Sebastian's store, the 1878 warehouse, the one-room schoolhouse, and the Hearst family ranch house—are still in daily use, as are the many buildings Julia Morgan designed for William Randolph Hearst in the 1920s and 1930s, from the glamorous Hearst Castle to the comfortable bunkhouse. If George, Phoebe, and William Randolph Hearst returned today, they would recognize the Hearst Ranch they built and also the land they cherished. Seven generations of the Hearst family have protected this special place, and the 2005 conservation agreement ensures this will never change. The Hearst Ranch at San Simeon will always remain a gift to the future, a beautiful landscape beloved by the Hearst family, who saved it and then shared it with us all.

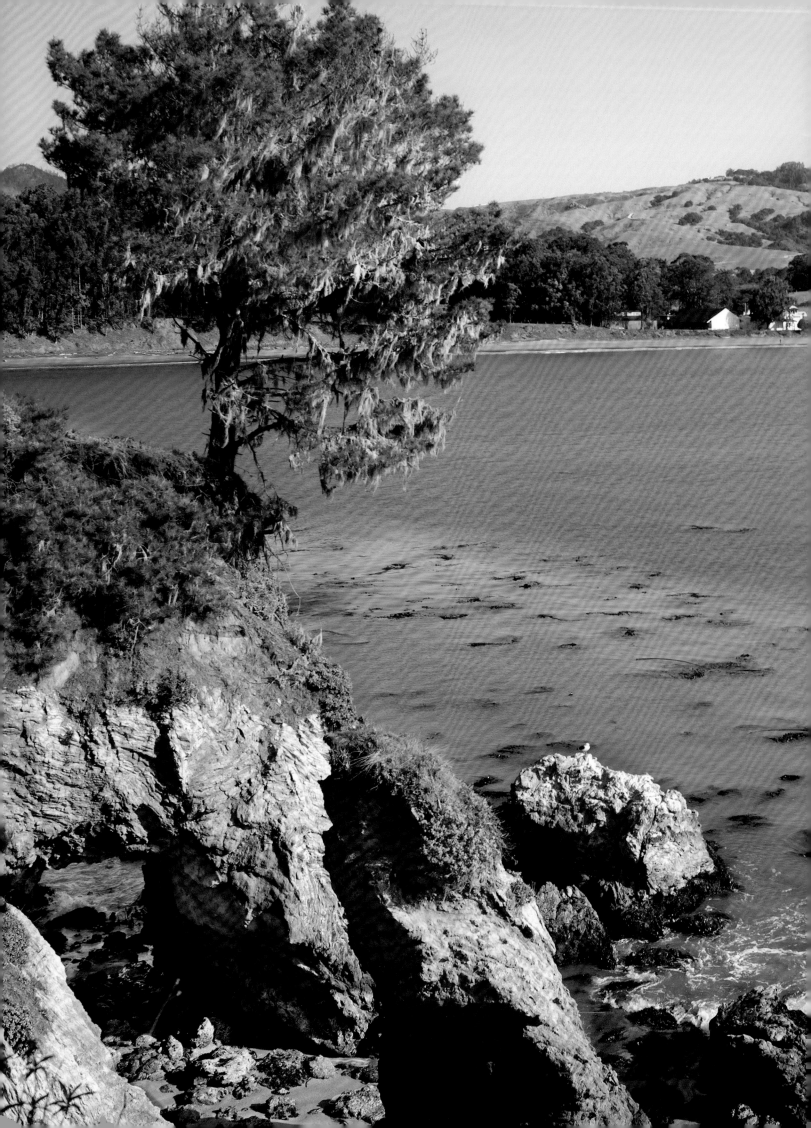

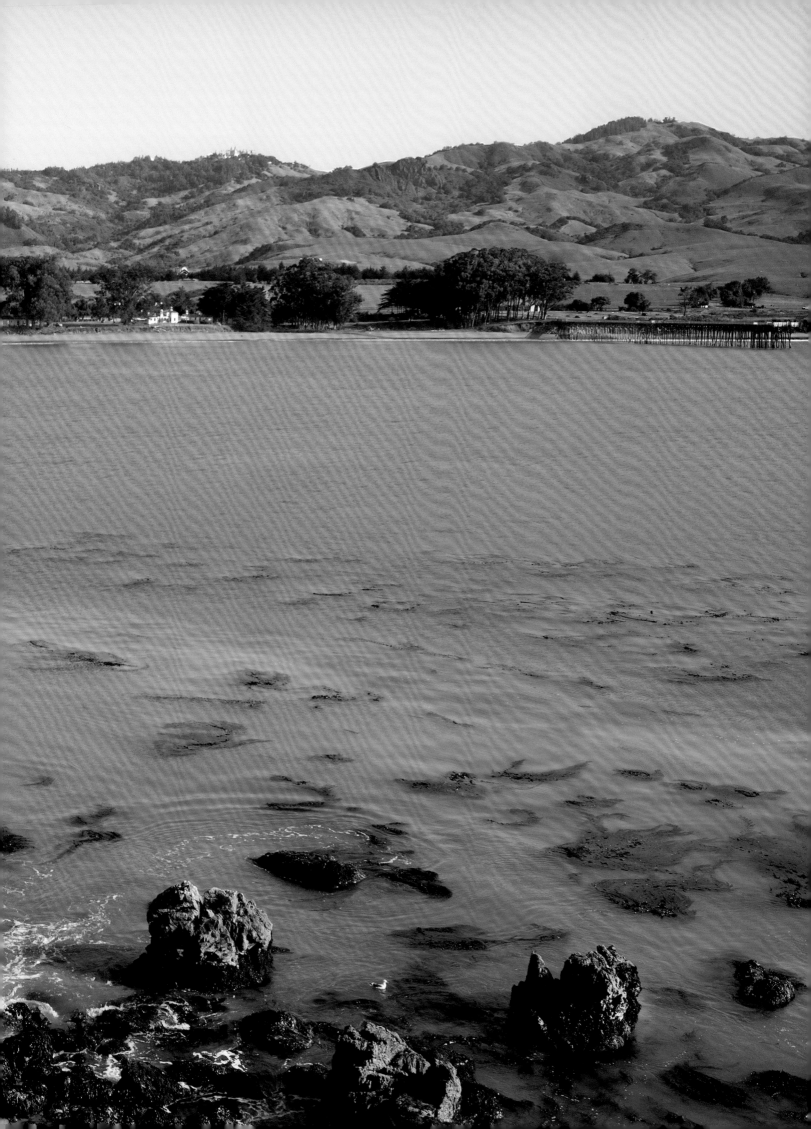

Notes

INTRODUCTION

1. William Randolph Hearst to Phoebe Apperson Hearst, c. August 1917. William Randolph Hearst Papers, 87/232c, Bancroft Library, University of California, Berkeley; Orrin Peck to P. A. Hearst, c. 1917. George and Phoebe Apperson Hearst Papers, 72/204c, Bancroft Library (hereafter "Bancroft Library"). (Unless otherwise noted, all correspondence is by letter. Grammatical errors that do not affect meaning have been silently corrected throughout.) They often staged elaborate "photoplays," or silent movies, on these camping trips. Orrin Peck, W. R.'s close friend, wrote Phoebe in 1917 about one plot: "The Don having sold ten thousand dollars worth of cattle must deposit the money before nightfall as the country has been infested with brigands & bandits. . . . The neighbors . . . arm themselves & go in pursuit [of the thieves]—finally after [crossing] gorges & numerous interesting points of scenery they locate the brigands who have Millicent tied to a tree—shots are fired [Don] Pancho [Estrada] is killed & . . . Millicent is released—(I don't know what becomes of the money—I only know I dont get any of it.)—A grand meeting [is held] at the neighbors home with banquet— after which we are all natural again & shaking hands with the bandits & smoking with the aforesaid murderers – to show it was all a play—"

2. "Hearst Disclaims Political Ambition," *New York Times*, May 4, 1922, 5.

CHAPTER 1

1. George Hearst, *The Way It Was* (N.p.: Hearst Corporation, 1972), 8. George wrote this short memoir in 1888, three years before his death. The first Hearst ancestor to arrive in America was John Hyrst in 1680. (By the eighteenth century, the spelling had changed to Hurst.) The family forebears were Presbyterian Covenanters who fled Scotland during the reign of Charles II.

2. Mr. and Mrs. Fremont Older, *George Hearst: California Pioneer* (Los Angeles: Westernlore, 1966), 29; Hearst, *The Way It Was*, 7–8. William Hearst's $10,000 debt in 1846 is equivalent to approximately

$250,000 today. Concerning his relations with Indians, George wrote in his memoir, "We never found the Indians to disturb us in the least. In fact, it is a strange thing that I have travelled all over the country and never had an Indian molest me in my life. I hardly know how to account for this except in the way of destiny. Perhaps because I was a boy amongst them I had a better chance to study their nature and habits, anyway the Indians seem to take to me and it may be because they felt that I understood them."

3. Hearst, *The Way It Was*, 12; Older, *George Hearst*, 41. Mrs. Fremont Older surmised that George was likely referring to Miguel Venegas's *A Natural and Civil History of California*, published in London in 1759.

4. Ibid., 9, 13. Among the party were George's cousins Joe and Jacob Clark.

5. William Randolph Hearst, *In the News*, March 27, 1940. In the same article an elderly William Randolph Hearst recalled George singing "blithely, if not brilliantly, for the edification of his infant son the song, 'Oh Susanna.'"

6. Jo Ann Levy, *They Saw the Elephant: Women in the California Gold Rush* (Norman: University of Oklahoma Press, 1992), 7. Cholera was the primary cause of death on the journey west.

7. Hearst, *The Way It Was*, 13–15; Older, *George Hearst*, 27. The Olders explained that French lead miners in Missouri had given George the five-franc piece in his boyhood. It had no monetary value.

8. Mark Twain, "Sam Clemens's Old Days," *The [New York] Sun*, October 16, 1898; Edmond D. Coblentz ed., *William Randolph Hearst: A Portrait in His Own Words* (New York: Simon and Schuster, 1952), 25–26. Phoebe served Mark Twain with "hog and hominy" at his special request, while other guests dined on more lavish fare.

9. George Hearst to Joseph Funk, March 19, 1858, quoted in Judith Robinson, *The Hearsts: An American Dynasty* (San Francisco, CA: Telegraph Hill Press, 1991), 40–41.

10. "He Envied Titled Ones," *New York Times*, June 25, 1886, 3. George Hearst was recently depicted in the fictional HBO

television series *Deadwood* as a sinister and hostile character. In fact, he was usually described as generous and loyal, and was known for supporting miners who were down on their luck.

11. Hearst, *The Way It Was*, 13.

12. Richard E. Lingenfelter, *Bonanzas & Borrascas: Gold Lust & Silver Sharks 1848–1884* (Norman, OK: Arthur H. Clark Co., 2012), 86. Unlike gold, silver was traded in shares, rather than in land. The Ophir mine (named after the land of gold in the Bible) was rich enough in silver that one inch represented one share.

13. Hearst, *The Way It Was*, 18. George was briefly arrested for using seditious language while he was in Missouri. Years later, he said, "My sympathies were with the South, and if I had a chance I would have stood in with the Confederacy; of course I see now that I was wrong." See "A Statesman Interviewed: Chunks of Wisdom from the Depths of a Great Mind," *Daily Alta California*, May 6, 1887, 8.

14. Mabel Reed, "Transcription of the Remarks of Mrs. Mabel Reed," *Founder's Day* (remarks to Beaufort, Missouri, PTA, February 14, 1964), Hearst San Simeon State Historical Monument Staff Library, 2.

15. P. A. Hearst to Eliza Pike, August 10, 1872, Bancroft Library. Phoebe Apperson Hearst spelled her Christian name "Phebe" in her early life. Ben Procter in *William Randolph Hearst: The Early Years, 1863–1910* (New York: Oxford University Press, 1998), 2, claims she began adding the classical "o" to her name in 1899.

16. William Lent to G. Hearst, January 20, 1863, Bancroft Library.

17. "He Envied Titled Ones," *New York Times*, June 25, 1886, 3.

18. P. A. Hearst to G. Hearst, July 14, 1868, Bancroft Library.

19. W. A. Swanberg, *Citizen Hearst: A Biography of William Randolph Hearst* (New York: Scribner's, 1961), 9.

20. Gayle Baker, *Cambria: A Harbor Town History* (Santa Barbara, CA: HarborTown Histories, 2003), 14–15. Both the Salinan

and the Chumash peoples lived in the region, dating back 10,000 years. The period from 1250 to 1850 was considered the cultural flowering of the Chumash, and included the construction of coastal villages made up of thatch and willow branches. The mission population of native peoples in the region dropped from 919 in 1803 to a mere 170 in 1838. See Bruce Miller, *Chumash: A Picture of Their World* (Los Osos, CA: Sand River Press, 1988), 14–15, 35.

21. David Igler, *Industrial Cowboys: Miller & Lux and the Transformation of the Far West, 1850–1920* (Berkeley: University of California Press, 2001), 9, 20–23. In Robert Glass Cleland, *The Cattle on a Thousand Hills: Southern California, 1850–1880* (San Marino, CA: The Huntington Library, 1951), 135, the federal census for cattle recorded nearly 1,234,000 cattle in California in 1860. By 1870 this number had dropped more than forty-five percent, to 670,000.

22. Stoner Brooke, "Lost on the Upper Naciemiento [*sic*]," *Overland Monthly* 13, second series, January–June, 1889, 153.

23. Hearst, *The Way It Was*, 34. George Hearst's estate in 1891 included seven dairies on his San Simeon properties, with as many as 150 cows on each dairy, for a total value of $34,480. See *Inventory and Appraisement of Estate of George Hearst*, Hearst Corporation Archives, 86.

CHAPTER 2

1. "An Embryo Metropolis," *Daily Alta California*, January 6, 1861. At 110 miles, the road from Visalia to San Simeon proposed in March 1861 would have saved one-third of shipping costs and cut travel time to San Francisco in half. It was never built. See "San Simeon Not Dead Yet," *Alta California*, March 9, 1861.

2. "San Simeon Set Back a Peg," *Daily Alta California*, March 6, 1861. For an account of the hardships endured by one family in the region, see Clark Colahan, *On the Banks of San Simeon Creek: San Simeon Pioneers*. (San Luis Obispo, CA: Central Coast Press, 2011). E. A. Clark and his family homesteaded in San Simeon from 1858 to the mid-1860s, during which time they experienced poverty, illness, and death.

3. "San Simeon Set Ahead a Peg," *Daily Alta California*, March 8, 1861.

4. "Copper Decline in San Luis Obispo," *Sacramento Daily Union*, November 8, 1865. In April 1865, George also purchased the oil and mineral rights on three sections of Miguel Avila's Rancho Santa Miguelito in Avila Beach, sixty-five miles south of San Simeon. See *San Luis Obispo County Deeds*, Book A: 705, 710 and 717, Abstracts 441, 443, and 447 (San Luis Obispo, CA.: San Luis Obispo County Government Center). He relinquished these rights after one year.

5. James Van Ness to G. Hearst, November 28, 1865, Bancroft Library. Van Ness continued, "In respect to Mrs. Wilson's interest in the Port, you had better authorize me to close it at once for $2,000. . . . Pacheco is not here, nor Pujol—as they might, and probably would, if they were here, put her up to asking more, or persuade her not to sell at all. Again, she might die, and then their interests would go into a dozen hands, and some of them minors, and you might have a terrible job, and one lasting several years, to get the thing in shape."

6. Hearst, *The Way It Was*, 10. For George's account of how he obtained the Ontario silver mine and the Homestake gold mine, see pp. 145–149, 154–158.

7. P. A. Hearst to G. Hearst, July 14, 1868, Bancroft Library. George fought Pujol's ownership in court, but lost the case. Pujol continued to repossess Estrada's Rancho Santa Rosa, leaving Estrada with only 1,500 acres, 1,340 of which he sold to George. Estrada's son Pancho took over the management of the remaining 160 acres at his father's death in 1871, and sold that portion to George in 1876.

8. J. Van Ness to Judge Solomon Heydenfeldt, February 17, 1869, Bancroft Library. Van Ness continued, "But assuming this to be so, and that it will be some years yet before his boy will be able to take charge of it, it may still be for rent."

9. J. Van Ness to G. Hearst, September 5, 1869, Bancroft Library. George bought the existing Piedra Blanca Rancho and named his own business operations the Piedmont Land and Cattle Company.

W. R. used this company as a subsidiary to operate the Hearst Ranch, beginning in 1929.

10. G. Hearst to James Ben Ali Haggin, March 23, 1879; March 6, 1879; J. A. Pollard to G. Hearst, August 16, 1870, Bancroft Library; Hearst, *The Way It Was*, 11. The *San Luis Obispo Tribune* wrote on June 22, 1878, "We understand that it is the intention of the owner of the wharf and that portion of the Piedra Blanca rancho which adjoins San Simeon Bay, to lay out a town, and subdivide and sell the rancho in lots to suit purchasers." George was also very interested at this time in acquiring what he called the "Napoma ranch," located along the coast in Nipomo, sixty-six miles south of San Simeon. He wrote to Haggin on March 6, 1879, "I want that property to make a magnificent estate and home out of. It is a fancy place and a valuable one and the last chance to get such a one. Please give my business as much of your time as possible which I know can't be much as I know you have a great deal to do and to think of."

11. P. A. Hearst to E. Pike, December 10, 1873; George W. Hearst to G. Hearst, April 11, 1877; P. A. Hearst to E. Pike, December 13, 1876, Bancroft Library. The "Missouri relations" Phoebe refers to were probably George's cousins, George W. and Richard S. Hearst, who came to California in 1873 and located in Green Valley near Cambria, six miles south of San Simeon. See Annie L. Morrison and John H. Haydon, *Pioneers of San Luis Obispo County and Environs* (Los Angeles, CA: Historic Record Co., 1917), 355. George W. Hearst wrote to George on April 11, 1877, "This is a very good country for moneyed men that are able to stand heavy losses and disadvantages. . . . I think that I will go to Texas where I can get me a home." George also employed Phoebe's younger brother Elbert. Phoebe wrote Eliza on December 13, 1876: "Eppy [Elbert] is to be married the last of the month. I am anxious to be there. He writes that he is doing splendidly at the ranch—will make from 8 to 10 thousand dollars per year from Mr. Hearst. Eppy receives a salary of $100 per month and board."

12. P. A. Hearst to E. Pike, September 26, 1873, Bancroft Library.

13. P. A. Hearst to E. Pike, September 26, 1873, Bancroft Library; William

Randolph Hearst, *In the News*, 23
November 1940.

14. P. A. Hearst to G. Hearst, May 11, 1873,
Bancroft Library.

15. "A Statesman Interviewed," *Daily Alta
California*, May 6, 1887, 8. See H. W.
Brands's *The Age of Gold: The California
Gold Rush and the American Dream* (New
York: Anchor Books, 2002), 469, for an
account of George naming the Homestake
mine based on Phoebe's suggestion.

16. August Mark Vaz, *The Portuguese in
California* (Oakland, CA: I.D.E.S.
Supreme Council, 1965), 41; David E.
Bertão, *The Portuguese Shore Whalers
of California 1854–1904* (San Jose, CA:
Portuguese Heritage Publications of
California, 2006), 160.

17. *The San Luis Obispo Tribune*, September 2,
1876, as quoted in Bertão, *Portuguese Shore
Whalers*, 161–162. Captain Clark's wharf
was called "Whalers' Wharf," located just
high enough to remain uncovered during
high tide. A wooden ramp led to three
huge vats, known as trypots. Here the
whale carcasses were boiled into whale
oil, which was used primarily for
lighting.

18. Charles H. Townsend, "Present
Condition of the California Gray Whale
Fishery," *Bulletin of the United States Fish
Commission, Vol. 6 for 1886* (Washington:
Government Printing Office, 1887),
347; Robert Pavlik, "Shore Whaling at
San Simeon Bay," *The National Maritime
Museum Association Sea Letter* 43, fall/
winter 1990, 20; Bertão, *Portuguese Shore
Whalers*, 169.

19. Hearst, *The Way It Was*, 35–36. The
Chinese seaweed farmers of the region
originated the practice throughout
California. For a thorough discussion,
see Dolores K. Young, "The Seaweed
Gatherers on the Central Coast of
California," in *The Chinese in America:
A History from Gold Mountain to the New
Millennium*, edited by Susie Lan Cassel
(Walnut Creek, CA: AltaMira Press,
2002), 157–158.

20. W. R. Hearst to P. A. Hearst, September
21, 1879; c. 1885, Bancroft Library. Will
continued to write gloomy letters to
Phoebe bemoaning the East Coast climate
while he was at Harvard.

21. P. A. Hearst to G. Hearst, February 5,
1879, Bancroft Library. On the same day,
the *San Francisco Chronicle* stated, "Juan
Castro has sold to George Hearst 23,000
acres of the Piedro Blanco Rancho [*sic*],
San Luis Obispo county, with 400 head
of stock, for $85,000."

22. W. R. Hearst to G. Hearst, March 29,
1878, Bancroft Library.

23. W. R. Hearst to P. A. Hearst, c. 1885; c.
1884, Bancroft Library. Will continued,
"The sky, the naked trees, and solemn
old college building are all reeking
with moisture and oozing out and
dripping off a clammy dew. If you want
to picture it to yourself read Dickens'
description of Chesney Wold in rainy
weather [from *Bleak House*]. My stubbed
and unpracticed pen is not equal to the
emergency." And in an undated letter to
Phoebe c. 1884, "If the Lord made New
England, he is ashamed of it."

24. W. R. Hearst to P. A. Hearst, c. 1884,
Bancroft Library.

25. Mrs. Fremont Older, *William Randolph
Hearst: American* (New York: Appleton-
Century Co., 1936), 42–44.

26. Hearst, *The Way It Was*, 20.

27. W. R. Hearst to P. A. Hearst, c. 1884,
Bancroft Library. This pertains to the
sale of their San Francisco residence
at 1501 Van Ness Boulevard, which was
purchased in 1881. Will continued,
"And then we would have our library
and when the wind was blowing rudely
outside and his weak-eyed sister clouds
were whimpering at his coarse behavior,
we could sit inside before a cheerful fire
and hold converse with Mssrs. Dickens
and Thackeray. . . . But really if you are
going to build you might as well put a
little more money into the house and
give us something we can recognize as
home."

CHAPTER 3

1. G. Hearst to P. A. Hearst, December 16,
1882, Bancroft Library. For a discussion
of Will's advent at the *San Francisco
Examiner*, see Kenneth Whyte, *The
Uncrowned King: The Sensational Rise of
William Randolph Hearst* (Berkeley, CA:
Counterpoint, 2009) 24–35.

2. W. R. Hearst to G. Hearst, April 19, 1883;
W. R. Hearst to P. A. Hearst, 27 April 1884,
Bancroft Library. Jack Follansbee was
the nephew of the Wall Street speculator
James R. Keene.

3. P. A. Hearst to G. Hearst, October 22,
1885, Bancroft Library.

4. W. R. Hearst to G. Hearst, January 4,
1885; January 29, 1885; W. R. Hearst
to P. A. Hearst, c. June 1885, Bancroft
Library. Will wrote to Phoebe c. June 1885:
"Everybody East here talks about going out
to California ranching when they graduate,
and, if they do, there wont be a ranch
bigger than a 50 vara lot in California. Just
remind papa that he has often let good
opportunities go by on account of thinking
too long, and don't let him neglect this if
you can help it."

5. W. R. Hearst to P. A. Hearst, July 25,
1886, Bancroft Library. In later years
when Eleanor Calhoun was an actress in
London, she wrote fondly of California,
"Indeed, the earth of my California
mountains still clung to my shoes. . . ." See
Lazarovich-Hrebelianovich, *Pleasures and
Palaces: The Memoirs of Princess Lazarovich-
Hrebelianovich (Eleanor Calhoun)* (New
York: The Century Co., 1915), 75.

6. P. A. Hearst to Orrin Peck, December 22,
1886, Huntington Library; W. R. Hearst
to G. Hearst, c. 1885; W. R. Hearst to P.
A. Hearst, c. 1886, Bancroft Library. Will
wrote to his father c. 1885, stating that
the town around the Anaconda mine
resembled "a box of those toy houses I
used to have when a child, but irregularly
arranged and considerably the worse
for wear and with its harmony ruined by
additions from another and still worse
worn set." Will was eager to demonstrate
his business acumen, writing Phoebe c.
1886, "I really don't see what is to prevent
us from owning all Mexico and running it
to suit ourselves."

7. David Nasaw, *The Chief: The Life of William
Randolph Hearst* (New York: Houghton
Mifflin, 2000), 59–60. Talented cowboy
artist Edward Borein was hired on at
Babicora in 1903. Borein helped drive
1,800 cattle from Babicora to Columbus,
New Mexico. He wrote about the trip's
many stampedes, injured vaqueros,
and arduous conditions. See Harold G.
Davidson, *Edward Borein: Cowboy Artist:
The Life and Works of John Edward Borein*

1872–1945 (Garden City, NY: Doubleday, 1974), 42.

8. W. R. Hearst to G. Hearst, c. April 1887, Bancroft Library. The *San Francisco Examiner* sponsored the capture of one of California's last grizzly bears. W. R. dubbed him Monarch, and ornamented the *Examiner*'s masthead with the motto *Monarch of the Dailies*. Monarch lived a long life penned in Golden Gate Park.

9. "A Great Breeding Farm: The Stock and Stables of Senator Hearst in this County," *San Luis Obispo Tribune*, August 15, 1889. These stables were located along Santa Rosa Creek and employed ten men.

10. W. R. Hearst to G. Hearst, telegram, June 28, c. 1889, Bancroft Library. George's partner James Ben Ali Haggin owned the world-famous racing stables, Rancho de Paso, in Sacramento. George bid $37,500 for King Thomas against Lucien O. Appleby, who bought the horse for $38,000. The following day George bought King Thomas from Appleby for $40,000. King Thomas never won a race. George seemed to view King Thomas's failings with equanimity: "Hearst never complained about the failure of King Thomas to live up to racing expectations. When asked why King Thomas so greatly appealed to him, George answered with a quaint smile, 'He is a friendly fellow. I like to rub his nose. He seems to know me.'" Older, *George Hearst*, 174.

11. W. R. Hearst to G. Hearst, c. fall 1889, Bancroft Library.

12. "Father and Son," *San Francisco Call*, July 29, 1890. In 1890 George attained the year's third largest winnings. His colt Tournament won $89,575—more money than any other horse had won. George hired the talented African-American jockey Tony Hamilton in 1889, and the renowned African-American horse trainer Albert Cooper in 1890. See "Racing Season of 1890," *Sacramento Daily Union*, December 7, 1890.

13. O. Peck to P. A. Hearst, April 28, 1891, Bancroft Library; "Honest George Hearst," *The Illustrated American*, March 21, 1891, 234. A well-known tale had George spelling b-u-r-d. When bets were laid, George wrote "bird." When

confronted, George replied, "Did you think I was blanked fool enough to spell 'bird' with a 'u' when there was any money up on it?"

14. Margaret Peck to P. A. Hearst, June 1, 1890, Bancroft Library. Orrin, his mother, and his sister Janet all received money from Phoebe. George's entire stable of racehorses was sold on May 14, 1891, for $128,100. See the *New York Times*, "Racing News and Notions," April 13, 1891; "High Prices for Racers," May 15, 1891. George's estate was estimated at $8 million, with the combined San Simeon and Santa Rosa ranches valued at $763,000. See the *San Francisco Call*, "Hearst's Fortune," July 12, 1891.

15. W. R. Hearst to P. A. Hearst, telegram, February 4, 1895, Bancroft Library; Leslie M. Freudenheim, *Building with Nature: Inspiration for the Arts and Crafts Home* (Layton, UT: Gibbs Smith, 2005), 53. The Hearsts owned several other farms in California, including the large fruit ranch in the Sierra foothills known as Palermo, which George bought in 1888. It totaled 700 acres, of which 250 acres were orange groves.

16. Albert C. Schweinfurth to Edward Hardy Clark, December 20, c. 1895, quoted in Freudenheim, *Building with Nature*, 53; P. A. Hearst to O. Peck, May 26, 1896, Huntington Library. Phoebe wrote to Orrin Peck in May concerning arrangements for the Chinese cooks and the ranch operations: "We will have all vegetables and small fruits grown on the place after this year—and have cows— [and] our own butter."

17. "California Girl Wins High Honor," *San Francisco Examiner*, December 6, 1898. This article on Morgan's admission was typical of the press she also received on attaining her diploma in 1901. Morgan completed the program in three years— half the average time.

18. W. R. Hearst to P. A. Hearst, c. January 1889, Bancroft Library. Hearst's collecting style was honed in his twenties and has been described as "extravagant, amusing, intuitive, and voracious." See Mary L. Levkoff, *Hearst the Collector* (New York: Abrams, 2008), 24.

19. W. R. Hearst to P. A. Hearst, c. summer 1906, Bancroft Library. Captain Murray

Taylor was a Confederate aide to General A. P. Hill in the Civil War. He was ranch manager from 1892–1908. On his retirement, Phoebe purchased back Fall Hill, his family estate near Fredericksburg, Virginia, and gave it to him as a gift.

20. Edward Hardy Clark Jr., "Remembering Wyntoon and the Hearst Family," interview by Metta Hake and Tom Scott, edited by Robert Pavlik, *Oral History Project* (San Simeon, CA: Hearst San Simeon State Historical Monument, 1991), 61. The "Piedra Blanca Rancho Payroll" records for June 1892 (HM 31157, Huntington Library) list fifty-three ranch employees. The vaqueros often had Spanish surnames (for example, "F. [Don Pancho Francisco] Estrada," and "Angelmo Abila"), the cooks and waiters were generally Chinese (for instance, "Ah Luis" was listed as "1st cook" and "Ah Wong" was listed as a waiter), and the foreman, blacksmith, and most other similar ranch employees had Anglo surnames ("Thomas Leggett" was listed as a blacksmith and "E. Hitchcock" worked with the stable and horses). Between January 1910 and December 1911, Don Pancho Estrada and his wife Mary lived in the Senator's House while he served as interim ranch manager. Phoebe remained actively engaged in ranch operations. She reviewed accounts, mediated disputes, and distributed gifts.

21. J. Smeaton Chase, *California Coast Trails: A Horseback Ride from Mexico to Oregon* (Boston: Houghton Mifflin, 1913), 162–163; Geneva Hamilton, *Where the Highway Ends: Cambria, San Simeon and the Ranchos* (San Luis Obispo, CA: Padre Productions, 1974), 160; Morrison and Haydon, *Pioneers of San Luis Obispo County & Environs*, 159. The Ferrari-Righetti hotel was built in 1876 on the lot adjoining the old saloon and the Frankl store. In 1904 Lorin Thorndyke Jr. purchased the store and took over the management of the hotel. The Bay View Inn was built in 1878. In 1914, the Thorndyke family sold the store to Manuel Sebastian Sr. In the 1920s the Sebastians lived at the Bay View Hotel.

CHAPTER 4

1. W. R. Hearst to P. A. Hearst, telegram, April 28, 1915, Bancroft Papers; Robinson, *The Hearsts: An American Dynasty*, 352; Nasaw, *The Chief*, 219.

2. W. R. Hearst to P. A. Hearst, August 30, 1917; O. Peck to P. A. Hearst, c. 1917, Bancroft Library. These camping experiences were rustic. Orrin Peck wrote to Phoebe, "It has been a delightful outing . . .Will shot a skunk yesterday—my room smelled as tho' it had been under my bed overnight. I heard a noise & it was only a wood-rat pulling my shoes around." W. R. wrote to Phoebe on August 30, 1917, "George is off now fishing with Pancho. Pancho used to be my companion, but I never see him any more, now that the children are here. He is either riding with John, fishing with George, or teaching William how to throw the riata, and in some way spends his time with them. It takes me back to the time, forty years ago, when I was a child on the ranch, and Pancho used to look out for me. How old is Pancho, anyway?"

3. W. R. Hearst to P. A. Hearst, c. September 1917, Bancroft Library; Morrison and Haydon, *Pioneers of San Luis Obispo County*, 597. Joseph Burwell F. Lee, nephew of Robert E. Lee, was hired as Captain Taylor's assistant in 1896. Lee became ranch manager in 1911. He married Don Pancho and Mary's daughter, Julia Estrada.

4. William Randolph Hearst to Julia Morgan, October 25, 1919, The Julia Morgan Papers, MS010, Special Collections, Robert E. Kennedy Library, California State Polytechnic University, San Luis Obispo, CA. Unless otherwise noted, all correspondence cited from the "Kennedy Library" is in the Julia Morgan Papers, and is used with permission. For background on Marion Davies, see Fred Lawrence Guiles, *Marion Davies: A Biography* (New York: McGraw-Hill, 1972). For background on country-house model farms, see Clive Aslet, *The American Country House* (New Haven, CT: Yale University Press, 2004).

5. W. R. Hearst to J. Morgan, February 6, 1923; O. Peck to J. Morgan, c. May 1920, Kennedy Library. Orrin Peck wrote to Morgan, c. 1920, "I told Will we will have to have a Hotel at San Simeon where real Mexican food can be had—a garden of course goes with it making it a popular stopover from Monterey (when the road come [sic] along the coast. . . . If we dont all die before its completed—we may have a good time some day—I'm having it now in contemplation." See "Hearst to Build Inn," *San Luis Obispo Tribune*, October 11, 1929.

6. W. R. Hearst to J. Morgan, c. September 15, 1923, Kennedy Library.

7. W. R. Hearst to J. Morgan, May 11, 1921, Kennedy Library.

8. W. R. Hearst to J. Morgan, telegram, June 2, 1921; W. R. Hearst to J. Morgan, second telegram, June 2, 1921, Kennedy Library.

9. J. Morgan to W. R. Hearst, May 27, 1924, Kennedy Library.

10. W. R. Hearst to J. Morgan, January 29, 1925; W. R. Hearst to J. Morgan, telegram, July 6, 1925, Kennedy Library. For a history of the Harmony Valley Creamery Association, see Paula Juelke Carr, "Harmony Along the Coast," in *Heritage Shared Studies in Central Coast History*, edited by Thomas Wheeler (San Luis Obispo, CA: Heritage Shared, 2008), 33–35. On September 11, 1927, in "Jerseys Win Honors in San Luis Obispo," the *Los Angeles Times* reported, "The Hearst Ranch made a clean sweep on champion cows, winning senior, junior and grand championships."

11. J. Morgan to W. R. Hearst, October 26, 1922, Kennedy Library.

12. J. Morgan to W. R. Hearst, April 22, 1925, Kennedy Library.

13. J. Morgan to W. R. Hearst, April 8, 1927, Kennedy Library.

14. W. R. Hearst to J. Morgan, October 18, 1927; J. Morgan to W. R. Hearst, November 20, 1927, Kennedy Library. Hearst wrote to Morgan on March 26, 1926 (Kennedy Library): "The ranch is not merely a game park it is primarily a cow park and profitable."

15. Stanley Heaton and Elmer Moorhouse, "Gardening and Road Construction," interview by Metta Hake, edited by William Payne and Robert Pavlik, *Oral History Project* (San Simeon, CA: Hearst San Simeon State Historical Monument, March 27, 1984), 7.

16. W. R. Hearst to Camille Rossi and J. Morgan, February 19, 1927, Kennedy Library.

17. W. R. Hearst to J. Morgan, August 14, 1929, Kennedy Library. In addition to building warehouses and employee residences, Hearst intended to build a saltwater pool at San Simeon. It was never constructed.

18. Thaddeus Joy to W. R. Hearst, October 23, 1926, Kennedy Library.

19. W. R. Hearst to J. Morgan, telegram, December 21, 1926, Kennedy Library.

20. J. Morgan to W. R. Hearst, telegram, December 28, 1926, Kennedy Library.

CHAPTER 5

1. W. R. Hearst to J. Morgan and C. Rossi, February 19, 1927, Kennedy Library.

2. W. R. Hearst to Arch Parks, September 19, 1926, Ranch Office Papers, The Hearst Corporation Archives, McCloud, CA (hereafter "The Hearst Corporation"). Cipriano Soto often rode in these parades. Soto was born in 1870 and worked for the Hearst Ranch from the age of seventeen. In the 1880s, Cipriano was the coachman for Phoebe Apperson Hearst. See Robert Soto, *An Old California Family: The Sotos of Cambria* (San Luis Obispo, CA: Central Coast Press, 2011), 88–89.

3. W. R. Hearst to A. Parks, October 4, 1926, The Hearst Corporation. Phoebe Apperson Hearst began collecting impressive silver saddles, largely from Mexico, and W. R. continued the tradition. Both the Pasadena Tournament of Roses parade and the Hollywood movie industry further popularized the use of elaborate saddles. See William Manns, "Silver Sensations," *American Cowboy* 11, no. 5, January–February 2005, 60–65.

4. Kenneth Winsor, "Cowboy on the Hearst Ranch, 1926–1930," interview by Zel Bordegaray and Metta Hake, edited by Michelle Hachigian and John Horn, *Oral History Project* (San Simeon, CA: Hearst San Simeon State Historical Monument, 2004), 3–5. There was a steady exchange of Spanish and Anglo cowboys moving between the Babicora and the Piedra Blanca ranches.

5. J. Morgan to W. R. Hearst, telegram, September 13, 1925, Kennedy Library. The 8,900-acre Rancho Los Ojitos

was granted to Mariano Soberanes by Governor Alvarado on April 4, 1842. The 13,329-acre Rancho El Piojo was granted to Joaquin Soto by Governor Alvarado on August 20, 1842. The 22,153-acre Rancho San Miguelito was granted to Jose Rafael Gonzales on July 24, 1841. George Dutton purchased the Jolon adobe and surrounding hundred acres in 1876 for $1,000. Dutton and Captain T. T. Tidball established a store. Tidball subsequently built a two-story hotel and additional store at Jolon. See Beatrice Casey, *Padres and People of Old Mission San Antonio* (King City, CA: The Rustler-Herald, 1957), 26.

6. Richard A. Clark to Harry Taylor, May 15, 1929, The Hearst Corporation. The Hearst newspapers' syndicated columnist and W. R.'s close friend Arthur Brisbane described eating "King City pink beans" at the Hacienda's thirty-by-fifteen-foot dining table. See Eva Taylor, *Oxcart, Chuckwagon and Jeep* (San Lucas, CA: Eva Taylor, 1950), 18. Hearst had a superb collection of Navajo rugs and blankets, many of which he displayed at the Hacienda. He donated more than 200 Native American textiles to the Los Angeles County Museum in 1942. See Nancy J. Blomberg, *Navajo Textiles: The William Randolph Hearst Collection* (Tucson: The University of Arizona Press, 1988), 11–14.

7. J. Morgan to W. R. Hearst, August 12, 1930, Kennedy Library; Victoria Kastner, *Hearst's San Simeon: The Gardens and the Land* (New York: Abrams, 2009), 10, 16. The Milpitas Hacienda provided a romantic return to an idealized early California. Its relationship to La Cuesta Encantada was similar to that of the Petit Trianon to Versailles.

8. John Steinbeck, "To a God Unknown" (unpublished manuscript), quoted in Susan Raycraft and Ann Keenan Beckett, *San Antonio Valley* (Charleston, SC: Arcadia, 2006), 31.

9. Taylor, *Oxcart, Chuckwagon and Jeep*, 31.

10. Adela Rogers St. Johns, "Hearst As a Host," interview by Gerald Reynolds, edited by Robert C. Pavlik, *Oral History Project* (San Simeon, CA: Hearst San Simeon State Historical Monument, April 1971), 7; John F. Dunlap, *The Hearst Saga: The Way It Really Was* (privately published by the family of John F. Dunlap, 2002), 580–581. Dunlap quotes from an undated letter in his personal collection, written by Hearst to his attorney, John Francis Neylan: "The result of ten years of separation is that we now have different tastes, different friends, and different interests. . . . Mrs. Hearst cabled you a year ago that she wanted a divorce. If she is still of the same mind she should proceed to get the divorce. If she does not do this I should go to Reno or Cuba or Mexico and get it."

11. Marion Davies, *The Times We Had: Life with William Randolph Hearst* (Indianapolis, IN: Bobbs-Merrill, 1975), 34; Dunlap, *The Hearst Saga*, 628. Hearst is quoted describing Marion Davies: "She is a patient model. I guess she is a pretty good girl all around. I have never seen anyone like her. She never loses her temper and her smiling good nature on all occasions—even trying ones—keeps other people from losing theirs."

12. Aileen Pringle, "Silent Movie Actress and Frequent Guest," interview by Metta Hake, edited by Robert C. Pavlik, *Oral History Project* (San Simeon, CA: Hearst San Simeon State Historical Monument, October 18, 1981), 4; Will Rogers, "Will Rogers Finds a Haven Out West for Man and Beast," in *Will Rogers' Daily Telegrams: The Hoover Years, 1931–1932*, eds. James M. Smallwood and Steven K. Gragert (Stillwater: Oklahoma State University Press, 1979), 122–123. Frequent guest Will Rogers wrote about the diversity of Hearst's guests: "If you have missed anybody from any part of the United States and can't find 'em they are here [as] guests of this ranch."

13. W. R. Hearst to George Bernard Shaw, March 17, 1927 (William Randolph Hearst Papers, Bancroft Library) quoted in Nasaw, *The Chief*, 389; Carlota Chapman Munroe, "Daughter of Princess Conchita Sepúlveda Chapman Pignatelli," interview by Jill Urquhart, edited by Jill Urquhart, Michelle Hachigian, and Joanne Aasen, *Oral History Project* (San Simeon, CA: Hearst San Simeon State Historical Monument, October 1, 2009), 31, 34. Carlota Chapman Munroe (the daughter of Hearst family friend and newspaper columnist Conchita Sepúlveda Chapman Pignatelli) recalled roasting marshmallows and telling ghost stories around the fire while on these camping trips.

14. Alice M. Head, *It Could Never Have Happened* (London: W. Heinemann, 1939), 381. Hearst employed many women in important capacities, including reporters Winifred Bonfils and Adela Rogers St. Johns, editor Cissy Patterson, and screenwriter Frances Marion.

15. Iron Eyes Cody, *Iron Eyes, My Life As a Hollywood Indian: By Iron Eyes Cody As Told to Collin Perry* (London: Muller, 1982), 122–123. Iron Eyes Cody was born Espera DeCorti in Louisiana in 1904. He lived most of his adult life as an Indian, marrying an Indian woman, changing his name to Iron Eyes Cody, and becoming an actor of Indian roles in the 1920s.

16. Ibid., 123–125.

17. Mrs. William Randolph Hearst Jr., *The Horses of San Simeon* (San Simeon: San Simeon Press, 1985), 215; Richard Meryman, *Mank: The Wit, World, and Life of Herman Mankiewicz* (New York: William Morrow, 1978), 227. Herman Mankiewicz, the screenwriter of *Citizen Kane*, recalled visiting San Simeon several years before the film. He went riding and fell off his horse. While he lay there in the dust testing his arms, legs, and head for damage, everyone was shouting, "Get the horse!"

18. Davies, *The Times We Had*, 94–95.

19. Eleanor Boardman, "An Interview with Eleanor Boardman," interview by Metta Hake, edited by Robert C. Pavlik, *Oral History Project* (San Simeon, CA: Hearst San Simeon State Historical Monument, July 20, 1982), 18.

20. King Vidor, *A Tree Is a Tree* (Hollywood, Calif.: S. French, 1989), 163. Hearst produced three Westerns among his dozens of film productions: *The Cowboy in Brooklyn* (Cosmopolitan for Warners) with Dick Powell, Pat O'Brien, Priscilla Lane, and Ronald Reagan, in 1938; *Return of the Cisco Kid* (Warners) with Warner Baxter, Lynn Bari, Cesar Romero, Henry Hull, and Kane Richmond, in 1939; and *Gold is Where You Find It* (Cosmopolitan for Warners) with George Brent, Olivia de Haviland, Claude Rains, and Sidney Toler, in 1938. In the latter Gold Rush movie, a minor character briefly portrays George Hearst.

21. Ben Yagoda, *Will Rogers: A Biography* (Norman: University of Oklahoma Press,

2000), 42, 139; Richard D. White, Jr., *Will Rogers: A Political Life* (Lubbock: Texas Tech University Press, 2011), 16. The Hearst press published some of Will Rogers's first articles in 1916. See "Will Rogers Sees California Life as in Premovie Days," *Washington Post*, August 12, 1927.

22. Charles Parlet, "Life on San Simeon Ranch 1921–1977," interview by Tom Scott, edited by Michelle Hachigian, *Oral History Project* (San Simeon, CA: Hearst San Simeon State Historical Monument, 1977), 8; Fred and Edna Calkins, "Dude Wrangler and Head Housekeeper at the Hearst Ranch," interview by Lee Greenawalt, edited by Laurel Stewart, *Oral History Project* (San Simeon, CA: Hearst San Simeon State Historical Monument, 1990), 28; Winsor, "Cowboy on the Hearst Ranch, 1926–1930," *Oral History Project*, 5.

23. Isabelle Orr, "Two Weeks at the Castle," interview by Joan Sullivan, edited by Laurel Stewart, *Oral History Project* (San Simeon, CA: Hearst San Simeon State Historical Monument, 1991), 5–7.

24. William R. Hearst Jr., *The Hearsts: Father and Son* (Niwot, CO: Roberts Rinehart, 1991), 189. One female guest arrived at the hilltop by taxi and was treated to an armed hold-up, to welcome her to the Wild West. Hearst cowboys played the bandits and brandished six-shooters. The effect was likely diminished because it was raining heavily at the time. See Archie Soto, "An Oral History Project Concerning the San Simeon Home of William Randolph Hearst," Senior Project Interview by James E. Woodruff (San Luis Obispo, CA: California Polytechnic State University, 1977), 20–21.

25. Colleen Moore, "The Jazz Age's Movie Flapper at San Simeon," interview by Eileen Hook, *Oral History Project* (San Simeon, CA: Hearst San Simeon State Historical Monument, January 25, 1977), 4.

26. Norma Bassi Monson, "Growing up in San Simeon with Grandparents Manuel & Mary Sebastian," interview by John F. Horn, edited by Michelle Hachigian and John Horn, *Oral History Project* (San Simeon, CA: Hearst San Simeon State Historical Monument, April 1, 2003), 9. Don Pancho was esteemed not only by W. R. but also by W. R.'s close friend Orrin Peck, a talented artist who painted two superb oil portraits of Mary Estrada (Don Pancho's wife) and Julia Estrada Lee (Don Pancho and Mary's daughter). These paintings remain in their descendants' possession.

27. Older, *William Randolph Hearst*, 539.

28. W. R. Hearst to J. Morgan, October 28, 1927, Kennedy Library; A. Parks to W. R. Hearst, April 27, 1927, The Hearst Corporation.

29. John R. Hearst Jr., "Life with Grandfather," *Reader's Digest* 76, no. 457, May 1960, 158–159. John Jr. "Bunky" Hearst was the only Hearst relative—and also the only child—to live on the hilltop for an extended time (from 1945 to 1947).

CHAPTER 6

1. Robert V. Hoffman, "The Country Gentleman of To-day," *Country Life in America* 61, January 1932, 65.

2. W. R. Hearst to J. Morgan, December 15, 1921, Kennedy Library.

3. W. R. Hearst to J. Morgan, c. December 1921, Kennedy Library.

4. W. R. Hearst to J. Morgan, February 6, 1923, Kennedy Library.

5. W. R. Hearst to J. Morgan, May 14, 1922; February 6, 1923, Kennedy Library. Hearst wrote Morgan on February 6, 1923: "I would like to see [reservoir hill south of the Castle] as completely as possible covered with conifers. First, because I want the conifers and second, I think that hill is one of the few things that is not very pretty as it stands and can be made wonderfully pretty as a conifer-covered mountain."

6. Nigel Keep, "Trees of San Simeon" (San Simeon, CA: Hearst San Simeon State Historical Monument), 1946

7. J. Morgan to W. R. Hearst, May 27, 1924, Kennedy Library; Walter L. Huber to Camille Rossi, 5 December 1923; W. L. Huber to J. Morgan, September 13, 1924, Walter Huber Papers, C-B 825, Bancroft Library. In a letter to Morgan, engineer Walter Huber reports, "The flow available at the existing farm buildings is approximately 80 times that from Portuguese Spring, 4-1/3 times that from Pat Garrity Spring, and 4-1/8 times the combined flow of the two springs." While arranging an inspection of the water systems, Huber wrote to Rossi, "I understand it will be necessary for us to make a trip of a couple days on horseback. This is one means of travel which I do not specially enjoy, and I want to put in a word in advance for a horse as gentle as a clotheshorse. Tramping afoot is very easy for me but riding horseback is another matter."

8. Maurice McClure, "From Laborer to Construction Superintendent," interview by Metta Hake, edited by Bernice J. Falls and Robert Pavlik, *Oral History Project* (San Simeon, CA: Hearst San Simeon State Historical Monument, September 13, 1981), 5.

9. Harley Boisen, "Dairy Worker, 1935–1937," interview by Ted Moreno, edited by Rayena Martin, *Oral History Project* (San Simeon, CA: Hearst San Simeon State Historical Monument, December 8, 1987), 6.

10. J. Morgan to W. R. Hearst, December 5, 1928, Kennedy Library.

11. Norman Rotanzi, "Fifty-Four Years at San Simeon," interview by Julie Payne, edited by Robert Pavlik, *Oral History Project* (San Simeon, CA: Hearst San Simeon State Historical Monument, June 6, 1988), 5. Norman Rotanzi began working as a gatekeeper at the ranch in 1934. He soon transferred to the grounds department, where he remained employed for fifty-eight years, until his death in 1992.

12. Brayton Laird, "Working in the Orchards of the Hearst Ranch," interview by Bruce Brown, edited by Robert C. Pavlik, *Oral History Project* (San Simeon, CA: Hearst San Simeon State Historical Monument, December 19, 1986), 6; Rotanzi, "Fifty-Four Years at San Simeon," *Oral History Project*, 2. The fruit was raised for Hearst's table and also sent in boxes to ranch employees living in San Simeon. In the fall the local women put up jams and jellies. Today the orchard in the pergola area is under restoration. The citrus groves on the hilltop still produce thousands of pounds of fruit each year, which is donated to local food banks.

13. W. R. Hearst to J. Morgan, April 3, 1930, Kennedy Library. See Bertha Hawley, "The Poultry Ranch, 1940s, Castle Waitress, 1950s," 1984, 1–3.

14. W. R. Hearst to A. Parks, December 23, 1930, The Hearst Corporation; "Nature Expert in Compliment to City's Zoo," *Los Angeles Times*, 25 April 1928. Featherhill Ranch in Santa Barbara—a private zoo with dozens of bird species—served as inspiration for their poultry operation.

15. Gladwin Read, "La Cuesta Encantada at San Simeon," (San Simeon, CA: Hearst Castle Archives, 1955), 28–29, 45.

16. W. R. Hearst to A. Parks, March 2, 1928, The Hearst Corporation. Their hogs were raised on a combination of grain and acorns. They raised mixed-breed hogs in the late twenties, though Hearst wanted to change to purebred hogs, just as they raised purebred cattle.

17. W. R. Hearst to A. Parks, March 10, 1928, The Hearst Corporation.

18. Arthur T. Goldsborough to Matthew T. Goldsborough, May 13, 1921, Hearst Castle Staff Library. Goldsborough worked for Phoebe Apperson Hearst at her Pleasanton estate.

19. W. R. Hearst to Edward H. Clark, July 19, 1927, The Hearst Corporation. Hearst wanted to operate the Milpitas Ranch directly rather than lease it out to tenants. He wrote Edward Hardy Clark on June 10, 1927: "[I] think 15,000 head of cattle can be carried on these ranches. We can carry at least 2,000 more head of cattle and sell our steers at 3 years old, but I think the way to reach the 15,000 head is to sell our steers at 2 years old. . . . I know this cannot be done immediately but should be done as soon as possible."

20. Betty Farrell Doty, "Cowboy at the Castle: King City Man Recalls Life at Hearst Ranch," *Salinas Californian*, fall 1990; Joseph Willicombe to A. Parks, October 16, 1927, The Hearst Corporation. An undated list from the period indicates the names of various hay fields: Gillis field, Fiscalini field, Little Adobe field, Stud field, Coast field, Knoll field, Pico Pond field, Bill Bushton field, Pines field, Potter field, and Pelkey flat.

21. W. R. Hearst to J. Morgan, April 16, 1928, Kennedy Library.

22. Boisen, "Dairy Worker," *Oral History Project*, 18; John Arnold, transcription of an interview by the author, May 9, 2012, 6. Arnold recalled being awakened by loud noises at the Burnett Cabin. A large black boar had caught his tusks in the fence wire and "he couldn't back up, and the dogs were biting him on the nose. . . . So I got the dogs off him. Then I had to go to the truck and get the wire cutter. I'm out there in my undies . . . [trying to] let the pig out." See also George Randolph Hearst Jr., interview by the author, June 28, 2010, 26. "The old cabin was just a one-room with a wood stove, and a kitchen table, and a sink. And that's where we used to stay in the early days. It had a lean-to covered with oak branches for shade." It was torn down and rebuilt in the 1970s.

23. Norman Rotanzi, "The Ranch, Dairy, Orchard, and Grounds: An Oral History Interview," interview by Tom Scott, *Oral History Project* (San Simeon, CA: Hearst San Simeon State Historical Monument, 1989), 2; George Loorz to W. R. Hearst, April 6, 1934, George Loorz Papers, History Center of San Luis Obispo County, San Luis Obispo, CA. (Unless otherwise noted all correspondence cited from the "History Center of SLO Co." is from the George Loorz Papers.)

24. "Is Wonderful Estate: Hearst Holding in Chihuahua," *Mexican Herald*, August 24, 1908, quoted in John Kenneth Turner, *Barbarous Mexico* (Austin: The University of Texas Press, 1969), 251; Linda G. Harris, *Ghost Towns Alive: Trips to New Mexico's Past* (Albuquerque: University of New Mexico Press, 2003), 206–207. The Babicora Ranch was run in conjunction with the Diamond A Ranch in New Mexico, owned by George Hearst, Lloyd Tevis, and James Ben Ali Haggin. They purchased it jointly in 1883 for $12,000 and established the Victorio Land and Cattle Company. The ranch itself came to be known by its cattle brand, the Diamond A.

25. Hector Marquez, "Son of Babicora Ranch Manager," interview by Robert Pavlik, edited by Laurel Stewart, Rayena Pavlik, and John Horn, *Oral History Project* (San Simeon, CA: Hearst San Simeon State Historical Monument, February 3, 1992), 6–7. See Robinson, *The Hearsts: An American Dynasty*, 360–361, and Nasaw, *The Chief*, 248–249, on the 1915 Pancho Villa uprising. Villa's troops killed men and appropriated land and livestock. Babicora remained in Hearst hands, but was much reduced in size. After the uprising, Hearst vociferously advocated United States intervention in Mexico.

26. W. D. Duke to A. Parks, January 20, 1929, The Hearst Corporation. Duke recalled Hearst saying "Babicora was supposed to brand about 27,000 calves in 1927."

27. R. A. Clark to G. T. Peter, August 18, 1933, The Hearst Corporation; "Hearst Cattle 'Feed Out,'" *New York Times*, December 4, 1932, 6. In 1932, the *New York Times* announced that Hearst Ranch interests had arranged to "feed out" at least 5,000 head of cattle in Brownfield, Texas, in 1932 and that this number might be increased to 10,000.

28. Archie Soto, "An Oral History Project Concerning the San Simeon Home of William Randolph Hearst," Senior Project Interview by James E. Woodruff (San Luis Obispo, CA: California Polytechnic State University, 1977), 37, 39, 56; Michael Edward Shapiro, et al, *Frederic Remington: The Masterworks* (St. Louis, MO: Abrams, 1988), 182. *The Bronco Buster* was Remington's first bronze sculpture, cast in 1895. He wrote to a friend, "My oils will all get old and watery . . . my watercolors will fade—but I am to endure in bronze. . . . I am doing a cowboy on a bucking bronco and I am going to rattle down through the ages."

29. Winsor, "Cowboy on the Hearst Ranch," *Oral History Project*, 26.

30. W. R. Hearst to William Robinson Brown, c. 1930, quoted in Mrs. William Randolph Hearst Jr, *The Horses of San Simeon*, 181. Phoebe Hearst owned Arabians as early as 1911. See Lucia Shepardson, "An Arabian Stud Farm in California," *Overland Monthly* LVII, January–June 1911, 56, and George H. Conn, *The Arabian Horse in America* (New York: A. S. Barnes and Co., 1957), 185. Some of Hearst's Arabian seed stock was acquired from the W. R. Brown stud of Berlin and the W. K. Kellogg Arabian Horse Ranch at Pomona, California.

31. Hearst, *Horses of San Simeon*, 143, 145. Hearst began his Morgan horse breeding

program in 1929 with the purchase of
fourteen young mares—five yearlings
and nine two-year-olds—from Roland
Hill. Twelve were daughters of the
Brunk-bred Pongee Morgan (Allen King
x Galva). Three lines of this stallion's
heritage traced to Daniel Lambert 62. The
other two young mares were by Querido
(Bennington x Artemisia). The dams
were bred by Richard Sellman and sold
to Roland Hill. See LaVonne Houlton,
"William Randolph Hearst and His
Morgan Horses," *The Morgan Horse* LX,
no. 7, July 2001, 130.

32. Robert B. Combs, "Horse Trainer,"
interview by Robert C. Pavlik, edited by
John Horn and Michelle Hachigian, *Oral
History Project* (San Simeon, CA: Hearst
San Simeon State Historical Monument,
January 27, 1987), 2–5; Brad Prowse, "The
Little Horse that Could," *American Cowboy*
3, no. 5, January–February 1997, 65.

33. Hearst, *Horses of San Simeon*, 150–151.
Hearst coined the name Morab for the
progeny of his two Arab stallions, Ksar
and Ghazi, which he crossed with Morgan
mares.

34. J. Morgan to W. R. Hearst, January 20,
1928, Kennedy Library. Hearst had the
vegetable garden on the ranch shut down
and many of the zoo animals sold.

35. W. R. Hearst to A. Parks, February 23,
1931, The Hearst Corporation.

36. W. R. Hearst to J. Morgan, telegram, July
6, 1925; J. Morgan to W. R. Hearst, July 7,
1925, Kennedy Library.

37. W. R. Hearst to J. Morgan, January 18,
1932, Kennedy Library.

38. J. Morgan to W. R. Hearst, January 20,
1932, Kennedy Library; Taylor Coffman,
*Building for Hearst and Morgan: Voices from
the George Loorz Papers*, rev. ed. (Berkeley:
Berkeley Hill Books, 2003).

CHAPTER 7

1. Edward A. Newton, *Derby Day and Other
Adventures* (Freeport, NY: Books for
Libraries Press, 1969), 216–217. There
was a gatehouse located above the old
ranch house, on a flat area overlooking
the ranch buildings as well as the
coastline.

2. Frances Marion, *Off with Their Heads! A
Serio-Comic Tale of Hollywood.* (New York:
Macmillan, 1972), 136.

3. Charlie Mitchell, interview by the author,
May 7, 2012, 3, 5, 12–13. In addition to
his job as a cattle transporter, Charlie
also worked as a chicken plucker and
warehouse guard at the Hearst Ranch.

4. Slim Keith and Annette Tapert. *Slim:
Memories of a Rich and Imperfect Life* (New
York: Simon and Schuster, 1990), 48,
50; W. R. Hearst Jr., *The Hearsts*, 166.
William Randolph Hearst Jr. wrote, "The
ketchup bottle seemed totally miscast
amid the splendor of great tapestries
and chandeliers, antique furniture and
silver candlesticks. But the old man had
a reason; it reminded him of those early
days when we first came to Camp Hill and
lived in tents."

5. Alice Marble with Dale Leatherman.
Courting Danger (New York: St. Martin's
Press, 1991), 109–113.

6. Roy Rogers to Wilmar Tognazzini,
February 7, 1977, Hearst Castle Staff
Library; Don Cusic, *It's the Cowboy Way:
The Amazing True Adventures of Riders
in the Sky* (Lexington: University Press
of Kentucky, 2003), 22. The Sons of
the Pioneers included Bob Nolan, Tim
Spencer, and Leonard Slye, who later
changed his name to Roy Rogers.

7. Davies, *The Times We Had*, 56–57; Hearst,
In the News, February 20, 1941. In this
daily column Hearst wrote, "Mind
you, your columnist is not opposed to
vivisection where it is necessary. But why
allow promiscuous vivisection, and why
vivisect man's most devoted friend? . . .
We are the only highly civilized nation in
the world that allows it."

8. Ludwig Bemelmans, *To the One I Love the
Best* (New York: Viking, 1955), 219–220.

9. Louella O. Parsons, *The Gay Illiterate* (New
York: Doubleday, 1944), 95.

10. Ray Milland, *Wide-Eyed in Babylon: An
Autobiography* (London: Bodley Head,
1974), 128–130. In addition to supplying
guests with riding gear, Hearst employed
dude wranglers to take them out on the
trails. Author John Dunlap stated that
in his personal collection he owned a
pamphlet that he claimed was placed in all

the guest rooms at San Simeon. It reads:
"*Horses Are At The Disposal Of All Guests.*
Please consider, however, that the hills
on the ranch are steep and exhausting.
The guides who accompany all riding
expeditions are in charge of the animals.
Kindly heed their advice and respect their
knowledge of the animal's limitations. An
old English catch phrase makes the horses
say: 'Ease me up hill,/Ease me down hill,/
And when on the level/I'll go like the
devil.'" Dunlap, *The Hearst Saga*, 695.

11. Arthur and Patricia Lake, "Dagwood
Bumstead and Marion Davies's Niece,"
interview by Metta Hake, edited by Rayena
Martin, *Oral History Project* (San Simeon,
CA: Hearst San Simeon State Historical
Monument, April 4, 1984), 23–27. It has
sometimes been asserted that Patricia
Lake is actually Hearst and Marion's
daughter, instead of their niece. David
Nasaw, Hearst's principal biographer,
refutes this claim. See Nasaw, *The Chief*,
338–339.

12. Hearst, "Life with Grandfather," 155.

13. Ibid., 156, 158.

14. McClure, "From Laborer to Construction
Superintendent," *Oral History Project*, 3–4.

15. Boisen, "Dairy Worker," *Oral History
Project*, 22. An earlier showing of
the nightly film was established, to
accommodate the workers.

16. Wilfred Lyons, "Working Various Jobs at
San Simeon," interview by Ted Moreno,
edited by Robert C. Pavlik, *Oral History
Project* (San Simeon, CA: Hearst San
Simeon State Historical Monument, July
12, 1987), 2, 7–9.

17. Guido Minetti, "Employee for W. R.
Hearst," interview by Tom Scott, edited
by Robert Pavlik, *Oral History Project*
(San Simeon, CA: Hearst San Simeon
State Historical Monument, January 16,
1982), 11–13. The orchard included the
pergola area as well as a lower area to
the southwest, known as the extension
orchard.

18. Marjorie Collard, "Mining at the Hearst
Ranch Polar Star Mine (1940s) and
Working in the Housekeeping Department
(1958–1976)," interview by Michelle
Hachigian, edited by John Horn, *Oral
History Project* (San Simeon, CA: Hearst

San Simeon State Historical Monument, May 30, 2001), 4, 11. The Polar Star was a quicksilver mine, discovered in 1870. In 1942, the Combined Metals of Idaho company entered a lease agreement with the Hearst Corporation. The mine was closed down in 1943.

19. Alex Madonna, "Madonna Family in San Luis Obispo, Moving a Hearst Castle Oak, 1946, the Bradenstoke Tithe Barn," interview by Michelle Hachigian, edited by Michelle Hachigian and John Horn, *Oral History Project* (San Simeon, CA: Hearst San Simeon State Historical Monument, April 7, 2003), 24–25. Alex Madonna was the builder and owner of the well-known Madonna Inn in San Luis Obispo.

20. Richard E. "Dick" Lynch, "Life at Pico Creek Horse Ranch, 1946–1952," interview by Tom Scott, *Oral History Project* (San Simeon, CA: Hearst San Simeon State Historical Monument, February 26, 1980), 2.

21. Hearst, *Horses of San Simeon*, 248–255; Parlet, "Life on San Simeon Ranch," *Oral History Project*, 5, 9; Carl Negranti, interview by the author, May 14, 2012, 8. Carl Negranti recalled, "When I went to work at the Ranch one of the first things Charlie Parlet told me one day was . . . 'We've got about 2,500 cows on this Ranch,' he says, 'and there's not a god-damned one of 'em knows the English language. So keep your mouth shut!'"

22. Byron Hanchett, *In & Around the Castle* (San Luis Obispo, CA: Blake Publishing, 1985), 153, 155–156. When he was laying phone line in the backcountry, Hanchett recalled, "If I had a choice between the jeep and horseback, I took the horse. Nothing was worse than riding in a jeep with a crazy cowboy driving."

23. Carey Baldwin, *My Life with Animals* (Menlo Park, CA: Lane Book Co., 1964), 12–16.

A COWBOY'S LIFE AT THE RANCH

1. Parlet, "Life on San Simeon Ranch," *Oral History Project*, 4, 6, 13–14, 19, 30, 33.

2. Vince Aviani, "Lover of the Land Spurs Cowboy's Calling," *The Cambrian*, December 10, 1987, 10.

3. Stephen T. Hearst at the Hearst Ranch 2012 Cowboy Reunion, May 2012, 2, 3–4. See transcription of an interview with Tara Scrivener by the author, May 9, 2012, 7. "I remember Steve would call over to ask Dad something, and Dad would just get on the phone and just be gruff! And I thought, 'Dad, that's Steve!' 'I know who he is!' 'Why are you being so mean when you talk to him?' He goes, 'Well, he puts his pants on one leg at a time just like I do!' And that's about the time he told me that the kids used to call him 'Billy Goat Gruff.'"

4. Ibid., 9.

5. Negranti, interview by author, May 2, 2012, 19.

6. Flint Speer, in Hearst Ranch 2012 Cowboy Reunion, May 2012, 10.

7. Huell Howser, "Hearst Ranch," *California's Gold*, ed. Michael Garber (Huell Howser Productions, January 10, 2010), 29; Cliff Garrison, interview by the author, February 20, 2012, 2, 7. Garrison continued, "You have to work the dogs quietly, training them by position to hold, to push, or to change their direction on command. And when it comes to the cattle that run on big ranches, the cowboys have to spend time to keep them gentle, not wild, as all critters become when freedom is thrust upon them."

A YEAR ON THE HEARST RANCH

1. Garrison, interview by the author, February 20, 2012, 20–21.

CHAPTER 8

1. Royal "Ray" Swartley to G. Loorz, May 30, 1934, George Loorz Papers, History Center of San Luis Obispo County Archives, San Luis Obispo, CA (hereafter, "History Center of SLO Co.").

2. G. Loorz to James Rankin, April 7, 1932, History Center of SLO Co.

3. J. Morgan to W. R. Hearst, September 16, 1932, Kennedy Library.

4. W. R. Hearst to J. Morgan, telegram, September 21, 1932, Kennedy Library.

5. G. Loorz to J. Morgan, September 15, 1932, History Center of SLO Co. Loorz's frankness and kindness were demonstrated in a letter he wrote on the same day to his colleague, Warren "Mac" McClure: "The fact is that we are both a bit stubborn and of hasty temper. . . . Let's do it this way, Mac. When one of the other displeases, let's not criticize in anger but first consider carefully the facts and do it as pleasantly as possible. It will come far nearer attaining results and will not jeopardize the friendship I hope we can always maintain for each other."

6. J. Morgan to G. Loorz, c. September 1932, History Center of SLO Co.

7. J. Morgan to G. Loorz, c. October 1932, History Center of SLO Co.; Bill Loorz, "Childhood in San Simeon, 1932–1938," interview by Michelle Hachigian, edited by John Horn, *Oral History Project* (San Simeon, CA: Hearst San Simeon State Historical Monument, March 2003), 20; Don Loorz, "Childhood in San Simeon: George Loorz, Julia Morgan, and Stolte, Inc.," interviewed and edited by Michelle Hachigian, *Oral History Project* (San Simeon, CA: Hearst San Simeon State Historical Monument, May 2003). George and Grace Loorz's son Don was six and their son Bill was four when the family moved to San Simeon in 1932. They lived there until 1938. Both boys vividly remembered Julia Morgan, who gave them (and their younger brother Bob) many small presents. Morgan dressed formally but was very kind to the boys. Both Don and Bill later recalled that she reminded them of Mary Poppins.

8. Suzanne B. Riess, ed., *The Julia Morgan Architectural History Project* (Bancroft Library, Regional Oral History Office. Berkeley: University of California, 1976), 204, 225; G. Loorz to P. Caredio, October 10, 1933, History Center of SLO Co. Loorz continues: "She is just as active as ever mentally and tries to do just as much physically. . . . She surely has some fight. Most of us would go jump in the ocean."

9. G. Loorz to J. Morgan, November 22, 1932, History Center of SLO Co.

10. G. Loorz to J. Morgan, May 8, 1933, History Center of SLO Co.

11. G. Loorz to Jim Hart and Harry Sommer of Victory Garage in Lovelock, Nevada, May 31, 1933, History Center of SLO Co.

12. G. Loorz to Armand Brady, August 5, 1933, History Center of SLO Co.

13. G. Loorz to Barbara Loorz (his mother), August 15, 1933, History Center of SLO Co.

14. G. Loorz to Fred Stolte, October 5, 1932, quoted in Coffman, *Building for Hearst and Morgan*, 41.

15. G. Loorz to Warren McClure, June 19, 1933, History Center of SLO Co.

16. G. Loorz to F. Stolte, August 11, 1934, quoted in Coffman, *Building for Hearst and Morgan*, 129–130. Loorz continued in the same letter: "You well know it originally must have been a cow trail. The bridge is completed with abutments, etc. and looks real well."

17. W. R. Hearst to A. Parks, January 20, 1926, The Hearst Corporation; W. R. Hearst to J. Morgan, October 2, 1927; October 7, 1927, Kennedy Library.

18. G. Loorz to J. Morgan, September 9, 1932, History Center of SLO Co.

19. Archie Soto, "An Oral History Project," 1977, 55–57.

20. J. Morgan to W. R. Hearst, July 17, 1930, Kennedy Library.

21. J. Morgan to G. Loorz, March 30, 1932, History Center of SLO Co.

22. J. Willicombe to G. Loorz, June 14, 1932; G. Loorz to George Wright, February 19, 1934, History Center of SLO Co.

23. W. R. Hearst to J. Morgan, November 9, 1931; J. Morgan to W. R. Hearst, February 28, 1921, Kennedy Library. Work on Highway 1 began in 1922. Morgan had apparently long anticipated the convenience it would provide. She wrote to Hearst on February 28, 1921: "It was a lovely warm day 'On Top,' a sudden warm wave sweeping in with the early morning. The road above Cambria, also near Morro, is almost impassable, but about a mile of new highway shows how delightful the trip will be some day." In response to construction of Highway 1, San Simeon Beach State Park opened to the public in 1932 as State Park Number 50. A 1937 guidebook explains: "The land was acquired in 1932, purchased from Mina K. Hotchkiss, Ira R. Whitaker, Vine Van Gorden, Lena Ivy Sanders, and others, and a gift was made by the Piedmont Land and Cattle Company of William Randolph Hearst." Don Morton, rev. ed. Camilla Wade, *History of California State Parks*. (Berkeley: California Department of Natural Resources Division of Parks, 1937), 1–2.

24. G. Loorz to A. Brady, September 26, 1934, History Center of SLO Co.

25. G. Loorz to Grace Loorz, June 26, 1937, History Center of SLO Co. See Marjorie Sewell, "Oral History," interview by Victoria Kastner, Victoria Garagliano, and April Smith-Hatchett (San Simeon, CA: Hearst Casstle Staff Library, May 6, 2010), 35. She recalled that Sebastian's "had a couple of telescopes. . . . People would come through and they would want to see the Castle and they'd pay the little nickel or dime."

26. Debbie Soto, *Glimpses of a Bygone Era: One-Room Schools Along the Hearst Ranch* (San Luis Obispo, CA: Central Coast Press, 2011), 79–80; Norma Bassi Monson, "Growing Up in San Simeon," 21–22, 25. Norma Bassi Monson, the granddaughter of Manuel Sebastian, recalled that during Prohibition, Julia Morgan was asked to design a secret closet in their duplex home for her grandfather's still. "It's behind the closet in the master bedroom which is downstairs off the front room."

27. G. Loorz to Louis Schallich, October 7, 1933, History Center of SLO Co.

28. W. R. Hearst to G. Loorz, May 20, 1937, History Center of SLO Co. The resulting building resembled the bunkhouse built at the Milpitas Hacienda in 1929, but was built in a Monterey Revival architectural style instead of Mission Revival. It was also considerably smaller.

29. W. R. Hearst to J. Morgan, February 27, 1937; Hearst to Morgan, February 28, 1937, Kennedy Library.

30. G. Loorz to Fran Apperson, March 4, 1937, History Center of SLO Co.

31. G. Loorz to Louis Reesing, April 12, 1937, History Center of SLO Co.

32. J. Morgan to G. Loorz, c. June 1937, History Center of SLO Co.

33. G. Loorz to Paul Polizzotto, October 22, 1937, History Center of SLO Co.

34. G. Loorz to Maurice McClure, June 1, 1937, History Center of SLO Co.

35. G. Loorz to J. Morgan, July 2, 1937, History Center of SLO Co. The shutdown marked the beginning of Morgan's slow process of consolidating and shutting down her architectural office in the Merchant's Exchange building in San Francisco.

36. G. Loorz to Phil Smith, January 11 1939 [1940], History Center of SLO Co. See Edward Alden Jewell, "Hearst Collection Put on Exhibition," *New York Times*, January 28, 1941.

37. Davies, *The Times We Had*, 199. The United States government purchased 153,865 acres of the Milpitas Ranch in December 1940 for $2.2 million.

38. Jud Smelser to G. Loorz, February 27, 1938, History Center of SLO Co. This was the greatest single disaster in the history of San Simeon. Lord Plunket was Terence Conyngham, sixth Baron Plunket. His wife, Lady Plunket, was the daughter of Mrs. J. W. Dean, the silent film star whose stage name was Fannie Ward. The pilot, Tex Phillips, was the substitute for Hearst's regular pilot, Al Russell. The other passenger, bobsled champion James Lawrence, survived with serious injuries.

39. G. Loorz to J. Morgan, June 5, 1939, History Center of SLO Co.

40. Ray Van Gorden to G. Loorz, January 2, 1940, History Center of SLO Co.

41. Suzanne B. Riess, ed., *The Work of Walter Steilberg and Julia Morgan*, vol. 1 of *The Julia Morgan Architectural History Project*, Bancroft Library, Regional Oral History Office, 49.

42. G. Loorz to J. Morgan, March 16, 1940, History Center of SLO Co.

43. Parlet, "Life on San Simeon Ranch," *Oral History Project*, 12.

44. Edmond D. Coblentz, ed., *William Randolph Hearst: A Portrait in His Own Words* (New York: Simon and Schuster, 1952), 297. See "Pancho Estrada, Pioneer Vaquero, Called by Death," *San Luis Obispo Tribune*, July 27, 1936; "Mrs. Estrada

Dies at San Simeon Home," *San Luis Obispo Tribune*, August 1, 1936; George R. Hearst Jr., interview by the author, June 28, 2010, 2; Bobby Soto and James Soto, "Oral History," interview by Muna Cristal with Victoria Kastner and Tom Craig (San Simeon, CA: Hearst Castle Staff Library, May 12, 2010), 65. George Hearst Jr. shared that the first time he was on a horse at the Hearst Ranch was when he was two and a half years old, in 1930. Don Pancho came riding up to George and his twin sister, Phoebe. He took one child "under each arm, and took off down the road with my mother present, and drove her crazy." Fifth-generation Hearst employee Robert Soto recalled that his father attended Don Pancho's funeral. The coffin was in a carriage pulled by a team of horses. "Behind it was a lone black stallion with an empty saddle."

CHAPTER 9

1. J. Morgan to Bjarne Dahl, c. January 8, 1943, Julia Morgan–Sara Holmes Boutelle Collection, MS027, Robert E. Kennedy Library, California Polytechnic State University, San Luis Obispo, CA. See Rex B. Meany, "Report on Construction of the Casa Grande Located on the Hacienda Babicora," Morgan–Boutelle Collection, Kennedy Library, October 1943, 1. The proposed courtyard building was planned to contain a master suite and eight guest bedrooms, in addition to staff quarters. Hearst also added a movie theater and swimming pool. This large adobe compound was never built.

2. J. Morgan to W. R. Hearst, July 6, 1943; W. R. Hearst to J. Morgan, July 9, 1943, Morgan–Boutelle Collection, Kennedy Library.

3. Edward Ardouin to J. Morgan, November 30, 1943; W. R. Hearst to Edward Ardouin, December 6, 1943, Morgan–Boutelle Collection, Kennedy Library; William Apperson, "Hearst Ranch Superintendent's Son," interviewed and edited by John Horn, *Oral History Project* (San Simeon, CA: Hearst San Simeon State Historical Monument, 7. According to his son William, it was Randolph Apperson who established a reciprocal program in which vaqueros were brought to San Simeon and Hearst cowboys were sent to Mexico for training. See "Mexico Will Take Vast Hearst Ranch," *New York*

Times, August 16, 1953. The Mexican government purchased Babicora from the Hearst Corporation in 1953 for $2.5 million.

4. *The Horse Lover* (February/March 1948) quoted in Conn, *The Arabian Horse in America*, 185–186. The fourteen imported Arabian horses ranged from two to eleven years old. The six stallions were Arkane, Bourhane, Ghamil, Mounwer, Snounou, and Zamal. The eight mares were Bint Rajwa, Layya, Lebnaniah, Kouhailane, Mansourah, Najwa, Nouwayra, and Rajwa. See Victoria Kastner, *Hearst Castle: The Biography of a Country House* (New York: Abrams, 2000), 206–207, for a discussion of Hearst Castle's costs for construction and contents, Hearst's return to San Simeon after the war, Morgan's involvement in the final years of construction, and Hearst's purchase of the Douglas DC-3C. In 1945, Preston Dyer became manager for the San Simeon stables. He had previously trained horses for General George S. Patton. See "Hunt for Arabian Horses Overseas Told ARABS Club," *Lodi News-Sentinel*, October 31, 1958, 2.

5. Guiles, *Marion Davies*, 329. See Nasaw, *The Chief*, 584–585, 600–601, for a discussion of Hearst's will.

6. W. R. Hearst Jr., *The Hearsts*, 250.

7. "W. R. Hearst, 1863–1951: Death Puts a Quiet End to the Press Lord's Unquiet Career," *Life* 31, no. 9, August 27, 1951, 24. See W. R. Hearst Jr., *The Hearsts*, 251: "Our mother lived for another twenty-three years [after William Randolph Hearst's death on August 14, 1951]. In that long span I never heard her say a disparaging word about my father. We had many happy times together. She continued with her charities and retained great interest in each son and his family."

8. Nasaw, *The Chief*, 602.

9. Davies, *The Times We Had*, 261, 265.

10. W. R. Hearst Jr., *The Hearsts*, 85.

11. J. Paul Getty, *As I See It: The Autobiography of J. Paul Getty* (Englewood Cliffs, NJ: Prentice-Hall,, 1976), 253. Getty built a house in Malibu overlooking the ocean and opened it free of charge to the public in 1954. He called this original residence

(which predates the Getty Villa by more than twenty years and is still located on the property today) "the ranch." It featured a small private zoo.

12. California Department of Parks and Recreation, *Unit History* (San Simeon, CA: Hearst San Simeon State Historical Monument, 1974).

13. Hearst, *The Horses of San Simeon*, 201.

14. Jim Evans, interview by the author, November 12, 2012, 14. Evans not only participated in the sale of many objects in the San Simeon warehouses, but also was instrumental in setting up the early tour program when Hearst Castle opened to the public in 1958.

15. Richard E. Berlin, president of the Hearst Corporation, and William Randolph Hearst Jr., vice president of the Hearst Corporation, to Goodwin J. Knight, Governor of California, May 21, 1957, telegram, Hearst Castle Staff Library.

16. David Niven, *Bring on the Empty Horses* (New York: G. P. Putnam's Sons, 1975), 278–279.

CHAPTER 10

1. Morgan North and Flora North, *Julia Morgan, Her Office, and a House*, vol. 2 of *The Julia Morgan Architectural History Project*, ed. Suzanne B. Riess, Bancroft Library, Regional Oral History Office (Berkeley: University of California, 1976), 193.

2. Hearst, *The Horses of San Simeon*, 257.

3. Ibid., 254.

4. Ibid., 254–255.

5. "Legal Question Delays Action in Hearst Castle Deal," October 17, 1963; "B & P Rejects All Castle Bids," *The Cambrian*, March 5, 1964. See "A Modern Tale of David and Goliath," Editorial, *The Cambrian*, March 5, 1964. The author is indebted to Dawn Dunlap for information on this lawsuit.

6. "Eight Villages Proposed Along North Coast Area," *San Luis Obispo County Telegram-Tribune*, November 13, 1964; "Board OKs $340 Million Hearst Plan,"

Los Angeles Times, April 6, 1965. See "$340 Million Development Planned on Hearst Ranch," *Los Angeles Times*, November 25, 1964: "No date for the start of the project has been set. It is expected that $113 million will be devoted to land development alone. The plan is to develop the project in stages over a period of several years." See Thomas Brown, *The Illustrated History of Hearst Castle* (Atascadero, CA: Nouveaux Press, 2012), 17, for an aerial photograph of San Simeon Point circa 1930, when the trees were relatively sparse.

7. David W. Myers, "Near San Simeon: Hearst Hotel Plan Stirs Controversy," *Los Angeles Times*, September 6, 1987.

8. Frank Clifford, "Hearst Corp. Plans Spark Coastal Fight," *Los Angeles Times*, June 30, 1996.

9. Hearst, *Horses of San Simeon*, 257.

10. George Hearst Jr., interview by the author, part two, September 22, 2010, 7.

11. George Hearst III at George Hearst Jr.'s memorial service, 5; William R. Hearst III at George Hearst Jr.'s memorial service, (San Simeon, CA: The Hearst Corporation, July 13, 2012), 7. William Randolph Hearst's grandson Will Hearst III expressed the attachment the entire Hearst family feels for San Simeon, especially during a time of mourning: "Another thing that made me feel better [about the 2012 death of his cousin George R. Hearst Jr.] was being on this land. Because George Hearst Sr., my cousin's namesake, was the George Hearst who acquired this ranch and launched this company. His great-grandson George Jr. knew the value of land—and horses, and business, and mining, and cattle. And George knew the value of family. It was really a very special feeling to be here and look out on those same hills where my cousin George had hunted and ridden. He introduced us to this wonderful place. That made things a little bit easier."

12. Frank A. Bennack Jr. at George Hearst Jr.'s memorial service, 9. Bennack continued, "George had three distinct careers that were vital to him. At the Hearst Corporation, where he worked for his entire adult life. Also in his life as a rancher. He loved the land, he loved cattle, and he loved horses. And also in his

ten years serving in the military [during World War II and the Korean War]. It amazed me how important this was to him, and how much he valued what he learned there."

13. Frank Clifford, and L. Sahugun, "Land Plan Opens Window on Hearst Rift," *Los Angeles Times*, January 20, 1998.

14. Stephen T. Hearst, interview by the author, April 29, 2012, 8–9.

15. Cliff Garrison, interview by the author, February 20, 2012, 2–3, 19. Garrison continued, "So what I do is manage for sustainability and long-term survival from year to year without a lot of grazing pressure. It's a form of rotational grazing, but for the most part, the important part is that it's moderate grazing. I try to take half and leave half. If I have a lean year next year, I've still got grass in the bank."

16. Marty Cepkauskus, interview by the author, December 1, 2011, 12–13.

17. *Hearst Corporation Conservation Framework*, prepared jointly with American Land Conservancy, November 21, 2007, 2. See Shirley Bianchi, at Roger Lyon's memorial service, 20 October 20, 2010, 11: "Steve and Roger had a one-page document which was beautifully written in its simplicity. It said things like 'There shall be no new roads.'" See John M. Broder, "Tentative Pact is Reached to Protect Hearst Ranch," *New York Times*, June 5, 2004. Nita Vail, executive director of the California Rangeland Trust, emphasized that the proposed deal was in the long-term public interest. "We are enthusiastic about our role in assuring the people of California the amazing cultural, historical and biological values the Hearst family has preserved."

18. Nick Madigan, "Hearst Land Settlement Leaves Bitter Feelings," *New York Times*, September 20, 2004; Stephen T. Hearst, interview by the author, November 15, 2012. See "Hearst Ranch Conservation Plan Finalized; Governor Calls Closing of Escrow, 'Vision for the State's Future, Value for the People,'" *Press Room: Update from the Governor's Office*, February 18, 2005: "'With this agreement, we have demonstrated what can be done when people are committed to the land and the resources here at the ranch,' said Stephen T. Hearst. 'I feel great that the hard work

of so many people came together to make today a reality. This is an excellent example of what can be accomplished through public-private stewardship agreements.'"

19. Kara Blakeslee, Conservation Committee Chair of American Land Conservancy, in an interview with the author, April 15, 2008. See Glen Martin, "Back at the Hearst Ranch," *California Coast and Ocean* 23, no. 3, January 2007: "The easement set a new benchmark, imposing conditions that went way beyond the usual standards of the day. It retired 97 percent of the ranch's development value and put tight constraints on the remaining three percent.'"

20. Stephen T. Hearst, interview by the author, April 29, 2012, 9–10; Stephen T. Hearst at George Hearst's memorial service, July 13, 2012, 1.

21. Kara Blakeslee, April 15, 2008. See Bruce Gibson at Roger Lyon's memorial service, October 29, 2010, 10. "Roger was a remarkable package—of vision and heart and intelligence and love and connectedness. He understood complicated and powerful things. He understood the ocean, and its power and its complexity. And he understood the powerful interests of politics. And from him I learned a remarkable amount. He was, as Steve indicated, wise counsel at all times. He gave me a knowledge of the world that I couldn't have learned from anyone else."

Bibliography

ARCHIVES AND LIBRARIES

Hearst Archives. California Historical Society, San Francisco, CA.

The Hearst Corporation Archives. Ranch Office Papers. San Francisco, CA: The Hearst Corporation.

George and Phoebe Apperson Hearst Papers. 72/204c. The Bancroft Library, University of California, Berkeley.

Hearst San Simeon State Historical Monument Archives, San Simeon, CA.

William Randolph Hearst Papers. 82/232c. The Bancroft Library, University of California, Berkeley.

Walter Huber Papers, C-B 825, The Bancroft Library, University of California, Berkeley.

George Loorz Papers. History Center of San Luis Obispo County, San Luis Obispo, CA.

Julia Morgan Papers. MS 010. Special Collections. Robert E. Kennedy Library. California Polytechnic State University, San Luis Obispo, CA.

Julia Morgan–Sara Boutelle Collection. MS027. Special Collections. Robert E. Kennedy Library. California Polytechnic State University, San Luis Obispo, CA.

Peck Family Papers. Huntington Library, San Marino, CA.

MANUSCRIPT AND DOCUMENTARY SOURCES

Apperson, William. "Hearst Ranch Superintendent's Son." Interview and edited by John Horn. *Oral History Project*, San Simeon, CA: Hearst San Simeon State Historical Monument, September 12, 1996.

Boardman, Eleanor. "An Interview with Eleanor Boardman." Interview by Metta Hake, edited by Robert C. Pavlik. *Oral History Project*, San Simeon, CA: Hearst San Simeon State Historical Monument, July 20, 1982.

Boisen, Harley. "Dairy Worker, 1935–1937." Interview by T. N. Moreno, edited by Rayena Martin. *Oral History Project*. San Simeon, CA: Hearst San Simeon State Historical Monument, December 8, 1987.

California Department of Parks and Recreation. *Unit History*. San Simeon, CA: Hearst San Simeon State Historical Monument, 1974.

Calkins, Fred, and Edna Calkins. "Dude Wrangler and Head Housekeeper at the Hearst Ranch." Interview by Lee Greenawalt, edited by Laurel Stewart. *Oral History Project*, San Simeon, CA: Hearst San Simeon State Historical Monument, 1990.

——. "Ranching and Wrangling: From Piojo to San Carpoforo and Jolon to Pacific Valley." Interview by KPRL Radio. *Oral History Project*. Paso Robles, CA: Hearst San Simeon State Historical Monument, 1988.

Clark, Edward Hardy Jr. "Remembering Wyntoon and the Hearst Family." Interview by Metta Hake and Tom Scott, edited by Robert Pavlik. *Oral History Project*, San Simeon, CA: Hearst San Simeon State Historical Monument, 1991.

Collard, Marjorie. "Mining at the Hearst Ranch Polar Star Mine (1940s) and Working in the Housekeeping Department (1958–1976)." Interview by Michelle Hachigian, edited by John Horn. *Oral History Project*. San Simeon, CA: Hearst San Simeon State Historical Monument, May 30, 2001.

Combs, Robert B. "Horse Trainer." Interview by Robert C. Pavlik, edited by John Horn and Michelle Hachigian. *Oral History Project*. San Simeon, CA: Hearst San Simeon State Historical Monument, January 27, 1987.

Heaton, Stanley, and Elmer Moorhouse. "Gardening and Road Construction." Interview by Metta Hake, edited by William Payne and Robert Pavlik. *Oral History Project*. San Simeon, CA: Hearst San Simeon State Historical Monument, March 27, 1984.

Howser, Huell. "Hearst Ranch." *California's Gold*. Edited by Michael Garber. Huell Howser Productions, January 10, 2010.

The Julia Morgan Architectural History Project. Edited by Suzanne B. Riess. The Bancroft Library, Regional Oral History Office. Berkeley: University of California, 1976.

Keep, Nigel. "Trees of San Simeon." San Simeon, CA: Hearst San Simeon State Historical Monument, 1946.

Laird, Brayton. "Working in the Orchards of the Hearst Ranch." Interview by Bruce Brown, edited by Robert C. Pavlik. *Oral History Project*. San Simeon, CA: Hearst San Simeon State Historical Monument, December 19, 1986.

Lake, Arthur, and Pat Lake. "Dagwood Bumstead and Marion Davies' Niece." Interview by Metta Hake, edited by Rayena Martin. *Oral History Project*. San Simeon, CA: Hearst San Simeon State Historical Monument, April 4, 1984.

Lynch, Richard E. "Dick." "Life at Pico Creek Horse Ranch, 1946–1952." Interview by Tom Scott. *Oral History Project*. San Simeon, CA: Hearst San Simeon State Historical Monument, February 26, 1980.

Lyons, Wilfred. "Working Various Jobs at San Simeon." Interview by Ted Moreno, edited by Robert C. Pavlik. *Oral History Project*. San Simeon, CA: Hearst San Simeon State Historical Monument, July 12, 1987.

Madonna, Alex. "Madonna Family in San Luis Obispo, Moving a Hearst Castle Oak, 1946, the Bradenstoke Tithe Barn." Interview by Michelle Hachigian, edited by Michelle Hachigian and John Horn. *Oral History Project*. San Simeon, CA: Hearst San Simeon State Historical Monument, April 7, 2003.

Marquez, Hector. "Son of Babicora Ranch Manager." Interview by Robert Pavlik, edited by Laurel Stewart, Rayena Pavlik, and John Horn. *Oral History Project*. San Simeon, CA: Hearst San Simeon State Historical Monument, February 3, 1992.

McClure, Maurice. "From Laborer to Construction Superintendent." Interview by Metta Hake, edited by Bernice J. Falls and Robert Pavlik. *Oral History Project*. San Simeon, CA: Hearst San Simeon State Historical Monument, September 13, 1981.

McCrea, Joel. "Hearst, Hollywood and San Simeon." Interview by Metta Hake, edited by Nancy E. Loe. *Oral History Project*. San Simeon, CA: Hearst San Simeon State Historical Monument, December 5, 1982.

Meany, Rex B. "Report on Construction of the Casa Grande Located on the Hacienda Babicora.," Morgan-Boutelle Collection, Special Collections, California Polytechnic State University, October 1943.

Minetti, Guido. "Employee for W. R. Hearst." Interview by Tom Scott, edited by Robert Pavlik. *Oral History Project*. San Simeon, CA: Hearst San Simeon State Historical Monument, January 16, 1982.

Monson, Norma Bassi. "Growing up in San Simeon with Grandparents Manuel & Mary Sebastian." Interview by John F. Horn, edited by Michelle Hachigian and John Horn. *Oral History Project*, San Simeon, CA: Hearst San Simeon State Historical Monument, April 1, 2003.

Moore, Colleen. "The Jazz Age's Movie Flapper at San Simeon." Interview by Eileen Hook. *Oral History Project*. San Simeon, CA: Hearst San Simeon State Historical Monument, January 25, 1977.

Munroe, Carlota Chapman. "Daughter of Princess Conchita Sepúlveda Chapman Pignatelli." Interview by Jill Urquhart, edited by Jill Urquhart, Michelle Hachigian, and Joanne Aasen. *Oral*

History Project. San Simeon, CA: Hearst San Simeon State Historical Monument, October 1, 2009.

Orr, Isabelle. "Two Weeks at the Castle." Interview by Joan Sullivan, edited by Laurel Stewart and Joanne Aasen. *Oral History Project*, San Simeon, CA: Hearst San Simeon State Historical Monument, 1991.

Parlet, Charles. "Life on San Simeon Ranch, 1921–1977." Interview by Tom Scott, edited by Michelle Hachigian. *Oral History Project*. San Simeon, CA: Hearst San Simeon State Historical Monument, 1977.

Pringle, Aileen. "Silent Movie Actress and Frequent Guest." Interview by Metta Hake, edited by Robert C. Pavlik. *Oral History Project*. San Simeon, CA: Hearst San Simeon State Historical Monument, October 18, 1981.

Read, Gladwin. "La Cuesta Encantada at San Simeon." San Simeon, CA: Hearst Castle Archives, 1955.

Reed, Mrs. Mabel. "Transcription of the Remarks of Mrs. Mabel Reed." *Founder's Day*. Beaufort, Missouri: Hearst San Simeon State Historical Monument Staff Library, February 14, 1964.

Rotanzi, Norman. "Fifty-Four Years at San Simeon." Interview by Julie Payne, edited by Robert Pavlik. *Oral History Project*. San Simeon, CA: Hearst San Simeon State Historical Monument, June 6, 1988.

——. "The Ranch, Dairy, Orchard, and Grounds: An Oral History Interview." Interview by Tom Scott. *Oral History Project*. San Simeon, CA: Hearst San Simeon State Historical Monument, 1989.

St. Johns, Adela Rogers. "Hearst as a Host." Interview by Gerald Reynolds, edited by Robert C. Pavlik. *Oral History Project*. San Simeon, CA: Hearst San Simeon State Historical Monument, April 1971.

Soto, Archie. "An Oral History Project Concerning the San Simeon Home of William Randolph Hearst." Senior Project Interview by James E. Woodruff. San Luis Obispo, CA: California Polytechnic State University, 1977.

Soto, Bobby, and James Soto, "Oral History." Interview by Muna Cristal with Victoria Kastner and Tom Craig. San Simeon, CA: Hearst San Simeon State Historical Monument Staff Library, May 12, 2010.

Winsor, Kenneth. "Cowboy on the Hearst Ranch, 1926–1930." Interview by Zel Bordegaray and Metta Hake, edited by Michelle Hachigian and John Horn. *Oral History Project*. San Simeon, CA: Hearst San Simeon State Historical Monument, January 1977.

BOOKS, PAMPHLETS, AND ARTICLES

American Land Conservancy. *Conservation Framework*. November 21, 2007

Aslet, Clive. *The American Country House*. New Haven, CT: Yale University Press, 2004.

Aviani, Vince. "Lover of the Land Spurs Cowboy's Calling." *The Cambrian*, December 10, 1987.

Baker, Gayle. *Cambria: A Harbor Town History*. Santa Barbara, CA: HarborTown Histories, 2003.

Baldwin, Carey. *My Life with Animals*. Menlo Park, CA: Lane Book Co., 1964.

Bemelmans, Ludwig. *To the One I Love the Best*. New York: Viking, 1955.

Bertão, David E. *The Portuguese Shore Whalers of California 1854–1904*. San Jose, CA: Portuguese Heritage Publications of California, 2006.

Blomberg, Nancy J. *Navajo Textiles: The William Randolph Hearst Collection*. Tucson: The University of Arizona Press, 1988.

Brands, H. W. *The Age of Gold: The California Gold Rush and the American Dream*. New York: Anchor Books, 2002.

Broder, John M. "Tentative Pact is Reached to Protect Hearst Ranch." *New York Times*, June 5, 2004.

Brooke, Stoner. "Lost on the Upper Naciemiento [*sic*]." *Overland Monthly* 13, second series (January–June 1889), 153–156.

Brown, Thomas. *The Illustrated History of Hearst Castle*. Atascadero, CA: Nouveaux Press, 2012.

Carr, Paula Juelke. "Harmony Along the Coast." In *Heritage Shared Studies in Central Coast History*, edited by Thomas Wheeler, 32–53. San Luis Obispo, CA: Heritage Shared, 2008.

Casey, Beatrice. *Padres and People of Old Mission San Antonio*. King City, CA: The Rustler-Herald, 1957.

Chase, J. Smeaton. *California Coast Trails: A Horseback Ride from Mexico to Oregon*. Boston: Houghton Mifflin Co., 1913.

Cleland, Robert Glass. *The Cattle on a Thousand Hills: Southern California, 1850–1880*. San Marino, CA: The Huntington Library, 1951.

Clifford, Frank. "Hearst Corp. Plans Spark Coastal Fight." *Los Angeles Times*, June 30, 1996.

Clifford, Frank, and L. Sahugun. "Land Plan Opens Window on Hearst Rift." *Los Angeles Times*, January 20, 1998.

Cody, Iron Eyes. *Iron Eyes Cody, My Life as a Hollywood Indian: By Iron Eyes Cody as Told to Collin Perry*. London: Muller, 1982.

Coblentz, Edmond D., ed. *William Randolph Hearst: A Portrait in His Own Words*. New York: Simon and Schuster, 1952.

Coffman, Taylor. *Building for Hearst and Morgan: Voices from the George Loorz Papers*. Rev. ed. Berkeley, CA: Berkeley Hills Books, 2003.

Colahan, Clark. *On the Banks of San Simeon Creek: San Simeon Pioneers*. San Luis Obispo, CA: Central Coast Press, 2011.

Conn, George H. *The Arabian Horse in America*. New York: A. S. Barnes and Co., 1957.

Cusic, Don. *It's the Cowboy Way: The Amazing True Adventures of Riders in the Sky*. Lexington: University Press of Kentucky, 2003.

Davidson, Harold G. *Edward Borein Cowboy Artist: The Life and Works of John Edward Borein 1872–1945*. Garden City, NY: Doubleday, 1974.

Davies, Marion. *The Times We Had: Life with William Randolph Hearst*. Indianapolis, IN: Bobbs–Merrill, 1975.

Doty, Betty Farrell. "Cowboy at the Castle: King City Man Recalls Life at Hearst Ranch." *Salinas Californian*, fall 1990.

Dunlap, John F. *The Hearst Saga: The Way It Really Was*. Privately published by the family of John F. Dunlap, 2002.

Freudenheim, Leslie M. *Building with Nature: Inspiration for the Arts & Crafts Home*. Layton, UT: Gibbs Smith, 2005.

Getty, J. Paul. *As I See It: The Autobiography of J. Paul Getty*. Englewood Cliffs, NJ: Prentice–Hall, 1976.

Guiles, Fred Lawrence. *Marion Davies: A Biography*. New York: McGraw-Hill, 1972.

Hamilton, Geneva. *Where the Highway Ends: Cambria, San Simeon and the Ranchos*. San Luis Obispo, CA: Padre Productions, 1974.

Hanchett, Byron. *In & Around the Castle*. San Luis Obispo, CA: Blake Publishing, 1985.

Harris, Linda G. *Ghost Towns Alive: Trips to New Mexico's Past*. Albuquerque: University of New Mexico Press, 2003.

Head, Alice M. *It Could Never Have Happened*. London: W. Heinemann, 1939.

Hearst, George. *The Way It Was*. N.p.: Hearst Corporation, 1972.

Hearst, John R., Jr. "Life with Grandfather," *Reader's Digest* 76, no. 457, May 1960, 152–153, 155–159, 161–162.

Hearst, Mrs. William Randolph Jr. *The Horses of San Simeon*. San Simeon, CA: San Simeon Press, 1985.

Hearst, William Randolph. "In the News," March 27, 1940–February 20, 1941.

Hearst, William Randolph Jr. *The Hearsts: Father and Son*. Niwot, CO: Roberts Rinehart, 1991.

Hoffman, Robert V. "The Country Gentleman

of To-day." *Country Life in America* 61, January 1932, 65–67.

Houlton, LaVonne. "William Randolph Hearst and His Morgan Horses." *The Morgan Horse* LX, no. 7, July 2001, 128–131, 133.

Igler, David. *Industrial Cowboys: Miller & Lux and the Transformation of the Far West, 1850–1920*. Berkeley: University of California Press, 2001.

Jewell, Edward Alden. "Hearst Collection Put on Exhibition." *New York Times*, January 28, 1941.

Kastner, Victoria. *Hearst Castle: The Biography of a Country House*. New York: Abrams, 2000.

——. *Hearst's San Simeon: The Gardens and the Land*. New York: Abrams, 2009.

Keith, Slim, and Annette Tapert. *Slim: Memories of a Rich and Imperfect Life*. New York: Simon and Schuster, 1990.

Lazarovich-Hrebelianovich. *Pleasures and Palaces: The Memoirs of Princess Lazarovich-Hrebelianovich (Eleanor Calhoun)*. New York: The Century Co., 1915.

Levkoff, Mary L. *Hearst the Collector*. New York: Abrams, 2008.

Levy, Jo Ann. *They Saw the Elephant: Women in the California Gold Rush*. Norman: University of Oklahoma Press, 1992.

Lingenfelter, Richard E. *Bonanzas & Borrascas: Gold Lust & Silver Sharks 1848–1884*. Norman, OK: Arthur H. Clark Co., 2012.

Madigan, Nick. "Hearst Land Settlement Leaves Bitter Feelings." *New York Times*, September 20, 2004.

Manns, William. "Silver Sensations." *American Cowboy* 11, no. 5, January–February 2005, 60–65.

Marble, Alice, with Dale Leatherman. *Courting Danger*. New York: St. Martin's Press, 1991.

Marion, Frances. *Off with Their Heads! A Serio-Comic Tale of Hollywood*. New York: Macmillan, 1972.

Martin, Glen. "Back at the Hearst Ranch." *California Coast and Ocean* 23, no. 3, 2007, 3–9.

Meryman, Richard. *Mank: The Wit, World, and Life of Herman Mankiewicz*. New York: William Morrow, 1978.

Milland, Ray. *Wide-Eyed in Babylon: An Autobiography*. London: Bodley Head, 1975.

Miller, Bruce. *Chumash: A Picture of Their World*. Los Osos, CA: Sand River Press, 1988.

Morrison, Annie L., and John H. Haydon. *Pioneers of San Luis Obispo County & Environs*. Los Angeles, CA: Historic Record Co., 1917.

Morton, Don, rev. ed. Camilla Wade, *History of California State Parks*. Berkeley: California Department of Natural Resources, Division of Parks, 1937.

Myers, David W. "Near San Simeon: Hearst Hotel Plan Stirs Controversy." *Los Angeles Times*, September 6, 1987.

Nasaw, David. *The Chief: The Life of William Randolph Hearst*. New York: Houghton Mifflin, 2000.

Newton, Edward A. *Derby Day and Other Adventures*. Freeport, NY: Books for Libraries Press, 1969.

Niven, David. *Bring on the Empty Horses*. New York: G. P. Putnam's Sons, 1975.

Older, Mr. and Mrs. Fremont. *George Hearst, California Pioneer*. Los Angeles: Westernlore, 1966.

Older, Mrs. Fremont. *William Randolph Hearst, American*. New York: Appleton-Century Co., 1936.

Parsons, Louella O. *The Gay Illiterate*. New York: Doubleday, 1944.

Pavlik, Robert. "Shore Whaling at San Simeon Bay." *The National Maritime Museum Association Sea Letter* 43, fall/winter 1990, 16–21.

Proctor, Ben. *William Randolph Hearst: The Early Years, 1863–1910*. New York: Oxford University Press, 1998.

Prowse, Brad. "The Little Horse that Could." *American Cowboy* 3, no. 5, January–February 1997, 64–65.

Raycraft, Susan, and Ann Keenan Beckett. *San Antonio Valley*. Charleston, SC: Arcadia, 2006.

Rogers, Will. "Will Rogers Finds a Haven Out West for Man and Beast." In *Will Rogers' Daily Telegrams: The Hoover Years, 1931–1933*. Edited by James M. Smallwood and Steven K. Gragert. Stillwater: Oklahoma State University Press, 1979.

Robinson, Judith. *The Hearsts: An American Dynasty*. San Francisco, CA: Telegraph Hill Press, 1991.

Shapiro, Michael Edward, et al. *Frederic Remington: The Masterworks*. St. Louis, MO: Abrams, 1988.

Shepardson, Lucia. "An Arabian Stud Farm in California." *Overland Monthly* LVII, January–June 1911, 52–59.

Soto, Debbie. *Glimpses of a Bygone Era: One-Room Schools Along the Hearst Ranch*. San Luis Obispo, CA: Central Coast Press, 2011.

Soto, Robert. *An Old California Family: The Sotos of Cambria*. San Luis Obispo, CA: Central Coast Press, 2011.

Swanberg, W. A. *Citizen Hearst: A Biography of William Randolph Hearst*. New York: Scribner's, 1961.

Taylor, Eva. *Oxcart, Chuckwagon and Jeep: Mission San Antonio, Milpitas Rancho, Military Reservation Memoirs*. San Lucas, CA: Eva Taylor, 1950.

Townsend, Charles H. "Present Condition of the California Gray Whale Fishery." *Bulletin of the United States Fish Commission* Vol. 6 for 1886. Washington: Government Printing Office, 1887.

Turner, John Kenneth. *Barbarous Mexico*. Austin: The University of Texas Press, 1969.

Twain, Mark. "Sam Clemens's Old Days." *The [New York] Sun*, October 16, 1898.

Vaz, August Mark. *The Portuguese in California*. Oakland, CA: I.D.E.S. Supreme Council, 1965.

Vidor, King. *A Tree is a Tree*. Hollywood, CA: S. French, 1989.

"W. R. Hearst, 1863–1951: Death Puts a Quiet End to Press Lord's Unquiet Career." *Life* 31, no. 9, August 27, 1951, 23–31.

White, Richard D. *Will Rogers: A Political Life*. Lubbock: Texas Tech University Press, 2011.

Whyte, Kenneth. *The Uncrowned King: The Sensational Rise of William Randolph Hearst*. Berkeley, CA: Counterpoint, 2009.

Yagoda, Ben. *Will Rogers: A Biography*. Norman: University of Oklahoma Press, 2000.

Young, Dolores K. "The Seaweed Gatherers on the Central Coast of California." In *The Chinese in America: A History from Gold Mountain to the New Millennium*, edited by Susie Lan Cassel. Walnut Creek, CA: AltaMira Press, 2002, 156–173.

Acknowledgments

Creating a book is a communal effort. Many people generously helped me with this volume, and I am grateful to them all.

I received assistance from many librarians and archivists, including Matthew Bailey, National Portrait Gallery, London; Mitchell Barrett, Hearst Corporation Archives; Stacey Behlmer and Faye Thompson, Margaret Herrick Library, Academy of Motion Picture Arts and Sciences; Sue Blesi, Phoebe Apperson Hearst Historical Society; Abbot Chambers, Sausalito City Library; Erin Chase, Jennifer A. Watts, and Anita Weaver, Huntington Library; Rachael Dreyer, American Heritage Center, University of Wyoming; Dawn Dunlap, Cambria Historical Society; Laura Foster, Frederic Remington Art Museum; Victoria Garagliano, Hearst San Simeon State Historical Monument Photo Archives; Sandra Heinemann, Liz Caldwell, Muna Cristal, Michelle Hachigian, Sandy Jennings, Sue Nash, and Jill Urquhart, Hearst San Simeon State Historical Monument Staff Library; Colleen L. Hyde, Grand Canyon National Park; Anthea M. Hartig, Debra Kaufman, and Alison Moore, California Historical Society; Patricia Keats, Alice Phelan Sullivan Library, The Society of California Pioneers; Chuck King, Bureau of Livestock Identification, California Department of Food and Agriculture; Carol L. Low, Will Rogers Memorial Museum; Ken MacLennan, Pleasanton's Museum on Main; Morgan Mangold, National Portrait Gallery, Washington, D.C.; Katherine Marshall, Sotheby's, London; Robin G. McElheny, Pusey Library, Harvard University; Suzi Morris, Arieana Arabians; Robert Pavlik and Paula Juelke Carr, Caltrans; Jonathan Pringle, Cline Library, Northern Arizona University; Peter Runge, Ken Kenyon, Catherine Trujillo, and Laura Sorvetti, Special Collections and University Archives, Robert E. Kennedy Library, California Polytechnic State University, San Luis Obispo; Irene Scheidecker, Butte Silver Bow Public Archives; Susan Snyder, Lorna Kirwan, and David Kessler, Bancroft Library, University of California, Berkeley; Katherine Staab, W. K. Kellogg Library, California Polytechnic State University, Pomona; Charles B. Stanford, New Mexico State University Library; Dace Taube, Doheny Memorial Library, University of Southern California; Marc Wanamaker, Bison Archives; Carolyn Weber, Homestake Adams Research and Cultural Center; Erin Wighton, Jill Fletcher, Richard Potts, and Allan Ochs, History Center of San Luis Obispo County.

I was fortunate to have the chance to interview and receive assistance from many people associated with the Hearst Ranch, including past employees, current employees, and several members of the Hearst family. Their personal recollections and private photographs enhance this volume. I would like to thank John Arnold, Aldo Avina, Mr. and Mrs. Harlan Brown, Roland Camacho, Jim Evans, Barbara Hearst, George R. Hearst Jr., George Randolph Hearst III, Stephen T. Hearst, Chris Herrera, Brian Kenny, Bill Loorz, Elena Macias, Kate Magnuson, Cy Mamola, Charlie and Debra Mitchell, Carl and Mary Negranti, Hermilla Nunez, Ryan Pascoe, Ellard Porte, Tara Scrivener, Marj Sewell, Robert and Debbie Soto, Vernon Soto, Flint Speer, Carmen Torres, Courtney Warner, and Tim Winsor. I would especially like to recognize Michael and K. C. Lynch, the descendants of Virginia Summers Lynch, and Michele and Michael Conroy and Renee Vargas, the descendants of Arch Parks, for opening their extensive photo archives for this publication. Cliff Garrison, Hearst Ranch manager, also generously assisted me on dozens of occasions.

I am grateful to many individuals at the Hearst Corporation, including Lisa Bagley, Frank A. Bennack Jr., Eve Burton, Mike Duncan, Will Hearst III, Esther Ingrao, Sarah Lemke, Paul Luthringer, Susan Macaulay, Kevin McCauley, Maureen Sheehan, and Deb Shriver. I would also like to thank Jim and Debi Saunders and Chanae Rodriguez of the Hearst Ranch Winery. I would particularly like to express my gratitude to Marty Cepkauskas, Director of Real Estate for the Western Properties Division of the Hearst Corporation, and Toyia Wortham, Special Events Director of the Hearst Corporation, who kindly and patiently assisted me numerous times over the past three years.

I also received generous help from the California State Parks staff at Hearst Castle. I would like to thank Doug Barker, George Cartter, Gwendy Cochran, Tom Craig, Wayne Craviero, Alan Fitch, Victoria Garagliano, Felicia Guy, Larry Hatchett, Sandra Heinemann, Regina Ibay, Tracy McConnell, Lisa McGurrin, John Porter, Sue Rauch, Jack Raymond, Peter Romwall, April Smith-Hatchett, Beverly Steventon, Eric Weiss, Elise Wheeler, and Frank Young. I am especially grateful to District Superintendent Nicholas Franco and Museum Director Hoyt Fields, both of whom gave their enthusiastic support to this project.

For logistics and technical assistance, my thanks go to Acme Computers, Mt. Shasta; Lisa M. Cipolla, U.S. Army

Garrison, Fort Hunter-Liggett; John B. Douglas, Joy Bowen, and Ann Ellis, Estrella Ranch; Martin Levin, Cowan, Liebowitz, & Latman; Roger Marlin, ASAP Reprographics, Morro Bay; Bob and Susan McDonald; and Bob Swanson, Swanson Images.

For carefully reading my manuscript and sharing their impressive knowledge and excellent insights, I would like to thank Michelle Hachigian, Dennis Judd, Robert Pavlik, and Ty Smith.

I am also very grateful to my three principal photographers, Richard Field Levine, Steve Miller, and Alex Vertikoff. They captured the essence of the Hearst Ranch in these pages.

This final volume is in fact the prequel to my other two books on Hearst Castle. As I conclude a project we began fifteen years ago, I extend my heartfelt appreciation to the staff at Abrams. It is a joy and an honor to be an Abrams author. I am grateful to Deborah Aaronson, the late Paul Gottlieb, David Blatty, Gabby Fisher, and Elisa Urbanelli. My special thanks go to my accomplished editor, Andrea Danese, her assistant Anna Oseran, and my talented book designer, Darilyn Carnes.

For their encouragement and friendship, I would like to thank Marie Alexander; Robert and Jeanne Anderson; Jo Barbier; Paul Beaver; Karen Beery; Katrina and Michael Berube; Tom Brown; Evelyn Carlson; Robert Carlson; John Carpenter; Martin Chapman; Les and Kyle Cristal; Martha, Rupert, and Hart Deese; Lindi Doud; Michelle Ellis; Elisa Feingold; Samantha Fogg; Stephanie Fuller; Karyn Gerhard; Phillip Gross; Jennifer and Grae Halsne; Burks Hamner; Andrew Harp; Mary Kay Harrington; William Hill; Jeannie Hobhouse; Brett and Natalie Ann Hodges; Natalie Howard; Jerry Howe; the late Huell Howser; Michelle Judd; Wendy Kaplan; Beverly Kirkhart; Robert, Maggie, and Annie Latson; Joyce and Jim Mackenzie; Patrick McGibney; William McNaught; Thomas Michie; Allison Mortimer; Wendy Nielsen; Margie Noble-Englund; Harry O'Neil; Rayena Pavlik; Jack and Trudi Rosazza; Marcella Ruble; Jennifer Sayre; Bruce, Kenji, and Anna Smith; Richard Somerset-Ward; Beverly Walls; Candace Ward; Giles Waterfield; Cecilia White; Jesse White; Robert Wilson; David Wurtzel; and Yoshiko Yamamoto.

When attorney Roger Lyon died in an aviation accident in 2010, Hearst Ranch lost one of its most loyal champions. Roger was instrumental in assisting the Hearst Corporation in its monumental effort to finalize a preservation solution for Hearst Ranch and the San Simeon coastline in 2005. Chapter 10 tells this story and is dedicated to Roger's memory.

My deepest gratitude goes to Steve Hearst, a great-grandson of William Randolph Hearst and the vice president of western properties at the Hearst Corporation. For many of us, Steve *is* the Hearst Ranch. He knows every rock, creek, and tree on its 82,000 acres, and wrote the wonderful foreword to this volume. I have been inspired by his devotion to this special place and his desire to preserve it unaltered.

There are currently more than sixty-five members of the Hearst family, and I haven't the space to express my thanks to each of them individually. But I know they share Steve's love for the ranch and his delight in revealing it to readers for the first time. I would specifically like to mention and thank Steve's father, the late George R. Hearst Jr., to whom this entire book is dedicated. As the oldest grandson of William Randolph Hearst, George embodied much of his grandfather's spirit. Like him, George was a journalist and a rancher who led a remarkable life of achievement and generosity.

Lastly, I would like to thank the three people who have helped me during every part of this journey. They are Muna Cristal, Hearst Castle librarian and guide; Mitch Barrett, Special Projects Coordinator for the Hearst Corporation; and Ruth Latson, my research assistant. This book is their achievement as much as mine.

Index

Photo Credits

The Bancroft Library, University of California, Berkeley: 23 (:2 Hearst, George), 25 (BANC PIC 1963.002:0093), 26 middle (:2 Hearst, Phoebe Apperson), 72 bottom (BANC PIC 1991.064).

Photograph by Mitch Barrett: 18.

Courtesy of Mr. and Mrs. Harlan Brown: 202.

California Department of Food and Agriculture, Bureau of Livestock Identification: 2, 138 middle, 191.

California Historical Society: 26 bottom (FN-36529/CHS2013.1113), 40 (FN-32545/CHS2013.110), 57 top left (Gift of the Janet Peck Estate, FN-1092/CHS2013.115), 57 bottom left (Gift of Janet Peck Estate, FN-24989/CHS2013.1109), 67 (FN-28161/CHS2013.1111), 100 top left (PC-PA.086.005), 128 (PC-PA.086.006).

Julia Morgan Papers, Special Collections, California Polytechnic State University: 62 bottom left, 74 right, 95 top, 162, 189 right.

Cambria Historical Society (Sebastian Family Collection): 34, 45 top and middle, 82 top, 83, 159 bottom.

Courtesy of Conroy and Vargas Families, Descendants of Arch Parks: 60 top, 90–91, 113 top left and bottom right, 114 bottom, 122 bottom, 169.

Frederic Remington Art Museum, Ogdensburg, NY: 60 bottom, 114 top.

Victoria Garagliano/© Hearst Castle®/CA State Parks: 8 middle, 176.

Harvard University Archives: 57 top right (HUP Follansbee, John G. [1]).

© Hearst Castle®/CA State Parks: 113 bottom left, 122 top, 189 left.

The Hearst Corporation: 3, 12, 14, 15 top, 26 top, 36, 62 top left, 65, 66, 68, 72 top, 109 top, 110 top, 116–117 top, 126–127, 130, 131, 136, 157, 161 top, 173, 178, 184 all, 192–193, 210–211, 213 all.

History Center of San Luis Obispo County: 11, 82 bottom, 120, 125.

The Huntington Library, San Marino, CA: 20 (2606), 62 bottom right (CL.359.229).

Photographs by Richard Field Levine: Front and back jacket, endpapers, 6, 8 top and bottom, 9, 17, 93, 102, 115 bottom, 118, 134–135, 137, 138 top, 139 all, 140 all, 141 all, 143 top, 144, 145 all, 146 all, 147, 148–149, 150, 186–187, 194, 195, 196, 197, 198, 199, 203, 204–205.

Courtesy of Bill Loorz: 152 top, 159 top.

Courtesy of the Virginia Lynch Family: 15 bottom, 45 bottom, 73, 103, 164.

Photographs by Steve E. Miller: Binding case, 13, 16, 19, 29, 32, 35, 39, 42–43, 46, 54, 58–59, 70, 76–77, 78, 79, 81, 88, 106, 109 bottom, 117 bottom, 121, 123, 155, 166, 208–209.

National Portrait Gallery, London: 57 bottom right.

Pleasanton's Museum on Main: 62 top right. Courtesy of Marjorie Sewell: 190.

The Society of California Pioneers: 24 (Lawrence & Houseworth Albums No. 1136/914 Nevada City, c. 1860–70. Gift of Florence V. Flinn).

Sotheby's: 100 right (Cecil Beaton Studio Archive).

University of Southern California, on behalf of the USC Special Collections, Los Angeles: 174 bottom (*Los Angeles Examiner* Negatives Collection, 1950–1961), 179, 182.

Photography by Alexander Vertikoff: 1, 4–5, 30–31, 47, 48, 49, 50, 52, 53, 85, 86–87, 94, 95 bottom, 96, 110 bottom, 132, 143 bottom, 153, 158, 160–161, 165, 170–171 all, 172, 180, 183, 200–201, 207, 214–215.

Marc Wanamaker/Bison Archives: 74 left, 99, 100 bottom left, 174 top.

Will Rogers Memorial Museums, Claremore, OK: 105.

Courtesy of Barbara Read Wilson: 115 top.

Courtesy of Tim Winsor Photos: 113 top right.

Editor: Andrea Danese
Designer: Darilyn Lowe Carnes
Production Manager: True Sims

Library of Congress Control Number: 2013935888

ISBN: 978-1-4197-0854-1

Printed and bound in China
10 9 8 7 6 5 4 3 2

THE ART OF BOOKS SINCE 1949
115 West 18th Street
New York, NY 10011
www.abramsbooks.com

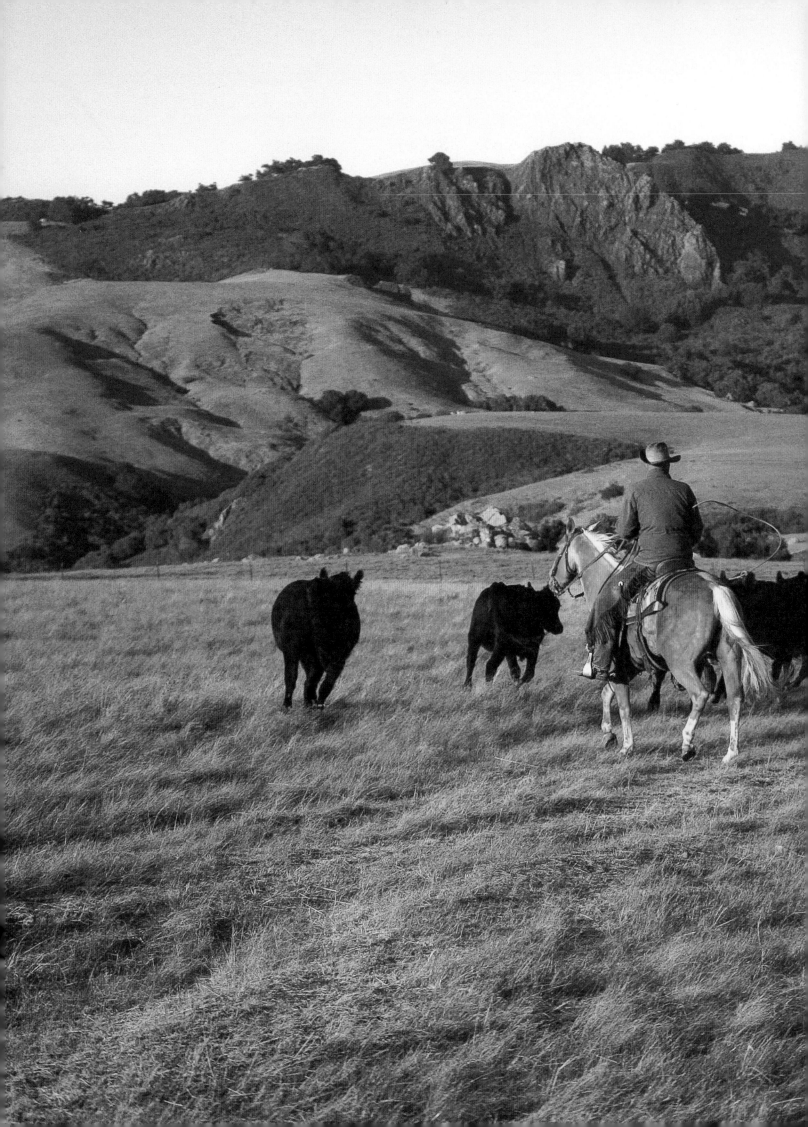